Prato

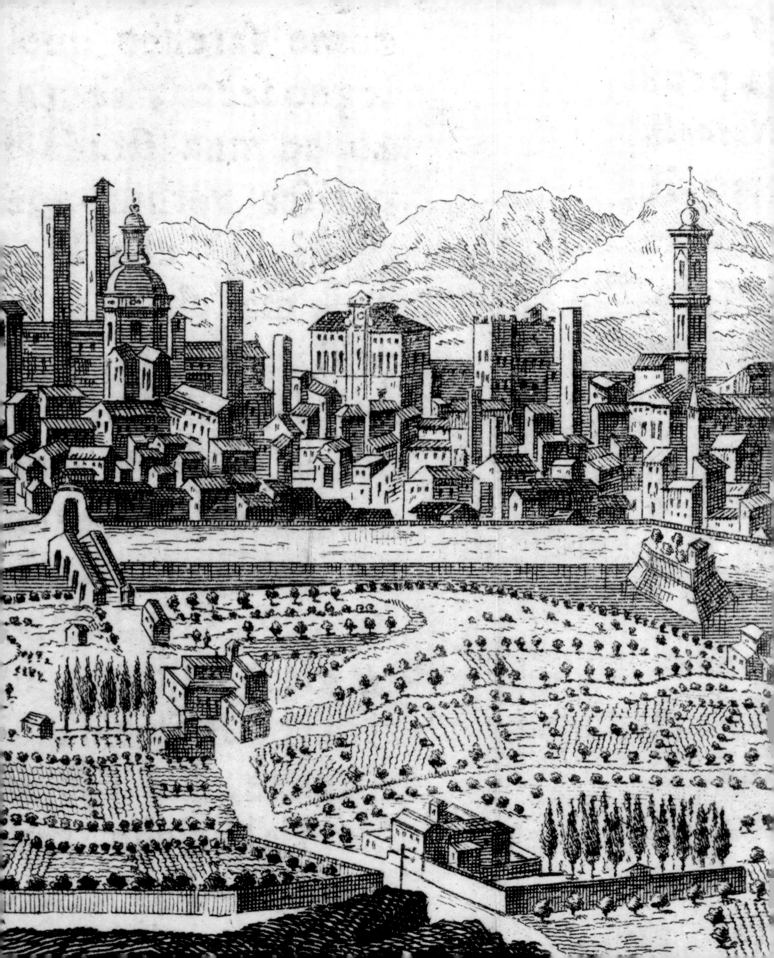

Prato

Architecture, Piety, and Political Identity
in a Tuscan City-State

ALICK M. McLean

YALE UNIVERSITY PRESS

NEW HAVEN AND LONDON

Publication of this book has been aided by a grant from the Millard Meiss Publication Fund of the College Art Association.

Designed by Leslie Fitch Design
Set in Scala and Scala Sans by Leslie Fitch
Printed in China through World Print

Library of Congress Cataloging-in-Publication Data
McLean, Alick Macdonnel, 1958–
Prato : architecture, piety, and political identity in a Tuscan city-state / Alick M. McLean.
 p. cm.
Includes bibliographical references.
ISBN 978-0-300-13714-9 (cloth : alk. paper)
 1. City planning—Italy—Prato. 2. Sociology, Urban—Italy—Prato. 3. Cities and towns, Medieval—Italy—Prato. 4. Prato (Italy)—Buildings, structures, etc. 5. Prato (Italy)—Social conditions. 6. Prato (Italy)—Economic conditions. 7. Prato (Italy)—History. I. Title.
HT169.I82P76 2008
306.0945'519—dc22 2008001372

A catalogue record for this book is available from the British Library.

The paper in this book meets the guidelines for permanence and durability of the Committee on Production Guidelines for Book Longevity of the Council on Library Resources.

10 9 8 7 6 5 4 3 2 1

Frontispiece: La Città di Prato nel Gran Ducato di Toscana, in *Istoria del mondo*, Salmon. Venice, 1757. Florence, Private collection.

P. vi: Detail, Agnolo Gaddi, *Michele Dagomari Arrives at Prato*, 1392–94. Prato, Cathedral of Santo Stefano, Chapel of the Sacred Belt.

P. 203: Pietro di Miniato, Detail, *Michele Dagomari and Francesco di Marco Datini flanking entry to Prato with Virgin above*, after 1395. Prato, Palazzo Pretorio, Ground Floor.

Cover illustrations: (front) Detail, Agnolo Gaddi, *Michele Dagomari Arrives at Prato*, 1392–94. Prato, Cathedral of Santo Stefano, Chapel of the Sacred Belt; (back) Map of Bisenzio watershed, Territory of Prato, nineteenth century. Prato, Biblioteca Roncioniana, Codex 436, carta 1.

To my family

CONTENTS

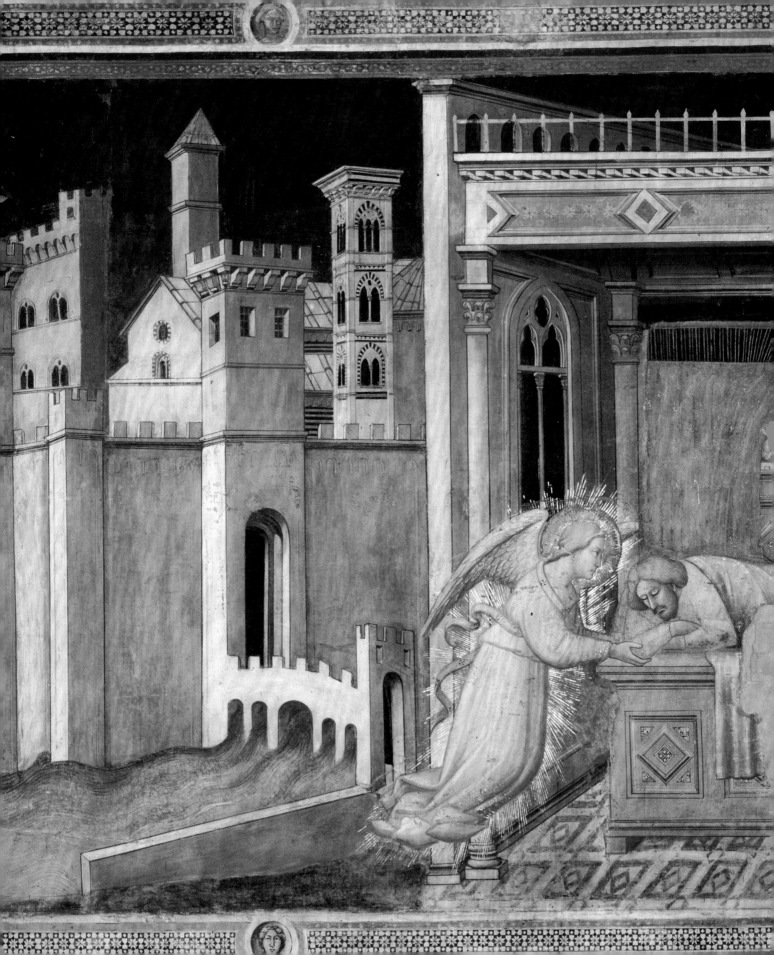

PREFACE: THE URBAN EVERYMAN

Everyman: Both Strength and Beauty forsaketh me—
Yet they promised me fair and lovingly.

Like Everyman in the late medieval English morality play, the medieval commune of Prato in Tuscany sustained the virtues and vices that could be found in every other city of its time. The city planning, architecture, politics, faith, and daily life of the Pratese were typical of late medieval Italy. Prato was ordinary, not extraordinary, yet so ordinary as to be nearly allegorical. In fields such as urban and architectural history, which chronicle the built environment, the story of the ordinary is seldom told. Prato began at the millennium and continues today as a city of laborers, artisans, and entrepreneurs. Its urban design was consistent with its other forms of cultural expression. Civic, religious, and private institutions and individuals used language, art, and ritual to frame urban commercial life apologetically, rendering the city as something grander, more noble. Such a contradictory self-image was typical of most communes in late medieval Italy. Architecture and urban design contributed to this double identity. The built environment provided the foundation for the economic and political successes of Prato and other medieval Italian city-republics. It also opened cracks in their identity that exposed them to eventual collapse.

My approach in this book is monographic and comparative, tracing the origins, construction, and demise of Prato in comparison to other cities that influenced, paralleled, or competed with it. Between the twelfth and fourteenth centuries, Prato existed as a sovereign state, the commune of Prato. It was one of the hundreds of free communes that rose in the northern half of the Italian peninsula during this period, an era which has its only analogue with the golden age of the Greek city-states fifteen centuries earlier. Scholarship on the Italian communes has focused on larger examples of city-republics such as Venice, Pisa, Siena, and Florence. The extraordinary quality of Italy's city-states —that even the smallest centers existed autonomously beside the largest—has received less attention. In

the present study I approach this aspect of the Italian city-state by looking critically at the intermediate-scale commune of Prato. What allowed minor sovereign communes like Prato to form beside, and even compete with, larger centers? When small centers eventually fell to larger cities, did this occur just by being outsized, or may there have been internal reasons? And may the eventual failure of larger Italian communes have been for some of these same reasons?

The analytical framework in this book is provided by urban architecture. Most studies have treated urban plans, streets, and piazzas as an autonomous discipline, as the background, or, at best, the reflection of the changing fortunes of cities. I submit that the process of building the image of the city constructed, united, and motivated the social body. Changes in urban form were not formally autonomous, nor did they simply reflect society, but rather they contributed to the successes and failures of the citizens of Italy's city-republics.

The scale of the city, its typicalness, and the extensive historical records recommend medieval Prato as a case study of urban architecture and political development. Prato does have one unusual characteristic that facilitates such a study. It has no Roman roots, making it possible to study the formation of communal architecture in a pure state. Its exclusively medieval origins were largely economic, whereas most communal centers were based on episcopal sees and originally on Roman municipal administrations. In this sense Prato provides an extraordinarily clear picture of what differentiates the medieval commune from the ancient city, namely the importance of commercial growth rather than exclusively military or administrative hegemony. The history of urban form in Prato begins, in fact, as a dialogue between commercial and administrative infrastructure and monuments, develops with the two increasingly in conflict, and ends with the dominance of monumental architecture serving administrative needs and neglecting, even undermining, the image and infrastructure of commerce.

The death of communal Prato resulted partly from citizens' incapacity to sustain an architecture capable of expressing their commercial self-reliance. Instead, they built themselves a city that was reassuringly familiar, assimilating or synthesizing a legacy of Roman imperial and early Christian conquerors and priests, yet utterly foreign to their own nature as artisans, laborers, shopkeepers, merchants, industrialists, and bankers.

□ □ □

It has taken me nearly fifteen years to finish this manuscript. The challenge was less that of revising my 1993 doctoral dissertation on Prato than of convincing myself that there might exist an audience for another kind of architectural history. This story is not of a great city, not even a name-brand one. The issues are typical

of the time and place. The protagonists are mostly working class or bourgeois. While all this may be far from what most audiences expect from the Italy of the popes, the Medici, and the Renaissance, it may not be so distant from the world of the reader, whether an academic researching Italy, who may sometimes miss seeing him- or herself in portraits of the past, or anyone who loves Italian towns or cities anywhere. The Everyman of this preface title could as easily be a citizen of New Haven, Connecticut, Syracuse, New York, or urban, even suburban, anywhere, as one of Prato or of medieval Italy. This book encourages one to see in the past oneself, rather than magnificent but distant others, and invites one to displace the myth of Italian urbanism and architecture with a rich but imperfect reality that regular folk first constructed, and then squandered. The recuperation of Italy as a popular, rather than elitist, construction may in turn provide courage to today's normal folk to build cities, in America or elsewhere, in the image not of others but of themselves.

ACKNOWLEDGMENTS

This book began as a dissertation, which in turn grew out of a six-week travel research grant, from the Princeton University Italian Studies Committee, to study the origins of the idea of magnificence expressed in Leon Battista Alberti's *De Re Aedificatoria* and in his Palazzo Rucellai. After three weeks in Florence I traveled to more than twenty communes in central and northern Italy, seeking Alberti's sources in their public palaces and domestic architecture. The first city I visited after Florence and Rome was Prato, where I arrived at the main station, located a distance from the medieval center. As I made my way from the station, a series of new buildings greeted me with the twentieth century, when I expected the fourteenth. Although they are not particularly noteworthy as monuments, they gave me the sensation of being in a city that was very much alive. After reminding me of the present — even with a Henry Moore statue punctuating my route — Prato then thrilled me with its past, first with the white crystalline geometry of the Frederick II's Castello dell'Imperatore, then with the city walls, the Piazza San Francesco, the Palazzo Datini, the Palazzo Pretorio and Piazza Comunale, the *avelli* of San Domenico, and finally the Duomo of Santo Stefano and its piazza. I sensed the same vitality in these medieval structures and spaces as I felt with modern Prato, and I became curious as to what culture could have fostered such a city, and what circumstances could have caused the hiatus in its development between the fourteenth and nineteenth centuries. I brought these questions to the other communes I visited during the remainder of my stay, but in no place did I note the same mix of past and present as registered in buildings spanning half a millennium. The disarming charm of medieval Prato diverted me from the study of Renaissance magnificence: it showed another, more appealing splendor on the scale of the entire community, where public structures and their spaces had not yet broken from the fabric of the city, though in important cases they already showed tendencies toward the purity and classicism that was to isolate Renaissance monuments.

What further coaxed me to shift the locus and period of my dissertation topic to Prato was the Pratese themselves, whose enthusiasm about their history is as remarkable as their willingness to share it. The citizens of Prato opened their city to me as they do to all that stray from the better known centers. The directors and custodians of Prato's religious and civic monuments and museums introduced me to their buildings and collections and made me feel altogether welcome. The shop-keepers along the Piazza del Duomo generously assisted me in my explorations of their basements and interiors. The employees of the Azienda di Promozione Turistica di Prato and of the City Planning Department were equally helpful and encouraging. The Pratese responsible for the town's libraries, archives, museums, and cultural sites made their extensive resources most accessible, particularly at the Archivio di Stato, Biblioteca Roncioniana, and Biblioteca Comunale "A. Lazzerini," the Assessorato alla Cultura of the Comune di Prato, the Museo Civico, the Musei Diocesani, and the Ufficio Beni Culturali of the Diocese of Prato. To all these Pratese and all that helped guide me to sources and images for my work, I offer my thanks. Particular individuals helped me in ways that went well beyond their institutional responsibilities: Claudio Cerretelli of the Musei Diocesani, Don Renzo Fantappiè of the Ufficio Beni Culturali of the Diocese of Prato, Paolo Piacini of the Museo dell'Opera del Duomo, Diana Toccafondi, Maurizio Acciai, and Signora Stabile Leonarda in Cavazzi of the Archivio di Stato, Cesare Grassi of the University of Florence, Maria Pia Mannini of the Musei Comunali, Don Enrico Bini, and the staff of the Biblioteca Roncioniana, Rita Iacopino of the Assessorato alla Cultura of the Comune di Prato, and Renzo Menici, photographer, together with his whole family, most recently Federico, one of his three photographer sons, who took some of the photos in this volume.

Institutions, foundations, and individuals outside Prato provided me with the resources to research and write the dissertation, and then to transform it into a book. I thank the directors and staff of the Kunsthistorisches Institut, of the Archivio di Stato di Firenze, of the Biblioteca Nazionale, and of the Villa I Tatti in Florence, as well as of the other libraries and research institutes where I worked, the Kunsthistorisches Institut and Universitätsbibliothek in Heidelberg, the Bibliotheca Hertziana in Rome, the Andover-Harvard Divinity School, Fine Arts, Loeb and Widener libraries at Harvard University, Bird Library at Syracuse University, the Syracuse University in Florence Library, the Roche Library at MIT, the Firestone, Marquand, and Urban and Environmental Studies libraries at Princeton University, and Deans Robert Maxwell and Ralph Lerner, Librarian Francis Chen, and the staff of the Princeton School of Architecture who were there during my doctoral work. Soprintendente Dott. Bruno Santi and Architetto Fiorella Fachinetti,

of the Soprintendenza per i Beni Architettonici e Artistici di Firenze, Pistoia e Prato, generously facilitated new photo campaigns and authorized their publication in this book. Grants from the Italian Studies Committee and Princeton Honorific Fellowship at Princeton University, the Fulbright Committee, Samuel Kress Foundation, and Architectural History Foundation funded my research, which was further supported by the Macintosh computer, programs, and printer provided to me by Andres Duany and Elizabeth Plater-Zyberk, Architects, by the School of Architecture, Princeton University, and by the generosity of Bernt Ture von zur Mühlen. I furthermore thank the Millard Meiss Publication Fund of the College Art Association for its contribution to funding the publication of this book.

The intellectual and personal support of more individuals than there is space to mention has made this work possible. Patricia Brown, David Coffin, David Friedman, Richard Goldthwaite, Robert Gutman, Robert Maxwell, Alan Plattus, and Marvin Trachtenberg inspired me to pursue urban history. My original dissertation advisors and readers, Howard Burns, Alan Colquhoun, Lester Little, John Pinto, Chester Rapkin, and Anthony Vidler, have guided me with insight, criticism, and patience. My fellow doctoral students and the professors at the Princeton School of Architecture and Department of Art and Archaeology, and at the Harvard University Graduate School of Design and Department of Fine Arts, and later my own students at the University of Miami School of Architecture, at the GSD, at Syracuse University in Florence, and other researchers and acquaintances in Florence and Prato have prodded, questioned, and inspired me. Brendan Cassidy alerted me to important aspects of the sculpture and iconography of the Sacred Belt of the Virgin in Prato. Caroline Bruzelius, Claudio Cerretelli, Giorgio Ciucci, William Connell, Roger Crum, Barbara Deimling, Ted Dengler, Richard Goldthwaite, Douglas Harper, Richard Ingersoll, Dick Marshall, Susan McLean, Madeleine McLean, Maureen Miller, Felicity Ratté, Bart Thurber, and Diana Toccafondi read and commented on the text at various moments in its gestation. Carol Krinsky proofread my manuscript from beginning to end; Diana Toccafondi helped me with transcriptions of the documents; Devorah Block and Hall Powell helped me on various photographic excursions, and Felicity Ratté, Douglas Harper, Mario Ronchetti, and Renzo Menici offered important tips in producing the photographs here; Federico Menici and Francesco Guazzelli reshot some of the images and helped me with the lighting and composition of others; Barbara Deimling, Rosangela Roque, Nikki Ryu, Andrea Tanganelli, Caitlin Claire Latini, and Emily Schiavone helped me produce and procure drawings and images, with Emily Schiavone and Barbara Deimling helping considerably with the timeline as well; Alexandra Korey has helped with other images, as well as with proofreading, indexing, and figure captions. The editorial staff at Yale University Press, especially

Michelle Komie, my acquisitions editor, John Long, Heidi Downey, Jenya Weinreb, Daniel Nagler, Daniella Berman, Mary Mayer, Leslie Fitch, and Patricia Fidler, have made the transatlantic production of this book a pleasure. Trudl and Waldemar Deimling and Bernt Ture von zur Mühlen have provided me with quiet and beautiful havens for writing during many summers, and have made me feel at home in Andernach and Frankfurt. My sister, Susan McLean, and particularly my mother, Madeleine McLean, have made me similarly at home during my stays in Boston and Manchester-by-the-Sea, and my mother's understanding and generosity have helped enormously throughout the many years this work has developed.

Few authors are so lucky to have an in-house reader, editor, draftsperson, photographic assistant, and organizer capable of performing just about anything with precision, speed, and intelligence. One person provided me such assistance, and more, first when we were students, and after as we have moved from Florence to Princeton and Miami, to Rome and back to Florence. For her enthusiastic support, logical rigor, patience — and even impatience — and for her inspiration and love, I dedicate this work to my wife, Barbara Deimling, and to the three children she has borne into our family, Sophia Mathilda, Gaia Alba, and Samson Carden McLean.

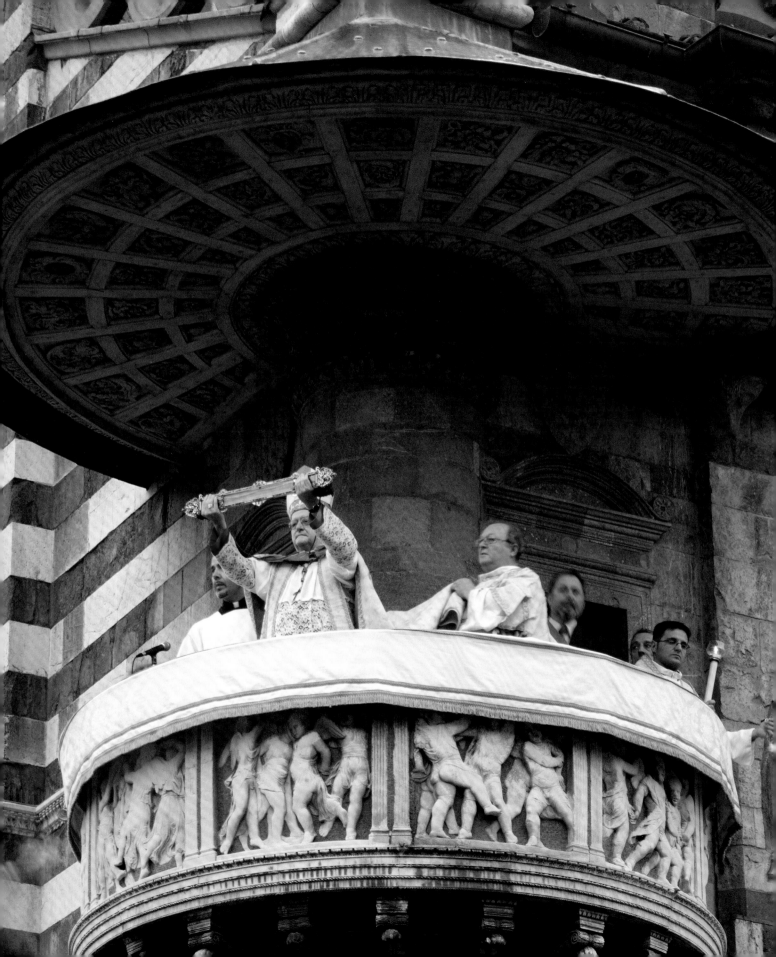

The Urban and Political Representation of the Pratese

A city is a self-portrait of its people. From the moment of their origins as a community, the residents of the lower Bisenzio valley, known today as Pratese, portrayed themselves in their choice and construction of their environment. Of the many motifs in the urban tableau of the Pratese, one has remained particularly characteristic: the Piazza della Pieve, today's Piazza del Duomo (fig. 1.1). As it appears now, it is at once monumental and desolate. The scale of the space and the grandeur of the Cathedral of Santo Stefano are at odds with the haphazard elevations of the secular buildings framing the church. The split between exalted monument and modest fabric is exacerbated by the grandeur intimated by the piazza's urban approaches. Via Garibaldi, originally Via del Borgo, originates from Prato's market square to the east and ends at Santo Stefano's dramatic campanile (fig. 1.2). Via Mazzoni, originally Via della Pieve, is the town's main artery, arriving from Piazza San Francesco and Piazza Comunale to the south. It terminates at the highly articulated western portal of the south cathedral elevation (fig. 1.3). Via Serraglio feeds from the north into Largo Carducci, which frames the western façade of the church and its remarkable exterior pulpit. Once in the piazza, however, the visitor finds the spell of Santo Stefano's elevations broken by its disappointing secular counterparts. The piazza elevations are too low to frame the vast space. It appears less grand than empty, recalling more the metaphysical spaces of Giorgio de Chirico than the bustling crucibles of daily life that one expects in a medieval Italian piazza.

This disjunction of scale is not uncharacteristic for the region. Brunelleschi's cupola, for all its fame, hovers above the cone of vision of spectators in Florence's tight cathedral piazza, coming into focus only at a distance along approach streets, and at a scale that becomes understandable only from the periphery of the city and beyond. The huge façade of Siena's unfinished cathedral extension is perceptible only because the church remains incomplete. Even so, the viewing space provided by the unfinished nave is constricted. The completed portions of the Siena Duomo

PAGE 2

FIGURE 1.1 Cathedral of Santo Stefano, three-quarter view. Prato.

PAGE 3

FIGURE 1.2 Approach to Santo Stefano from Via del Borgo (today Via Garibaldi). Prato.

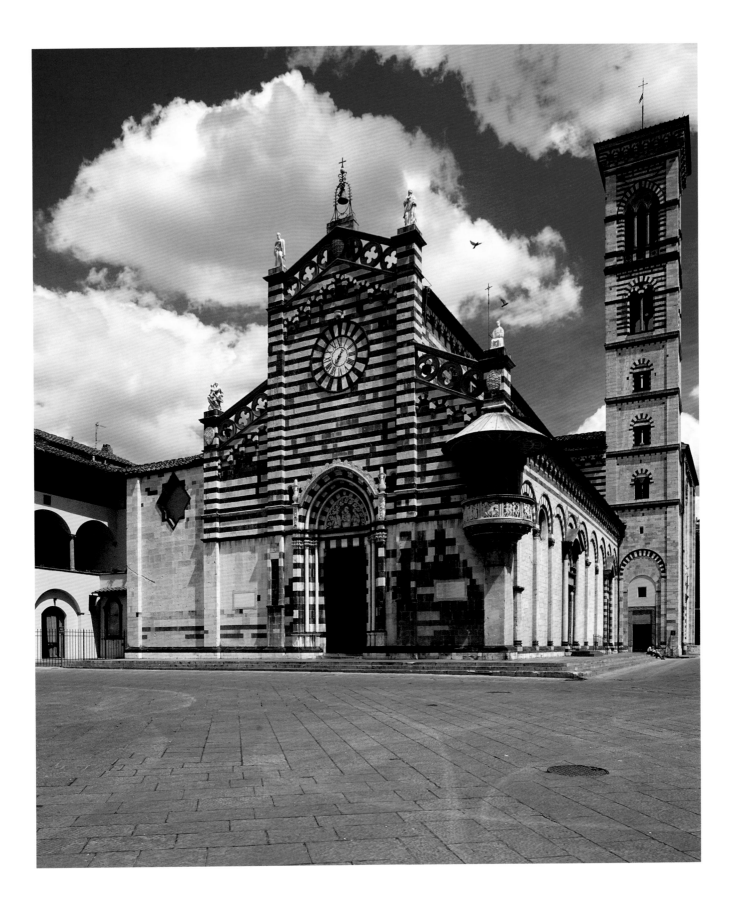

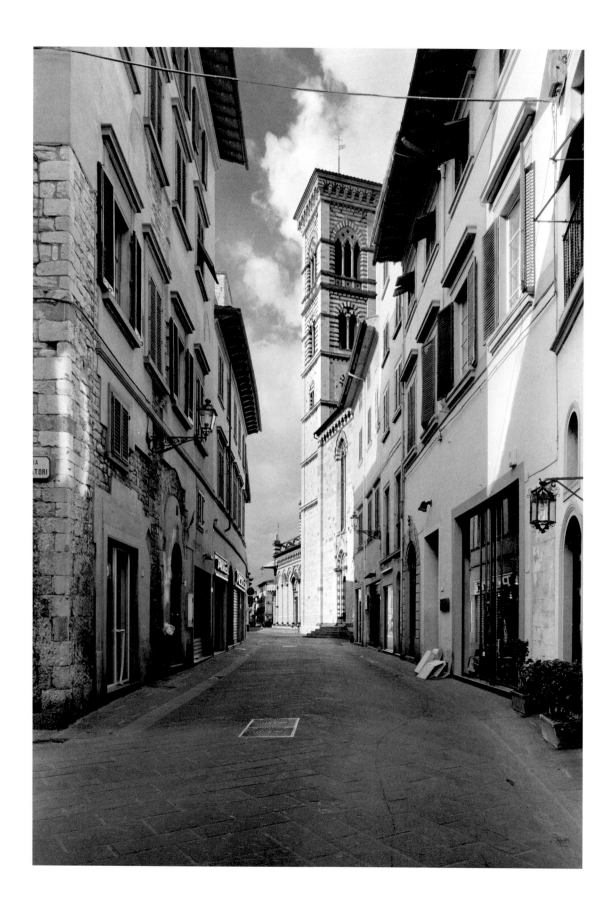

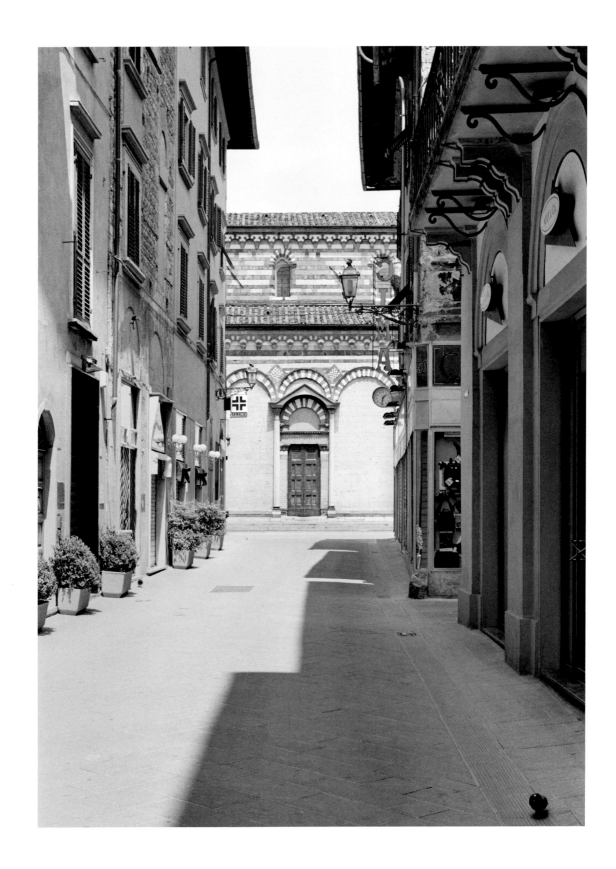

overwhelm their setting, and constitute coherent elements in the urban landscape only from the edge of town.

OPPOSITE

FIGURE 1.3 Approach to Santo Stefano from Via della Pieve (today Via Mazzoni). Prato.

Within this catalogue of oversized Tuscan monuments, Prato's Piazza del Duomo distinguishes itself with an excess of space rather than structure. The aesthetic intentions of the Pratese are partially explained in a series of housing and aesthetic ordinances determining the design process. The legislative origins of these and similar ordinances from nearby communes indicate that urban design was considered a political tool in communal Tuscany. The Florentines and Sienese constructed disjunctive local readings of their cathedrals to provide well-composed territorial readings. They did so during a period when regional expansion at once guaranteed communal sovereignty and diverted resources and political power from both neighborhoods and neighbors to the apparatus of the emerging territorial state. The fact that Prato ultimately failed to protect its sovereignty by no means precludes an intention on the part of the Pratese to build a territorial-scale space in order to compete. The legislative evidence, in fact, points to such a policy, justifying the redesign of the piazza as a draw for population from the countryside and neighboring towns. Such a clear statement of political intentionality behind the design of a public space is rare. The same legislation goes so far as to critique the existing space, deeming it "too big and deformed," and proposes a new configuration and elevations more attractive to potential residents. It is curious in the presence of such aesthetic intentionality that the new space, albeit well formed, remains awkwardly large.

An attempt to understand this apparent mismatch between intent and design leads away from considering architecture, and even urban space, as political tools, and to the more fascinating and fundamental question of how architecture, and, particularly in the case of Prato, public space, can document, even negotiate, political relationships. It remains to be seen whether the findings of this inquiry apply to contexts outside of Prato or communal Tuscany. On the one hand, there appears to have been an unusually strong tradition in Prato of designing and encoding spaces with social and political meaning. That may be as unique to the town as its very distinct linguistic dialect. On the other hand, the proximity of very different dialects — whether of speech, building, or space making—in the communes of medieval Tuscany is itself evidence for localized means of expressing a quasi-national sovereignty that has seldom occurred in Western history since the era of the Greek city-states. The near parity of the scale of the state with the scale of the community is extraordinary. Even more extraordinary is the potential that existed for these nation-communities to work, to gather, to celebrate, and finally to define themselves in single, coherent spaces where, as in the Greek *agora*, politics and *polis* corresponded. As with the ideal citizenry of five thousand in Aristotle's *Politics,* a

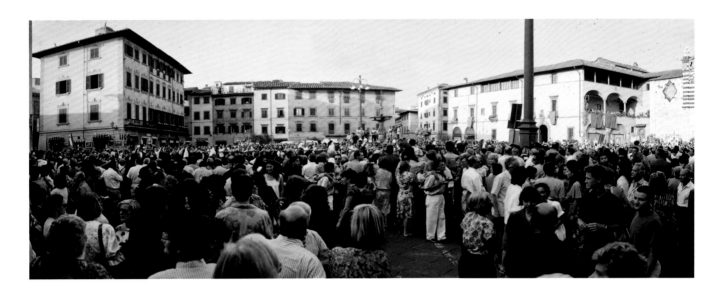

modest scale afforded a place for the ordinary individual in the representational apparatus, which, arguably, was as much spatial as institutional.

Prato's tradition and scale of space-making allow us to study both highly localized and potentially very general relationships between urban and political representation. The peculiarities of some of its spaces, such as the scalar disjunction of Piazza del Duomo, compel a further investigation into the causes for anomalies in urban representation and their consequences for political representation. Prato, or rather the communal Pratese, failed in sustaining their sovereignty. So did the Sienese and, eventually, the Florentines. The fact that all of these communes began their decline, albeit differently paced, during the same time that they initiated their most significant urban projects introduces the possibility that these urban projects may be partly to blame for the fall of each commune. It is not common practice to attribute agency to buildings. The significant investment of wealth and expectations in the art of city-making during the communal period nonetheless justifies a near inversion of the historiographic tradition. Cities were neither passive settings, nor simple reflections of the world of politics, faith, commerce, and daily life. Building, space, institution, and spectator fused at the sites of urban representation to condition the actions of the citizenry, and their concepts of the state and of themselves.

Evidence for this general claim, as well as for the characteristics and agency of Prato's Piazza del Duomo, need not be sought exclusively in archival legislative records or archeological remains. The power and danger of urban design lies in its persistence in our environment. Prato is no exception. On four days each year—Christmas, Easter, the feast of the Assumption of the Virgin, and September 8—the Pratese of today transport the piazza, themselves, and any willing visitor back to the space of the communal period. These are the dates when the clergy

and communal officials of Prato present the city's—and one of Tuscany's—most venerated holy relics, the Sacred Belt of the Virgin, from the pulpit at the façade of the church. The most notable of these dates is September 8, the birthday of the Madonna, when the piazza fills with enough people and activities to make its scale appear fitting and the space appealing, even though the secular buildings facing Santo Stefano have been altered since the fourteenth century. The choreography of the events of this feast day furthermore explicates the peculiar geometry of the piazza and its minor trapezoidal forespace, Largo Carducci (fig. 1.4). The ritual begins with costumed representatives of cities from across Italy parading through the medieval streets of Prato to Piazza del Duomo, entering its west end from Via Serraglio. Upon their arrival at Largo Carducci, which links Via Serraglio to the piazza, each processing group, clad in the colors of its particular city, breaks rank with the groups behind it and begins its final, direct approach to bishop and town magistrates seated at the church façade. At this moment the marchers of each group, from Palermo or Gubbio or Siena or Prato, shift their steps to the rhythm of choreographed displays of courtly or chivalric pomp, ranging from dances to music to flag throwing, in honor of the priesthood and civic dignitaries seated before them, and in veneration of St. Stephen and the Virgin, the patron saints of the church. The entire area in front of the Duomo is engaged by both players and spectators, leaving only the base of the piazza's L-shaped space, running along the side façade of the church, uninvolved, though thronged, with its audience stretching to catch glimpses of the panoply in front of the main portal.

When the procession and music end, those waiting beside the arcaded flank of Santo Stefano begin to win the reward for their patience, as they and the rest of the throng before the church shift their gazes from the western threshold of the piazza to the exterior pulpit protruding from the exposed southwest corner of the church, above the eye level of onlookers (fig. 1.5). At this moment the church becomes the stage for a new set of rituals building up to the climactic rite of the day. At first, trumpeters appear on the pulpit to introduce the coming event, and then deacons swing incense to purify the space. Finally, the bishop himself arrives, holding high the object of veneration, the Sacred Belt of the Virgin, and gradually turns its gem-studded case for the faithful on the side and in front of the church to behold (fig. 1.6). The ritual sequence, of trumpets, incense, and relic, repeats two more times, after which the bells of the medieval church campanile ring the end of the ceremonies and the crowd disperses.

The ritual presentation of the Sacred Belt of the Virgin today does much to explain the configuration of the piazza. The trapezoidal Largo Carducci provides an ideal entry point, aligning the parading venerators with the façade of the church in the final sequence of their passage through the city. The vast scale of the main space accommodates the overflow crowds, far too large to fit within the church of Santo

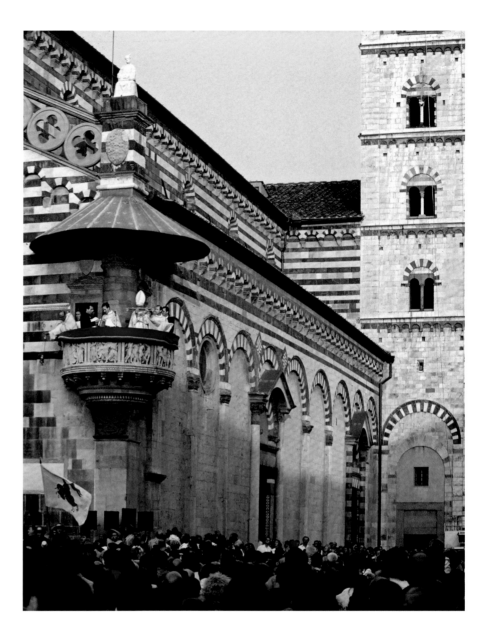

Stefano. The breadth of the space facing the side elevation of the church extends the piazza's capacity, and takes advantage of the corner location of the pulpit.

Reading backward from the contemporary ritual presentation also hints at the political significance of the piazza and church: the communal officials co-presiding over the ceremonies received from neighboring and distant communes the same reverence as the adjoining church canons and bishop. Only at the final demonstration of the relic itself did the bishop become the single focus of attention. What appears as a matter of protocol today was a matter of great political seriousness in the late thirteenth and the fourteenth centuries, when the commune began to promote the cult of the Belt. The evidence for the earnestness with which the

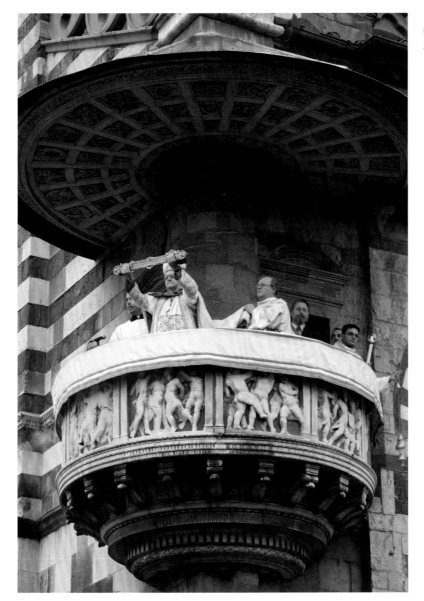

FIGURE 1.6 Presentation of the Sacred Belt of the Virgin. Prato.

commune composed its role and the setting for the presentation of the Sacred Belt exists in a sequence of urban design ordinances that town legislators enacted between 1297 and the fall of the commune in 1351. This legislation culminated a tradition of conscious place-making in Prato dating from its origins. What follows is an examination of this tradition of place-making as a process of social construction, in which the ordinary, sometimes special, and sometimes odd characteristics of public spaces at once housed and defined the Pratese, from the origins of their commune to the point of its fall shortly after—and partly because of—the reprogramming and redesign of Piazza della Pieve as a site of sacred spectacle.

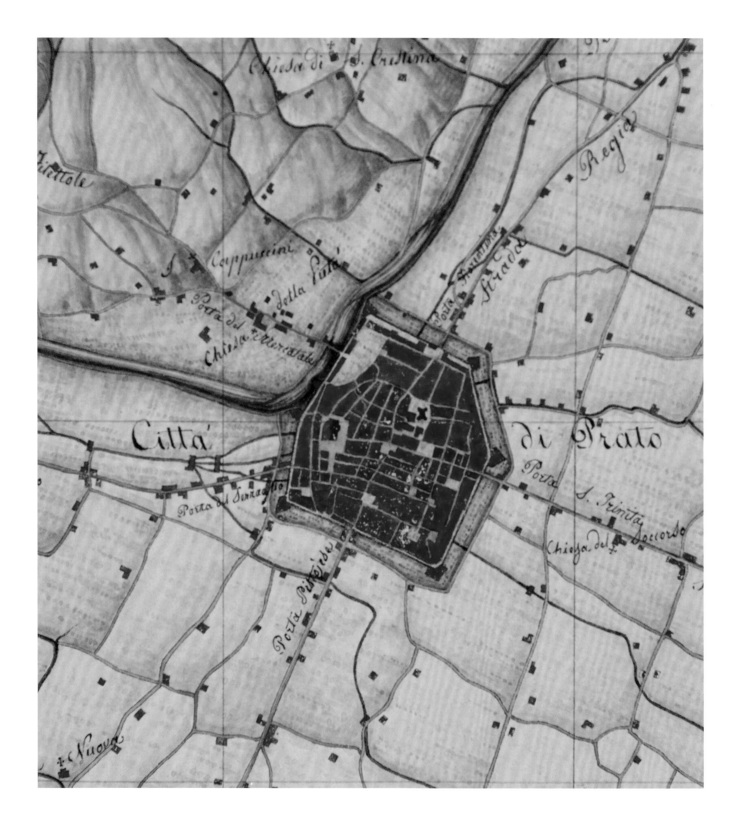

Prato Before Prato

Polycentric Settlements, Monuments,
and Social Order

Topography, Economy, and the First Recorded Settlements of the Lower Bisenzio

Until the end of the first millennium, the people who eventually became Pratese portrayed their community through an urban design that was rudimentary yet essential: selecting their site and establishing the infrastructure to channel its resources. They inhabited the area where the Bisenzio river concludes its rapid descent from the Apennines and begins a slower, meandering course to its confluence with the broader Arno river to the south. The exceptional aspect of the site was the absence of anything exceptional. The settlement had no monuments from Roman antiquity, whether an urban wall, grid, or public structure. The Bisenzio valley had been peripheral in the topography of Roman Tuscia, forming part of the natural boundary between Pistoia, the *civitas Pistoria,* fifteen kilometers to its west, and Fiesole, *civitas Faesulae,* nineteen kilometers to its east.[1] Only the linking road between these two towns, the Via Cassia, registered the presence of Rome in the valley, originally crossing the river where Prato exists today or slightly upstream from that point.[2] After the establishment of the colony *Florentia,* eighteen kilometers to the east, around 41 B.C., the Romans centuriated the Arno plain up to and possibly beyond the confluence with the Bisenzio. At this point, the Via Cassia was probably shifted slightly toward the south to link to Florence (figs. 2.1, 2.2).[3]

Toponyms—place names—and the presence of rural parishes, deriving from Roman agricultural communities, testify to the numerous minor Roman settlements that had been established throughout the area during and after its territorial gridding, known as centuriation, by the Romans.[4] Centuriation provided an effective means for land distribution and improved transit. Furthermore, along the lower Bisenzio valley, near its confluence with the Arno, centuriation included land recuperation, allowing once swampy areas to become arable.[5] The prevalent form of Roman settlement, well adapted to the area's rural economy, was the villa, originally a self-sufficient agricultural manor.[6] Villas had been plentiful enough to

PAGE 12

FIGURE 2.1 Regional map of Prato with Bisenzio, Arno, Ombrone rivers, Roman roads to Fiesole, Florence, and Pistoia, Roman centuriation between Florence and Prato, and medieval canals and roads.

DETAIL: FIGURE 2.2

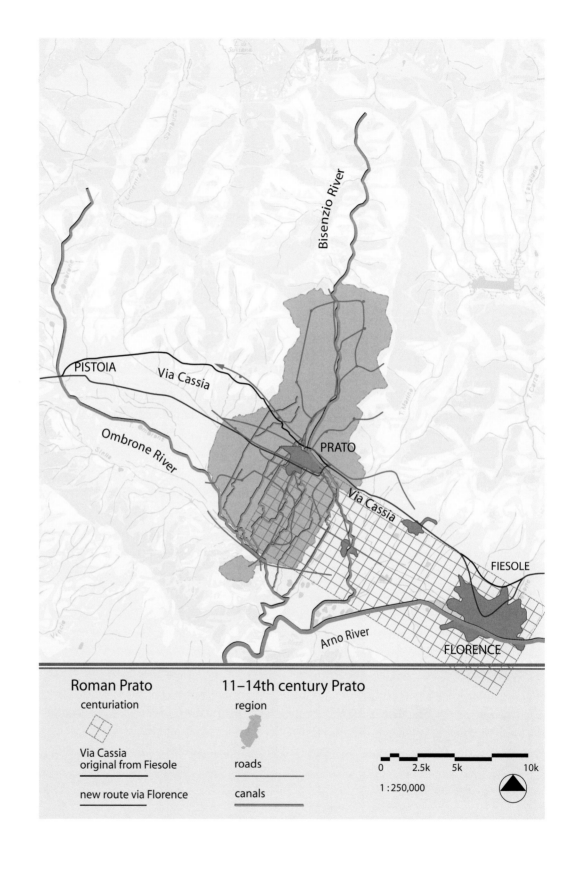

Bisenzio River

PISTOIA Via Cassia

Ombrone River

PRATO

Via Cassia

Via Cassia

FIESOLE

Arno River

FLORENCE

Roman Prato

centuriation

Via Cassia
original from Fiesole

new route via Florence

11–14th century Prato

region

roads

canals

0 2.5k 5k 10k

1 : 250,000

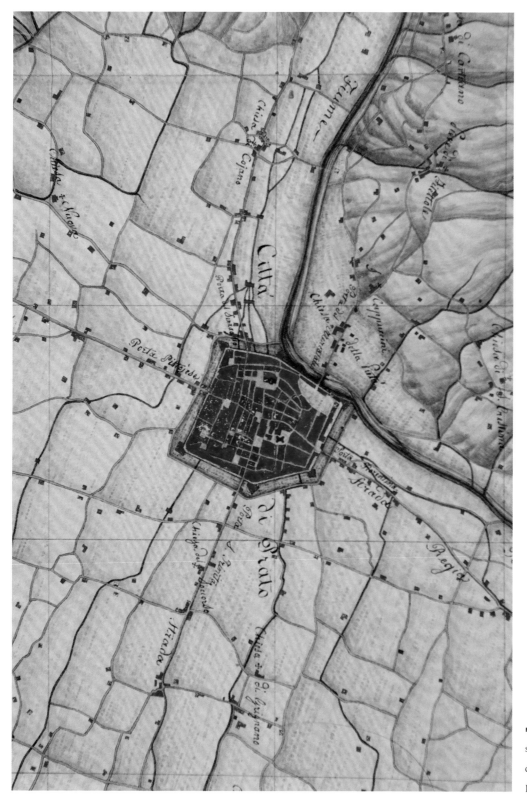

FIGURE 2.2 Map of Bisenzio watershed, Territory of Prato, nineteenth century. Biblioteca Roncioniana, Prato, Codex 436, carta 1.

maintain a pattern of small landholdings and attached rural communities across the Bisenzio plain. Though they declined in late antiquity, they were adopted by later settlers. When the Lombards took over much of northern and central Italy, they established themselves at as many as forty-eight villas in the area of Prato.[7] They followed the Roman framework of resettling returning soldiers. In this and other ways, they sustained some aspects of Roman mores and social structure and contributed to the rural economy, especially to animal husbandry.[8] The extent of Lombard settlements in the lower valley was limited by frequent skirmishes with the Byzantine Exarchate. Battle lines fluctuated across the ridge of the Apennines, isolating the higher elevations from the plains. After the victories of Liutprand over the Byzantine Exarchate in the early eighth century, and particularly with the arrival of the Carolingians, the upper, mountainous part of the Bisenzio valley became reintegrated with its lower portion. This provided a basis for the growth of settlements, particularly at the point where the river shifts course at the plain.[9]

The Carolingians sustained the upswing in population of the ninth century with their rationalization of land tenure, formalizing Lombard and Roman practices in their feudal hierarchy. Geography favored the development of north-south mountain passes and east-west regional thoroughfares. The point of intersection among roads, population, and economy was the site that was to become Prato. Residents began to shift their activities from subsistence farming to commercial farming and husbandry, industry, and trade. They channeled the force and volume of the Bisenzio river as early as the tenth century into an extensive canal system across the plains. These canals powered mills for grain and olive presses, provided water for some of Tuscany's earliest cloth manufacturers, and allowed for the distribution of industry and agriculture throughout the valley.[10] One of the clearest representations of this economic activity is the capillary extension of the north-south and east-west highways, branching across the territory. Incipient Prato was becoming the hub of a network of communication, water power, and commerce, linking all the minor settlements of the territory to its mills and marketplace, and from there to the more distant centers at Florence and Pistoia, and beyond the Apennine pass.[11]

By the tenth century, the Bisenzio had grown from a valley of minor importance to an area with greater population, a more developed economy based on agriculture, husbandry, manufacturing, and trade, and better communication links along its spine than had existed during or since the Roman centuriation of the area. At least at this early stage, the site and its mix of transportation, water energy, and commercial potential determined the character of the area far more than its attenuated connection to a rural Roman past.

As early as the ninth century, the inhabitants of the lower Bisenzio valley are recorded to have begun clustering into two discrete settlements at the junction of mountains and plain (fig. 2.3). They were known as Borgo al Cornio, deriving from the Lombard "burg" for walled settlement and the Latin *cornus,* a type of cherry tree, and as Castello di Prato. As these communities grew and thrived, it was inevitable that they would attract the notice of their longer-established neighbors. A document of the Florentine cathedral canonicate mentions for the first time a "loco Cornio" in 880.[12] From this moment, it was simply a matter of time until these communities ceased to define themselves in isolation. Geography and self-reliance had been enough to establish the original character of the Bisenzio settlements. Site and labor were not, however, sufficient to provide the residents of the Bisenzio valley with a clear model for formalizing their community as it grew from two villages to a unified town and as it began to interact with its more established neighbors. The institutional and architectural frameworks for defining the emerging communities were therefore not generated exclusively from the town's rural setting, but were also adopted or imposed from outside. The frameworks varied in their appropriateness to the settlements' characters and needs.

The Borgo al Cornio and the Provost Church of Santo Stefano

The second documentation of the future site of Prato by one of its powerful neighbors, the bishop of Pistoia, occurred in 994, referring to a *burgo* associated with the parish church of Santo Stefano.[13] The text indicates that the settlement not only had been recognized by the bishop of the major city to the west, but also had become a part of his diocese. The document records the sale of various goods and of a house near the parish church. The governing authority ratifying this transfer of property was the bishop of Pistoia, through his delegate at the local parish church. A document from a few years later renders the picture more fully. A 998 diploma of Emperor Otto III records that both Borgo, now with its full name, Burgo al Cornio, and the church of Santo Stefano were under the control of the bishop of Pistoia.[14] Santo Stefano provided an outpost of the bishop's authority to secure a site at the edge of his diocese, bordering those of Fiesole and Florence. The nature of the outpost indicates that the bishop considered it more important than a regular parish church. He established it as a provost's church, or *propositura.* The full name of the church provided this new community with its first link to a cultural framework beyond the Bisenzio valley: it was the "church of Saint Stephen, the first martyr." The patronage of St. Stephen emphasized the linkage of the church with the first martyr of Christianity, recorded in the *Acts of the Apostles* (7: 54–60) as stoned to death at the edge of Jerusalem.[15] It furthermore associated the site

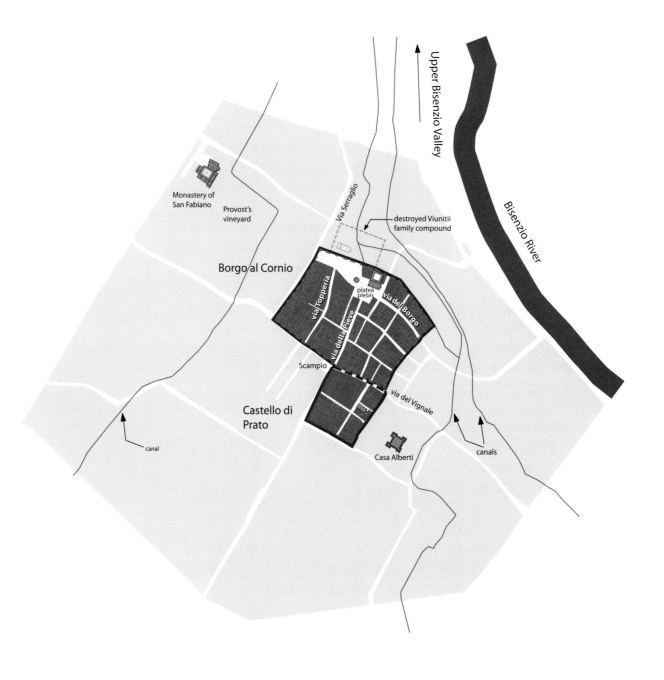

Upper Bisenzio Valley

Bisenzio River

Monastery of
San Fabiano

Provost's
vineyard

Via Serraglio

destroyed Viunitii
family compound

Borgo al Cornio

platea
plebis

via Topperia

via della Pieve

via del Borgo

Scampio

via del Vignale

Castello di
Prato

canal

canals

Casa Alberti

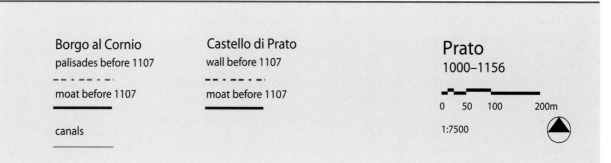

Borgo al Cornio

palisades before 1107

— · — · — · —

moat before 1107

——————

canals

——————

Castello di Prato

wall before 1107

— — — — —

moat before 1107

——————

Prato
1000–1156

0 50 100 200m

1:7500

with one of the earliest and most important pilgrimage churches in central to northern Italy, just across the Apennines beyond the source of the Bisenzio. This was the church of Santo Stefano in Bologna, the earliest portions of which date back to the fifth century.[16]

OPPOSITE

FIGURE 2.3 Plan at 1:7500, before and after 1107 destruction of fortifications and before 1157 communal walls. Borgo al Cornio and Castello di Prato (Prato).

The civil transaction recorded in the 994 document indicates that the provost's church of Santo Stefano provided the administrative as well as religious center for the settlement. A mix of secular and religious authority characterized the broad powers of the early medieval episcopal hierarchy. During the decline of Roman imperial authority, bishops throughout western Europe had assumed most of the administrative functions of the imperial magistrates preceding them.[17] Though their power was temporarily eclipsed by Byzantine patriarchs, by Lombard *gastaldi* after the sixth century, and by Carolingian counts and dukes in the eighth and ninth centuries, bishops began to reclaim their late antique and early Christian authority in the vacuum of power following the dissolution of the Carolingian empire in the ninth century.[18] Episcopal courts sustained both secular and religious hegemony up to the twelfth-century formation of lay communal governments. Then as today bishops subdivided their territories according to Roman hierarchy and terminology, placing clerics locally, in each *plebs,* or parish, a jurisdictional unit that derives from the late Roman administrative term for "people."[19]

The term provost, or *proposto,* referred to the head of a provost's church, the propositura. It derived from the Latin *praepositus,* which designated a local representative of imperial Roman authority. The provost of Santo Stefano was somewhere between a parish priest and bishop. Canons affiliated with the church augmented his authority to minister to the laity in his region. Together with his canons, the provost formed the institution of the propositura, which, at the beginning of the eleventh century, controlled at least eight rural parishes, extending from the Bisenzio to the Bardena river.[20] By delegating authority to the propositura, the bishop of Pistoia was able to maintain closer control over the population of these distant parishes than if he were to have continued to administer them directly from Pistoia.[21] This episcopal delegation of authority had developed from Roman and Carolingian administration.[22] Borgo al Cornio, albeit a purely medieval foundation, became thus part of a political-religious hierarchy that dated back to classical antiquity.

The Pieve of Santo Stefano at Borgo al Cornio was primarily a territorial and administrative entity, and only secondarily a building. The building took on its significance in housing the institution of the propositura, and in representing the wide range of its official activities. From the church, the provost administered justice, witnessed contracts, regulated the marketplace, and served as an arbiter, purportedly above local interests, as a representative of the Roman Christian *imperium* at the new settlement.[23] The church therefore not only provided a practical

structure where the local faithful might congregate for sacred and secular activities. It also represented the relationship of the community to the ultimate authorities of church and state, following the tradition of its typological ancestor, the Roman basilica, which had housed both local and centralized imperial authority.[24]

Insufficient archeological evidence exists to reconstruct just how the church architecture expressed the relationship of the institutions to the laity during the tenth and early eleventh centuries. The earliest coherent portions of the structure that have been excavated are those from the late eleventh century, which will be described in the next chapter. There are sufficient documentary records, however, to provide a schematic picture of the urban presence of the church complex by the early eleventh century. The buildings of the propositura comprised a church, a baptistery, the canons' residence, or canonicate, and, eventually, a cloister. They were situated within the Borgo al Cornio settlement, which was surrounded by rudimentary fortifications (see fig. 2.3).[25]

The establishment of the complex of Santo Stefano was part of the Church's reinvigorated building campaign at the end of the tenth and throughout the eleventh centuries. In Tuscany, for instance, thirteen monasteries were founded in the eighth century, but only three in the ninth, and none during the tenth until 978, when the Badia of Florence was founded by Willa, the mother of the Marchese Ugo. Between 978 and 1010, however, nineteen foundations or refoundations are documented.[26] Of at least fifty parishes documented to have been established in Tuscany before 1000, most underwent reconstruction or expansion between the eleventh and thirteenth centuries. Only after 1000 did rural or minor urban parishes begin to show signs of architectural or decorative sophistication.[27]

In Prato, as throughout Tuscany, the early eleventh-century upswing in building activity appears directly linked to economic and demographic change. The growth in agricultural productivity, industry, and commerce increased the wealth of town residents and supported a rise in population.[28] More residents with more wealth meant higher potential revenue for the bishop, as well as greater prestige. The decision by the bishop of Pistoia to furnish the parish of Borgo al Cornio with a provost in charge of villages throughout the Bisenzio valley suggests a policy to favor the activity and wealth of Borgo al Cornio and the entire area on which its economic and population growth depended.[29]

The Castello di Prato and the House of Alberti

The most significant of the settlements presided over by the propositura was another, more fortified settlement immediately adjoining Borgo al Cornio, Castello di Prato. Though first recorded in 1027, Castello di Prato probably dates from at

least a century earlier.[30] Its walls and nucleus were built by the Alberti counts as a typical feudal village serving their adjoining fortified residence, the Casa Alberti. The Alberti appear to have inherited or acquired many of the villas and the territory occupied by the Lombards in the area. Alberti holdings extended up the Bisenzio valley, beyond Vernio, roughly following the river's watershed.[31] The first official document of enfeoffment of the Alberti dates from 1103, although they are already mentioned as counts in 1028 and 1075.[32]

The Alberti's enfeoffment by the Holy Roman Empire confirmed a status in the area at least equal to that of the propositura. The propositura may even have been located at Borgo al Cornio by the bishop to provide a counterbalance to the Alberti presence. In fact, when Emperor Otto III mentions the propositura in his brief of 998, he was accepting, even encouraging, checks and balances between regional institutions, a policy common to emperors and popes since Charlemagne. The location of the parishes, churches, and monasteries under the propositura's jurisdiction provides further evidence for this policy: they follow the lines of the Alberti territory, occupying each of its centers of population. Given the good relations between the emperor and church during the tenth and early eleventh centuries, this counterbalancing of power may just as well have been perceived as an alliance between the bishop of Pistoia and the Alberti, with the former accepting de facto if not de jure the latter's territorial holdings by mirroring them with those of his own ecclesiastical vassal, the provost of Santo Stefano. The two forces together would certainly have formed a barrier to any potential incursions from Fiesole or Florence. The absence of any record of threats by these neighbors up to the beginning of the twelfth century suggests the utility of this combination of episcopal and feudal power for the territorial integrity of the diocese of Pistoia.

The institutional and built presence of the bishop of Pistoia at the propositura marked his assertion of hegemony over an area that for the first time in its history was worth controlling. The presence of the Alberti, and indirectly the Holy Roman Emperor, indicates that the bishop was not alone in his interest in the area. Through the propositura and the Alberti, the church and empire offered to the Bisenzio valley the same services they purported to provide to localities throughout medieval Italy: interlocutors with God, a supra-local legal and juridical structure, as well as divine and military protection. Sanctity was available only through the church structure; law, justice, and protection were attainable only through church and imperial representatives. The church of the provost, his parish structures in minor villages, and the castle and protective walls of the Alberti functioned like the holy vestments of the provost or the armor and heraldry of the Alberti. They clothed in exaggerated form the abstract—some would say imaginary—benefits

of divine and political hierarchy to the paired villages of Borgo al Cornio and Castello di Prato.

The Canonicate as Negotiator Between Church, Castle, and People

The interrelated goods offered by the bishop of Pistoia, the Alberti, the pope, and the Holy Roman Emperor only partially explain the construction of Santo Stefano and its relation to the other churches along the Bisenzio valley. Simple assertion of divine and political hierarchy would have failed to address, and could even have undone, the local economic self-reliance that made the area worthy of consideration in the first place. One component of the Santo Stefano complex indicates that the bishop of Pistoia and the propositura intended their institution and its architecture to negotiate with the incipient Pratese, rather than only to assert power.

This component is the residence of the canons, the canonicate of Santo Stefano. Unlike contemporary monastic residences at complexes such as at Cluny or Montecassino, this was a modest construction with little to buffer its holy residents from the profane environment of the town (see fig. 3.1). The canonicate extended from the north wall of the church to the walls of the town, and was located between the canons' garden and a cemetery.[33] Its accessibility was consistent with its siting in the town, and with the variety of secular and religious activities the canonicate sustained. Its functions ranged from housing members of the propositura to providing the site for signing important contracts and accords.[34] It comprised the canons' living quarters and a small enclosed area functioning as a rudimentary cloister. The architecture, its siting, and the documented activities indicate that the propositura had constructed its canonicate as an intermediate space between sacred and profane, as a locus for contact between clergy and the laity.

It is impossible to overemphasize the influence of the canons and their architecture on the lay community that was to become Prato. The impact of the canons on rural and urban centers in Italy of the period remains, in fact, little studied and underestimated. Canonicates were hybrid institutions, linked both to the episcopal hierarchy and to the tradition of monasticism. They consisted in a brotherhood of canons, directly paralleling monastic brotherhoods, living under an order — generally that of St. Augustine — and presided over by a bishop or provost, who functioned like an abbot as the leader of the brotherhood. While the bishop or provost was not answerable to his congregation for his decisions, he was answerable to his canons, who were organized as a parliamentary body. Like abbots, bishops or provosts had to receive approval from the canons for certain decisions, and the decision-making process of canons was deliberative and democratic.[35]

At the time of the first mention of Santo Stefano, the western Christian institution of canons was in transition. During the ninth and tenth centuries, canonicates functioned as intermediaries between the church and the laity, but generally in ways that had little to do with their holy mission. Canons frequently owned church property, seemingly a contradiction in terms, leased it out for their personal profit, and even tried to pass it on from one generation to the next, undermining the inalienability of church goods. They were using church offices to extend the wealth and power of their noble families. While the church property in question offered significant income from agricultural tenancy, lessees also provided a second type of revenue — tithes to local churches, together with gifts and testaments. As the agricultural economy of the Bisenzio improved, both types of revenue would have increased. At the same time, the more that the economy diversified into industry and trade, the more the second form of income — tithes, gifts, and testaments — increased. While canons holding individual village benefices could assure the payment of tithes by either force or threat of damnation, they could rely less on intimidation to assure gifts or testaments.

As voluntary gifts and testaments became significantly larger in the overall potential revenue of a parish, the institution of canons, like the church in general, began to feel internal and external pressure to change. Canons had to woo, more than take, wealth from parishioners. While they could not offer the military protection or legal assistance of their feudal counterparts, they could distinguish themselves with their ministry of sacred goods, ranging from masses, marriage, and baptism to preaching and the remission of sins. However, so long as they were perceived to be accruing individual wealth through these offices, they compromised the apparent sacredness of the offices. By the mid-eleventh century the order of canons, and indeed the entire church, began reforming itself, addressing both their ministry and their perceived wealth. Canons began to model themselves increasingly on the apostles and their *vita communalis,* or life in common. They became active in addressing the needs of the lay congregations. In reformed brotherhoods, canons gave up all personal wealth, which the brotherhood then held in common. The apostolic mission and lifestyle of reformed canons increased dramatically their appeal to the laity and their potential for winning voluntary gifts and testaments. While individual canons and their families faced a loss of income and power, the institution of canons grew considerably in its prestige, and their associated churches, parishes, and diocese became wealthier.

The canons' establishment by 1048 at Borgo al Cornio was at the beginning of this period of reform. As a new foundation, the canons of Santo Stefano were not yet accustomed to the wealth and privileges of benefices and prebends of earlier-

established canons elsewhere. As was characteristic of many semirural and rural canonicates, they may have submitted more easily than their urban brothers to the apostolic mission and lifestyle. While the siting of their building was consistent with a reforming agenda, accessible but inconspicuous, we do not have enough documents to tell us whether it was officially reformed.[36] What is clear is that the presence of canons at the propositura of Santo Stefano afforded the propositura and the bishop of Pistoia a second means for addressing the laity, beyond a purely hierarchical relationship.

The simplicity and urban siting of the canonicate at Borgo al Cornio facilitated and bore witness to the canons' mission of fraternal organization and evangelism. That the location of a canonicate in the center of a town was perceived to be of major significance for the reform of the church is documented in the twelfth century by the astute analysis of the major apologist for the canons, Anselm of Havelberg, Bishop of Havelberg and later Archbishop of Ravenna (†Milan, 1158). Anselm distinguished the practitioners of the core concept of monastic and canonical life, the *vita apostolica,* or the life in common sworn by the disciples of Christ in the primitive church, by their location. Those sited nearest to or within lay settlements were by nature closer in behavior to the apostles of the primitive church than those sited more remotely: "some of them are separated from the tumult of society altogether…whereas others are placed near men in towns and castles and villages…and still others live among men."[37] Anselm made it clear throughout his text that he considered the fraternal organizations living "among men" to be superior to their more isolated counterparts. They were living a life in poverty, holding their goods in common, a necessary but not sufficient element to constitute a vita apostolica—and were also engaged in the first core apostolic activity, preaching, and ministering to the laity.

Anselm reflected accurately the fundamental change that the notion of religious brotherhood had been undergoing during the eleventh and twelfth centuries, based on an originary interpretation of the vita apostolica.[38] Anselm's support of a faithful New Testament interpretation of the life in common—of both shared goods and proselytizing—met with disapproval from some monastic establishments and many bishops.[39] The threat that the canons posed to the existing religious order was not only a rhetorical one, but also a political one, eclipsing rural monasteries and even their bishops in wealth and prestige, and in some cases even unseating bishops and supporting popular revolts.[40]

Given the canons' ideology in the eleventh and twelfth centuries, their presence as a brotherhood and their representation of that presence in an urban canonicate appear to have constituted nothing less than a time bomb planted in the midst

of outmoded ways of hierarchically organizing and centrally ruling religious or secular communities. No model could have been better timed or more appropriate for industrious citizens, such as those of the Bisenzio valley. Not only did the canons provide a blueprint for collaborative coexistence, matching the polycentric organization of Borgo al Cornio and Castello di Prato, but their apostolic mission also valorized the active over the contemplative life, and labor over meditation. Through the canons, the once remote dream of Augustine's *City of God* could equally be projected in the cloister and in the city streets.

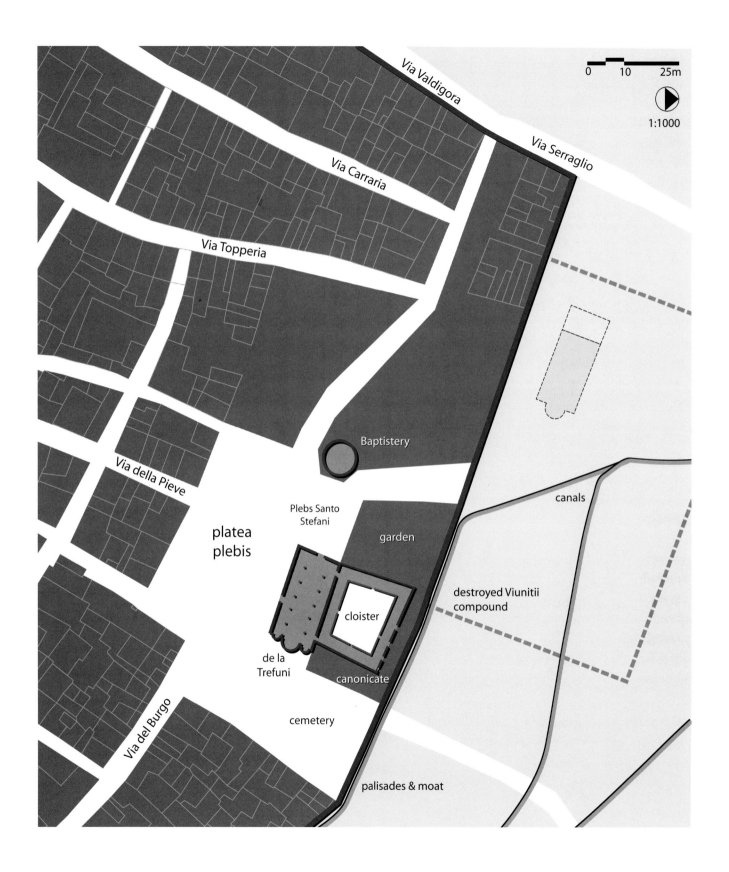

Via Valdigora

Via Serraglio

0 10 25m

1:1000

Via Carraria

Via Topperia

Baptistery

Via della Pieve

canals

Plebs Santo
Stefani

platea
plebis

garden

destroyed Viunitii
compound

cloister

de la
Trefuni

canonicate

cemetery

Via del Burgo

palisades & moat

CHAPTER THREE

Prato Unified and Independent
Centralized Urban Expression

The Toponym of Sovereignty

The initial impact of the bishop of Pistoia's establishment of the provost and canons at Santo Stefano in Borgo al Cornio appears to have been positive for all parties involved. The papers of the propositura indicate a marked increase in activity at the Pieve of Santo Stefano beginning in the early eleventh century. The parish was becoming the site and institution of local authority, strengthening symbiotically the bishop and provost's tradition of hierarchical rule and the canons' apostolic mission to live and to inspire the life in common. The growing importance of the propositura paralleled the continued growth of the settlements in the eleventh century. As the two communities and eight parish congregations under its control thrived and multiplied, the propositura began to show signs of shifting its responsibilities from emissary of the bishop of Pistoia to representative of the local populace (fig. 3.1).

The institutional development of the propositura was a natural consequence of the mandate of the provost and canons, supported implicitly by the reform-minded bishops of Pistoia, to take seriously their role of caring for the souls of their congregations. This development was paralleled by an increase in the secular duties of the propositura, which was at once a natural expression of the traditional power vested in the provost by the church hierarchy and a necessary response to a growing and more economically, socially, and therefore administratively complex environment. In the crucible of the Bisenzio valley, which provided both a geographic definition and, through the Alberti landholdings, a feudal territorial coherence to the spiritual and temporal mission of the propositura, the fusion of pastoral liberality with secular authority became temporal autonomy.

The bishop of Pistoia realized late and with understandable alarm that in the particular situation of the Bisenzio valley, delegating control was tantamount to losing it. The more strongly Pistoia reacted, the more the varied parties and sites along the Bisenzio near Santo Stefano united to form a political collectivity centered

FIGURE 3.1 Plan at 1:1000 showing Santo Stefano complex, c. 1000–1106, before 1107 destruction of walls. Borgo al Cornio (Prato), platea plebis (today's Piazza del Duomo).

at the propositura, independent from the bishop of Pistoia. By the beginning of the twelfth century, the provost, canons, Alberti counts, and laity had joined forces to give both a name and an architectural expression to something that the traditional logic of imperial Roman and episcopal cities denied could exist—a new *civitas,* replete with territory, named Prato.

The first evidence for the development of a unified community along the Bisenzio dates from April 21, 1031. On this day the title Prato was first used to signify the region between the Bisenzio and a smaller river to the west, the Bardena: "in loco et finibus Petianense prope Prato, fini fluvio Bisentione usque ad fluvio Bardena."[1] Between 1084 and 1097 three documents mention the location of Santo Stefano as Prato.[2] In 1147 its piazza is mentioned for the first time. Again, the title of the location is Prato.[3] This displacement of the toponym Borgo al Cornio by the name connected with the Alberti's settlement at Castello di Prato seems strange, given all evidence that the major administrative, though not military, authority in the area at the beginning of the twelfth century was that of the propositura of Santo Stefano, located in the Borgo. The Alberti appear to have had only limited jurisdiction by the late eleventh century, even at the Castello di Prato adjoining their *casa.*[4] There was a further peculiarity of this bias of community identity. During the time that the two settlements were fusing under the name of Prato, the walled Castello di Prato seems to have been losing its importance as the center of population and activity, with the emphasis shifting to the unwalled area by the Pieve.[5]

The shift in usage from Borgo al Cornio to Prato as the toponym of the site of Santo Stefano registered a spatial identity centered at the site of religious and increasingly administrative authority, the church and piazza of Santo Stefano, but verbally connected with the local feudal power, the Alberti counts. The reason for this lies most likely in the military power of the Alberti, which made them uniquely capable of organizing the defense of both of a unified town and its territory, across which they had stationed their castles.[6] The military associations during the period of the term pratum, as a grazing area for horses, or as a marshalling ground for cavalry and troops, would only have reinforced the message that the new community was politically unified, as well as militarily defensible.[7] The defensive character of the name is further supported by the mid-twelfth-century unification of the town with a single circuit of walls, when the consular regime of Prato rebuilt the fortifications of the Castello and Borgo on a larger scale, encompassing both villages.

The extension of the name Prato to the entire area may even indicate the formalization of the alliance between the Alberti and the propositura implied in their stable relations, as described in the previous chapter. The Alberti were the strongest military force in the region. Their fortress in Prato was their principal seat: docu-

ments throughout the eleventh and twelfth centuries record even distant members of the family as being "Alberti di Prato."[8] Alliance with the Alberti brought with it the backing of their overlord, the Holy Roman Emperor. This chain of secular authority seems to represent an ideology opposed to the early Christian vita communalis espoused by the canons residing at Santo Stefano. However, the canons had already enjoyed the protection of the emperor and his vassals since at least the tenth century. In the case of Prato, long-standing associations with the Alberti may have been sufficient to retain ties of good faith that justified formalizing an alliance despite the heightened rhetoric of the Gregorian reform movement in the second half of the eleventh century. An added incentive on the part of the provost, canons, and their congregation to engage in this alliance was that only with the protection of the Alberti could they assert and defend their regional sovereignty.

The Architecture of Sovereignty

The application of the name Prato to the location of Santo Stefano in documents between the late eleventh and mid-twelfth centuries marks the formal acceptance of the name Prato by both communities, and the formation of a unified civic identity, with its center point at Santo Stefano. Whatever practical reasons existed for such a fusion, the scope of the collective was expanding to include the provost, canons, Alberti, and commoners. The provost and canons formed the focus of this collectivity, and may have provided the model of sharing resources with their idea of a life in common. The implicit transfer of the Castello's administrative capacity, however limited, to the propositura justified the expansion of the church and its outbuildings. Documents of the period imply, in fact, that there was building activity at Santo Stefano. In the first text to locate Santo Stefano in Prato, from 1084, the church was described as "Santo Stefano posta in Prato," in the second, from the following year, as "edificato nel luogo detto Prato," and in the third, of 1097, as "costruita e edificata nel borgo di Prato."[9] The use of "edificato" and "costruita e edificata" versus the use of "posta" or "sito in" in earlier texts suggests that the church was expanded or rebuilt. The beginning point of construction may have been around 1069 when an earlier document used the term "edificata ... in Burgo de Cornio."[10] Between this and the next use of the term "edificato," the name of the site changed from Burgo de Cornio to Prato. The fact that the process of renaming the site of the church is coincident with indications of construction suggests that the rebuilding of Santo Stefano was one part of a general policy, sponsored by the propositura alone or in league with the Alberti and townspeople, to forge a new identity for the community.

Archeological evidence at the site offers qualified support for a construction program in the second half of the eleventh century. Excavated remains of walls

and floor mosaics beneath the crypt level, at the northernmost of the three original apses, are traceable to this period (fig. 3.2). The mosaic paving found at Santo Stefano has been dated stylistically to the second half of the eleventh or first half of the twelfth century.[11] The green and white marble mosaic shows interlocked curved geometry and curving vegetal and animalistic figures. This decoration resembles the paving at the nearby Benedictine monastery of San Fabiano (figs. 3.3, 3.4). Both may have been executed by a local workshop.[12] The first mention of San Fabiano, in 1087, coincides with evidence for reconstruction at Santo Stefano.[13] The other source for the artistic workshop at Santo Stefano is that of its mother church, the Cathedral of Pistoia, which has a similar bichromatic, purely geometric mosaic paving in its pre-Romanesque crypt, which dates before 1108 (figs. 3.5, 3.6).[14] The connection to Pistoia is further confirmed by the similarity of the Santo Stefano mosaics' geometric design to manuscript initials common to Pistoiese illuminations of the eleventh and early twelfth centuries (figs. 3.7–3.9).[15]

The paving mosaics at Santo Stefano are partially framed by wall fragments. The northernmost edge of the walls and the floor fragments coincide with today's north church wall, bordering the cloister (fig. 3.10).[16] Taken together, they provide the clue to the church's orientation at the time (see fig. 3.17). The curved shape of the wall fragments indicates three parallel apses terminating a three-aisled basilica, findings supported by documentary evidence. The area behind the church was called "de la Trefuni" in various documents between 1108 and 1116.[17] Again, Pistoia may have provided the model: its Romanesque crypt also terminated in a triple apse.[18]

Other early Romanesque aspects of Santo Stefano, such as the cloister, the windows on the north nave wall, or the two portals on the south elevation, are more difficult to date. Until now, any of the visible portions of the church, besides the mosaics, have been dated between the twelfth and early thirteenth centuries, when documents show that the cloister and south elevation were reconstructed.[19] These interventions must have displaced whatever cloister and south wall existed in the eleventh century. However, the north wall of the church, facing the cloister, differs in its construction and appearance from the twelfth-century or later portions of the cloister and south wall of the church, and can only have been built in the late eleventh century. Both a cloister and a church were documented at that time, and while both were subsequently changed and enlarged, the wall joining the two remained fixed.[20] A pragmatic reuse of a church wall was not unusual; it occurred at San Frediano in Lucca, also built in the second half of the eleventh century and rebuilt in the twelfth. There, the north wall was kept during the enlargement of the church.[21] The rough stonework of Santo Stefano's north wall is older than the masonry across the nave. The monolithic arches crowning the narrow windows

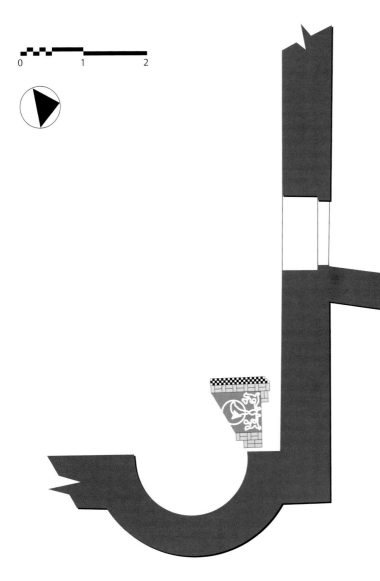

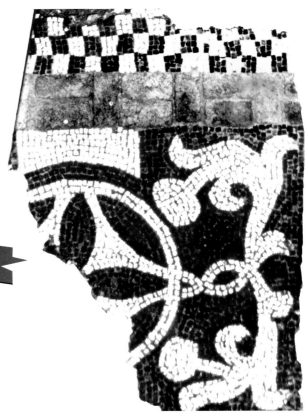

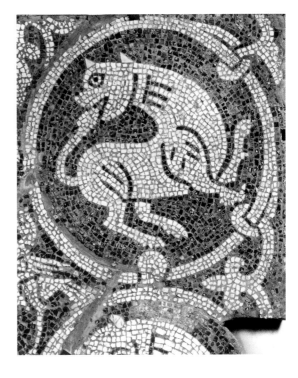

ABOVE

FIGURE 3.2 Plan of northeast apse paving at 1:50, late eleventh century. Prato, Santo Stefano.

ABOVE RIGHT

FIGURE 3.3 Excavated mosaic in crypt, late eleventh century. Prato, Santo Stefano.

BELOW RIGHT

FIGURE 3.4 Floor mosaic, late eleventh to early twelfth centuries. Prato, San Fabiano.

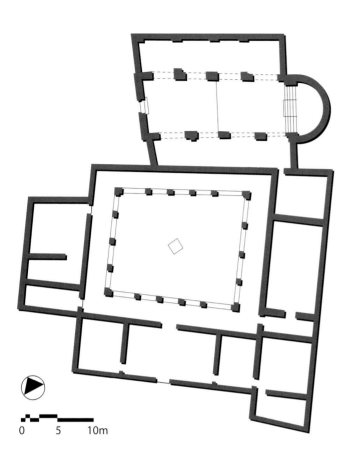

FIGURE 3.5 Plan at 1:500, late eleventh to early twelfth centuries. Prato, San Fabiano.

FIGURE 3.6 Façade, twelfth century. Prato, San Fabiano.

and their monochrome masonry are both characteristic of architecture in the region in the second half of the eleventh and first half of the twelfth centuries (figs. 3.11–3.13). Comparisons can be seen nearby and wherever there were stylistic links to Pratese or Pistoiese architecture, notably the Badia di Montepiano (figs. 3.14, 3.15) and the Pieve di Brancoli (fig. 3.16); see also the eleventh-century apse of San Silvestro di Santomoro northwest of Prato, the coeval apses of San Giusto di Monte Albano, just south of Prato,[22] and of San Pietro in Gropina, near Arezzo,[23] or the eleventh-century portion of San Pietro Sorres in Borutta, Sardinia, which was closely tied to building workshops at Pisa and Pistoia.[24]

The figures on the exterior frame of the windows at the north wall of Santo Stefano also appear more primitive than do the sculptural reliefs executed at later portions of the building, such as on the south elevation or cloister portals (see figs. 4.29–4.31). The hunter figure on the east window (see fig. 3.11) has a large head and exaggerated features. His bulging eyes, protruding ears, club feet, and frontal posture—awkwardly contradicting the lateral gesture of the sword stretched to-

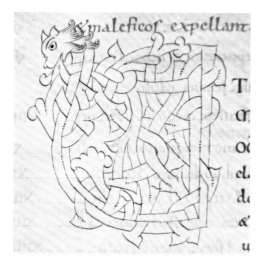

FIGURE 3.7 Initial, eleventh century. Pistoia, Archivio Capitolare, Codex C. 140, fol. 103v.

FIGURE 3.8 Initial "P," early twelfth century. Prato, Biblioteca Roncioniana (originally in the Cathedral Treasury), Codex 1, fol. 178v.

FIGURE 3.9 Initial "C," early twelfth century. Prato, Biblioteca Roncioniana (originally in the Cathedral Treasury), Codex 1, fol. 160v.

FIGURE 3.10 North wall of church overlooking cloister, late eleventh century. Prato, Santo Stefano.

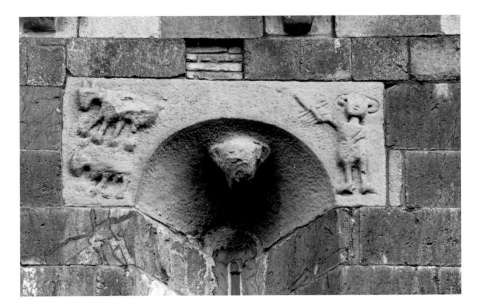

FIGURE 3.11 Detail of window with animals, projecting head, and hunter with sword, late eleventh century. Prato, Santo Stefano.

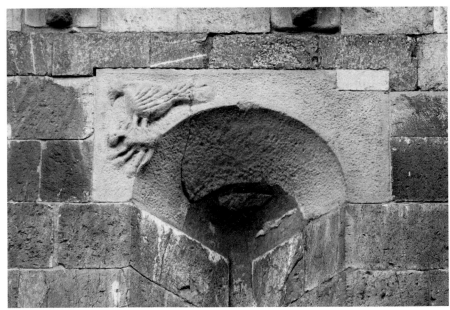

FIGURE 3.12 Detail of window with birds, late eleventh century. Prato, Santo Stefano.

ward the fleeing animals across the frame are either archaic or archaizing.[25] These reliefs are remarkably similar to those at the portal tympanum and the historiated corbel of the Badia of Santa Maria di Montepiano, at the northernmost point of the Bisenzio valley, dated to 1005.[26]

The only likely addition to the north wall of Santo Stefano since the late eleventh century was to its length. The narrow, historiated window frames penetrating the upper portion of the north wall of the nave occupy only the portion of the church along the cloister. A door built in the next century, and still visible

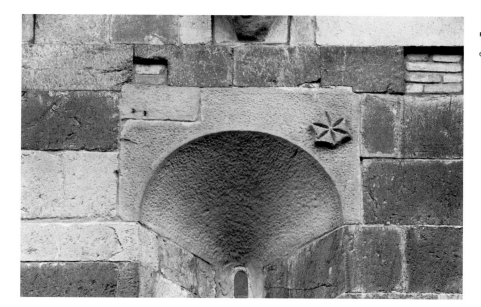

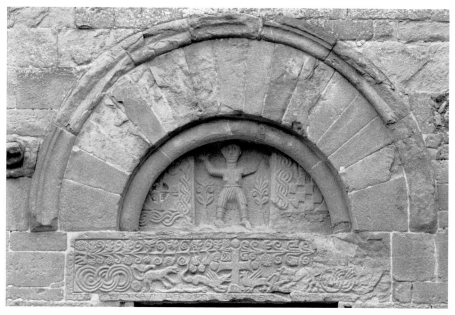

today, opens through the ground floor just past the cloister's original exterior wall (fig. 3.17). This aligns with a door on the opposite wall of the church nave, which in turns aligns with the main east-west street passing through the town, the Via della Pieve. The two doors therefore form a natural break in the fabric of the building. This seems to correspond to an original terminus of the eleventh-century structure, before its enlargement during the next building phase in the twelfth century. The north wall originally would have extended only as far as the western edge of the cloister visible today.

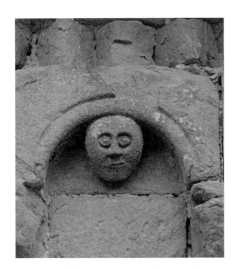

FIGURE 3.15 Historiated corbel with projecting head, late eleventh to early twelfth centuries. Montepiano, Badia di Montepiano.

Further archeological evidence is needed to confirm whether this was the original length of the church. At one of Prato's other, contemporary churches, San Fabiano, a nave of equal or even shorter length than the cloister existed. On an urban scale, the aligned cloister and nave termini would have provided a continuous elevation across the façades of both church and cloister, punctuated by the facing baptistery.

Whatever the extent of the eleventh-century nave, the correspondence between the three north wall windows and the new cloister provides a framework for understanding the dynamic relationship between church, cloister, baptistery, and the region that was developing during the period. The cloister added an important element to the expression of the propositura in the community. The canons were housed in the center of town and also had a representational space of their own. The north wall figures described above are all that remain of any decorative program for this cloister at the time—the columns, arches, and capitals visible today are all from later in the twelfth century. Though limited in scope, the north wall figures indicate that the canons were continuing to provide an intermediary between provost, townsfolk, and the Alberti. The three sets of profane figures on the extradoses of the windows on the north wall of the nave (see figs. 3.11–3.13) presented simple, familiar imagery to the local populace. The man holding the sword, perhaps a feudal lord slaying a threatening beast, communicated the protective role of knights such as the Alberti, and attached its apotropaic defense to the church itself. The flower could be a primitive variant of a classical rosette, or just a flower, in either interpretation alluding to the countryside, as does the image of the bird catching its prey. The protruding bare headed face may also have been apotropaic, guarding the window. Its likeness appeared at corbels, portals, and windows of churches throughout Italy during the period. All three window figures link to life in the countryside, whether the lord's hunt, the serf's field, or the magical imagery animating both.[27] These figures spoke less the language of salvation in the afterlife than of salvation from the wild and provision for earthly sustenance. The reliefs repeated the imagery of earthly protection and fertility that echoed the world and needs of the laity. These reliefs were consistent with similar imagery at other early Romanesque parish and urban churches with close ties to villages and countryside.

Written evidence from the period confirms that the propositura was actively reaching out to the laity. Beginning at the same time that the church was being reconstructed in the eleventh century, documents record the ritual freeing of serfs at the altar of Santo Stefano.[28] Not only was the church drawing the rural populace to its heart, but it was also offering, at the core of its interior, at the altar itself, freedom. The propositura was thereby augmenting both its congregation and participants in

the local economy, and it was removing the same individuals from their previous, rural overlords. The result was to shift the balance of population and power from both lay and religious institutions in the countryside toward the growing and now unified settlement of Prato, and thereby to reconfigure the Bisenzio valley from a polycentric array of settlements to a single center commanding its territory.

Urban Space and Sovereignty

Construction work at the Pieve during the late eleventh century accompanied the articulation of its newly unified urban setting. Documents, place names, and extant tower houses allow us to locate certain public streets and houses and trace the perimeter of a *castrum,* or fortified area, that surrounded the Pieve and the entire Borgo al Cornio in the late eleventh century (see fig. 2.3).[29] The major streets passing through this castrum and connecting it to the territory were Via del Borgo, leading to the old Roman consular road arriving from Florence; Via del Vignale, forming the southern border of the castrum; Via della Pieve, connecting the Castello and its adjoining piazza, the Scampio, to the Pieve; and Via Serraglio, leading to the upper Bisenzio valley.[30]

The castrum itself was defined by ditches and ramparts, and, in some places, by moats provided by the town's canal system or by defensive towers. At its northwestern extremity, it coincided with the preexisting fortified compound of the feudal

FIGURE 3.17 Plan at 1:500 of original church and cloister, late eleventh century. Prato, Santo Stefano.

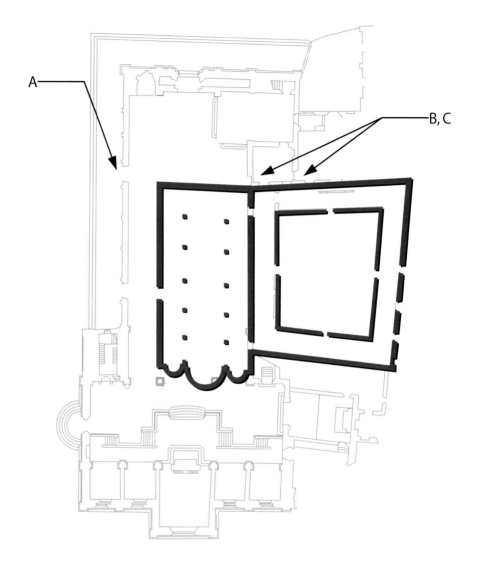

A, B & C: Later portal and interior
doors aligned with
facade of eleventh-
century nave and cloister

Santo Stefano

0 5 10 20m

Vuinitii family.[31] The document of 1069 which called the Pieve "edificata…in Burgo de Corgnio," mentioned also the ruined state of this compound.[32] It is conceivable that the poor state of the compound was due not only to the departure of the Vuinitii, but also to the recent integration of the compound into the new defensive boundary of the Borgo, during which process the ramparts on the unexposed faces would have been cannibalized to fortify the new perimeter.[33] At its southern border, along Via del Vignale, the Borgo would have met with the walled fortifications of the Castello di Prato.

The meeting of the two fortified settlements at this short section of common walls was the first step in the fusion of the two communities, parallel to the citing of Santo Stefano's location as "luogo detto Prato," or as "borgo di Prato." The process was completed by another ring of stone walls, built in the middle of the next century, that encompassed the two centers.[34] The eleventh-century architecture of the Pieve registered the propositura's success in winning the financial support of their Alberti neighbors. The changes to the church and its setting, in turn, generated further support. The Alberti counts were consistent advocates of the church. They are documented as patrons, and as diplomatic allies and military defenders.[35] This support by local feudal powers of church construction was not uncommon in Tuscany, and it offered, among other advantages, the prestige of being associated with an impressive gift and beautiful building.[36]

The propositura's success in stimulating the engagement of the rest of the laity in the cause of Santo Stefano is revealed in records from as early as 1078. Documents from this year indicate that the townspeople were beginning to redirect their attention, in the form of pious gifts, away from the traditional locus of divine authority, the bishop of Pistoia, toward the propositura of Santo Stefano.[37] A similar shift in pious donations occurred within the city of Pistoia itself, with residents at times stipulating that gifts go directly to the cathedral chapter and, explicitly, not to the bishop.[38] In the case of Pistoia, this has been attributed to the reformed mission of the canons, with their more direct appeal to the congregations.[39]

The common pattern of lay donations in Pistoia and Prato suggests that the canons in Prato exercised similar influence. Their mission, described in the previous chapter, was likely the decisive factor in drawing the Pratese's generosity. The canons provided a credible third party free to facilitate the establishment of relations of admitted secular self-interest between the Alberti or the provost and local residents. The unadorned, uniform dress of the canons emphasized their simplicity. The cloister architecture, with its central void, absence of hierarchy, and well-established connection to monasticism, represented the canons' apostolic life of poverty and brotherhood.

Beyond all this, the canons' vows to hold goods in common provided a model for the construction of a state based on consensus that was a viable alternative

to the imperial Roman or feudal models based on authority and coercion. Their example provided a practical framework for interacting in a collective to the benefit of all. Following the lead of the canons, the various parties inhabiting the Bisenzio valley pooled their resources. They were thereby able to enrich themselves more than if they either offered blind allegiance to the bishop of Pistoia or pursued their fortunes independently. The channeling of gifts by the Alberti and the townspeople to the canonicate can be seen as investment in a common good. While some of the wealth directed toward the propositura found its way into monumental and urban architecture, some portions were reinvested by the propositura into other sectors of the economy. The propositura increased its own agricultural and industrial investments, particularly in vineyards and mills, and thereby enhanced its long-term capacity to fund its architectural needs and its spiritual and charitable missions. The first grant of this sort was made on April 19, 1048, and included a mill, a vineyard, and other land beside the Bisenzio river.[40] One of the most noteworthy documents recording the industrial investments of the Pieve is one of September 24, 1128, when the Alberti "invested" the propositura with the right to derive water for mills or other structures. These other structures, "aliud aedificium," must refer to other buildings harnessing the power of water, possibly for wool production.[41] During the eleventh and early twelfth centuries, across Latin Europe, church officials in charge of monasteries, cathedrals, and parishes with landholdings were beginning to feel responsibility for maximizing the return on their agricultural and industrial investments. This policy was sometimes in competition, sometimes in collaboration with the lay nobility holding parallel power. The symbiotic relationship of the Alberti and propositura was typical of the latter type, which often focused religious and secular energies around the construction of sovereignties. One of the best documented cases of such collaboration was the construction of the kingdom of France, ideated—at least in land tenure and architectural style—by Abbot Suger at the properties and church of the Abbey of St. Dennis, which he helped construct as the pantheon of French kings and the Gothic paradigm of French royal culture.[42] Members of the Alberti family had a characteristically Italian approach—they appear to have encouraged particularly the urban economy.[43] For the townspeople, the strategy of reinvestment came naturally. Both mill owners and artisans could sustain and increase output by maintaining and improving their means of production. The confluence of religious, noble, and burgher investments in Prato constituted an important shift in the economy from one of hoarding wealth in treasure to reinvesting earnings in infrastructure and production. The construction of Santo Stefano, of city streets, mill channels from the river, and urban fortifications were urban-scale forms of reinvestment, and they

indicate that the propositura and Alberti were aligning with the local population, not only politically and spiritually, but also economically.[44]

The cloister reinforced the role of the canons in negotiating between the diverse interests of provost, laity, and Alberti. Unlike the monumental church, the cloister expressed divinity with the absence of architecture. All that existed at the center was natural, not man-made. The enclosed garden isolated a corner of nature, with its presiding reliefs recalling the diversity of pagan and feudal traditions of the countryside. Such a positive image of nature was becoming increasingly possible in the region due to the labors of farmers, lords, and the church to turn wild and threatening territories, like those of the Bisenzio, into fruitful ones. Its focus on the natural and the spiritual, even the redemptive, made the cloister more of a radical vision of the canons' mediatory roles, between church, lord, and laity or between man and God. Gifts to the canons did not increase their material wealth or monumental presence but rather their capacity to minister to their congregation and to distribute resources to the entire community through charity. Gifts to the canons were ultimately sacrifices to God and, indirectly, to the community. In simple economic terms, the canons assured local reinvestment rather than distant hording of gifts. Furthermore, if the laypeople supported the canons with such gifts and imitated their model of a spiritual life in common, they would increase their chances for membership in a larger and more enduring community than that of Prato, the community of saints in paradise. The adoption of the vita communalis on earth was therefore a means both to enhance one's material well-being and to increase the chances for spiritual, and therefore eternal, salvation.

The urban cloister was an instrument in the apostolic mission of the canons to propagate their ideology of the Christian life in common outside the monastery, following the words of the most famous of eleventh-century reformers, Gregory VII, whose battle cry was "not to flee, but to conquer the world."[45] The militant language of Gregory VII failed to capture just how radical canons or other essentially urban religious orders, such as the Vallombrosans, could be. Urban brotherhoods by their very nature introduced an alternative moral framework to coercion for ruler-subject relations. The pairing of such charismatic missions with the traditional church and with the executive authority of priest, provost, or bishop terminating its axis ran the risk of undermining one or the other of these images of authority. The bishop of Pistoia, like many of his peers across northern Italy, seems to have been willing to take such a risk in order to woo the new urban congregations and thereby bolster the common causes of reformed episcopal autonomy and the papal reform movement in general. He seems not to have taken his urban pawns sufficiently seriously. In the case of the new community of Prato, the fraternal canons

and their cloister may have transformed from tools for conquering the world of the laity to models for representing that world as an autonomous entity, with the common interests of provost, canons, Alberti, and townsfolk existing apart from the oversight or interference of neighbors.

The Regional Response to Sovereignty

The physical manifestations of the incipient eleventh-century commune at Prato were the church and cloister complex and the integrated townscape. The extent of construction work undertaken by the provost and local residents, particularly in fortifying the Borgo, also indicated to other powers in the region the de facto autonomy of the community and its prosperity. The architectural and urban definition of Prato, and its population growth and autonomy, would have been disconcerting signs to its neighbors, whether Pistoia or Florence, particularly since Prato's situation represented ideas of secular rule and forms of economic enrichment that were novel and less restrained than those of these two traditional cities.

The bishop of Pistoia was the main party to suffer from Prato's autonomy, as he lost control over a strategic stronghold in his territory and was deprived of gifts directed now to the propositura and canons by the increasingly wealthy Bisenzio valley residents. The growth of Prato was all the more alarming due to its extra-regional implications, as it allowed another power, of a far greater weight than Prato, the Alberti, Pistoia, or Florence, to assert its presence in Tuscany. This other power was the Holy Roman Emperor, who was allied with the Alberti and through them even had an administrative base in Prato. The emperor's presence is recorded at the end of the eleventh century in the Borgo itself, in two tower houses described as residences of an imperial vicar and of another, originally Lombard type of magistrate, a *gastaldo*.[46]

The association that was emerging at the end of the eleventh century among this new, thriving town, the Alberti, and the Holy Roman Emperor coincided with the high point of the investiture struggle that was splitting Tuscany and all of Italy between pro-imperial and pro-papal forces. Prato therefore constituted a threat to the uneasy balance between the imperial and papal camps that was far out of proportion to the population or aspirations of the fledgling town.

Though the bishops of Pistoia were inconsistent in their dealings with the Holy Roman Emperors, the Florentines, who were bound up with the politics of the margrave of Canossa and the reform papacy, were against both the Alberti and the Holy Roman Emperor.[47] Because both Pistoia and Florence were threatened by the consolidation of power at Prato, they shared an interest in separating the

Alberti from this strategic site, perched at the edge of both of their territories.[48] In June 1107, Florence and Pistoia, together with Lucca, Arezzo, and an anti-imperial faction of Tuscan nobles, all under the leadership of Countess Mathilda of Canossa, laid siege to Prato. The pro-imperial forces of the region, Pisa, Siena, and Volterra, allied themselves with Prato and the Alberti counts.[49] The descriptions of the siege in documents from the period and later are consistent with the usage described above, applying the place name "prati" or "terra di Prato" to the entire fortified area.[50] Though the Pratese won recognition of their new name, they lost the battle. The invaders "went in ranks to the land of Prato, and took it by force of battle, and destroyed the defensive walls, filled in the ditches, razed the fortresses."[51]

The absence of any mention of Santo Stefano indicates that the church survived the siege. The rapid rebound of the propositura and community of Prato after the siege further suggests that the religious and economic base of the town was not broken. The violence of the aggressors seems rather to have been directed at the outer fortifications and particularly the Alberti and imperial fortresses inside and outside the walls. Inasmuch as the defensive walls could signify the juridical presence of an "urbs," destruction of Prato's fortifications erased, for the time, any potential claim for autonomy.[52] Both juridically and strategically, the assaulting forces succeeded in removing Prato as a regional political threat. Not only did they defeat the Alberti troops and raze their fortifications, but they also demonstrated to the Alberti how vulnerable they were in the open plain of the lower Bisenzio valley. The Alberti responded by retreating from the *campus martius* of their "prato," or "field," to more defensible settings in the mountainous upper Bisenzio valley, the Mugello, and elsewhere in Tuscany, where they and their imperial overlord ceased, at least for a time, to pose an immediate threat to the balance of powers controlling the increasingly urbanized settlements of the Arno plain.[53]

The direct result of the defeat of Prato and the departure of the Alberti was a complete split between the political and religious authority of Prato and the Alberti or the emperor. This split became reinforced by alliances the provost made in the twelfth century with the adversaries of the Alberti, namely the papacy and Florence.[54] For the following century, the presence of baronial power was broken in Prato. The most important result of the defeat of 1107 and the reduced presence of the Alberti was a vacuum in local secular authority and in its representational forms. This opened opportunities both for the propositura and for new organisms of lay administration—first the *boni homines,* and then the lay consular government—to develop and to define their institutions in architecture and civic space.

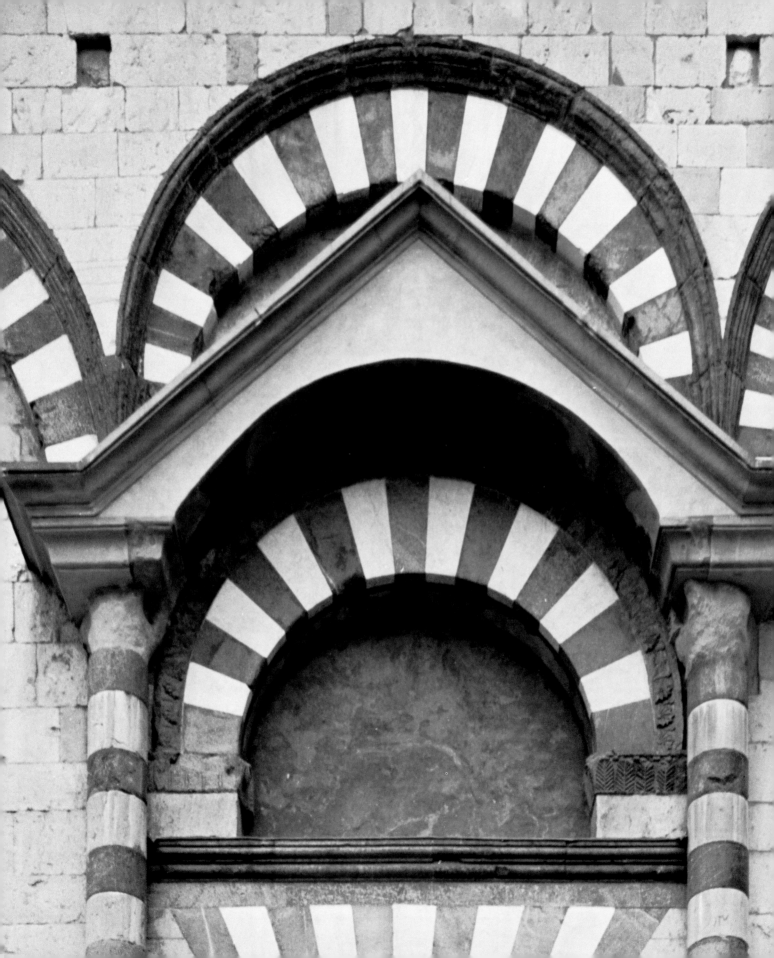

The Architectural and Urban Expression of Autonomy by the Propositura in the Twelfth Century

The Urban and Political Setting of Twelfth-Century Prato

The next mention of construction work at Santo Stefano after the 1107 defeat by the Florentines came in 1163. A document of December of that year records a payment by the provost and canons to Carboncetto "marmolarius," a local master mason or architect, whose one recorded work was Santo Stefano.[1] The amount, between sixty-six and eighty-six *lira lucchese,* depending on how one interprets the terms of the contract, indicates a considerable expenditure for the time, enough to pay for extensive construction work at the church.[2] The archeological and stylistic evidence confirms a major reconstruction of Santo Stefano and its cloister.

The town had recovered by this time from the destruction by Mathilda's forces. The settlement was growing in scale and its leaders in ambition. The provost and canons were closely connected to the growth of Prato and its leadership, partially filling the void in secular power left by the departed Alberti. The church officials were extending their authority over the town and over the entire territory held by the Alberti along the Bisenzio. As in contemporary cities throughout Italy, their investment in architecture registered an increase in wealth and promoted an image of local sovereignty.

The basis for the propositura's rise in wealth may have been the laity's positive reception of the model of the canons. Two events between the 1107 defeat and the 1163 Santo Stefano construction contract suggest that the laity had taken to heart the vita communalis of the canons, and indicate that they were pooling their wealth for the common good. The first of these events was the establishment of a consular regime in 1142.[3] The appearance in Prato of the consuls is typical of northern Italian consular foundations, which often arose during absences of episcopal or imperial power. In cities with liberal canonicates, such as Prato, Pistoia, and Florence, this transition tended to be smooth rather than revolutionary; the converse was the case, for instance, in Milan.[4] Prato's consular regime was, moreover, capable of defending itself militarily. Indeed, the new lay institution appears to have combined

FIGURE 4.1 Plan at 1:7500 of unified town, 1163–1210. Prato.

the organization of the canons with military skills learned from the Alberti. Many consuls were lesser nobility themselves, and older consuls had gained valuable military experience defending the city against Mathilda and her allies.

The new consular regime combined the lessons of its two role models in the second important event of the mid-century. By 1157 the consuls had started to build a ring of masonry walls. These replaced portions of the palisades and ditches that had encircled the city in the eleventh century, and extended to enclose new neighborhoods outside the old walls, to the west and south (fig. 4.1). Prato's first communal walls were begun two decades before Florence built its earliest communal defenses.[5] The first reference to Prato's walls, on January 19 of that year, as "castello de Prato" indicates that they were conceived as extensions of the defensive structures of the Alberti, uniting both settlements. These permanent fortifications may even have been initiated primarily as a politically representational rather than military act.[6] The new walls reasserted the town's rights as an autonomous city. While celebrating the unity and independence of the town in its region, the construction of the walls also registered the capacity of the consular regime to pool private resources to public ends outside of a clerical or imperial tax structure.[7] The modern word "tax" describes the nature but not the spirit of this initiative: the consuls and their fellow citizens were repeating on the scale of the town the sharing of wealth that characterized the canons' vita communalis. By fusing into one corporate entity the institutional and military expertise of the canons and the nobility, the laity of Prato was able, within a few decades of its first mention, to take the lead in transforming the community into a major regional presence.

The success of the consular regime benefited the propositura. The consuls peacefully assumed jurisdiction of many matters regarding the marketplace, and used their first-hand experience and interest in these matters to stimulate the economy.[8] Economic growth could only mean increased revenue for the church, and the attendant population growth increased its congregation and prestige. The consuls' assumption of the military and diplomatic role previously occupied by the Alberti provided continuous support for the territorial autonomy of the propositura, whether in relation to the bishop of Pistoia or to other nearby religious institutions. There was, nonetheless, a threat to the propositura in the success of the consular regime, in ways that never appeared to have existed with their lay predecessors, the Alberti. The consuls were dangerously similar to the canons. Both were bodies of equals, making decisions after consulting textual precedents and after deliberating, and then pooling resources to implement these decisions. The improvement of economic and social conditions even allowed a convergence of the goal—to attain paradise—that the clerical and lay institutions had in common. The greater the success of the consuls and the nearer they were to creating a paradise on earth, the

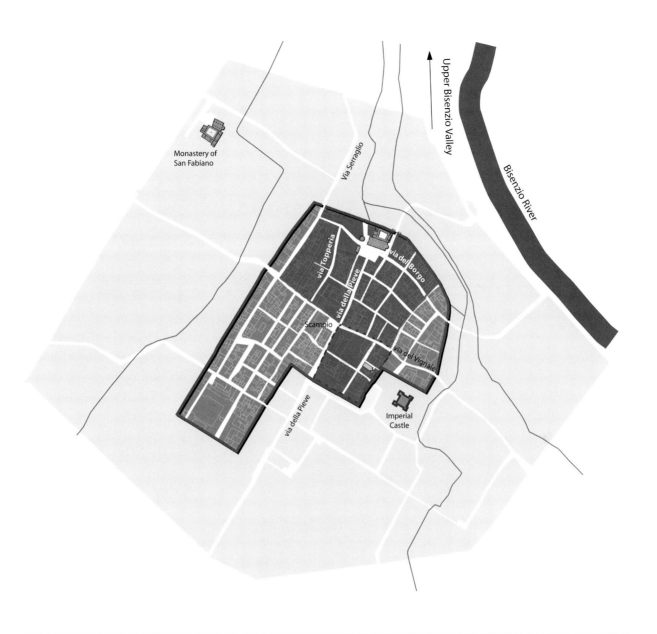

Upper Bisenzio Valley

Bisenzio River

Monastery of
San Fabiano

Via Serraglio

via Topperia

via del Borgo

via della Pieve

Scampio

via del Vignale

via della Pieve

Imperial
Castle

1157 walls

Borgo & Castello fortifications

canals

Prato
1163–1210

0 50 100 200m

1:7500

more they threatened to render obsolete the social functions of the propositura. The propositura had provided a politically neutral party calling for deliberative rather than willful (noble) action. This neutrality had fostered its economic role as a focal point for the investment of common and surplus resources. Most important, it had functioned as the sole purveyor of paradise. Nor were the consuls and the lay Pratese alone in posing a threat. Nearby parishes and monasteries, not to mention the often openly antagonistic bishops from Pistoia and even Fiesole, sought in various ways to undermine the propositura's administrative, religious, and territorial sovereignty.

Architecture offered the late twelfth-century propositura the tools to fend off threats to its authority, and even to enlist the lay Pratese in its territorial disputes. The character of the design of the new Santo Stefano complex (fig. 4.2), for this period sufficiently extant to discuss in detail, indicates that the propositura sustained the symbolic appeals to the laity of the eleventh-century project, with a language inflected to the increasingly urban society. The new church design even extended the imagery of the vita communalis, but in a way that confirmed that the vita apostolica and the salvation it conferred were accessible only through the institution of the propositura. The siting, iconography, and character of this architecture tread a fine line between continuing to draw the political and economic support and spiritual engagement of the laity and clarifying the uniqueness, otherness, and sanctity of the propositura and its attendant claims to religious and territorial sovereignty.

The Twelfth-Century Reconstruction of Santo Stefano

The portions of the Carboncetto project that are still visible include parts of the cloister, south elevation, and west façade. He also transformed the earlier triple apse into a single one, though his apse as well as any interior work on the nave was torn down during later interventions (figs. 4.2–4.6). It is worth spending some time to distinguish his interventions in order to clarify as much as possible what the provost, canons, or average citizens could have seen upon Carboncetto's completion of the project. As this phase of the church has received only passing attention in previous scholarship, the following visual and documentary archeology of twelfth-century Santo Stefano is necessary to breathe some life into the building, its urban context, and its period reception.

Today's fourteenth-century west façade hides another façade, begun by Carboncetto and finished later. The lower portion is Carboncetto's. His stonework is monochromatic, varying in the thickness of the courses, but remarkably consistent in the quality and color of the stone. The upper, bichromatic portion is later, added in the thirteenth century by Guido da Lucca. The same two phases are visible at the

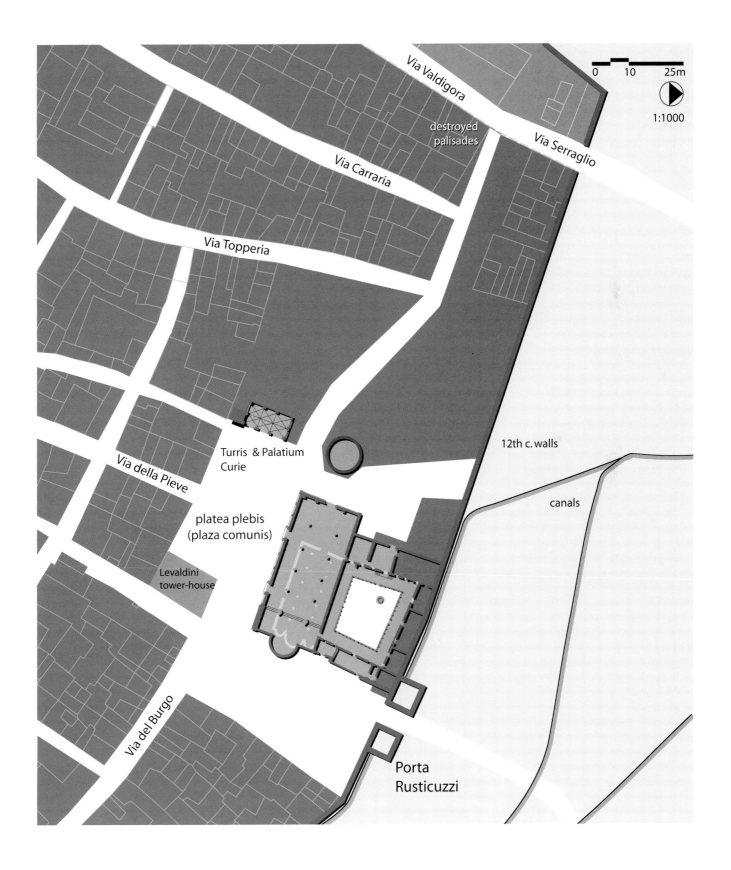

Via Valdigora

destroyed
palisades

Via Serraglio

Via Carraria

Via Topperia

0 10 25m

1:1000

12th c. walls

Via della Pieve

Turris & Palatium
Curie

platea plebis
(plaza comunis)

canals

Levaldini
tower-house

Via del Burgo

Porta
Rusticuzzi

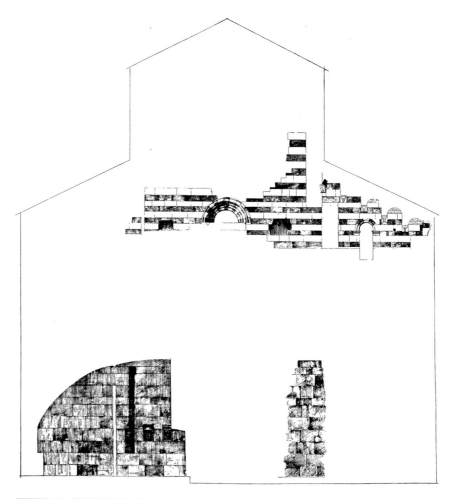

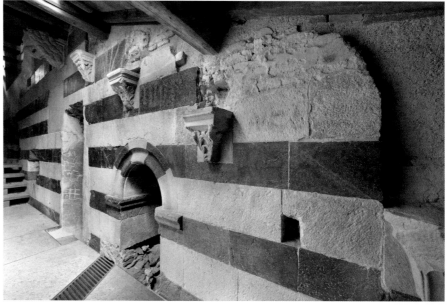

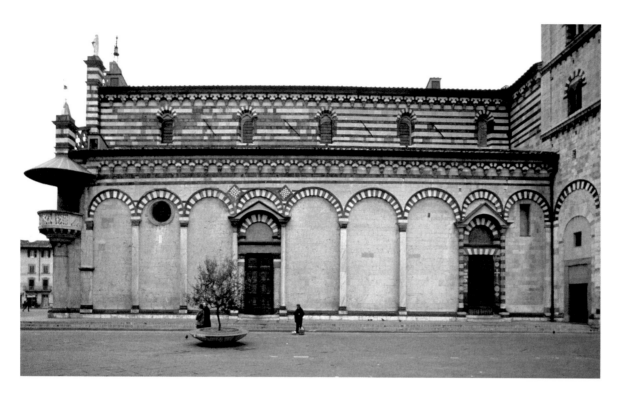

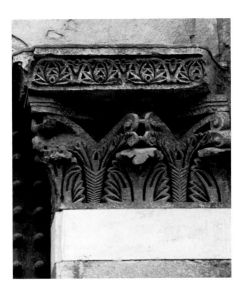
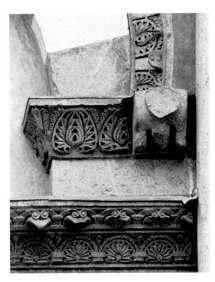

FIGURE 4.7 Carboncetto, south façade, west portal capital, 1163. Prato, Santo Stefano.

FIGURE 4.8 Carboncetto, south façade, west portal capital, 1163. Prato, Santo Stefano.

south façade of the church.[9] The seam between the work by Carboncetto and later interventions by Guido da Lucca is where the polychromatic banding and corbel table begin. Carboncetto was not averse to polychromy—the striped arches are his design, as is the first horizontal band of green stone immediately above the arches.[10] However, his use of it was more limited than in later phases of construction.

The distinction between the two phases is also visible in the architectural ornament. At both elevations Carboncetto articulated his capitals with highly geometric, deeply carved acanthus leaves, such as at the south façade west portal (figs. 4.7, 4.8) or the same elevation's terminating western pilaster (fig. 4.9). These are distinguishable from the less incised, more curvilinear acanthus leaves executed later by Guido da Lucca (fig. 4.10).

The two construction phases visible at the west and south elevations of the church are also present at the cloister (fig. 4.11). The earlier lower phase by Carboncetto corresponds to the monochromatic courses of stonework on the cloister wall directly behind the remaining eastern portion of the ambulatory, and the lower portion of the ambulatory arcading (see fig. 4.6), up to the string-course at the base of the second-floor plate. As at the south elevation, Carboncetto introduces some bichromatic decoration, but the uniform banding above the string-course, as at the upper exterior church façades, is later. Carboncetto's treatment of ornament, whether the acanthus leaves mentioned above or his limited bichrome details, is consistent at the cloister and south façade. The points of difference are in the extant corner capital, fourth cloister capital from the left, and middle cloister portal capitals. These are far more elaborate than anything on the façade. The acanthi of the corner capitals reveal their origins as classical spolium in their delicate foliage and deep undercarving. The fourth cloister capital and adjoining central cloister portal

capitals depart from the simple or angular forms of the other contemporary cloister capitals and from the capitals of the south façade. They are attributed convincingly to an itinerant sculptor working with Carboncetto, the Master of Cabestany.[11] The presence of work by an internationally active sculptor at the cloister indicates its importance in the overall project.

At first glance it seems as though the first four levels of the campanile are also by Carboncetto. They are primarily monochrome except at the arches, which are similar to those at the south façade (figs. 4.12, 4.13). There is, however, no mention in the Carboncetto contract of work on a campanile. While there was likely a bell tower, it may have been integrated into the façade or apse, not infrequent at contemporary churches, such as the 1185 oratory of San Galgano at Monte Siepi, rather than semi attached as today to the south elevation. Closer inspection of the Santo Stefano campanile design lends credibility to the documentary record. The campanile has a different shade of white stone. Its detailing is executed in lower relief, and there are no pilasters beneath the campanile arches above the ground level. The one banded arch that continues from the south elevation onto the ground level of the bell tower shows signs that it may have been grafted from another location. If one accepts the documentary record rather than the inconclusive visual evidence, and rejects the campanile's construction during this phase, one is left with a question: from where might the ground-level arch have been grafted?

The answer to this question transforms the reading of the Carboncetto south façade into a more coherent design in itself and one more consonant with the extant cloister elevation. Without the bell tower there is space for exactly two more arches of the same span as the easternmost one visible today. One of these provided the voussoirs later cannibalized for the grafted arch on the ground level of the cam-

FIGURE 4.9 Carboncetto, western pilaster capital with geometric acanthus, 1163. Prato, Santo Stefano.

FIGURE 4.10 Guido da Lucca, covered west façade capital with curvilinear acanthus, 1211. Prato, Santo Stefano.

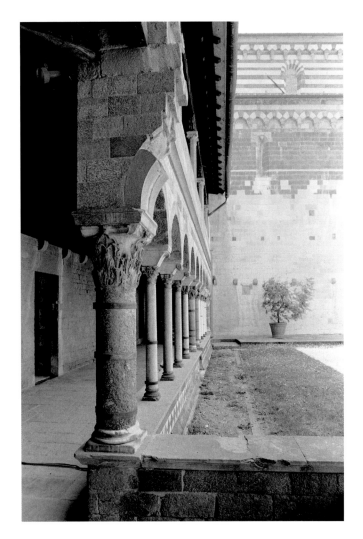

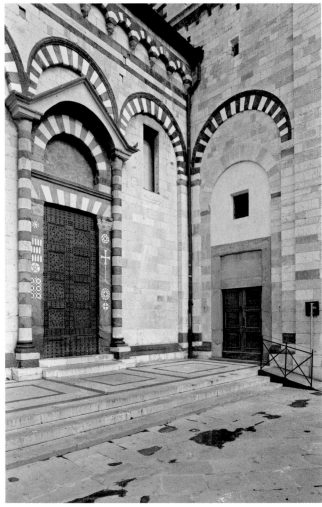

FIGURE 4.11 Carboncetto, cloister, wall behind ambulatory and portion of earlier north wall, eleventh–twelfth centuries. Prato, Santo Stefano.

FIGURE 4.12 Carboncetto, south façade, arches and pulpit door by base of campanile, 1163. Prato, Santo Stefano.

panile. Not one but three arches concluded the eastern end of the south elevation. The result was a symmetrical design, with two shorter ranges of arches framing a central, wider range, creating a rhythm of AAA B CCC B AAA (figs. 4.14, 4.15; see also fig. 4.5). The actual Carboncetto south façade was therefore in all probability an eleven-bay composition supported by twelve pilasters, echoing the number of bays and columns at the extant cloister elevation.

The Architectural Iconography of the Twelfth-Century Cloister

The new Santo Stefano was a collaborative project by church and laity. Both parties registered their collaboration with the similar ornamental details and overall arcaded composition of the canons' cloister and lay piazza. At the same time, the primary determinants of both designs were the provost and canons. A closer look

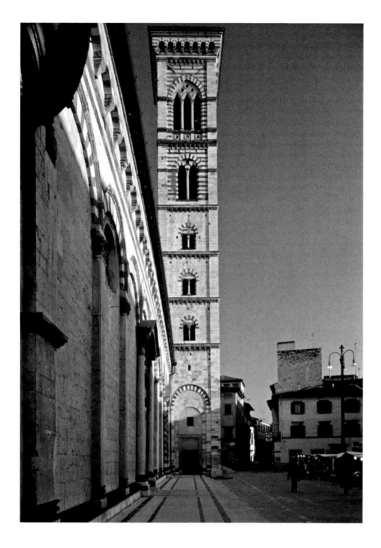

FIGURE 4.13 Guido da Lucca, campanile, 1211. Prato, Santo Stefano.

at the cloister affords a view of how they conceived themselves architecturally in the twelfth century, and helps in deciphering the intent behind their pairing of cloister and piazza.

Carboncetto's cloister was arcaded originally on all four sides. The eleven arches that spring from twelve columns on the extant façade were repeated at the other three elevations. The number twelve was by no means coincidental. It formed part of a matrix of numerological references characteristic of cloisters throughout Latin Christendom. The number twelve was linked to the astrological signs and months of the year. It also reflected the number of apostles, and therefore recalled the apostolic life upon which the order of canons was based. Twelve in architecture, especially in a perimitral structure, was linked to the originary architectural iconography of the apostles at the foundations of each of the tower gates of the

FIGURE 4.14 Reconstruction of Carboncetto plan at 1:500 showing twelve pilasters and AAA B CCC B AAA bay rhythm, 1163. Prato, Santo Stefano.

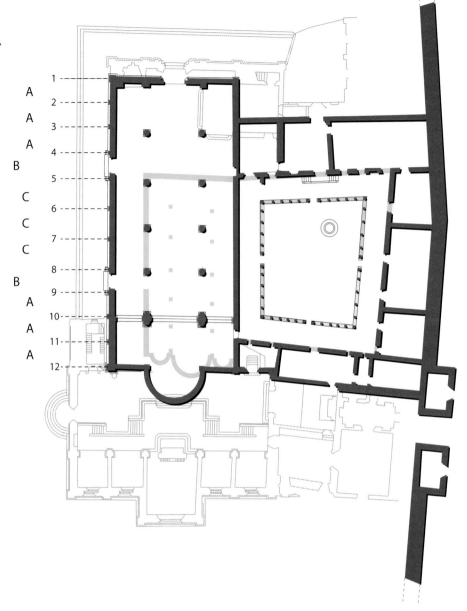

Santo Stefano

0 5 10 20m

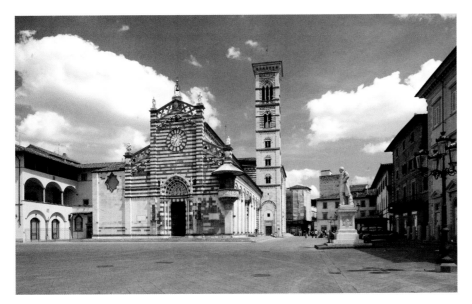

heavenly Jerusalem, as reported by John the Divine.[12] The cloister echoes the imagery of a site surrounded by such towers with its twelve stouter green columns at the corners and flanking the portals.

The other number emphasized in the cloister columns is four: the four corner columns or the four passages framed by pairs of green columns correspond to the four seasons, the four evangelists, and the four rivers of paradise.[13] The cloister was animated therefore by the numerological cycles of the zodiac, the months and the seasons, the apostles, evangelists, and heavenly Jerusalem—as such it was at once typical and yet unusually emphatic. The inlay circles with different designs above each column are as individual as the signs of the zodiac or as the personalities of the apostles. The overlaid groupings of twelve and four columns sustain the walls of a small, but earnest, heavenly and earthly Jerusalem.

The abundance of numerological and architectural iconographic references at cloisters in Prato or elsewhere suggests an exaggerated need to assert the type's holiness. The sacred quality of the cloister was in fact a contentious issue in the twelfth century. Cloisters were dear to theologians as literal centers of piety. Neither the architectural type nor the two institutions it could house, monks or canons, had any biblical precedent. Wayne R. Dynes expressed the problem quite simply. In the absence of a legitimate biblical origin, theologians had to invent one.[14] Architecture provided an important means for doing so. Numerology helped, but for the honed analytical minds of scholastics, it linked the cloister only to paradise and to heavenly Jerusalem, not to the historical city of Jerusalem. Something more significant had to be found. Starting in the early twelfth century, monastic commentators began to speak explicitly of the cloister not only as prefiguring paradise

but also as the architectural and institutional origins of the monastery. Three commentators, Honorius of Autun (1095–c. 1135), Sicard of Cremona (1160–1215), and William Durandus (1230–96), declared that the origin of the cloister form was the portico at the Temple of Solomon in Jerusalem, where the apostles took the oath to live their lives together: "Now the whole group of those who believed were of one heart and soul, and no one claimed private ownership of any possessions, but everything they owned was held in common" (*Acts* 4:32);[15] and "Now many signs and wonders were done among the people through the apostles. And they were all together in Solomon's Portico" (*Acts* 5:12).

The particular choice of the portico at the temple has been explained in terms of the rising interest in sacred geography, following the reconquest and occupation of the Holy Land in the first crusade.[16] In fact, twelfth-century crusader maps of Jerusalem echo the textual definitions of the cloister's origins at the portico of the temple, showing that the idea was diffused beyond the monastic intellectual elite. These maps show a linear portico near the *Templum Domini,* at one side of the Temple Mount, which is labeled as the *claustrum,* or "cloister," rather than the "portico" of Solomon (fig. 4.16).

The renaming of the portico as cloister takes on particular significance in light of the religious order that became associated with this structure after the reconquest of Jerusalem. This was the order of canons, which was charged with caring for the Temple of the Lord.[17] I propose that the canons' association with this place was specifically related to the new definition of the apostolic life that they, more than the monastic orders, were responsible for following—an earthly mission to minister to the faithful in the earthly Jerusalem, just as the first apostles did from this portico qua cloister, once they took their oath. The architectural-typological inaccuracy of applying the name of the quadrilateral, internally focused cloister to a linear structure open to the city, only emphasizes its ideological importance. The canons were perceived, and probably were defining themselves, as the true followers of the apostles in Jerusalem. The renaming of the Portico of Solomon, where the apostles founded their "order," allowed every other canonicate cloister, including that of Santo Stefano in Prato, to trace its institutional origins and redefined apostolic mission to this actual historical place.

In whatever way the canons at Jerusalem or Prato sought to redefine their cloister, it remained nonetheless a sacred space set apart from its surroundings through restricted access. Its image of brotherhood remained exclusive and therefore rooted in the monastic past. This persistent, traditional character of the cloister was consistent with the theological historian Marie Dominique Chenu's idea that the canons had difficulty in keeping up with the pace of religious change in the twelfth century.[18] The Santo Stefano cloister expressed the transitional nature of the

FIGURE 4.16 Crusader map, plan of Jerusalem showing Christianized holy sites, c. 1200. The Hague, National Library of the Netherlands, KB 76 F 5 fol 1r.

institution itself, whose architecture, administration, and organizational structure was still tied to the monastery, even though the canons were increasingly occupying themselves with the souls of the urban faithful, and deriving their revenue from the urban economy. Their architectural image was still that of the elect, of apostles already admitted to paradise, though now sometimes sharing their authority with the laity in order to respond to the demands of urban life, economy, and religious reform. This was the only area for which the internationally active Master of Cabestany was hired to work. The splendid materials, expensive craftsmanship, rich patterns, rigorous order, and insistent numerology and architectural iconog-

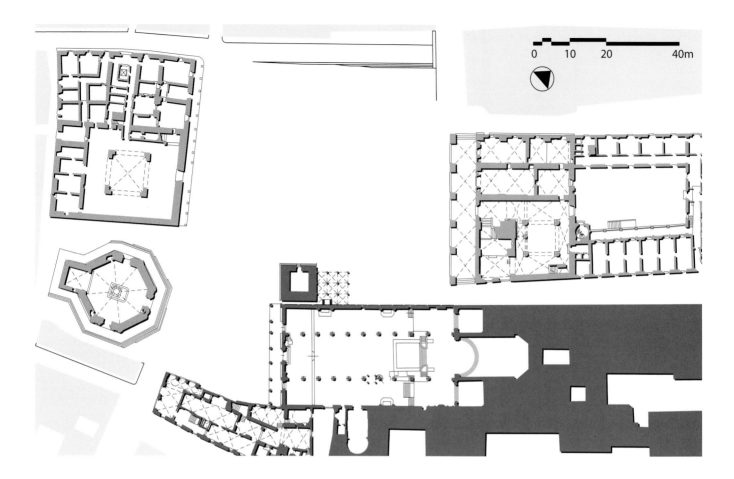

FIGURE 4.17 Plan at 1:1000, twelfth–thirteenth centuries. Pistoia, Piazza del Duomo.

raphy of the Santo Stefano cloister described the heavenly and earthly Jerusalem, as well as the elect institution in control of it.

Regional Sources and Local Identity

The canons and their provost repeated the imagery of election from the cloister at the south façade of Santo Stefano. The contemporary construction of the cloister and south elevation of Santo Stefano and their similar articulation assured that the reference would have been clear for anyone experiencing the south façade in the twelfth century. The canons of Santo Stefano seem to have been affirming Gregory VII's reform mandate to make the locus of their mission not away from the urban world, but within it.

The urban projection of imagery internal to the church, such as Prato's cloister, was consistent with late eleventh and twelfth-century architecture in Tuscany. Starting at the Baptistery of Florence and San Miniato al Monte, builders projected the polychromatic stone, classicizing ornament, and harmonic composition of church

complexes to the exterior. This practice was novel in Christian architecture, which, since the first Constantinian basilicas, had reserved its finest articulation for the interior. The extension of interior to exterior in twelfth-century Florence recalled Roman pagan and civic architecture. The origins of this practice in Florence also link it to Gregory VII's reforming predecessor, Nicholas II, who was both bishop of Florence and the first pope elected by cardinals since the ninth century. The practice began as an architectural expression of the sacred imperial claims of the reform papacy, but it was so quickly adopted across Italy and Europe by imperial as well as papal camps that it could no longer be used as a proof of allegiance to one party or the other. What the new wave of monumental church exteriors did prove was that powerful institutional patrons were willing to invest considerable energy and expense to address a broader public than previously.

<center>□ □ □</center>

One of the cities in Tuscany where reform bishops transformed their townscape in the eleventh and twelfth centuries with elaborate bichromatic, classicizing façades was that of the diocese in control of Prato, namely Pistoia. The resemblance is striking between Santo Stefano and Pistoia's cathedral of San Zeno, which was rebuilt after a fire in 1108 and partially again after another fire in 1202 (figs. 4.17, 4.18).[19] Both share arcaded side elevations, and bichrome decoration fusing green Pratese marble with white *albarese* stone. Other contemporary projects in Pistoia, such as Sant'Andrea, San Bartolomeo in Pantano, and San Piero, share not only the blind arcading and bichromy of San Zeno, but also specific details, whether classicizing columns, or complex inlay.[20] The closest match to the south elevation of Santo Stefano in Pistoia is San Giovanni Fuorcivitas, which shares the arcades, the detailing, and the primary focus on the side elevation. The similarities should come as no surprise, as the bishop of Pistoia granted San Giovanni Fuorcivitas to the canons of Santo Stefano in 1119, after which the canons built most of the church visible today (figs. 4.19–4.21).[21]

The propositura was at once contributing to the Pistoia architectural tradition and differentiating itself. The school of Pistoia fused elements from the two dominant schools of northern Tuscany, those of Pisa and Florence. At Santo Stefano, Carboncetto shifted the balance of this fusion toward that of Florence. The Pisan school had provided strongly plastic elements, robust portals, and arcaded galleries at Pisa, Pistoia, and Lucca (figs. 4.22–4.24). The Florentine school pioneered locally planar inlay and harmonic control of compositions, and it was the source for the ground-level blind porticos at Pistoia, Prato, or elsewhere in the region (figs. 4.25–4.28). Carboncetto selectively used these sources. He rejected, for instance,

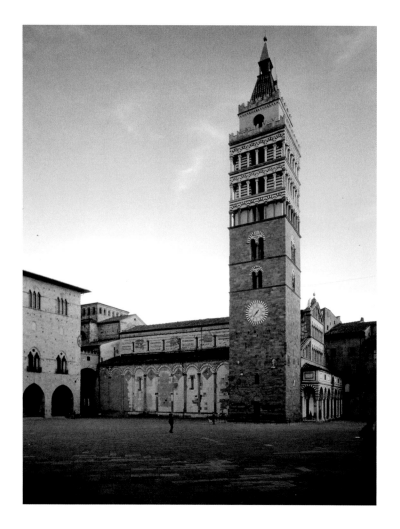

FIGURE 4.18 View of piazza and cathedral from north, twelfth–thirteenth centuries. Pistoia, Cathedral of San Zeno.

FIGURE 4.19 Detail of portal, twelfth century. Pistoia, San Giovanni Fuorcivitas.

the rotated squares within arches, fields of banded masonry, and multiple gallery arcades of western Tuscany, and yet layered his elevations more sculpturally than his Florentine models, particularly at the portals.

The qualified connection of Santo Stefano to nearby architectural traditions is consistent with the cool relations between the propositura and the bishop of Pistoia, despite the spirit of unity implicit in the 1119 grant of San Giovanni Fuorcivitas. What the bishop of Pistoia intended as a fraternal offer may have been perceived as paternal by the propositura. The provost and canons conveniently accepted the grant of San Giovanni Fuorcivitas but maintained the drive toward autonomy that they had begun with the Alberti and other lay Pratese since the late eleventh century. The distinctly local architectural dialect of Prato's Santo Stefano expressed in architecture what the provost was seeking openly in diplomacy: to win independence from the bishop of Pistoia with the establishment of a new episcopal seat in Prato—something that would remain unrealized up to 1653. Nonetheless, within fifteen years of the San Giovanni Fuorcivitas grant, Pope Innocent II responded to

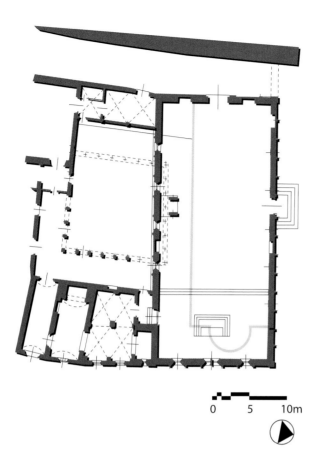

FIGURE 4.20 Plan at 1:500, twelfth century.

Pistoia, San Giovanni Fuorcivitas.

pressure from the provost and diplomacy by their old allies, the Alberti, and granted the propositura limited independence from the bishop of Pistoia. This included the right to collect tithes and to accept pious donations and testaments.

The Pistoiese architectural forms at Santo Stefano are therefore unlikely to have been intended as acceptance of dominion. Rather, the propositura was coopting them for its own propagandistic ends. Both the bishop of Pistoia and the propositura of Prato projected an image of the common life in their architecture to unify disparate members and institutions in their community and territory. The bishop and provost simply had different ideas of the location and extent of that community.

Local Projections of Collaboration and of Institutional Autonomy

The most powerful argument that the provost and canons had for their right to constitute a new, sovereign episcopal seat was the growing congregation of Prato. The church had engaged since the eleventh century in policies to encourage the

FIGURE 4.21 Three-quarter view, twelfth century. Pistoia, San Giovanni Fuorcivitas.

growth of its community, and the considerable investment involved in rebuilding Santo Stefano can be seen as a continuation of that policy. The same practice of projecting unifying images of a sacred imperial order that was developed in Florence and adopted in Pistoia provided the propositura a powerful tool for boosting the appeal of Santo Stefano and its settlement to recent and would-be rural immigrants. Carboncetto projected the cloister forms to the laity, inviting them to participate in the church. He did so both with the composition of the south elevation, echoing the arcades and ornament of the cloister, and with the plan of the resulting piazza. The buildings facing the *platea plebis* made the piazza into an analogous claustral space with the implication that the laity occupying its space constituted an analogous holy order to the canons within.

The status of the lay Pratese as a new, lay order parallel to the canons in the other, traditional cloister of Santo Stefano, is reinforced by number symbolism.

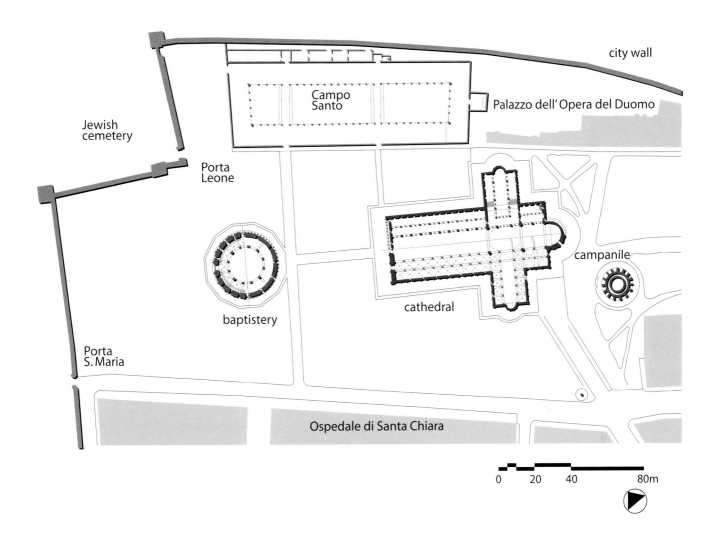

city wall

Campo
Santo

Palazzo dell'Opera del Duomo

Jewish
cemetery

Porta
Leone

campanile

baptistery

cathedral

Porta
S. Maria

Ospedale di Santa Chiara

0 20 40 80m

As evident in the reconstruction of his original project, Carboncetto built Santo Stefano's twelfth-century south elevation with eleven bays supported by twelve pilasters, just as at his cloister elevation (see fig. 4.5). These columns, too, can be read as the twelve apostles, whether as the twelve foundations of the celestial Jerusalem, or as living a life in common under Christ at the Portico of Solomon. The south-façade iconography confirmed the reading of the platea plebis as an analogous cloister for a life in common to be shared by the citizens of Prato.

I use the term analogous cloister because the platea plebis differed significantly from the actual cloister. The arcaded space was not closed but open-ended, and, with only one monumentally articulated wall in the piazza, nonuniform and off-balance (see fig. 4.2). The church elevation thereby created a hierarchical bias toward the Pieve, with its blind arches at once attracting the public to its polychrome walls and setting the church above its surroundings. Carboncetto selectively drew

FIGURE 4.22 Plan at 1:2000, eleventh–thirteenth centuries. Pisa, Campo dei Miracoli.

FIGURE 4.23 View from Porta Leone, eleventh–thirteenth centuries. Pisa, Campo dei Miracoli.

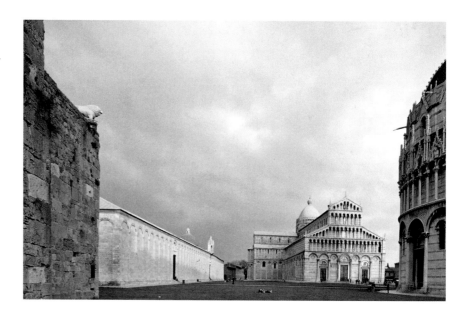

FIGURE 4.24 Façade, eleventh–twelfth centuries. Lucca, San Michele in Foro.

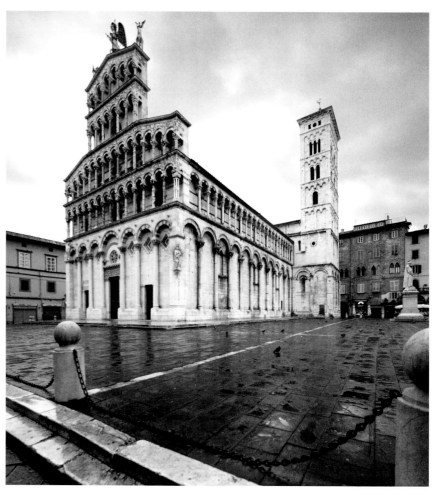

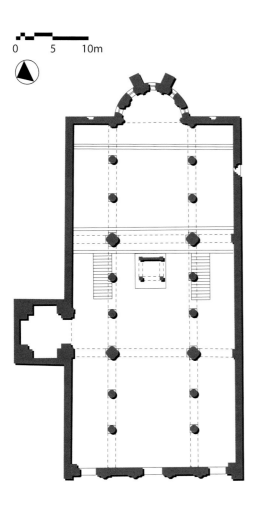

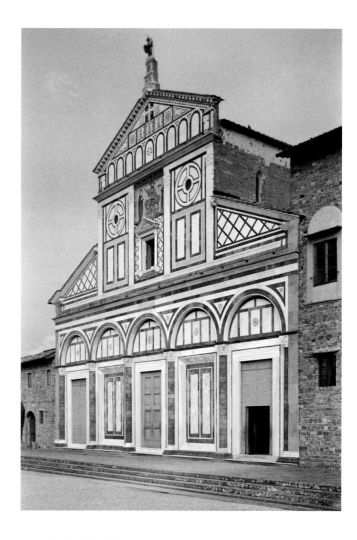

elements from regional sources to allow him to distinguish dramatically church from setting. He modulated between planar and sculptural, monochromatic and polychromatic, closed and open. He established moments of intensely concentrated visual information that exaggerated or exceeded practical needs of enclosure or passage within overall contexts of formal simplicity. The density of structural elements, of design and of ornament at points of passage, the two south portals or the cloister portals, simultaneously celebrates passage and congests it to the point of slowing movement (figs. 4.29–4.31). Entry is formalized; it is beautiful and special, to be wondered at, and even desired, but only to be approached with restraint and dignity.

The contrast evident between the elaborately composed arcades and portals of the south elevation and their simple monochromatic backdrop was echoed in the relation of the south façade to the facing piazza (see figs. 4.2, 4.15). Documentary and archeological remains at the piazza indicate an overall asymmetrical, disordered

FIGURE 4.25 Plan at 1:500, eleventh century. Florence, San Miniato al Monte.

FIGURE 4.26 Façade, eleventh century. Florence, San Miniato al Monte.

composition and the simple, monochromatic materials of its individual buildings. Tower-houses of brick and unornamented white stone proliferated along Via del Burgo and Via della Pieve, today's Via Garibaldi and Via Mazzoni. Massive interior walls at the corner of Via della Pieve with the piazza indicate that a tower was also located there. Other buildings that remain on the south side of the piazza date to the early thirteenth century at the latest. At the east end of the piazza, several tower-houses belonging to the Levaldini family occupied an entire block, bringing the piazza wall further to the west.[22] The overall effect of the approach streets and piazza was therefore of a bristling and irregular array of towers interspersed with lower structures, varying in lot width, height, and material; the street and piazza elevations had no discernible pattern to their composition.

The south façade of the church, in contrast, was symmetrical in its composition, with the two terminal ranges of shorter bays and the central range of wider ones. Variations in material complement the ordering framework of the individual architectural elements and groups. The bichromatic banding and green molding of the arches emphasize their form and rhythm and link them across the entire façade.

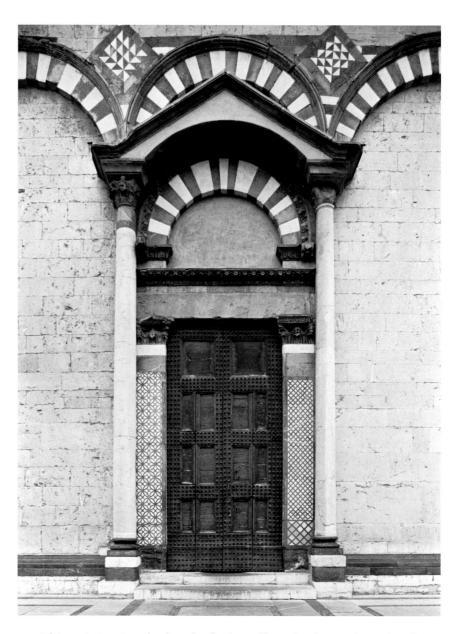

This variation in color has the further effect of isolating the arches from the wall surface, accentuating the relief already present. When combined with the repetition of triplets at the overall façade and the highly articulated portals, this sense of depth at the arches reads as an entry portico compressed against the threshold of entry. This reading of a flattened porch is supported by the imbalance of the four piazza elevations. The platea plebis appeared therefore more as a forecourt to the church than a final destination. It functioned less as a lay cloister than as a threshold to other, more sacred spaces beyond it. When integrated into its urban perception, the main public face of Santo Stefano functioned hierarchically. Unlike the nondirectional cloister, it emulated the axial movement of a nave,

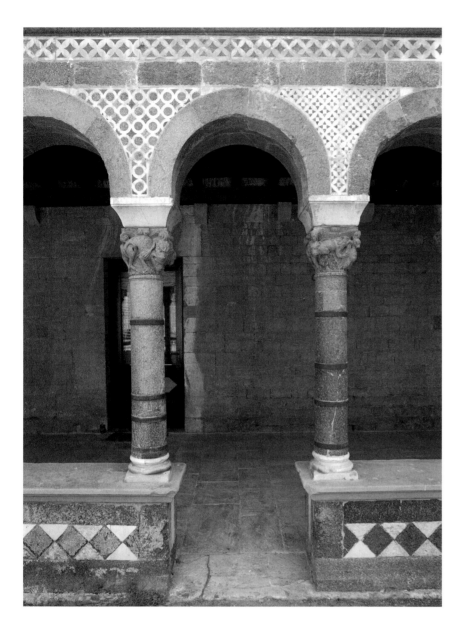

where the beholder was drawn to the altar. Carboncetto's south façade attracted the spectator first to the platea plebis, next lured the viewer closer to its elaborate composition, and finally drew one through it and into the truly sacred nave and cloister within.

The formal tensions built into the south elevation and the piazza of Santo Stefano visualized a mixed message to the laity. The provost and canons were courting the lay Pratese, encouraging individuals to move to the town, to participate in the new community, and to take on as their cause the church's cause of local sovereignty. The propositura's most powerful means for winning the hearts of the laity was its capacity, as a representative of Latin Christian authority, to expedite the

FIGURE 4.31 Carboncetto, cloister, portal, 1163. Prato, Santo Stefano.

passage of the faithful to salvation among the community of saints, through the administration of sacraments, blessings, and indulgences. A sovereign propositura could provide access to that salvation much closer to the laity than a distant bishop. At the same time, there was to be no illusion that the laity could ever aspire to such a power themselves. The provost and canons were already elect, and the laity would be able fully to participate, on equal terms, only in the afterlife.

The building contract between the propositura and Carboncetto clarifies how such a paradoxical broadcasting of brotherhood and of control over salvation served the general policy interests of the propositura in relation to the local laity and religious sovereignty. The contract makes clear that the propositura was willing to invest in its new architectural image even to the point of sacrificing other material resources. The costs were so high that the propositura was forced to reallocate church investments. To pay Carboncetto, the contract stipulated that the parish mortgage all of its agricultural holdings and even some of its devotional and liturgical treasures, including a manuscript of St. Augustine and a *pallium,* a liturgical vestment. The financial burden incurred by the project partially explains the presence of another group at the signing of the contract with Carboncetto, a delegation of *boni homines,* or laymen of good standing.[23] They represented the growing class of lay nobility, merchants, and industrialists in the town, who would have provided a reserve of wealth to back up the propositura's debt. A building program beyond the provost's traditional budget forced him to indebt himself and the canons to the architect and, implicitly, to the laity.

It is worthwhile considering how Carboncetto came into so much wealth that he could make such a loan to the propositura. Part of his loan may have been his own labor, but that could not have provided more than a small fraction of the total. The labor of his assistants would have required his regular payment to them, and so he would have had to have considerable funds. The term *marmolarius* may be of assistance here. In the area of Prato, a marble worker may well have had more wealth than a stonecutter or master mason. The most important source for decorative green marble in Tuscany was Prato's own Monteferrato. Whoever controlled the quarries, or even managed their operations, would have received considerable revenue, as most major church projects of the Tuscan Romanesque, from Pisa to Florence, used this stone for the characteristic bichrome effect.

The provost's sacrifices for the sake of the new complex made the church far more dependent on its income from tithes than from agriculture. With this shift in economic focus, the church was forced to reassess the value of its entire holdings. In order to cultivate, so to speak, the fields of its urban parishioners, precious manuscripts and expensive vestments had to be sacrificed for a far more effective medium for the urban ministry—magnificent architecture.

The agricultural and industrial holdings that the provost promised to Carbon-cetto were some of the propositura's fields and vineyards and the revenue from all of its mills. This reduced the sources of revenue available to the propositura. The parish was left with houses, apartments, and shops that it rented out. The income from rent paid was probably insufficient to sustain the church financially. Other sources of property revenue were the Pieve itself and churches under its jurisdiction. The yield from these is somewhat more difficult to define. Part was from the cultivation or grazing of land associated with its many parishes and chapels. Another portion consisted of tithes that the congregations paid, although if this were all that a church provided, there would have been little economic incentive to invest in any construction besides that which added capacity. A significant further source of revenue consisted in new, tithe-paying parishioners attracted to the area, people who may have responded to the beauty and, more important, the apparent holiness of the churches.

The greatest documented form of revenue was, in fact, from pious gifts. The competition for pious gifts during this time, between the propositura of Prato and the Pistoia bishopric, and between the propositura and the new monastic and hospital foundations establishing themselves in the area,[24] points to a strong incentive to invest in the beautiful and holy image of the church, and to try to keep up with the latest trends in architectural representation adopted by competitors. As with the agricultural and other architectural holdings of the Pieve, there may have been a strong sense of a relation between investment and return. Investments in architecture, in an area where population was growing rapidly, may have seemed—and probably were—more astute than keeping all wealth tied up in land and even mills. This would have been particularly true because the income from pious bequests usually came from gifts of more agricultural and architectural properties, which would have replenished the endowment of the church and compensated for the lost earnings from the mortgaged properties.

Carboncetto himself must have been aware of this or of some other extra revenue sources for the church, as he included a clause in the payment contract entitling him to the earnings from existing mills and from any new ones constructed by the church. The funds to build and finance these mills could only have come from rent, gifts, and tithes. His anticipation of gifts and tithes may have been, as it would be for any astute investor, in relation to the productivity of the money he was currently lending. As this money consisted in the marble, labor, and design costs that he incurred in constructing the Pieve, he must have had confidence not only in his own handiwork, but, more fundamentally, in the power of architecture itself to inspire the generosity of the local faithful.

The agreement by the Pieve to this penultimate clause in the contract seriously

compromised its prospects for strictly economic return from their considerable investment in church construction. The only economic explanation for this decision could be a desire—to put it in crude economic terms—to expand its market share of piety. By investing in magnificent architecture, even at a loss, the provost may have hoped to project sufficiently charismatic and threatening images of wealth and temporal and spiritual power to the urban laity in order to secure the allegiance and generosity of all the residents of the area. A monopoly over piety would have led to secure long-term profits that outstripped the short-term debts incurred. This outlook would have been consistent with the general expansionist policy of the Pieve, as well as with the conspicuous expansionist and monopolistic policies of the region's leading commercial city at the time—Pisa—which was aggressively building a mercantile and territorial empire.

The probability that the propositura was investing in architecture to advance its policy interests is supported by its efforts in the eleventh century to block the construction of churches within its territory by other religious institutions, particularly nearby parishes and monasteries.[25] The propositura even enlisted support from the papacy and their old allies, the Alberti, who were now situated at the northernmost confines of the propositura's territory at Vernio. Church construction by others within its territory was seen as a threat to the propositura, and, conversely, its own construction program was essential to the extension of its power.

The threat from other churches was simply that of drawing away the Pieve's parishioners, and with them their tithes, gifts, and testaments. The propositura tried to block any such incursions, which were, in fact, remarkably similar to what it had been doing in asserting autonomy from the bishop of Pistoia. To these ends, the propositura requested and received from the papacy sole rights over the construction of churches in its territory, in a letter of May 21, 1133.[26] The Pieve had secured a similar reinforcement of its monopoly over church construction from the Alberti in 1132.[27] These were less preventive measures than means to halt incursions that were already occurring in the Pieve of Santo Stefano's jurisdiction by neighboring religious institutions, such as the monasteries of Santa Maria di Grignano and San Fabiano, and the parishes of San Giusto, San Paolo, Sant'Ippolito, Santa Maria di Colonica, and Santa Maria di Filettole.[28] Some of these institutions had been trying to build their own chapels or monasteries within or near the city walls of Prato. The propositura rightly saw these architectural incursions as attempts by its rivals to continue to receive tithes, gifts, and testaments and to perform religious rites for the former members of their congregations who had moved to Prato, and were therefore removed from their jurisdiction. The issue was a difficult one, as canon law, in Gratian's decretal, set down that the parish of birth and baptism was entitled to the care of an individual's soul until death.[29] In supporting Prato, the

pope opted not to uphold this outdated practice, which, like the planting and harvesting metaphors of the decretal's text, was based on the mentality of agricultural society and its more fixed demographics. Instead, after what Innocent II noted as serious deliberation, he recognized the peculiar needs of the clergy in the new and rapidly growing urban center of Prato, which was responsible for caring for the souls of numerous immigrants from the countryside.[30]

Various popes ratified the de facto territorial autonomy of the propositura and classified its authority in relation to actual and potential parishioners, but while the parallels in religious imagery of redemption and ecclesiastical hierarchy were strong between Prato's Santo Stefano and San Miniato of pro-papal Florence, it would be difficult to prove that this actually affected the propositura's relations with the papacy. The primary means of winning papal support was diplomatic. Of particular importance was the intervention by the Alberti, who traveled to Rome with Emperor Lothar and offered their support to Pope Innocent II, condemning Anacletus II the Antipope.[31] The simultaneous alliance of the propositura with the pope and the pro-imperial Alberti should be seen not as a contradiction, but as revealing the complexity of the situation in Prato. The Alberti, like the emperors, often aligned with the papacy, particularly during crusades. The Alberti were as opportunistic as any other power at the time, even shifting their support away from the emperor and backing the pope, when they refused to accept the Antipope Anacletus, and stood by Innocent II, who encouraged the independence and local autonomy of the propositura. The Alberti's willingness to support the architectural monopoly of the provost and canons was consistent with their earlier support for the propositura, and, as the territory of the Pieve roughly coincided with that of the Alberti, it may have helped the Alberti to reinforce their secular power, by avoiding any ambiguity in the religious authority in the area.

The same papal decree of May 21, 1133, written by Pope Innocent II on behalf of the Pratese regarding competing parishes and monasteries, indicates the provost and canons' success in winning Rome's support for their bid for autonomy from the bishop of Pistoia and in their maintenance of control over religious institutions in their own territory. One papal letter indicates how effective papal protection could be: the pope actually forbade Pistoia's Bishop Atto from excommunicating the Pratese "without just cause."[32] The necessity of formalizing this protection reveals how powerful the threat of excommunication must have been.

The papal interventions that helped the propositura to maintain control over its religious power within its territory were as impressive as the papal support for the cause of the propositura's claims for autonomy from Pistoia: twenty-four letters over fifty-four years, through the reigns of seven popes. In all but one case, the pope was on the side of the propositura, denying the claims of neighboring parish

churches over their former parishioners. In place of older ties to lord, emperor, and rural parish, based on feudal bonds and place of birth, the papacy offered the immigrants to Prato and to similar commercial centers membership in the papal empire, as represented locally by Prato's propositura.[33] This papal policy may even have been intended to weaken the rural nobility's power over rural parishes, as the former often had family members appointed as clergy in rural parishes in their feudal territories. The support of the propositura removed any tie of fealty of previous serfs or freemen to their earlier lords, thereby making the move to the city easier and the depletion of the rural, feudal population more rapid. In the particular case of Prato, the Alberti seem not to have fought this trend, but even to have encouraged it, while at the same time cleverly shifting their own focus from countryside to town. In fact, between the beginning of the eleventh and late twelfth century, numerous chapels are documented as having been transferred from lay control to that of the propositura. This conferred their stewardship to the canons of Santo Stefano. Papal support legitimized the status of the propositura as papal representative, and reinforced its power to offer salvation or threaten excommunication.

While it is impossible to assess whether the new architecture of the propositura affected its alliance with the papacy, or even whether the propositura intended this, the successful effort to secure a religious architectural monopoly shows that the propositura considered architecture to be a crucial component of its religious and territorial policy. The importance that the propositura put on regulating the location of other religious institutions indicates that the provost and canons saw the presence and siting of churches to be the most important means for structures to enhance the power of resident institutions. The twelfth-century construction program at Santo Stefano fulfilled these criteria. Carboncetto lengthened and widened the church, moving the façade westward from its alignment with the cloister wall, thereby extending the length of the south elevation and allowing a new, second portal on that elevation to align precisely with the town's main cross street, the Via della Pieve (see figs. 1.3, 4.2). The church was now at the intersection of the town's two main thoroughfares, providing a larger presence both inside and on its expanded piazza. The polychromatic elaboration of the new structure further affirmed the propositura's dominance over other ecclesiastical entities in Prato. The green and white walls differentiated it from its surroundings, demarcating the sacred realm at the center of town. The false portico and hyperarticulated portals simultaneously offered and limited entry to the holy precinct, echoing the religious power of the provost and canons. To the degree that the blind portico and its bichrome inlay recalled iconographic and decorative forms employed by proponents of papal reform at nearby Florence, the church design reminded the Pratese and the antagonists of the propositura that its figurative promises and

threats were supported by the greatest spiritual power in western Christendom. The scale, siting, and articulation of Santo Stefano broadcast the propositura's authority and its alliance with the papacy more immediately and more widely than earlier religious architectural forms or other means, such as sacred vestments or richly illuminated manuscripts.

The expression of hieratic authority and papal imperium constituted only one of the ideologically expressive readings at the twelfth-century Santo Stefano complex. The other was seemingly its antithesis, the image of spiritual brotherhood present, in variant forms, at both the cloister and the south façade. The coexistence of the symbolic threat of spiritual force with an image of religious brotherhood in the architecture of Santo Stefano ceases to be contradictory when one considers their common message, that access to paradise was controlled by the propositura. By making the architecture of Santo Stefano into a convincing image of a peaceful and equitable paradise, the provost and canons increased the value of the object for those both denied and offered access.

The propositura's ambiguous generosity is consistent with its resistance to involving the consuls as equals in the funding and administration of the new church structures. At the signing of the contract with Carboncetto, not even the consuls were present, only the unofficial lay organization of boni homines, and then only as witnesses, not as cosigners. The refusal to allow the laity equal say in architectural decisions is understandable. The power of the propositura was based, in part, on its sovereign control over access to the architectural prefiguration of paradise and to salvation itself. So long as the lay Pratese fulfilled their duty of supporting the church's bid for religious autonomy, they too would be able to participate as equals in the realm of the elect, the four-sided cloister qua paradise—in the afterlife.

Later generations of lay Pratese lost patience. The advantages of winning control over this religious architectural iconography became increasingly apparent with the success of buildings such as Santo Stefano. Buildings became potent tools of religious institutional power, which only increased in strength as the fever of lay piety spread during the following century. The perpetuation of a double and fundamentally contradictory iconography and ideology of apostolic life ensured that the traditional institutions and ideals of the church maintained a powerful presence in Prato despite the explosive growth and revolutionary changes of its urban society. However, like any good tools of war or persuasion, the traditional iconographies of both brotherhood and empire carried within them a persuasive force that could overcome their original institutional affiliation. Over the next hundred years the provost and canons' architectural rhetoric proved too powerful for them to control. Within a generation, their architectural innovations provided the means for their subjects to become their masters.

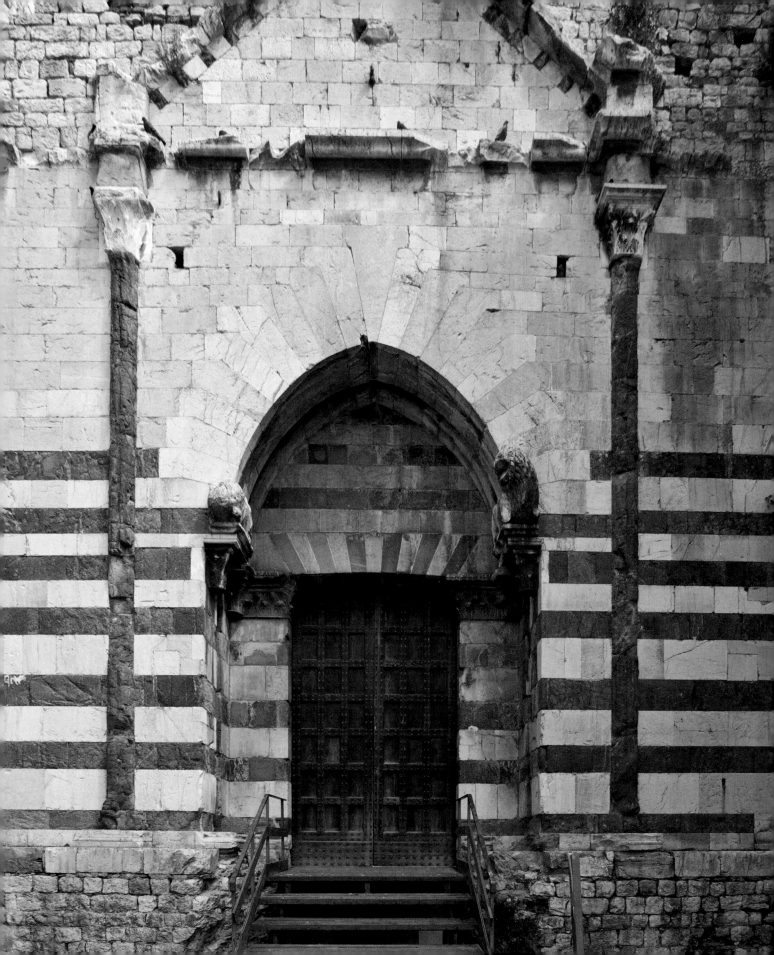

The Expression of Secular Authority by the Early Communal Regime

The Construction of the First Civic Center

The dawn of the thirteenth century saw the first monumental buildings by the lay government of Prato. This moment had been long in coming. For the first time since the tenth century, when the lay residents of the Bisenzio valley initiated the area's economic rise, a secular government represented the townspeople with monumental architecture and spaces. Intimations of this architectural coming of age were already present in the previous century, first when the consular government began the unified town's first ring of city walls, and then when lay boni homines witnessed Carboncetto's contract to expand Santo Stefano and its cloister. The tentative beginnings of the consular government's architectural patronage shifted, as if on cue, around 1200. By 1201, a *palatium curie* (senate palace) on the platea plebis was occupied by the consular government.[1] In 1208, the same urban space was mentioned under a new name, the *plaza comunis*. The 1208 text refers as well to another administrative structure, the *turris curie*. In 1211, the consuls signed a contract with the architect Guido da Lucca to continue work initiated by Carboncetto and to expand the church and cloister.

The construction of a consular palace and a communal tower by 1208 and the changed name of the space from platea plebis to plaza comunis gave an architectural and verbal presence to Prato's new lay government at the very site of the town's previous secular and religious authority, the propositura (see fig. 4.1).[2] These new urban features could even be construed as displacing the propositura. That interpretation would accord with theories of the secularization of medieval society.[3] There is no question that the construction of the palace and tower and the renaming of the piazza expressed the gradual process of state formation that would continue to the end of the commune's independent existence in the mid-Trecento. These architectural expressions paralleled the bureaucratic, juridical, legislative, and other cultural processes of concentrating power in the hands of a lay regime claiming to be acting in the interests of the whole town.[4] However, it

DETAIL: FIGURE 5.10

does not necessarily follow that the process of state formation, even in a state ruled by a lay government, weakened the hold of religion on society, particularly when the rhetoric of power remained strongly based on religious images and creeds.

Rather than being signs of secularization, the character and siting of the consular government's work around and at Santo Stefano suggest that its members could conceive of their authority only in the same terms as their episcopal and propositura predecessors did. This is consistent with the development of lay governments in city republics throughout central and northern Italy. Prato's new communal government depended on the propositura as it established itself, and the two authorities continued to develop the symbiotic relationship they had started when they had joined to make Carboncetto's employment possible. At the same time the propositura showed itself willing to sacrifice some of its autonomy in church architecture, as we will see in the next chapter, in order to extend its church and its imagery in competition with the rapidly growing commune. The rise of the lay government was therefore less a secularization of power than a delegation of divinely based power from one institution to another, in this case to the authority with the most money to spend on monumental architecture. The basis of power remained nonetheless divine.[5]

The political developments of the period support the interpretation that the architectural assertion of power by the consular government at the plaza comunis was made in alliance with the propositura. The major challenge for the merchants, bankers, and artisans of Prato in the thirteenth century was to sustain the town's territorial autonomy established by the Alberti and by the propositura. The consuls continued the church's policy of abrogating the autonomous powers of lesser nobles in the countryside. The church had done so in two ways: by placing their reformed canons in control of district churches and chapels previously controlled by the laity; and by assisting in the freeing of serfs. Both had the effect of drawing rural population to the city. The consular regime benefited from this for the same reasons that the church had benefited, of increasing the working population and therefore revenue base, and so the laymen continued to support the extension of the propositura's religious sovereignty and the freeing of serfs.[6] On a regional scale, the consuls, as already shown in their construction of city walls, both advertised and defended the independence of city and territory through a careful mix of alliances and regional battles.[7]

These policies irritated the rural nobility and led to increased violence by noble families in city and region. This, in turn, threatened the economic prosperity and defensibility of the city. Leading the violence were the feudal *consorterie*, whose members had once been kept in check by the Alberti but who now were indepen-

dent of any authority except the interests of their extended family groups.[8] The only power to which they did show fealty and respect was the emperor himself. By the thirteenth century, however, the imperial presence in Tuscany had become increasingly antagonistic to communes supporting the papacy, one of which was Prato. To make matters worse, since the late twelfth century, the emperor had encouraged the subversive tendencies of the consorterie both in person and in image through the presence of an imperial vicar stationed at the *palatium imperatoris* less than one hundred meters south of the town walls.

The Portico of the Palatium Curie and the Control of the Marketplace

The documented tensions in the city between the commune and its secular antagonists, not between the commune and the church hierarchy, indicate that the location of the palatium curie at the church piazza was intended to fortify the authority of the communal regime by associating it with the longer-established authority of the propositura. Documentary records, topography, and architectural symbolism reveal that the designers of the palatium curie had incorporated into their novel building type traditional expressive characteristics of the church. The palatium constituted one element of a redefined but still unified space, projecting an alliance of new and old authorities. The descriptions of the palatium in the document of 1201 and in another of 1266 show that the senate palace had a portico and that it, together with the tower, terminated the west end of the piazza (see fig. 4.2). The 1201 text mentions that the palatium curie was built with a ground level that was part open and part closed, "partim incasatis et partim non," and that benches were located within this semi-enclosed area, probably for administrative offices as well as for retail shops.[9] The 1266 document indicates that this area was termed a *porticus,* or portico, which was probably situated beneath the upper-level main assembly hall, or residence, of the government.[10] This kind of portico was typical of the mixed-use loggias, generally arched rather than trabeated, built at the ground level of bishop's palaces and early communal town halls throughout northern and central Italy. Early examples include the bishop's palace of Pistoia (eleventh–twelfth centuries) (figs. 5.1, 5.2), the Palazzo della Ragione of Bergamo (1198) (figs. 5.3, 5.4) and of Milan (begun 1228) (figs. 5.5, 5.6), the *pallatio novo* of Cremona (1206), and the Broletto of Como (1215).[11] This type appeared at least as far south as Todi (figs. 5.7, 5.8), with the Palazzo del Popolo (1213) and Orvieto, with its Palazzo Comunale (1216–19).[12] The arcades that characterize these governing structures may derive from market arcades, such as at the Mercato Vecchio in Florence, where traces of the old Roman Forum arcades lined the medieval market area, or at the Bisenzio market at Prato, and even along important retail

FIGURE 5.1 View, eleventh–twelfth centuries.
Pistoia, Bishop's palace.

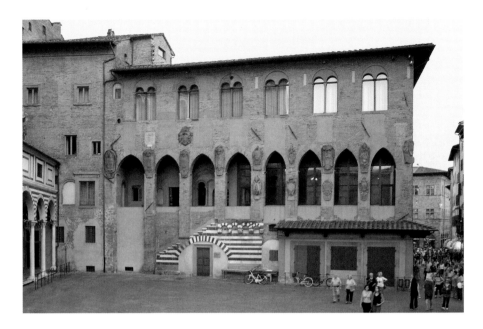

thoroughfares, as in Bologna, and throughout communal Tuscany. The proliferation of arcades in commercial areas seems to suggest a purely functional, secular origin and a nonrepresentational character.

Earlier sources for the regular lining of sites with arches, however, were closer at hand for the Pratese of the early thirteenth century, in the arcaded market areas attached to the sides of Romanesque churches (such as at Ferrara's cathedral of 1135), in cloisters, and even in the flattened version lining the market area of the very piazza in which the palatium curie was located—the blind arcade of Santo Stefano's south façade.[13]

The arcades attached first to church complexes and then to market and town-hall structures provided public infrastructure and services to facilitate the smooth functioning of the market. Porticoes protected commerce from the elements. They also housed government officials who controlled weights and measures, determined just prices, collected taxes on exchanges, and settled legal disputes between commercial parties.[14] In Prato, the first of these authorities, as discussed above, was the provost and his canonicate.[15] It was natural that the commune adopted the same arcades for its own administrative seat. By doing so it was not simply providing more covered locations for commercial activity. It was also associating itself with a visual function of the Santo Stefano south façade not mentioned in the last chapter, the propositura's image of organization and control over the market. The new communal palace even extended that image to its own institution. The bays of the arcade measured and demarcated the space for commerce; they provided an architectural means for authorities to approve, to individuate, and to delimit commercial activities.[16]

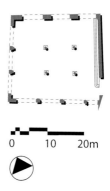

The blind arcades of Santo Stefano's south elevation were by nature more figurative than practical. Transactions occurred either at the cloister or in the platea plebis: real estate or contracts at the cloister; all variety of transactions, including merchandise, at the platea plebis. This hierarchy of authority over transactions was embedded in the hierarchy of the architecture, because the cloister was the more sacred and formal of the two spaces. The two-dimensional repetition of the cloister arcade, first by the blind arches of Santo Stefano's south façade and then by the palatium curie, suggests that the image of commercial order and control originated in sacred architecture, just as actual economic legislation derived from canon law administered by church authorities.[17] Similar situations in other Italian communities of the Romanesque period corroborate this. Arcades had become practically the signature of religious buildings of the same Lombard, Venetian, Emilian, Tuscan, and Umbrian towns where the communal palace and "pure" market types appeared. In nearly every case, the religious examples preceded the secular ones and continued to be built during the time that the communes were laying out their civic arcades. The arcades were in many cases built at churches by *opere*—building committees administered by communal authorities.[18] These were often the same opere that were building the ostensibly secular arcades along public streets and piazzas, as well as at town halls.[19]

The use of arcades at these religious structures was both structural—in the naves, crossings, chapels, fenestration, portals, and porticoes—and ornamental, at inaccessible galleries or blind arcades. Arcades had supported and adorned church naves since the second generation of early Christian basilicas.[20] What was unusual in the Romanesque churches immediately preceding and during the early com-

FIGURE 5.3 View, begun 1198. Bergamo, Palazzo della Ragione.

FIGURE 5.4 Plan at 1:1000, begun 1198. Bergamo, Palazzo della Ragione.

munal period was the omnipresence of arches, appearing as the major decorative motif on all vertical surfaces, usually without a structural function. The ancient origins of the arch and its strong association with arcaded naves, apses, atria, and porticoes of churches may have led to the perception of the arcade type as bound with religious buildings, and, therefore, with the architectural representation of sacredness. During the years of the investiture controversy, when many of these churches were built, the application of the arcade to the prominent surfaces of church structures may have advertised the holiness of the authority resident in these churches, as sanctity was the attribute upon which they based their claim for universal religious and secular imperium.[21]

Commercial activities did not secularize the arcades; the arcades blessed and therefore legitimized the marketplace.[22] The hieratic function of the arcades was one aspect of the alliance between secular and religious authorities that developed in the early communal period. The new trade and industrial economy was eclipsing agricultural production and military power as a source of political power in cities and their territories.[23] The alliance between church and state to control the urban economy is a subject that deserves analysis beyond the scope of this study. The moral presence of the church was essential to the functioning of new urban markets, which, based now on monetary transactions and not on barter or oaths reinforced by kinship or fealty, depended on a level of trust between parties that had often only one common interest—salvation.[24] The connection between faith in monetary transactions and religious faith is apparent in the financial records and commercial correspondence of Pratese merchants and shop owners, as late as that of the late fourteenth-century Francesco di Marco Datini. The letters often begin with the phrase "In the name of God and of Profit." Such a purposeful confusion of money and faith may be a characteristic element of the bourgeois economy. Max Weber provides a more recent example, with the comment of a salesman quoted by Weber in 1904, while traveling in America: "Sir, for my part everybody may believe or not believe as he pleases; but if I saw a farmer or businessman not belonging to any church at all, I wouldn't trust him with fifty cents. Why pay me, if he doesn't believe in anything?"[25]

Such an important status for the church in matters economic was the norm during the twelfth and thirteenth centuries, when Italy's communes were being established. The church became explicitly involved in the morality and smooth functioning of the marketplace, whether in determining just prices or in the interdict against usury.[26] The physical presence of the church, or at least of its symbolism, was the most effective means to remind merchants of religious economic morality and of the punishment for subverting it.[27] A civic arcade assured all par-

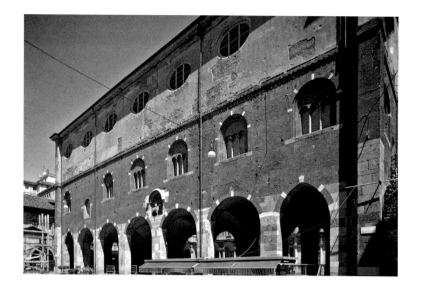

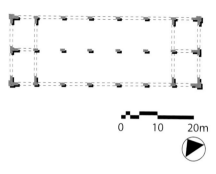

ties that the local government was present, with the church and with God behind it, as an unbiased, noncommercial authority, ready to ensure fair transactions, adjudicate differences, collect taxes, and punish fraudulent merchants according to both temporal and canon law. If nefarious traders were not apprehended by secular or church authorities, they would certainly be apprehended by the divine *numina,* such as the symbolic twelve apostles figured in the pilasters of Santo Stefano's façade. The power of this divine presence was to bless or to curse, even with eternal damnation.[28]

The same threat against swindlers and usurers applied to violent individuals or groups, such as the urban nobility and their courts, and to heretics. The ability of the arcade symbolically to control action reinforced the way that it physically and visually regulated the span of the wall and the modules of market benches. The potency of this physical, visual, and symbolic control made the arcade type the logical choice, and probably the only available one, when secular governments began to build their governing structures and to increase the market spaces in their communities.

The Plaza Comunis as Fraternal Cloister and Hieratic Nave

The effective functioning of the arcades as a medium of control, however, depended on their continued religious symbolism. The consuls of Prato reinforced this symbolism when they built their palatium directly on the church piazza. Their palatium registered the town's acceptance of the symbolic offer of alliance from the provost implicit in the fraternal reading of the south façade by Carboncetto. The location of the consul's own palace even extended the claustral imagery implicit in

FIGURE 5.5 View, begun 1228. Milan, Palazzo della Ragione.

FIGURE 5.6 Plan at 1:1000, begun 1228. Milan, Palazzo della Ragione.

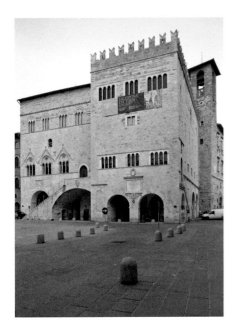

FIGURE 5.7 View, begun 1213 and 1290–6, respectively. Todi, Palazzo del Capitano and Palazzo del Popolo.

FIGURE 5.8 Plan at 1:1000, begun 1213 and 1290–6, respectively. Todi, Palazzo del Capitano and Palazzo del Popolo.

the south elevation to two sides of the now quadrilateral space. With their closure of this space, the consuls were at once expanding and delimiting the scope of the life in common. The piazza included not only the monuments sponsored in common by the laity and the propositura, but also the commercial transactions and judgments ratified by lay and religious authorities. In Prato, at least, it is therefore possible to isolate historically and spatially the adoption of the religious concept of the apostolic common life by the political common good.[29] Further studies may be able to determine whether it was by chance or intention that the actual term used in Prato and other city-republics for their new governments, comune, echoed the vita communalis of the monastery and canonicate. The terms *res publica* and comune, in fact, mean the same: "thing(s) public" or "in common." The latter only redefines the classical prototype in terms of the primitive Christian church and its vita apostolica, which was synonymous at the time with vita communalis.[30] The proliferation of these terms in twelfth-century Italy strongly suggests that the medieval and modern Italian political term comune, best translated by its English counterpart, commonwealth, derives from the vita communalis of re-formed canons, and registers the transposition of the apostolic "life in common" from the monastery to the urban laity. The spatial representation of this transposition in Prato is the mirroring of the canonicate onto the plaza comunis.

The common good, like the life in common, could be available only to those who accepted the monastic or canonic life of individual sacrifice in the interest of the whole. For those who wavered, disciplinary measures discouraged excessive individualism, including threats or even excommunication. Urban space had greater difficulties in sustaining a similar purity of common life. While discipline and its imagery were present but limited at the cloister, there was a far greater need for them at its analogue—appropriately named the plaza comunis. The planners of the space achieved this effect by fusing imagery from the cloister and nave of the church. The short arcade of the communal palace terminating the space, at the endpoint of the south façade, shifted the orientation of the space from the long façade of Santo Stefano, terminating the Via della Pieve with its west portal. The new palace became the equivalent in its space to the sanctuary terminating the nave in the church. The implicit iconography of the palatium curie as church sanctuary was strong enough to alter the reading of the piazza, emphasizing the image of hieratic authority at the space. It was as much an exterior nave as an urban cloister, parallel literally and symbolically to its counterparts within the church complex. This exterior nave and terminating arcade at the portico of the palatium curie expressed the parallel, secular authorities in the community, who were no longer content to reflect the subordinate status of the canons in their cloister. Instead they were emulating the dominant status of the provost himself, exercising power *ex*

cathedra, from beneath the monumental arch of the apse. By basing themselves on the provost's hieratic power, the consuls extended not only the sacred common life to the plaza comunis, but also the imagery of divine control that the provost had previously embedded into the south elevation of the church.

The Palatium Curie as Senate

The titles and typologies of the palatium curie and turris curie reinforce the meanings apparent in their design and siting. *Curia,* or senate, derives originally from the Roman senate, which was housed in a structure at the *Forum Romanum* in Rome, a republican judicial and market area. The consular government's reference to this historical building had the same significance as the arches at its base: the palatium curie denoted the judicial and administrative authority presiding over the space. The Pratese were by no means original in reviving the language and institutions of the Roman republic. After Nicholas II and the college of cardinals had formalized the election of popes in 1059, the term *curia* came increasingly to signify the site of papal authority in Rome, the mix of secular and religious power the pope and cardinals held, and the life in common that they were advocating for their ministries.[31]

Local models that had developed in response to the papal reform movement further determined the institutional composition of the civic curia in Prato. These began with the communities of canons and other institutions linked to the bishop of Pistoia and the propositura of Santo Stefano. With the eleventh- and twelfth-century expansion of trade and industry, bishops were encouraged to delegate fiscal and juridical responsibilities over lay matters. They and their representatives, such as the provost in Prato, began to foster the development of volunteer groups of upstanding citizens, boni homines, without, initially, giving them political power. Before the formation of the consular government, the same bankers, wealthy merchants, judges, and urban nobles who were to become consuls had thus advised the provost in economic, administrative, infrastructural, and military matters.[32] When formalizing this institution as a distinct governing entity, the boni homines, now consuls, chose a title for their institution that embodied their role as advisors to a higher authority, just like the cardinals to the pope, while implying a certain autonomy.

This reading of the political and religious significance of curia is corroborated by the first locations of the consular assembly in Santo Stefano, and later, when their administrative and judicial activities grew with the population and prosperity of the commune, also in San Donato, located on the Scampio, which was the site of the grain marketplace of the town.[33] The palatium curie was, in fact, the third location of the Pratese consuls, who continued to use the other spaces simultaneously.[34]

Their physical presence at one of the other market areas of the town is consistent with their physical and architectural presence at Santo Stefano, supervising and protecting market activities.

The Palatium Curie as Episcopal and Imperial Palace

The name palatium curie and its architecture bore another significance at the time. The origin of the word *palatium* was the Palatine hill in Rome, where the Flavian emperors had built their residences. The intermediate use of this term through which it was transmitted to the Pratese was for the palaces of bishops and Holy Roman Emperors. Although palatium was never applied to the residence of the provost, it was used to refer to bishops' residences throughout Italy immediately before consuls in Prato and other communes established their first lay palatium. This chronology was not coincidental. Maureen C. Miller has shown that some bishops responded to the rise of the consular governments by renaming and even redesigning or rebuilding their residences, from *casae* to *palatii*.[35] Such bishop's palaces still stand in Prato's neighboring Pistoia, as well as in nearby Lucca. By assuming the name and design of bishop's palatii, consular regimes in Prato and throughout central and northern Italy sought to ratify their autonomy by appropriating for themselves episcopal tradition.

The term palatium also registered another traditional authority resident in Prato. Late in the twelfth century, Frederick Barbarossa and Henry VI had established a presence of the Holy Roman Empire in Prato, at the site of the Casa Alberti. This structure, which became one of the Holy Roman Emperor's most prominent seats in northern Italy, was occupied and renamed *palatium imperatoris* by 1191–92 (figs. 5.9–5.12).[36] Only ten years later, palatium curie was applied to the consuls' headquarters in the document of 1201.

The imperial and communal palatii bore more resemblance to one another than just their names. The palatium imperatoris embodied both the classical palace tradition and the fortification tradition of the late imperial and feudal castle. A lower structure, with a court or curia lined with arches, was framed by corner defensive towers. Prato's consuls took over the defensive tower of the palatium imperatoris in their turris curie. They also grafted another element that may or may not have been present at the palatium imperatoris, but that was strongly associated with imperial palaces since Diocletian's palace at Split.[37] This was the imperial palace entry façade, which consisted in a meeting hall located above and figuratively controlling an arcaded portal or city gate below. Nearby examples of this type were at the imperial palace of Theodoric and at the palace of the Byzantine exarchs in Ravenna.[38] Prato was not the first to adopt this type—it was also present at the early communal palaces at Bergamo, Como, and Orvieto, as well

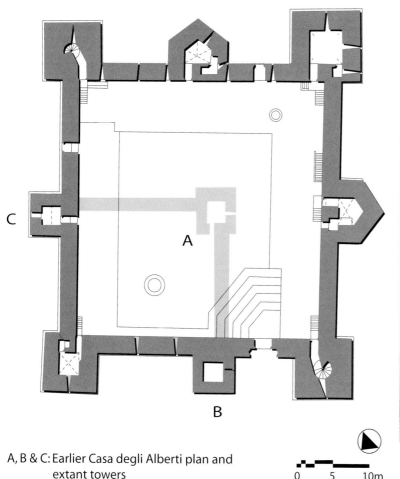

A, B & C: Earlier Casa degli Alberti plan and
extant towers

0 5 10m

as at the gates to major churches and monasteries before them, such as at Old St. Peter's, the Carolingian gatehouse to the monastery of Lorsch, and at the entry to Desiderius' monastery at Montecassino.

The appearance of the imperial palace entry façade in Prato and at other communal palaces, like the use of the term palatium by other communes, indicates the ideological aspirations that the ruling Pratese had in common with other communal regimes: they were all assuming the status and power of the emperor in their own communities.[39] Italy's communes had been impersonating imperial authority literally, by demanding imperial rights and even by asserting unilaterally their independent status from Frederick Barbarossa and then from Henry VI.[40] The emperors' hesitation and occasional aggression in the face of the hubris of the Italian communes led to confrontations between them and to communal alliances such as the Lombard League in the north[41] and the league of Genesio in Tuscany.[42]

FIGURE 5.9 Plan at 1:500, eleventh–thirteenth centuries. Prato, Imperial Palace.

FIGURE 5.10 Portal, twelfth–thirteenth centuries. Prato, Imperial Palace.

FIGURE 5.11 Tower, Casa degli Alberti, eleventh century. Prato, Imperial Palace.

FIGURE 5.12 View from twelfth-century city walls, twelfth–thirteenth centuries. Prato, Imperial Palace.

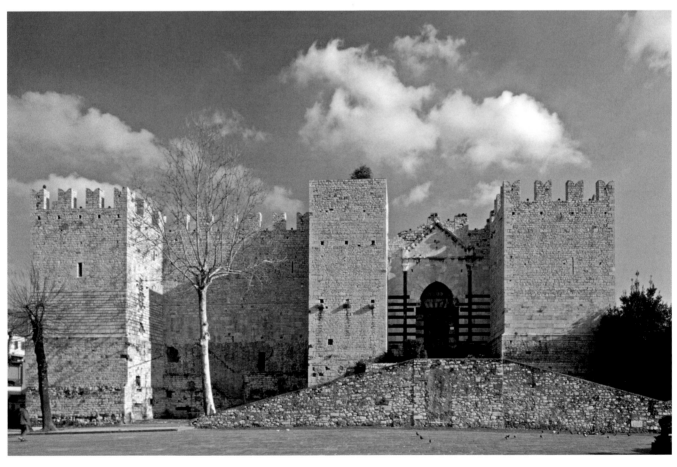

The feudal imperial associations that communes such as Prato expressed in their earliest public buildings did not contradict the sacred readings of these structures, nor the peaceful coexistence of lay governments with church institutions. More often than not, bids for independence by the communes in the twelfth and thirteenth centuries were supported by the papacy. Antagonism had persisted between emperors and popes following the investiture conflict. The papacy sought to break the emperor's power in Italy and to build up its own empire by nurturing communes as allies. Mutual anti-imperial interests help to explain the new alliance of sacred power that the papacy and communes appear to have been working together to formulate. Their new sacred imperium in Italy comprised local, semiautonomous republics that were practically religious fiefdoms, with more political freedom than they had enjoyed under the empire but with stronger ties to the church, whether local or Roman. This local imperium defied the Holy Roman Emperor and his vassals with its reflection of imperial imagery.

The alignment of the commune of Prato with the propositura and, by extension, with the entire papal hierarchy, may nonetheless be seen as a sign of the precariousness of both institutions in relation to the emperor and to other opposing groups. The emperor himself seldom stayed in Prato. He nonetheless commanded strong local support from the consorterie of rural and particularly of urban noble families who were linked with the emperor by their feudal roots or by oaths of fealty.[43] Other threats to communal order were heretics, who undermined the church and the idea of hieratic authority upon which both church and state were based.[44] The commune helped suppress heresy and adopted the language of religious orthodoxy, including references to divine judgment when framing their own legislation. Obedience to the communal law was seen as obedience to God's law, with the commune of Prato even naming its statutes "sacratissima," and beginning every legislative entry with an invocation to Christ and the city's patron saints.[45]

The Civic Visualization of Force: The Turris Curie

The need for both a display and a control of force on the part of the new commune explains the structure adjoining the palatium curie—the senate tower, or turris curie. The notarial act of December 18, 1208, which records the possession of a house by a private citizen, Bonato di Baldanza, gives a good description of the siting of the turris curie (see fig. 4.2). The Bonato house was "in front of the parish of Santo Stefano, next to the tower of the curie; to its east is a street, to its north the piazza of the commune, to its west and south the properties of Baldanza."[46] The location of the tower beside the palatium curie followed standard practice at the time at communes, visible at extant early communal complexes such as at Bergamo and Como.

BELOW

FIGURE 5.13 Typical tower-house complex, eleventh–thirteenth centuries.

RIGHT

FIGURE 5.14 View of tower-house remains, eleventh–thirteenth centuries. Florence, Piazza San Pier Maggiore.

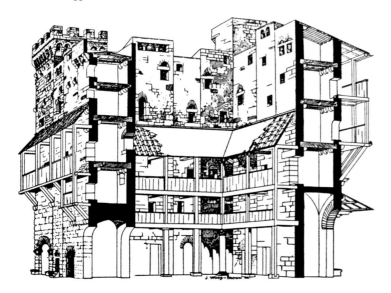

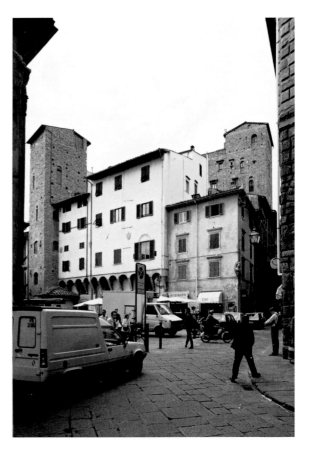

The sources for the communal tower type and its imagery were the fortifications of the urban consorterie and of rural feudal lords. Numerous consorterie had built urban towers both within Prato and just outside the city walls, where the castle of the Alberti and later the palatium imperatoris were similarly fortified. During the late eleventh and twelfth centuries, in Prato and other Tuscan communes, there had been a boom in the construction of towers within the city walls that registered the migration into the city centers of previously rural-based nobility.[47] The tower-houses that they built were usually large agglomerations, often taking up one or more city blocks (figs. 5.13, 5.14). They were sealed off from public access and defended from the heights of the towers against aggressor tower-house complexes and families. Each new consorteria family that arrived constructed and manned its own maze-like urban bastions, often with entire rural communities and infantries.[48] The topography of rural power was transposed to the emerging communal cityscape at a denser scale. These towers helped perpetuate the antagonisms between rival urban consorterie and also between consorterie and the consular government.

Contentious parties seeking dominance within the eleventh- to thirteenth-century communes were not limited to the church and state.

With their construction of the turris curie, the new consuls were responding to the proliferating consorteria towers and to the palatium imperatoris, with which the urban consorterie tended to align themselves. The commune resorted to the same architectural and military expressions of force as their adversaries did in its struggle to maintain peace and to defend itself.

□ □ □

The expression of intimidating physical power in the tower of the commune tipped the balance from brotherhood to religious authority at the new lay regime's urban setting. The original egalitarian reading of the platea plebis gave way to the more hierarchic reading of the plaza comunis. It was now the locus of the new, secular component of the community's theocratic authority. The palatium curie provided the arcade from which the consular senate could preside at the symbolic cathedra terminating the reading of the space as an exterior nave. These architectural images expressed both the aspirations and increased responsibilities of the consuls. The unstable and violent political scene of early thirteenth-century Prato may have led them to emphasize and even to adopt, consciously or unconsciously, the imperial authority of the Santo Stefano blind arcade, and to deemphasize, though not entirely to suppress, its imagery of collegiality and apostolic life in common.

In assimilating the image of hierarchic authority from Santo Stefano, the consuls were not assuming that image exclusively for themselves. Their actions should be seen as the consuls' recognition of their own inability to project, unaided, an image of powerful authority. This aid took the form of the architectural and urban symbolism of the church, overlaid onto forms borrowed from the government's imperial and feudal adversaries. An actual alliance with the propositura backed up the commune's threat of divine retribution to nefarious traders, political antagonists, or heretics. Religious architectural forms continued to be as potent expressions of authority as military and aggressive rhetoric, such as that of the turris curie, so long as individuals remained as preoccupied with their spiritual salvation as they were with their physical welfare. At the same time the valorization of images of authoritarian control and physical force threatened to isolate both state and church from a citizenry that was ever less involved or interested in the world of lords, bishops, emperors, or popes and increasingly committed to the modest, day-to-day concerns of getting and spending, and to the accompanying Pratese tradition of individual self-reliance and self-determination.

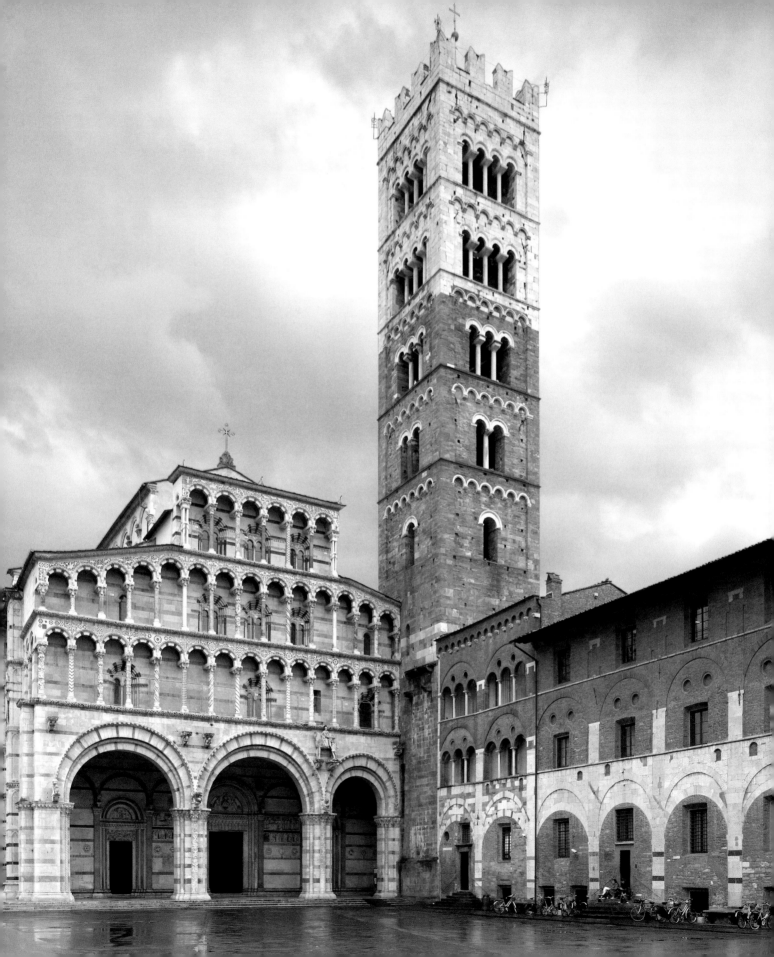

The Expression and Defense of Religious Authority by the Early Communal Regime

The Contracting and Organization of Work at Santo Stefano in the Early Thirteenth Century

The clearest indication that the commune's construction activities at the plaza comunis was not a secularization of that space is their initiative to enlarge the Pieve of Santo Stefano itself. No longer content with the passive role of previous generations of laity, the consuls made themselves partners with the provost and canons in authorizing, overseeing, and underwriting construction work at the church. Apparently, the consuls considered the siting and the application of religious architectural forms to their own palace insufficient to establish their linkage to the traditional religious authority at Santo Stefano. Rather, they sought actively to engage in supporting the church institution itself, and to invest in its architectural and spatial expression. Their own words indicate that they considered their support of the church to be a means for enriching the commune as a whole and, implicitly, for supporting their claim to represent that commune.

The evidence for the commune's policy goals in engaging in church architecture is spelled out in the contract the consuls signed in the cloister of Santo Stefano on June 8, 1211, for architectural work on the Pieve.[1] The parties to the contract were Guido da Lucca, the architect of the Cathedral of San Martino at Lucca, the Provost Henrico, canons, consuls of the commune, and merchant consuls.[2] From this point on, the commune increasingly funded building work at Santo Stefano, and also participated in the entire building administration, including the choice of designer and the making of design decisions, over which the contract gave them equal authority with the provost and canons.[3]

The contract provided for the completion of construction work on Santo Stefano, as well as for the redesign of certain portions that may have been unsatisfactory. The previous work referred to was most likely that initiated under Provost Ubertus in the second half of the preceding century, executed by Carboncetto. The funds that the provost had offered Carboncetto, by mortgaging much of the church's

DETAIL: FIGURE 6.2

earthly goods, appear not to have sufficed for the completion of the church, or at least for its completion according to the ambitions of the new Provost Henrico. Henrico may have involved the commune in the 1211 project in order to raise the necessary extra funds to finish construction, and also to rework portions that may have been executed unsatisfactorily, due to either the limited funds of the previous stage, the artistic limitations of the local marmolarius Carboncetto, or a change in stylistic tastes. It cannot be excluded that the consuls themselves persuaded Henrico to expand the church after having completed their own secular governing structures. The commune's financial involvement in the church expansion is made particularly clear by the presence of the consuls of the merchants, who acted as representatives for the wealthiest class of citizens. The price that the provost had to pay for financial assistance was the say of the commune and the merchant consuls in the project's administration.

The mechanism for coordinating the various interests of the consuls, merchant consuls, provost, and canons was the *opera,* a new institution that may have been created in Prato, and in other communes of the time, exactly to mediate between the architect and workmen and the various institutional patrons.[4] The experimental character of this institution is clear in the unwillingness of the various patron institutions to grant the head of the opera complete control over the architect: "And [he shall be available] at whatever time that the provost, or his chaplains, or the consuls or *podestà* of Prato or the commissioner of said *opere* wishes to retain him." One can only imagine the difficulty Guido would have faced in negotiating the needs of all these different parties. The completion of the project indicates that the various patrons nonetheless delegated sufficient authority to the opera commissioner to keep design and construction moving under a clear chain of command. The availability clause may have been added less to compromise the authority of the commissioner and more to assure that Guido had many eyes watching him, lest he be lured to other communes.

The jealous retention of Guido was not just a practical means to ensure the rapid and economical completion of the church. It was also a way for both the provost and the commune of Prato to keep other communes, besides Lucca, from which they hired Guido, from using his skills to build churches of competing beauty. This suggests the range of reasons for the commune's engagement in church architecture in the first place. The wording of the document indicates that the commune stood to benefit in ways unmentioned from the construction at Santo Stefano. Guido was hired to execute a project "for the condition and utility both of the works of said parish and of the entire commune of Prato." This statement, which comes early in the text, is repeated at the conclusion. It shows that the consuls and merchants expected the physical condition and usefulness of

Santo Stefano to affect the welfare and prosperity of the entire city. The expected effect may have been simply that a magnificent construction would beautify the entire city. The embellishment might have been expected to attract pilgrims or business, and to intimidate neighbors with the apparent wealth of the population. A beautiful church building would thereby increase the utility of the city.

"Good and Equal in All Its Parts"

The aesthetic quality of the structure is the primary concern in the document, and it is stressed in two distinct ways. Guido was given license to rework old portions of the church. He was directed to do it so as to construct a building that was "good and equal in all its parts." This injunction suggests a loose design principle, that the church be harmonious and unified.[5] Harmony and unity may have been sufficiently important to the provost and consuls to justify removing incongruous elements in Carboncetto's nave, upper-west façade, and exterior clerestories on the south and north elevations, for which no traces remain, and then to allow Guido to rebuild them. Judging what should be kept, what destroyed, and how the entire structure should be rebuilt in order to make it "good and equal in the major parts of its body" was left to Guido's expertise. That the commune had such faith in him as to leave this important clause to his discretion shows the esteem that could be accorded to an architect in communal Italy.[6]

The description of Guido, when introduced in the contract, as "magister Guido marmolarius S. Martini de Luca," makes it clear that the commune chose him because of his accomplishments. It may even indicate that they expected a work similar to that at Lucca, and, more specifically, that they considered that his work in Lucca was "good and equal in the major parts of its body." The mastery by Guido of certain challenges at Lucca made him an excellent choice for managing similar difficulties with the existing context at Santo Stefano. He had equalized major disparate elements into a unified whole in his signed façade portico (figs. 6.1, 6.2).[7] The presence of an earlier campanile forced a truncation of the right side of the façade, rendering it asymmetrical. Guido resolved this design challenge on the upper-story arcade by cutting two bays.[8] For the ground-level arches, Guido narrowed and shortened the bay adjoining the tower. He laid out the two remaining bays to the left with wider modules of approximately the same breadth. He made the central bay slightly higher, thereby emphasizing its centrality and that of the façade, while maintaining the ample proportions of the ground-level arcade. The façade portico thereby retains the proportions of the nave arcade within the church while it continues the modules of the arcade running along the flank of the church. This choice took advantage of another series of structures beside the church forming the bishop's palace complex, which were unified on the ground

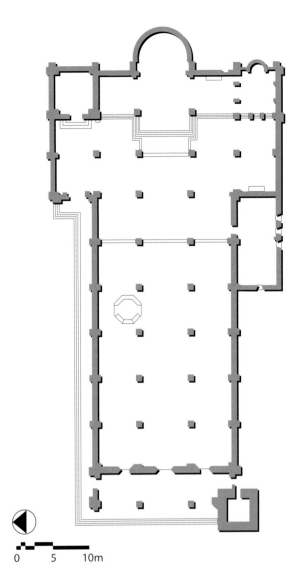

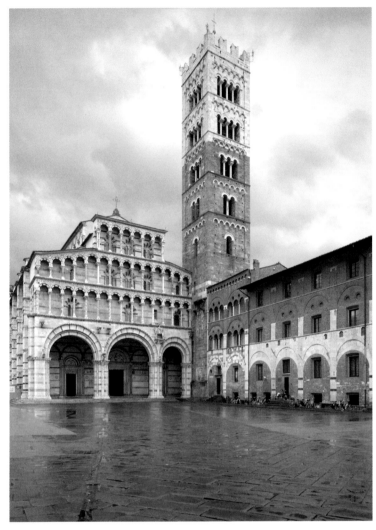

FIGURE 6.1 Guido da Lucca and others, plan at 1:500, eleventh–thirteenth centuries. Lucca, San Martino.

FIGURE 6.2 Guido da Lucca, view of façade, 1204. Lucca, San Martino.

floor and piano nobile by regular arcades. The far right, shorter bay of the cathedral reconciles the two arcade scales of the cathedral piazza, acting as an intermediary between the bays of the bishop's palace and cathedral arcades, almost as if the joint between the Duomo and palace geometries occurs partway along the cathedral façade and not at the joint between the building planes.

The effect of Guido's intervention in Lucca was to unify the disparate geometries and scales of the entire space. Guido used another method to unify the disparate cathedral portico bays themselves, by overlaying them and the entire structure with bichrome banding, similar to that at the side elevations of Pisa cathedral, which was the most influential church design in the area, and similar also to that at the exterior galleries of Lucca's own San Michele in Foro (see fig. 4.24). Guido's striping at San Martino repeated the rhythm of San Michele, which

was closer together and more regular than that at Pisa, with a rhythm of one dark course for every three white bands, or ABBB. The consistent application of these bands up to the top of the façade, running behind the smaller-scale arcades of the upper levels, unifies the elevation also vertically, linking the base of the façade to its upper stories.

Guido's work at Lucca proved him capable of resolving similar challenges at Prato's Santo Stefano. It is worth recapitulating the existing conditions established in the previous chapters in order to understand his interventions. The exterior south façade was originally made up of eleven bays divided into three triplets of blind arcades separated by the two portals (see figs. 4.5, 4.15). The first and last triplets were made up of shorter bays than the middle. Bichrome banding was used primarily on arch and window frames, and less horizontally across wall surfaces, which were generally of a consistent white stone.[9] There is no evidence for how or even whether Carboncetto designed the upper level of the south and west façades, or the nave interior.

The interventions by Guido included the upper portions of the west and south façades, the restructuring of the interior nave and its clerestory, the construction of a campanile, and the second level of the cloister.[10] Much of what he did is still intact. The tendency of the sections remaining by Carboncetto to be on the ground level and those by Guido to be above suggests that Guido simply completed the work initiated by Carboncetto. The major challenges that Guido faced in designing and building these completions or additions were to insert a campanile into the south façade arcade composition, to build or to reconfigure the interior to have more "equal members," as specified in the contract, and to unify the overall effect of the outside and inside.

Guido appears to have torn down whatever interior nave arcading may have been completed by Carboncetto or earlier architects, as allowed under his contract (figs. 6.3, 6.4). The insistence on "equal members" in the contract suggests that whatever existed earlier was irregular. Guido's nave lived up to his contractual agreement with its perceptually consistent column rhythm. He chose this solution rather than the most radical, and probably too costly and time-consuming one, of razing the entire structure and starting from scratch. This still left him with the problem of reconciling his more regular interior bays with the existing portals of the south elevation. He succeeded in doing this with minimum obstruction of passage through the portals and past his interior columns. He gave the new bays an ample span, similar to what he had achieved in Lucca's San Martino exterior and interior, which was based on a far larger module and therefore had fewer bays than did the exterior blind arcades. At the same time Guido diminished gradu-ally the bay modules toward the east (see fig. 4.14). This produced a perspectival

FIGURE 6.3 Guido da Lucca, interior facing east, 1211. Prato, Santo Stefano.

foreshortening guiding movement toward the sanctuary that is so subtle that it can be detected only by pacing off the bays.[11]

The sanctuary terminated the nave axis with a single, broad apse. Guido reinforced passage along the main axis of the nave with the bichrome decoration. He repeated Carboncetto's striped arches of the south blind arcade on the interior arches but rendered them as a flat surface, continuous with their abutments. He then linked the banding of each arch with the next by applying horizontal striping to the abutments and above them, extending them along the entire length of the nave. The absence of any relief between the arch extrados and the abutments even exaggerated this continuity, fusing the arches and wall into a single surface. The effect is most remarkable just above the springing line of the arches, where their parallel banding fuses them into single forms that recapitulate the continuous banding above the arches. Guido's alternation of dark green entablatures above the white stone capitals on dark green columns continues this bichromatic alteration, and emphasizes the horizontal flow of the nave elevations toward the sanctuary. The capitals at once support and slow this movement. The consistent foliation at their lower portions links them horizontally, but the varied figurative or geometric decoration at their crown establishes individuality for each.

In every aspect of its design, the nave concentrates movement toward the sanctuary. The striping distracts the viewer from the unusual location of columns on axis with the entries from the south façade of the church: it immediately redirects motion perpendicular to entry. Movement is channeled along the nave to the apse by the combined effect of the gentle foreshortening of the arches, the elevation of the crypt, and the corresponding stepping-up of the column bases, capitals, and arch apexes to the high altar. Originally, no transept was present to break the movement along the nave, which culminated at the new apse. The relentless banding of the broad, gracious arches of the nave would have guided energy toward the single elevated, giant so-called triumphal arch framing this apse.[12] The only break in the passage, at the vertical pilaster marking the beginning of the steps, led down to the crypt or up to the sanctuary and altar, mapping the stages of death and salvation symbolically controlled by the priesthood at the main altar.

The strongly homogenizing effect of the nave banding was one of the most innovative aspects of the church design, and it shows how seriously Guido took his contractual commitment to the "unifying of the major parts." The perfect interlock of arch and wall banding in Prato is one of the earliest examples in Romanesque Italy, and it may have provided the model for similar practices in Tuscany and Sardinia later in the thirteenth century, in structures ranging from San Pietro Sorres, Borutta, Sardinia, or the Siena Cathedral.[13]

The overall impression of the interior was consistent with the increased axiality of the plaza comunis, recently terminated by the new senate palace and tower. It provided another version of the image of hieratic authority projected by both the commune and the propositura to bolster their political alliance. Guido's work on the church exterior presented a similar sign of strength. The addition by Guido of a campanile at the final two bays of the original church made the church seem shorter from the piazza (see fig. 4.5). Instead of eleven bays being visible, now only nine were. Guido compensated for the shorter length of the south elevation between the campanile and west façade. He applied an arch identical to those from the earlier work to the campanile, perhaps even reusing the original stone (see fig. 4.12). He thereby virtually restored one of the three bays covered by the campanile to nearby viewers of the south façade. This campanile arch furthermore provided passage through the tower, opening to the remaining bays of the church and thereby diminishing the rupture created by the massive campanile.

Guido used the same banding on the south elevation that he applied on the interior, to emphasize horizontality. He added a second course above the striped arcade, and then repeated the banding across the entire surface of the clerestory. He managed also to accelerate the rhythm of the remaining nine bays of the south façade by running a blind arcade cornice above them, on top of the horizontal banding, and repeating this motif on the clerestory. The striped-arch frames of the clerestory windows further emphasized horizontal movement, though they also provided a reading of passage through the surface, with the brackets articulating the spring points of their arched frames.

By these various means Guido reestablished a strong horizontal reading at the south elevation of Santo Stefano that was slightly less emphatic than that of the nave. The wall still had the reading of a portico-like passage through it, as it originally had. The horizontal banding of the top of the ground level and of the clerestory may even have increased its horizontal force over that of the original elevation, despite its shorter length, and therefore have emphasized the hierarchical bias alternately toward the new palatium and turris curie or toward the campanile, terminating the west and east ends of the south elevation.

The placement, height, and articulation of Guido's campanile did the most to bolster the hierarchical reading of the space. Though it reduced the number of bays visible on the piazza, and therefore decreased the differentiation between the short and long arcades of the palatium and church elevation on the piazza, it restored emphasis to the shorter ends of the space, reflecting the turris curie to the west. The striping and window treatment emphasized the height of the tower, which extended up to only the fourth level of the six that exist today (see fig. 4.13).

Guido applied banding to the frames above the windows and around their enclosed bifore, but not horizontally across the surface beside the windows. Consequently, the striping links the windows vertically. He joined the arch extrados to the wall surface with a chromatic rather than a relief break. The wall plane is therefore continuous up to the corner piers of the tower that channel the surface vertically, past the miniature blind arcade friezes, to each successive window. The gradually increasing height of each window reinforces the vertical sequence. This articulation served less to distinguish each level than to build up to the strongest expression on the hierarchically most important top story, which is the only one to have windows on all four sides. This effect, which was typical of Italian church campanile design from the earliest Carolingian bell towers in Milan, Ravenna, and Pomposa, assured that the structure was legible throughout the city and in the territory.[14] The distant and near reading of the campanile was also achieved by fusing the aggressive verticality of the turris curie and tower-house type with polychromy and a unity of parts, producing an image of physical and religious dominance over the space. Just like the turris curie, this image was a response to the owners of the twelfth- and early thirteenth-century tower-houses at and near the Pieve, and at the reinhabited Casa Alberti, now palatium imperatoris, which had a bell tower, perhaps as early as its late twelfth-century occupation by Frederick Barbarossa and Henry VI.[15] Guido's bell tower at Santo Stefano, coupled with the turris curie, emphasized the status of the church vis-à-vis the emperor. The impact would have been not only visual, but also aural—the bells of the campanile would have sounded daily masses, the beginning and end of the workday and intermediate pauses, even meetings for the town hall and alarms for the community.[16]

As the bells controlled the rhythm of daily life, the visual presence of the campanile and south wall commanded movement in the piazza. The viewer on the outside is led from the framing campanile, past the arcades and horizontal banding, toward the front of the church, alternately to the palatium curie terminating the piazza or beyond the piazza, to the west façade of the church, facing Santo Stefano's Baptistery of San Giovanni Rotondo.[17]

Guido's work on the west elevation is visible behind the late Trecento and early Quattrocento façades (see figs. 4.3, 4.4);[18] it extends upward from the top of the side elevation arches, above the monochromatic portion completed earlier by Carboncetto. Guido maintained the monochrome stone of the lower, earlier structure. He created a similar linkage with the banding on and above the arcade and along the clerestory, which he wrapped around the corner of the church and across the upper level of the west façade. Guido repeated the bichrome-arch motif of the south clerestory and campanile windows on the windows of the west façade,

but with a different effect. The striping here is continuous with the wall surface in color, but not in relief. The elaborate articulation of the window frame moldings produces a similar result to the brackets at the imposts of the clerestory windows, only more pronounced. Here, the reading of the windows is emphatically one of penetrating the surface, directing vision and motion through the wall plane and into the building interior.

Guido's articulation of his windows and interior arches with bichromy and relief expresses variations in movement past or through surfaces, depending on the relation of each elevation to overall movement around and through the church. By maintaining the arch banding as a constant, modulating its relation to the adjoining surface only with color and relief, Guido succeeded in unifying the outside elevations of the church along the sequence of movement, recalling at each new point the most recent variant on the banded arch theme. The sequence begins at the point of arrival from the Via del Borgo at the campanile (see fig. 1.2). It continues past the earlier blind arcade and Guido's clerestory addition, around to the west façade of the church. Then, as at Florence's San Miniato, the upper-level central window of the Santo Stefano basilical façade offers a figurative entry to the attic temple, an entry denied by the physical inaccessibility of the window.[19] This sequence is recapitulated within the church, where movement is accelerated by the banded waves of interior arches and their visual propulsion to the sanctuary. Movement along the visual axis is denied now, however, by the sectional break of the crypt, and so the viewer is forced to pass into the crypt itself or to either side of the nave, up the restricted side-aisle stairs and finally into the apse, which was tied primarily to the world of the canons and provost by a portal linking the sanctuary to the second level of the cloister added by Guido.[20]

Guido not only achieved the unity of parts requested in his contract but also answered the ideological needs that lay behind his patrons' insistence on unity. Even along the preexisting south façade he unified the irregular rhythm and neutralized the frontal original elevation. He gave the elevation a strong horizontal effect that transformed its primary reading from passage through the surface to passage past it. Here and elsewhere, Guido produced a sequence of equalized parts in varied elevations that emphasized movement toward the hierarchical termini of both exterior and interior spaces—the palatium curie and campanile on the exterior, and the west wall and east sanctuary inside. External and internal termini were open on their ground levels, but then restricted above, thereby dominating from their axial, elevated, and exclusive positions. Both projected the image of the monumental arch, whether in the multiple bays of the palatium portico, the superimposed articulated arches of the campanile portal and windows, or the single grand arch

of the apse hemicycle. The new church and its transformed piazza now reflected each other, as two versions of the same image of hieratic authority.

Guido thereby went beyond his written mandate of "harmony and order" to articulate a clear expression of axial dominance within the nave, at the front and side façades and at the campanile. Individual elements were more strictly subordinated to the overall unity and hierarchy of the composition than at Carboncetto's church. The emphasis on the horizontal axis, particularly of the south façade, changed its character from the earlier frontal reading. The church had for the first time on its exterior and nave the same, if not greater, formal unity, which was once reserved for the cloister. The church and community were more confident in projecting their own unity than ever before, offering a clear vision of the sacred. This image extended beyond the arches or even the powerful banding that unified the south elevation, now to include tangible evidence of complementary authority capable of defending earthly and divine law with the echoing campanile. With the new complex of palace, tower, church, and campanile, the allied consuls and propositura broadcast to the consorterie, the emperor, and nearby communes the sanctity of this autonomous political alliance, of the fruits of respecting this alliance, and of the salvation that would be blocked for those threatening or abrogating it.

The Contestation of Aesthetic Unity by Noble and Imperial Factions

An intention to intimidate and finally to pacify the consorterie and to send a warning to the emperor can be inferred only from the communal interventions at the piazza and the contract with Guido for his work on the church. Other documents, however, which are generally cited to indicate the completion of the first four levels of the campanile and of the rest of the construction in 1221, provide direct evidence that the new church was perceived as a threat by two of Prato's powerful consorteria families. The documents record a suit between the church and consuls on one side and the Levaldini and Dagomari families on the other.[21] The Levaldini had apparently built a bridge supporting a tower that extended from their own tower-house across Via de Burgo, up to and against the new campanile (fig. 6.5). The incursion covered the south wall of the campanile, probably up to the base of the fourth story, the only level with a window in it.[22] The differences between the Levaldini tower and the earlier turris curie on the piazza indicate that the family had intentions less benign than the commune's. The communal tower was legally built, did not impinge on other existing structures, and provided the combined consular/church authority with the tower they had lacked at the time. The uninvited attachment of the Levaldini tower to the new campanile, which increased the prominence of the family's tower-house complex on the piazza, indicates that their intentions were not to reinforce the image of the church or commune, or to

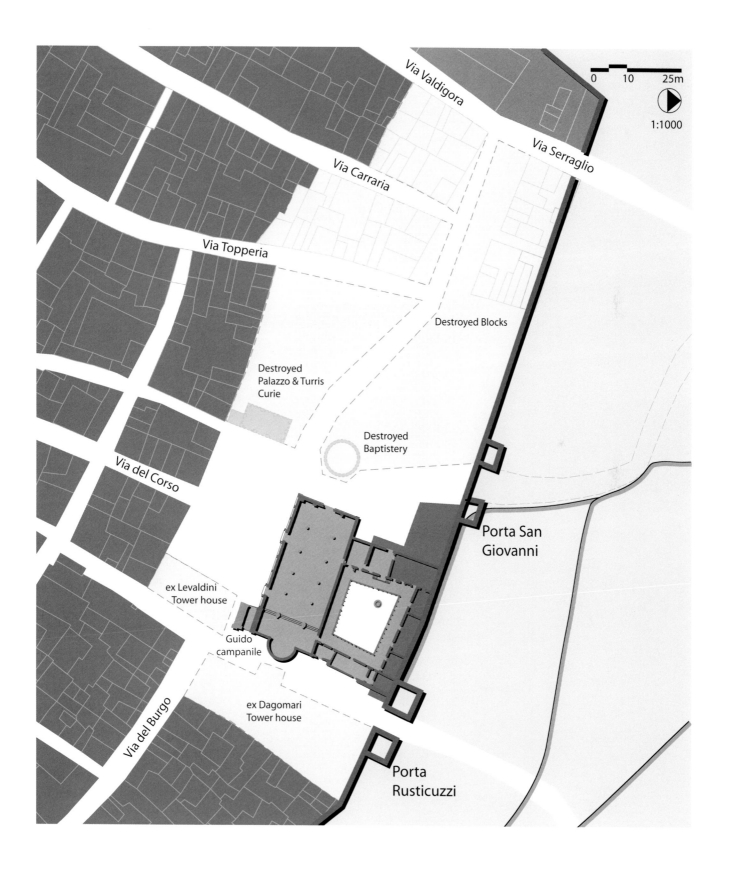

Via Valdigora

Via Serraglio

Via Carraria

Via Topperia

Destroyed Blocks

Destroyed
Palazzo & Turris
Curie

Destroyed
Baptistery

Via del Corso

Porta San
Giovanni

ex Levaldini
Tower house

Guido
campanile

Via del Burgo

ex Dagomari
Tower house

Porta
Rusticuzzi

0 10 25m

1:1000

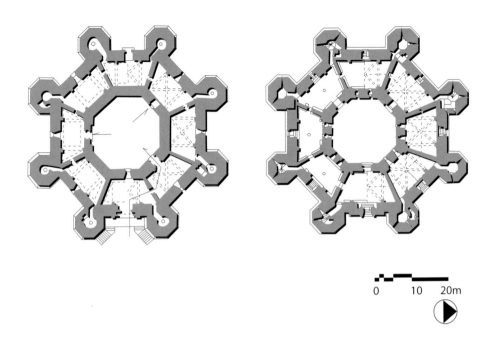

0 10 20m

FIGURE 6.6 Plan at 1:000, thirteenth century. Apulia, Castel del Monte.

proclaim their alliance, but rather to repudiate the sign of authority presented by the provost and consuls in the church expansion and campanile. The new campanile must have been seen by the Levaldini as a threat, but one without sufficient legal or physical force to back it up; they seem even to have been bent on proving the weakness of their adversaries. This episode clearly delineates both the expressive potential of architectural rhetoric during the period, the limits of its success, and the facility with which competing parties used architecture to vie for dominance within overlapping territories.

The response of the propositura and consuls to the architectural assault on their recently completed masterpiece indicates the degree to which they worked together, and particularly how important the provost's papal connections were in reinforcing the temporal authority of both provost and consuls. The church and commune retaliated not with more building, but with legal force. They brought a suit against the Levaldini and the Dagomari families before Pope Honorius III, who sent a bull via the region's highest ranking papal emissary, the Papal Legate Opizino, canon of the archdiocese of Florence. He pronounced the pope's sentence in favor of the provost, canons, and consuls of Prato, requiring demolition of the Levaldini tower and forbidding any later structure from touching the campanile.[23]

The chain of hierarchy, from papacy to the canon of the archdiocese of Florence to the provost and consuls of Prato, indicates both the extent of the alliance available for the Pratese to support their claim for authority and their willingness to resort to it. The Levaldini did everything possible to ignore or deflate this author-

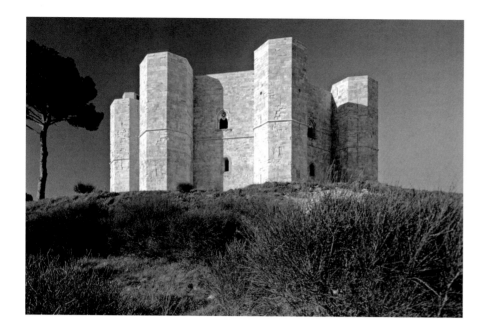

FIGURE 6.7 View, thirteenth century. Apulia, Castel del Monte.

ity, first by their attachment of the campanile, then by refusing to appear in court, and finally by not removing their appendage until at least 1243.[24]

The Levaldini's persistent arrogance in face of the local and church authority emphasizes the precariousness of that authority, and the strength of the urban consorterie. Part of that strength was their skill at arms, another their urban fortifications—their tower-house enclaves—which were inaccessible to communal authorities. Their local force was augmented by the alliance of many consorterie to the emperor.[25] Indeed, during the 1230s and 1240s, the tensions between Frederick II and the pope were dividing all of Italy's nobility between pro-imperial, or Ghibelline, and pro-papal, or Guelph, parties.[26] The emperor's presence at the palatium imperatoris in Prato emboldened the Ghibellines in the town. The Levaldini's delay in complying with the papal sentence may be related to the emperor's reinforced presence in Prato between 1238 and 1249. At this time Frederick II was increasing his hold over the town, first through Podestà Rodolfo di Capraia and other Pratese Ghibellines, and later by the appointment of his own son, Frederick of Antioch, as vicar at the imperial palatium. Most important in this context, Frederick of Antioch was overseeing a major construction campaign by Frederick II at the palace, resulting in the structure visible today, which originally was graced with taller towers on the west and north walls (see figs. 5.9–5.12).[27]

The design of Frederick II's additions to the palatium and further details of the original suit help to explain why the Levaldini considered themselves exempt from local and papal judgment. The plan of the palatium imperatoris was completely

regularized under Frederick II.[28] He greatly enlarged the original fortifications, creating a layout that was nearly symmetrical across both axes. The resolution of the earlier tower structures within this plan, and the constant band of crenellation ringing the elevations, had a similar effect to the use of the blind arcade frieze and campanile by Guido da Lucca—to subsume the irregular old portions of the structure within the more regular framework of the additions, and then to offset the horizontal with an articulated vertical element, in this case one of the existing towers, which, interestingly, was outfitted as a bell tower. Frederick II achieved even greater unity at the interior of the castle—like Guido's nave—by lining it with a cloisterlike courtyard, the arcading of which sprang from classicizing capitals. On the exterior, Frederick II took over Guido's application of stripes to both arch and abutment surface, varying his scheme only by using pointed arches. This bichrome design for a secular building was extremely unusual at the time, as it was generally reserved for religious structures in the region.[29] Equally unusual was his application of a classical temple front, above the bichrome arch of the main portal, which was supported by elegantly carved Corinthian capitals on top of fluted dark green pilasters. The only local sources for these motifs could have been San Miniato and other attic temple fronts on churches based on its design, whether in Pisa, Lucca, Empoli, or Fiesole (see figs. 4.26–4.28). Most likely, however, Frederick II was responding to the attic temple front, bichrome banding, and classicizing side portals and campanile windows of Prato's Santo Stefano itself. In the process of echoing the classical vocabulary at Santo Stefano he was extending and enriching his palatium by maintaining the same fidelity to antique forms and proportions seen in his other monumental projects, such as Castel del Monte (figs. 6.6, 6.7) or the arch of Capua.[30]

Frederick II was coopting the Santo Stefano arch type, temple front, and overall aesthetic of unity. Unlike the new communal government, he was not assimilating himself or his noble allies to the local and Roman church, but rather advertising his presence as a competing ultimate authority, with a jurisdiction as valid as that of the propositura, and that could therefore even justify behavior counter to the pope's wishes. Frederick had never been afraid to assert his independence from the church. He even launched a crusade while excommunicated. He and his allies never actually rejected the church or the institution of the papacy. He took the excommunication seriously, as a personal blow, and as detrimental to imperial prestige, since it reduced his ability to sustain the fidelity of vacillating supporters. He appears to have perceived it less as a fundamental stigma than as one of a series of considerations to manage in his relations to the church. The very frequency with which popes turned to excommunication in their relations with

emperors and pro-imperial forces may have reduced their potency for Frederick. He and his allies learned to live with them and were not so intimidated as to desist from pressing claims for what they considered their deserved status and rights, both with the pope and his local representatives.[31]

Frederick II's architecture helped to sustain his relative autonomy from the church. The religious architectural forms he adopted had an ideologically expressive capacity that was not specific to the particular party that built them. The arches of Santo Stefano's south façade and cloister represented the sacredness of the church, and not just the authority housed there, and they pointed to older traditions of holiness that both the church and palatium curie built upon. The arcade, triumphal arch, temple front, and the recent horizontal bands were the established means for expressing the sacred authority vested in a building. The idea of *auctoritas* since Constantine, and even since the origins of the imperial cult under Augustus, was linked with the divine character of authority. Popes and holy Roman emperors were bound to use the same symbolic topoi to express their imperium.[32] The vocabulary of authority was based on imperial Roman terminology, received through the filter of Christian divine imperium. Architectural language was no different in its roots and significance. When Frederick II used classical forms, such as the antique temple front and Corinthian column capitals at the Prato palatium, or the sculptural programs at the Capua gate, he was doing just what his predecessors had been doing—asserting himself as the rightful successor of Constantine to rule the unified Roman Christian empire.[33] Inasmuch as the pope and his hierarchy, down to the Prato provost, and the aligned communes wished to assert a similar lineage to Roman Christian empire, they used the same forms and language.

The arches at Santo Stefano, at the palatium curie, or at the portal and interior court of the palatium imperatoris all derive from the same sources and propagandistic intentions. The only means for differentiating them is in the degree to which their settings, whether axial or frontal, emphasize hieratic or egalitarian readings, but even these distinctions indicate only the degree to which the builders deploying these forms were indicating threatening or conciliatory biases. The forms never identify the actual party, whether church or empire, Guelph or Ghibelline. The only means of determining the party affiliations of forms was not in architecture, but in the documents of the time, by uncovering who was aligned with whom, or, more obviously in the case of Guido's Santo Stefano in Prato, which parties were together in signing the building contract.

The impossibility of copyrighting the architectural iconographies of power became increasingly an issue as more parties had the resources to construct them. Pope, bishop, provost, emperor, commune, and nobleman proliferated indepen-

dent and even overlapping images of sacred empire in Italy during the communal period. That was the fear of the provost when demanding a monopoly over church construction in the twelfth century; similarly, this must have been the anxiety when the commune saw the emperor first occupy the Casa Alberti (in 1191–92) and apply the title palatium imperatoris. The justification for these fears is evident in the emperor's strong claims for authority. Some of these claims were still recognized by the Pratese themselves, who selected one Hildebrand as the "judge and notary" to record and notarize the Guido contract; Hildebrand affirmed the legitimacy of his notarial office by referring to his status as *imperiali auctoritate*. This title was a reference not only to his imperial legal training, but also to his investment by the emperor, just as a priest is invested by the pope, to act as a representative of the emperor's imperium. The anxiety of the commune and provost concerning reinforcement of the emperor's competing imperium at Prato must have increased when Frederick II undertook to rebuild the palatium imperatoris. Their fears would have been heightened when the emperor imitated the Pieve's sacred forms for the Castello decoration, whether the striped arches and wall surfaces, or the overall classical vocabulary and unifying aesthetic.

This assertion of Frederick's competing imperium in the territory of Prato since his beginning of construction after 1238 may explain how the Levaldini could have justified their impertinence to the local, regional, and Roman seats of papal authority. The Ghibelline Levaldini were directly affiliated with the emperor. They may have defended themselves by referring to their recognition of the emperor as the only legitimate temporal auctoritas of late medieval Italy. The intrusive attachment of their tower to the church campanile may even have been a way of reinforcing the status not only of their own family, but also of the entire separate world of jurisdiction that had its local seat beneath another bell tower, in the court behind the flared crenellation of the palatium imperatoris.

Emphasis on imperial architectural iconography at monumental and even private buildings in Prato during the first half of the thirteenth century literally overshadowed the earlier imagery of fraternity at the cloister. Even Guido's limited interventions there, the addition of a second level showing his characteristic striping, shifted the focus of the cloister from a variegated community of equals to a monolithic unity. The campanile explicitly suppressed the reading of a public cloister and the associated symbolism of brotherhood by blocking two of the south elevation's eleven arched bays and the apostolic iconography of their twelve pilasters. The overall impression of the work is therefore less the conciliation of admittedly diverse parties, as in previous incarnations of Santo Stefano at the site, than of the fruit of conciliation, a unified authority of commune and propositura, now ready to defend its sovereign unity against a contentious

plurality of interests. The cosigners of Guido's contract were unlikely aware that their vaunted aesthetic unity could only further polarize the papal and imperial camps that were splitting the city and the entire peninsula.[34] The equal ability of Guelphs and Ghibellines to trace their authority to an ideal of theocratic imperium discouraged efforts to win over adversaries with promises of equality, as the provost had done with the laity of Prato in the twelfth century. The rhetoric of empire instead aggravated tendencies of both sides to seek to awe and to threaten each other with increasingly exaggerated constructions of the theocratic ideology that they held in common. By accepting the rhetoric of empire and building it into the center of their city and its institutions, the consuls of Prato, the provost, and the canons planted an imagery that stood at odds with the site and its people. Meanwhile, an increasing number of Pratese were busier with the minor crises of day-to-day life than geopolitics. They became attracted to a new, thirteenth-century piety of brotherhood, more revolutionary even than that of the eleventh-century canons, that was beginning to rise in Prato and across Italy during the years in which Guido was completing his campanile.

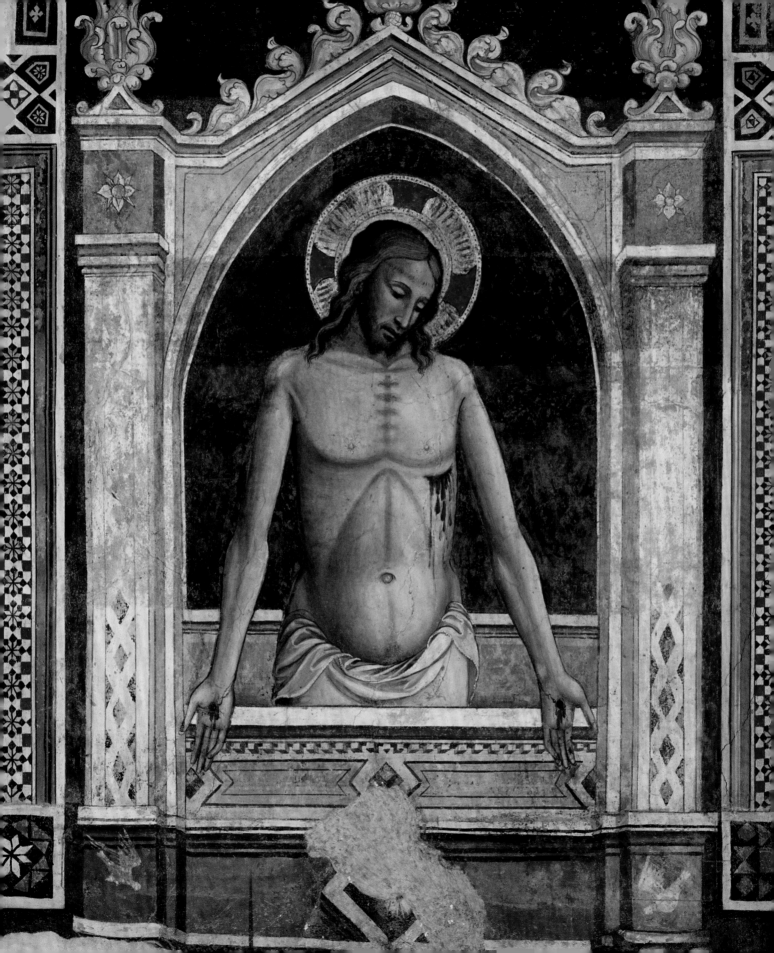

The Destruction of the Plaza Comunis and the Shift of Civic Patronage from the Propositura to the Friars

Aesthetic Politics and War

The competition over architectural and spatial representations of religious and temporal power paralleled tensions that troubled all aspects of life in early thirteenth-century Prato. The jockeying for prestige created by images of absolute authority between the propositura and commune on the one hand and the emperor and consorterie on the other set the stage for tragic events that pitted neighbor against neighbor and led to the same destruction of much of Prato's monumental core that occurred in other communes riven by Guelph and Ghibelline strife. We cannot tell how much a contested architectural monumentality catalyzed these events in Prato. It is nonetheless worth questioning whether Walter Benjamin's assertion that "all efforts to render politics aesthetic culminate in one thing: war" is limited to modern capitalist, industrial society, or whether demagoguery and violence have deep, atavistic roots sustained by our reception of historical forms, if not by the forms themselves.[1] The competing towers at the thirteenth-century plaza comunis certainly made public the competing claims for divinely vested authority by the propositura, the commune, and the Levaldini. The exclusive claim of stable authority by independent institutions using similar imagery for the same site received its initial expression in architecture but soon devolved to other means of persuasion.

The connections of the local factions in Prato to the larger-scale papal and imperial parties of Guelphs and Ghibellines may explain not only the recalcitrance of the Levaldini, but also the increasingly dire responses on both sides. Across Italy, the reaction of the opposing Guelph and Ghibelline camps to competing claims of absolute authority followed the same pattern as other such situations in the history of diplomacy. Having abandoned the techniques and imagery of conciliation, each party became intransigent. The evidence in Prato supports the findings of scholars such as Giovanni Tabacco, Daniel Waley, Phillip Jones, and others: that Guelphs and Ghibellines do not represent distinct class interests or a

DETAIL: FIGURE 7.17

struggle between the bourgeoisie and nobility, respectively.[2] While there may have been more *popolani grassi,* or wealthy merchants, in the ranks of the Guelphs, they aspired to behave like their noble counterparts among Guelphs or Ghibellines. It was therefore in the nature of the period's construction of noble identity, as that of the fighting class, for both sides to express capacities for violence. The next step was to take recourse in it. When they did so, however, they produced the same results as the emperors and popes had since the beginning of the investiture struggle in the eleventh century: they made a mockery of the leadership role for which they fought. First the Ghibellines, in 1260, and then the Guelphs, in 1266, became Pyrrhic victors, celebrating in the ashes and rubble of their contested cities and monuments.

At the climax of this tragic absurdity, something extraordinary began that testifies to the resiliency of the citizens of communes such as Prato. A wave of reaction welled up against the partisan interests destroying one another and the city's monumental center. Some laymen, particularly those uninvolved in the issues and peripheral to the downtown battlefield of the Guelphs and Ghibellines, began to organize in radically new forms of religious, social, and political organization, with equally novel architectural and urban expression. A new spirit of religious reform led this change, under the guidance of the new mendicant orders. In Prato this occurred in two waves immediately before and after the 1260s. Greater percentages of the Pratese took part in their own religious and political destiny than had been the case since the first record of settlement, and the town was not to see the likes of such participation afterward, up to the city's establishment as provincial seat in 1992. During these brief windows of extraordinary religious, social, and political engagement in the second half of the thirteenth century, more and more Pratese abandoned the town's traditional public building types and instead made their doorsteps, neighborhood streets, and piazze into places of collective expression, action, and commemoration.

The Politics of Architectural Destruction

The impact of the mid-Duecento civic strife on public building in Prato is told as much through the absence of architecture in documentary records as through its presence. From their creation at the beginning of the thirteenth century to midcentury, the town hall and civic piazza at Prato's Santo Stefano appear regularly in documentary records. The importance of the site in city life during the first half of the century is registered in the addition, circa 1245, of a new city gate northwest of the church, terminating the street leading past the palatium curie and baptistery; it was appropriately named the Porta San Giovanni (see fig. 6.5).[3] The need to add a gate indicates how busy this section of the city had become. It redirected traffic

and visual emphasis from the earlier Porta Rusticuzzi and the adjacent canonicate to the communal palace, which was now the center of secular authority. The plaza comunis continued to be mentioned up to 1266, when the palatium curie appeared for the last time in a juridical document.[4]

After 1266, the documents are silent regarding this section of town, up to 1290, when the residents near the Porta San Giovanni curiously requested that their portal be reopened.[5] The explanation for the previous closure appears in two ordinances of 1291 and 1293, in which the commune ordered the rubble from the fallen palatium curie to be cleared.[6] At some point after 1266, therefore, the palatium had been destroyed, and the formal and practical grounds for directing traffic through the Porta San Giovanni, instead of through the nearby Porta Rusticuzzi, were so diminished that the commune simply sealed the gate.

It is likely that the palatium curie was destroyed between 1266 and 1267. Evidence for this lies in the absence of any mention of the palatium curie in later legislative records of the new Guelph regime, established in 1267.[7] They indicate only meetings of the general and special councils at the church of Santa Maria di Castello and at private residences. These clues suggest that the Guelphs had razed the old communal palace,[8] during or immediately after the fighting of 1266–67, and may have destroyed all documentary evidence of the Ghibellines' existence.[9] That destruction would also have been a characteristic sign of dominance at the time. As early as the end of the twelfth century, architectural destruction had extirpated pro-imperialists from Lombard-League cities. League members actually swore an oath to do so: "If he is a citizen in my city I shall in good faith do my best to bring it about that any house he may have in the city should be destroyed and that he himself should be expelled from the city."[10] A tradition of architectural violence was established in Prato by 1221, with the papal order to raze the Levaldini and Dagomari tower-houses. And it was precisely in the 1260s and 1270s that the tower of the Ghibelline Levaldini was finally leveled, together with numerous other towers of the exiled Ghibellines.[11] Given these events and the fierceness of civic violence, it is likely that the palatium curie was a casualty of the policy that the new civil authorities exercised over individual Ghibelline families, one of literally humiliating (from Latin *humus, -i*, ground, earth).

The wholesale destruction of the buildings of the Levaldini, of other pro-imperial magnates, and possibly of the communal palace from which the Ghibellines most recently governed marked the apex of the antagonisms that had been developing since the first appearance of the Ghibellines and Guelphs in Prato in the early thirteenth century.[12] According to commentators at the time, these parties doubled as covers for local antagonisms between powerful consorteria families, who still congested Prato and other communes with their tower-houses.[13] It

would nonetheless be a mistake to ignore the significance of the new ideological justifications that the Ghibelline and Guelph parties provided for the families of the urban nobility, and for their clan mentality and military way of life. The Ghibelline loyalty to the emperor and the Guelph loyalty to the pope expanded the locus of oaths of allegiance and vendetta from local kinship groups to either of the competing ideas of theocratic empire that had been promoted by the emperor or pope since the investiture controversy nearly two centuries earlier. The effect of the Guelph and Ghibelline parties was therefore to introduce into the militarism of the consorterie a sense of divine political destiny, which led them for the first time to seek to establish an institutional framework for their militaristic power that was statelike, akin to earlier bishops' or consular regimes.[14] Both Ghibellines and Guelphs adopted imperial Roman and Christian expressions of imperium. Thus when the Ghibellines triumphed in Prato in 1260, shortly after the imperial victory over Tuscan Guelphs at Montaperti, they took over the palatium curie and exercised authority much as their consular predecessors had done.[15]

To be sure, significant differences existed between the Ghibelline government that assumed authority in 1260 and that of earlier communal regimes. The Ghibellines had a clan conception of the body politic, as a group limited to their partisans and supporters. The primary means for defending their authority was military rather than diplomatic. For the first time in Prato's history, power was seized by force, and not by compromise, and the losing faction was deprived not only of representation, but also of their right to remain in the community. The Ghibelline regime reinforced its "monopoly of violence"[16] by confiscating and often destroying Guelph properties, thereby thwarting their return. The triumph of the Ghibellines constituted the moment of inversion in Prato's communal politics: just when the state was powerful enough to enforce its will it began to behave like a large-scale version of the consorterie that the commune had previously tried to pacify. The new state abjured compromise with those outside of their loyalty group, and instead excluded them, even unleashing upon their competitors the vendetta.

While the violence of this exclusion was new, the idea of the exclusive community was not a Ghibelline invention. It was implicit in the idea of a monastic or canonical apostolic community, ready to reject anyone unwilling to live by the institutionalized rules for a life in common. Even the violence was anticipated, in Last Judgment depictions, when the rejected suffer the tortures of hell. However, the tribal regime of the Ghibellines based the criteria of inclusion or exclusion not on agreement to uphold a monastic or other sacred or secular law, but on unquestioning allegiance to kinsmen bound by blood or oath, regardless of their behavior to outsiders.

The triumphant return of the Guelphs to Prato after the battle of Benevento

in 1266 only changed the names of the loyal groups and the cast of characters; the Guelph state was fundamentally the same as that introduced by the Ghibellines. The politicization of the Guelph and Ghibelline warrior class did not end the practice of clan exclusiveness but opened the possibility for extending the tribal mentality to encompass the entire state. It was in danger of becoming redefined as a perverse fusion of clan identity with the religious and militant-imperial ideologies of the Holy Roman Empire and of the crusades.[17]

This new communal social-political identity has been defined by historians, and historians of art, as *campanilismo,* or civic pride. While it would be tempting to rely instead on the term tribalism or clanship, neither quite catches the mix of military, noble, and religious valor that made this brand of clanship attractive. It is probably best described as "Guelphism" in Prato, not in opposition to Ghibellinism but interchangeably with it, preferred only because the Guelphs won in most northern Tuscan communes. Guelphism insinuated itself gradually into the communal imagination over the late thirteenth and the fourteenth centuries, even affecting popular elements in the city uninvolved in the noble factions. The effect was reduced when the first and second *popolo* aspired to power and increased when they achieved and sought to retain it.[18] Its presence can be detected, for instance, in the new popular regime that was established shortly after the 1267 Guelph return, the secondo popolo, which offered representation to both artisans and merchants. The influence of Guelphism on this new regime led many powerful merchants to participate in exclusion and violence, often cloaked in the guise of sophisticated legislation, in order to establish and maintain authority. Thus the first acts of the secondo popolo consisted in exiling Prato's most powerful Ghibelline families, in seizing and, in many cases, destroying their properties. One may have been the building from which both Guelphs and Ghibellines had previously ruled.[19] Paradoxically, in destroying the town's original public palace on account of its brief association with one faction, the new regime helped to assure that the government and its architecture would cease to be above factionalism.

Like their predecessors, the secondo popolo in Prato began by using architectural and urban representation as a tool of their authority. The destruction of the tower-houses of Ghibellines or of any force that threatened the civic authority was one novel side of this. Another related aspect is the symbolism of the space left vacant by acts of destruction.[20] The destruction of the palatium curie and of Ghibelline houses at the plaza comunis in Prato (see fig. 6.5) recalls the demolition of the Uberti tower-house in Florence in 1258. When the Florentines razed the centrally located palace of the hated Ghibelline family of the Uberti, they cursed the site and forbade any further building there, as a lesson to families or factions threatening the regime.[21] In Prato the commune never rebuilt on the site of the

OPPOSITE

FIGURE 7.1 Plan at 1:1000, fourteenth century.
Prato, Piazza della Pieve.

communal palace, and it even continued to clear houses, whether of "rebels" or of properties legitimately purchased. The commune showed no desire for formal expression in the piazza other than the emptiness of the space itself.[22]

This architectural aphasia represented the commune's power to eradicate its enemies and enforce its will. Because buildings were perceived as embodiments of clans, their destruction had a totemic significance: the "casa" Levaldini could equally stand for the building or the family, as the word "house" does in English. When the house was destroyed, the family was uprooted and erased from both the urban topography and society.[23]

These practices recalled the imperial Roman practice of *damnatio memoriae,* according to which all architectural, visual, and textual evidence of the person condemned was erased. The Pratese and their counterparts in other Italian communes were updating this practice, and, furthermore, gave it Christian significance. Typically, houses were set afire. The burning of the house paralleled, and may have even been intended to assure, the future burning of the family in hell, just like the burning of heretics. This linkage of house burning and damnation was strongly suggested by Duccio di Amadore's 1340 versified curse of Pamphollia di Dagomari, a mysterious half-historical, half-legendary figure whom the poet conflated with the Dagomari and Levaldini.[24] Duccio ironically condemned Pamphollia for his excessive display of wealth (*divitie*) in his private palace, enclosed garden, and twin towers, which the poet considered to be signs of arrogance to his countrymen and to God. Duccio described Pamphollia's public humiliation, with the leveling of his house to the empty space of the piazza by fire and other means, and then drew the parallel to Pamphollia's burning in hell, where Fama anticipated his arrival, calling out "Pamphollia is coming: add wood to the fire!"[25]

The plaza comunis therefore persisted as a representational space, but now more symbolizing the humiliation and damnation of public enemies than the relation of the commune to the church. This may be one reason the commune tolerated its deformity and even the rubble strewn across—as was the case at the *platea Ubertorum* in Florence. Only twenty-six years later, in 1293, did the town clean up the ruins of the destroyed palatium, and not until 1335 did the commune actually begin to give the space a regularized geometric form (fig. 7.1).

Early Mendicant Urbanism: The Diffusion of the Sacred Throughout the City

Prato's political, architectural, and urban representation from the eleventh through the mid-thirteenth centuries showed a balance between brotherhood and conciliation on the one hand and hierarchical, centralized rule and absolute power on the other, which was characteristic of central and northern Italian city-republics. For much of this period brotherhood and hierarchical authority existed in a dynamic

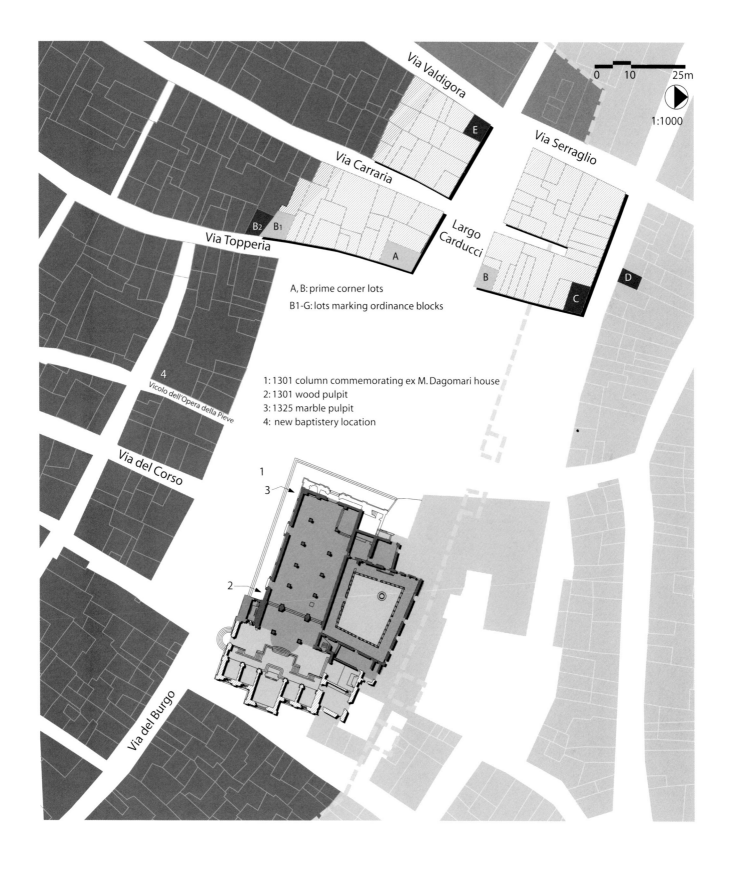

Via Valdigora

0 10 25m

1:1000

Via Serraglio

Via Carraria

E

B₂ B₁

Largo
Carducci

Via Topperia

A

B

D

A, B: prime corner lots

C

B1-G: lots marking ordinance blocks

4

Vicolo dell'Opera della Pieve

1: 1301 column commemorating ex M. Dagomari house
2: 1301 wood pulpit
3: 1325 marble pulpit
4: new baptistery location

Via del Corso

1

3

2

Via del Burgo

tension that balanced an expansion of the ranks of the politically enfranchised with an increasingly absolutist articulation of the power of secular institutions. The events of the 1260s and 1270s added a component of violence and intolerance of dissent that threatened to skew this balance toward hierarchical, theocratic-imperial forms of authority. Even the Guelphs, ostensibly enemies of the imperial cause, turned out to represent the pope in his emperorlike role as territorial crusader, rather than as spiritual reformer, and their concept of victory was one more of vindication than peace. However, once the victors of 1266–67 had spent their fury by banishing their enemies and destroying Ghibelline architecture, the Guelphs of Prato found that they had put themselves temporarily out of business, having no more battles to fight. Like any postwar military class, the Pratese Guelphs lost their significance in peace. Other members of the community came to the fore. The horror of the decade of the 1260s appears even to have led most Pratese not to cheer the victory but to respond with revulsion toward the bloodshed they had witnessed.[26] The secondo popolo, for a moment in the early 1270s, turned away from Guelphism and embraced principles and architectural programs of brotherhood and conciliation to an unprecedented degree, drawing short only of inviting Ghibellines back into the town. The circumstances and mood of the 1270s and 1280s temporarily rendered dormant the ideas of clan and intolerance that had dominated the first days of the Guelph triumph, allowing a truly communal public life and public architecture to thrive for a brief but extraordinary period.[27]

Within this context, the architectural eradication of the Ghibelline houses and of the palatium curie and turris curie and the attendant deformation of the plaza comunis take on another meaning. The initial destruction was an act of vengeance, but the continued refusal to rebuild the palace, tower, and space may be construed as a loss of interest, even as a boycott of the theocratic imperium and violence that tainted the imperial and papal parties that had been resident at the piazza, including the propositura itself. The cost of this boycott was the loss of the image of urban cloister that was embodied in the original platea plebis and still present in the plaza comunis. However, the memory of this form and the idea of collective life behind it were kept alive by the commune elsewhere in Prato through an unprecedented policy of urban property grants and architectural patronage.

In the 1270s and 1280s the commune began actively to support religious orders that not only professed but actually practiced religious poverty and the apostolic life—the mendicant orders. During these years, the commune offered public land and funding for mendicant brotherhoods, including the Franciscans, Augustinians, and Dominicans, to establish large piazze that formed a ring of devotional spaces around the city (figs. 7.2, 7.3).[28] The mendicant orders used these spaces as both outdoor churches and public cloisters. They preached, initi-

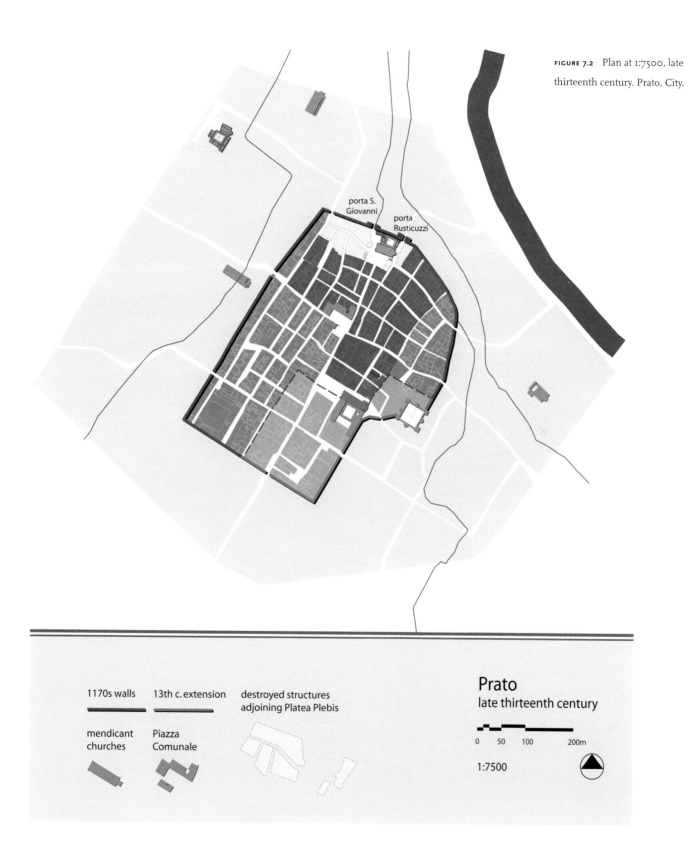

FIGURE 7.2 Plan at 1:7500, late thirteenth century. Prato, City.

porta S.
Giovanni

porta
Rusticuzzi

1170s walls

13th c. extension

destroyed structures
adjoining Platea Plebis

mendicant
churches

Piazza
Comunale

Prato
late thirteenth century

0 50 100 200m

1:7500

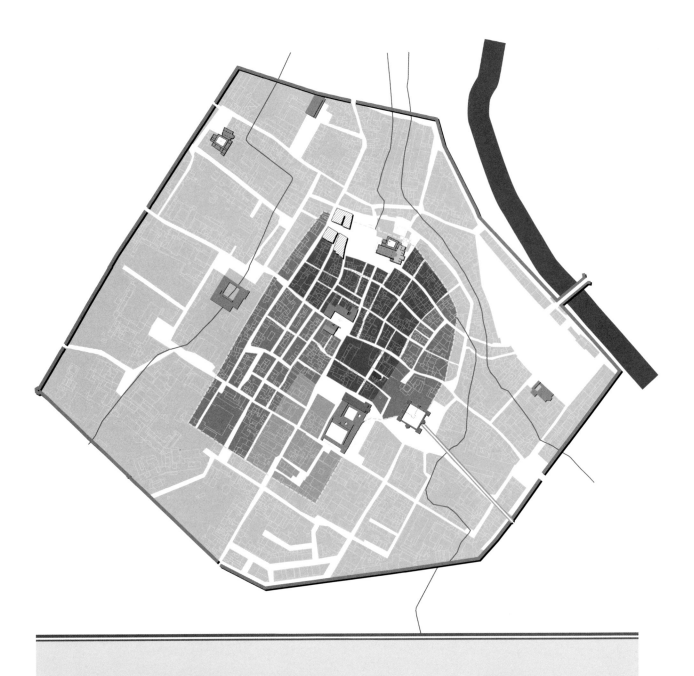

OPPOSITE

FIGURE 7.3 Plan at 1:7500, fourteenth century. Prato, City.

ated processions of their own friars and lay brothers, and lived in the piazze. The mendicants thereby pursued their mission of converting the urban faithful to the friars' own fusion of apostolic and monastic life.[29] Through their celebratory and penitential processions, the friars and their lay brothers transformed their piazze and the rest of the city into places for religious celebration and discipline. The traditional dichotomy between sacred and profane became blurred, if not abrogated. The entire city became potentially sacred space, and all its citizens participants, not spectators, in the apostolic life once carefully guarded within the presbytery, canonicate, and cloister of Santo Stefano.

The means by which the friars colonized the entire city of Prato as a sacred space departed from all previous models for asserting spiritual power since the time of Constantine. Their strategy bore little resemblance to that of the earlier propositura, which had won papal injunctions to allow its independence from Pistoia and its autonomy from nearby parishes and monasteries, and which had emphasized its rule with magnificent buildings. Instead, the friars adopted a strategy that must have made them appear pitiful to the propositura. The Franciscans, who set the tone for the other, somewhat later mendicant orders, initially advocated radical poverty. They were too poor to build, and St. Francis would not tolerate the possession of churches, let alone new construction. The Franciscans instead preached in open spaces or in churches borrowed from parish or episcopal authorities. Though they technically played the same role of catering to the pious needs of the populace as well-frocked bishops or canons raising the host at the terminus of ornate naves, the Franciscans' setting, dress, comportment, and language presented a different image, remote from that of emperor or king, closer instead to Christ. The Franciscans, and soon the other mendicant orders, thereby provided far more direct access to the image, personality, and spiritual intercession of Christ than did their priestly counterparts. The mendicants did so literally at the doorsteps of the new citizens who settled around the peripheral piazze of Prato and other contemporary central and northern Italian cities.

Evidence for the impact of the mendicants on the urban laity comes from contemporary sources. A Dalmatian law student, Thomas of Spalato, recorded his impression of St. Francis preaching at the public square of Bologna on August 15, 1222:

> I saw Francis preaching in the square in front of the public palace, where practically the entire city had gathered.... He spoke so well and sensibly that this preaching of an unlettered man stirred the very enthusiastic admiration of even the especially erudite people who were there. He did not, however, hold to the classical manner of preaching but just shouted out practically whatever came to mind.... His

clothing was filthy, his whole appearance contemptible, and his face unattractive. But God put such force in his words that many factions of nobles, among whom the wild fury of old hatreds had caused much bloodshed, were in fact peacefully reconciled. So great was the respect and devotion of this audience that men and women crowded in on him, seeking to touch his hem or to carry off a piece of his ragged clothing.[30]

Thomas was caught off-guard by Francis. Despite or perhaps even because of the secular setting, his poor dress and hygiene, and unclassical delivery, Francis communicated directly with the simple, the erudite, and the violent alike. He did not represent a strand of low culture coexisting with but mutually distinct from a high cultural stratum. He penetrated the high culture itself, winning the hearts of the powerful with his directness. In a time of increasing conflict among the powerful, his unifying voice made him essential to the church, however subversive his technique may have been. Other records of his preaching and mission indicate that he was equally capable of restoring heretics to the church as of pacifying the urban nobility.[31]

Francis' versatile talents led Pope Innocent III to approve the Order of Lesser Brothers, led by Francis of Assisi, and his *regula primitiva,* in 1210, and Pope Honorius III to accept the order's expanded and final rule, the *regula bullata,* in 1223. Perhaps due to this formal papal recognition, the Franciscans seem to have caught most local church organizations unawares, as they did Thomas of Spalato. Perhaps their modesty was at once winning and unthreatening even to local bishops and other religious authorities. In Prato, the Franciscans at first met none of the resistance that the propositura had shown to San Giusto and the Vallombrosans at Sant'Iacopo. By the time the propositura realized how much it had compromised its own position, it was too late.

The mendicant friars at first approached urban siting and architecture with the same attitude that Francis brought to his preaching: to find the nodes of urban life, and to present themselves humbly yet charismatically. Throughout Italy, this first phase of mendicant settlement focused purely on occupying public space, with no component of monumental architecture. Upon their arrival in Prato in 1228, a small group of Franciscans refrained from building a church.[32] All that they requested from the commune was a space to locate a small chapel and living quarters, without even a formal cloister.[33] They preached in the churches of established institutions, and more and more in a piazza near their settlement, which became identified with them as the Piazza San Francesco. They continually expanded this space over a period of 120 years, establishing the model for other mendicant settlements (figs. 7.4–7.8).[34]

The Augustinians also made do without a church on moving to Prato in 1270, literally camping out on an open space in a tent from the commune which they used as their sacristy and sanctuary for the celebration of mass, for the ministration of sacraments, and for the setting of a podium from which to preach.[35] When a third order, the Dominicans, requested from the commune permission to settle in Prato, in 1281, most of their letter to the commune consisted in a description

FIGURE 7.5 Diagram of piazza and friary development, thirteenth–fourteenth centuries. Prato, Piazza San Francesco.

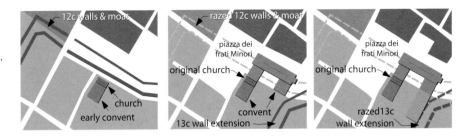

FIGURE 7.6 Section at 1:1000, thirteenth–fifteenth centuries. Prato, San Francesco.

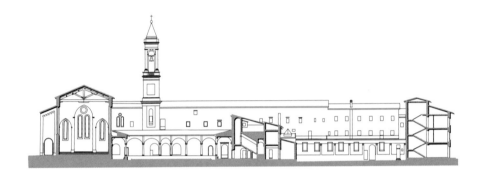

FIGURE 7.7 Plan at 1:1000, after Moretti, thirteenth–fifteenth centuries. Prato, San Francesco.

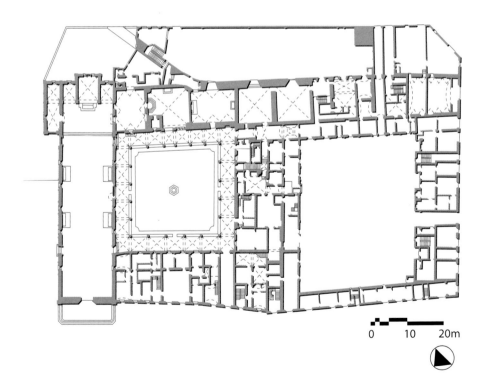

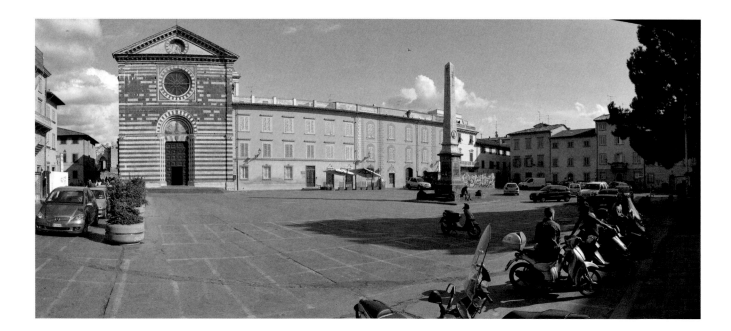

FIGURE 7.8 View, thirteenth–fifteenth centuries.
Prato, Piazza San Francesco.

of the space and of its layout, with next to no comments about the church itself, which began as a characteristically small oratory, a mere adjunct to the exterior space.[36] Even when they built churches, each of these orders continued to use their outdoor spaces for preaching and rituals. They willingly competed for the attention of passersby with the market activities that often filled their spaces. By situating themselves at profane nodes of urban life, they assured the dissemination of their message and the popularity of their orders.

The friars adopted, and then transformed, the relation of city, church, and space that had been established earlier at the Pieve. Each new order set itself up at the center of a new neighborhood growing at the edge of or beyond the city walls, along a major street passing through one of the city's gates. Unlike the propositura, the mendicant orders were numerous and therefore created many nodes of sacred ministry. The city was transformed from a single, now seemingly moribund, hieratic core to a polycentric array of religious spaces. The Franciscans were to the south of the city by the Porta Santa Trinità, the Augustinians to the north, outside the Porta Travalii, the Dominicans to the west, outside the Porta Gualdimaris, and the Carmelites to the east, outside the Porta Tiezi. They were all therefore distant from the Pieve of Santo Stefano, but also as far as possible from one another.[37] These mendicant piazze and churches quickly became the focal points for the identity of each of the respective city-gate neighborhoods, with citizens making gifts and testaments that increased the friaries' material resources. The mendicant settlements repeated the growth pattern of the Pieve of Santo Stefano in relation to the bishopric of Pistoia, only more densely. Santo Stefano had evolved to serve the

needs of the Borgo al Cornio and Castello di Prato, which were ill provided for by the distant bishop. The friars grew similarly to fulfill the need of Prato's peripheral neighborhoods. Their settlements were justifiably close to the Pieve and to other friaries because the population density had increased in the town and its region since the eleventh century.

High Mendicant Urbanism: The Spatial and Architectural Containment of the Sacred

In Prato as elsewhere, the mendicant orders grew quickly in size and attracted increasing gifts and bequests. As wealth continued to flow their way they began to abandon their initial radical poverty. The architectural manifestations of this change were monumental church-building projects to house congregations, and the construction of adjoining cloisters for ever more friars and novices. Nearby Florence's Santa Maria Novella and Santa Croce are two among many examples. These once modest friaries came to resemble and even to surpass in scale the original sacred sites of their cities, whether Florence's Santa Reparata and Baptistery, or Prato's platea plebis, with Santo Stefano and its cloister. Prato's mendicant settlements even recalled, at times directly, the formal and symbolic relationship between piazza and cloister at Santo Stefano. Some important differences from the early situation of cathedrals in other cities or of Prato's propositura, however, distinguished this second, monumental phase of mendicant settlement in central and northern Italy, termed here high mendicant urbanism. The friars shifted the bias of the relationship between monuments and outdoor spaces to the latter. The great density of the thirteenth-century city may explain this shift in focus. The case of Prato is typical. While the propositura of Santo Stefano had been able to establish a strongly built presence by constructing the original Pieve and cloister complex large enough to contrast with the relatively unsettled area surrounding it, the congested cityscape later led the friars to invert the figure to ground relationship of structure to space. The relation of foreground to background in the piazza and church elevations was also reversed from earlier religious urbanism; now friar churches played the role of background to the foreground of the preaching, congregations, and religious rituals in their spaces, whether in Prato or elsewhere.

The shift from an early, spatial phase of friar settlement to one balancing monument and space, architecture, and outdoor worship can be seen by looking at each order. The first piazza of the Franciscans was near to, but not immediately beside, their primitive chapel and small conventual structures; it was just on the other side of the city walls from their buildings, at the area known as the Piazza dell'Appianato. After the commune extended the city walls to the south between 1270 and the end of the century, the Franciscans built a new church directly on the

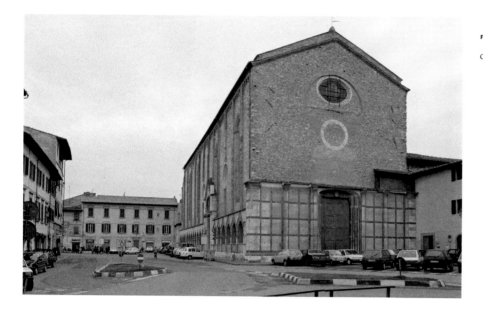

piazza. They gave the space an L-shaped form oriented east-west, with the longer portion along the street leading from the Porta Curtis; echoing the Piazza della Pieve facing Santo Stefano's south elevation. When more space became available the Franciscans expanded the space to the full breadth that it has today, oriented more north-south than east-west.[38] After this the copy became the model, with the Piazza San Francesco providing the blueprint for the future development of the Piazza della Pieve.

The Augustinian settlement began with the Piazza Sant'Agostino. The space was a long rectangle extending roughly north-south, at first without any church. The first church, after 1270, was built along the side of the space, at its northwest corner. Later, between 1395 and 1410, the Augustinians shifted and expanded the church to put it in an axial relation to the piazza, terminating its north end, and provided it with two cloisters.[39]

The Dominican settlement at the Piazza San Domenico began and remained in a configuration that was most similar to that of the twelfth- and early thirteenth-century platea plebis (figs. 7.9–7.12). It was again a long rectangle, running east-west, primarily along the side of the church, but with a small area in front of the façade, and with its major approach even passing a series of bays with a false perspective diminution, leading the viewer to the west front of the church.[40] The space was articulated with a ground-level arcade, built into the north elevation of the church of San Domenico. The deep, nearly inhabitable relief of the individual arches, housing tombs known as *avelli*, echoed the blind arcade of Santo Stefano's south façade and the cloister within (fig. 7.13). The visual similarities do not betray

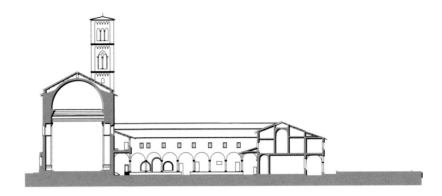

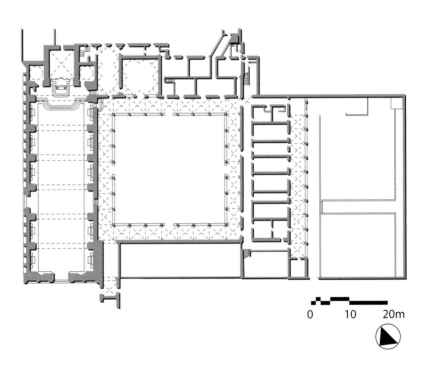

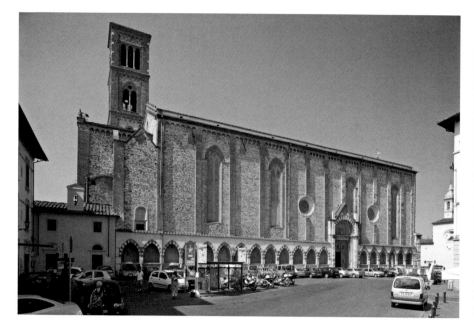

FIGURE 7.12 Piazza and friary church, thirteenth–
fourteenth centuries. Prato, San Domenico.

FIGURE 7.13 Avellus, fourteenth century. Prato,
San Domenico.

the original use of the avelli. Rather than dividing the space of the sacred from that of the profane, they literally engaged the laity in the body of the church, blurring the threshold of the sacred.

Avelli were common at Dominican churches throughout Tuscany. As at San Domenico in Prato, they were located on the ground level of the church exteriors and piazze, with each "monument," as they were called, crowned with an individual arch, forming essentially an arcade for those awaiting salvation, which decorated the church piazze. Though there are examples of avelli that are not at Dominican structures, such as those at the church of San Paolo in Pistoia (fig. 7.14), the majority are at Dominican sites. The most extensive use of avelli is at Santa Maria Novella in Florence (figs. 7.15, 7.16), where they extend beyond the church elevations to encompass a portion of the piazza. Some of the same Dominican architects who worked at Santa Maria Novella also built the San Domenico avelli. It is therefore likely that the use of contracts regulating the construction of avelli in Prato was transmitted from a similar practice at Piazza Santa Maria Novella in Florence.[41] These practices represent a form of church-supported, public-private urban design that anticipated legislation for the design of monumental civic spaces in Tuscan cities in the fourteenth century. The patronage and construction of one of the avelli for the Manelli family at Santa Maria Novella in Florence are described in detail in a document of January 12, 1314.[42] It was to be built by the portal opening from the new piazza in front of the church to the cloister, at a specific point along the exterior wall, and it was to be completed by the feast of the Assumption of the Virgin the following August. The 1314 document specifies where it was to

be built in the preestablished framework of avelli and that it was "to be made and constructed of stones, mortar and white and black marble, so high and wide and deep and with such a form, on such a scale and in such a fashion as are the other marble tombs adjoining it along the walls."[43] The form and array of the avelli along the north elevation of San Domenico in Prato are identical to their counterparts in Florence. This link, together with the presence of Dominican architects from Santa Maria Novella at San Domenico in Prato in the early Trecento, make it highly probable that contracts were the means by which individual tomb patrons were accommodated within the avelli in Prato.

Avelli provided tombs for the burial of third-order families in the cloisterlike space of the piazza. They projected the image and actual participants of third-order mendicants onto their piazze; at the same time the contact with the religious body and design of the church made the avelli into sacred refuges, even portals to the afterlife. A fresco inside the chapter house of Sant'Agostino confirms the redemptive associations of avelli—it depicts Christ as the Man of Sorrows, framed within a tomb set behind and framed by avellus elements—pilasters supporting a pointed arch (fig. 7.17). Avelli sanctified the spaces they framed. Both they and their sites were in turn sanctified by the memorial liturgies and processions for the deceased, as well as by the regular preaching and processions at the side of the church. At the same time, the avelli memorialized and monumentalized the presence of friars and their congregations. In capturing and representing the imagery of mendicant brotherhood, the avelli also locked it into the confines of church and piazza, halting and even reversing the diffusion of mendicant piety throughout urban space.

The intention to contain the expansion of sacred space to the boundaries of mendicant churches and piazze is evident in legislation. Public authorities began to enact laws to regulate the activities in the spaces, to prevent the construction of buildings on them, and even to thwart the construction of towers and sporti, or balconies, facing them. The most elaborate of these regulations in Prato were those of the Piazza San Domenico, which stipulated precisely the geometry of the space, and later the design of the avelli.[44]

High Mendicant Urbanism, Political Enfranchisement, and Social Control

Why did Prato and nearly all other communes support the friars? The communal land grants and favorable legislation should be seen as continuing the same religious building policies of the propositura in the eleventh and twelfth centuries and of the commune in the early thirteenth century. Though the commune did not locate its permanent headquarters at any mendicant space, it did situate a Palace

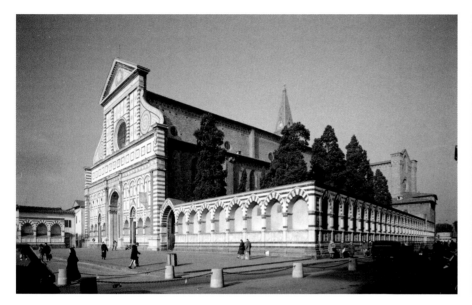

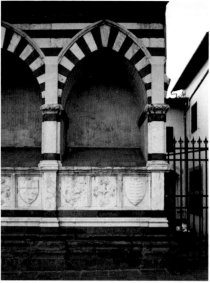

of Justice at the Piazza San Francesco, and even used a tower connected to the convent as a prison.[45] However, to focus on any one site for the link between the communal government and the friars would miss the point. By financing the friars, the commune was able to extend the connection between secular authority and the vision of paradise from its original and now fallen site, at the plaza comunis, to a ring of sacred spaces encompassing the city. While the original platea plebis had been capable of representing the common life and then the commonwealth of the small early settlement, by the thirteenth century the city had grown too far for the interlock between sacred and secular space and activity to be intimately centered at Santo Stefano. The institution of the propositura was, by the thirteenth century, too distant from the new urban classes settling at the town periphery and, furthermore, too tied into the dominant Guelph and Ghibelline class structure to bother to focus its ministry on the growing settlements just outside the city walls. The propositura had, therefore, become the equivalent of what the bishop of Pistoia had been to the Borgo al Cornio and Castello di Prato in the eleventh and twelfth centuries: distant and out of touch, embodying traditional authority in a community filled with new classes unrepresented by such authority.

The Franciscans and other mendicants settled at the periphery and were accepted there precisely because the urban laity in Prato and other communes was spiritually disenfranchised. Mendicant friars furthermore offered an updated version of the common life, for both themselves and the laity, pushing the ideas of poverty and brotherhood developed by the canons 150 years earlier to their limits. It is quite revealing that monumental building projects played no role in their initial

FIGURE 7.15 Façade, thirteenth–fourteenth centuries. Florence, Santa Maria Novella.

FIGURE 7.16 Avellus, thirteenth–fourteenth centuries. Florence, Santa Maria Novella.

FIGURE 7.17 Anonymous, *Christ as Man of Sorrows* in avellus-like tomb, fourteenth century. Prato, Sant'Agostino.

mission. Their images of brotherhood and conciliation were their own bodies and voices, and, as Thomas of Spalato described so well, they could play their roles brilliantly. They used the gestures and spoke the language of the laity, eschewing church Latin. They used the existing formal and informal market spaces of the town, sanctifying them through their presence. Because they were not cloistered, not even properly housed, the friars became omnipresent in the urban streets and spaces, offering a constant vision of an apostolic mission that opened itself to the laity rather than sealing itself off in a monumental urban precinct. Unlike the canons' cloister, the institutional structures and spaces of the mendicants did not provide ideal but unattainable models for the emulation of the laity. The mendicant structures, at least initially, were all the town's buildings, and, according to Francis himself, the friars' cloister comprised the totality of city streets and piazze.

The foregoing explains how the mendicants won over the residents of the periphery of Prato and of other central and northern Italian cities, but not how they could win the votes from the well-established members of urban society sitting in the town council. The two are connected because the friars provided models and institutional frameworks for lay citizens to organize themselves. The friars formalized the engagement of their growing congregations by establishing

lay associations, known as third orders of mendicants, whose members could retain their families and professions. These third orders were distinguished from the first and second orders of friars, the male and female congregations, whose members fully renounced their worldly lives.[46] Members of the third orders participated enthusiastically in the rituals and charity of the friars. The openness of the friars provided a compelling alternative to the exclusive imagery of the canons at Prato's propositura, at cathedrals elsewhere, or to the blood and clan bonds of the partisan factions that were dividing the city. The third orders were quickly filled with both old and new families, putting individuals together in such a way as to empower the newcomers and revitalize long-established citizens. The openness of the mendicants thereby bred a similar openness in third-order members of the town council, who welcomed new citizens and their energy into the town government.

Swelling enrollments in the third orders at Prato had already changed the composition of the government by the 1250s, when the primo popolo was established as the first regime to open its ranks to a wide range of professions and therefore classes. In the 1270s, a decade after the Ghibelline takeover of the town, the secondo popolo distinguished itself from its Ghibelline or Guelph predecessors by investing considerable resources in the mendicant orders. The members of the secondo popolo were simply supporting their original neighborhood pious institutions. At the same time they were encouraging through piety what they sought to

FIGURE 7.18 *Flagellation of Christ* in *Libro dei capitoli della compagnia di S. Noferi*, fourteenth century. Prato, Biblioteca Roncioniana, Codex 270, fol. 40r.

FIGURE 7.19 *Flagellant*, Compagnia di S. Noferi, in *Libro dei capitoli della compagnia di S. Noferi*, fourteenth century. Prato, Biblioteca Roncioniana, Codex 270, fol. 66v.

achieve politically—to unite a divided city. The mendicants provided the scale and topographic diversity to allow them to expand the public life in common, which encompassed not just the old town, but now also the new.

The mendicant diffusion of piety across class and urban space occurred in many of the communes of Tuscany, Umbria, and, to a lesser degree, northern Italy. This phenomenon is so unusual in the history of Western religion, architecture, and urbanism that it can be understood only in the context of equally extraordinary circumstances. The violence poisoning the cities had become so virulent that some were teetering on the edge of oblivion. Giovanni Villani recounted just how close Florence had been to such a fate.[47] Shortly after the triumph of the Ghibellines at the battle of Montaperti, the Guidi, Alberti, Santa Fiore, and Ubaldini counts of Tuscany, together with the majority of the Ghibelline party, including Florentines, proposed and were in agreement to "disfare," literally "to undo," the city of Florence. It was only the mixture of eloquence and obstinacy of one Florentine Ghibelline that prevented them from relegating the city to history. That one man could succeed against so many so united and so vindictive may also be attributable to the fact that the Florentine in question had had a bitter first-hand experience with actual and symbolic destruction—he was Cavaliere Messer Farinata degli Uberti. With the extinction of his house at the future site of the Piazza della Signoria, the entire city had become his locus of identity. Similar traumas suffered by Guelphs and Ghibellines alike in Prato may have led them to open themselves, at least for a brief time in the 1270s and 1280s, to the mission of brotherhood of the friars, and to a conception of the entire city as a locus for religious, social, and political identity.

The undoing of many Guelph and Ghibelline families and the parallel but unrelated religious and political awakening of laborers, artisans, shopkeepers, merchants, and bankers led to a period of twenty years when the commune and the mendicant orders worked in unison. Civic and mendicant institutions joined forces to achieve two major policy goals: to unify city residents, and to quell violence. The mendicants offered the commune a network of pious institutions and an array of religious-persuasive tools for achieving these ends. By investing in the religious spaces and structures of the friars throughout the city, the commune was linking its authority to their preaching and ministry, essentially using the friars and their spaces as conspicuous reminders, and even guardians, of communal laws regulating the behavior of citizens. The aspect of social control in the commune's patronage of the new orders explains the location of Prato's Palace of Justice at the Piazza San Francesco. This was more than an analogue between the earthly justice of the town and divine justice represented at the church. The Franciscans were responsible in Prato as elsewhere for the inquisition.[48] The term

heresy became used increasingly freely in the second half of the thirteenth century to apply to anyone not obedient to the institutions of authority, whether church or state. Forgers of money, for instance, were called blasphemers. On a more sinister note, which may indicate an incipient union between the friars and Guelphism, Ghibellines were often branded as heretics.[49] The location of the Palace of Justice and even the communal prison near the Franciscans makes it quite clear that the friars and their piazza were meant to warn dissident forces of the punishment for wrongdoing, not only at the stake, but also in the fires of hell.

The role of the mendicants as judges of orthodoxy recalls the power of the provost and canons in the twelfth century, broadcasting their exclusive control of admission to the paradise of their brotherhood. Unlike the canons, or the more atavistic exclusive group of the period, the clan, the mendicants eschewed exclusivity, and even actively invited nonmembers to join one of their three orders. Of any institution or group discussed to date, even the earliest lay residents of Prato, the mendicants were closest in spirit to the vital element in the vita apostolica, evangelism. Exclusion was held out as a potential punishment, but inclusion was their fundamental mission. Even their methods against heretics were based on conversion first, and only afterward, if all else failed, on physical punishment or banishment. The limits of mendicant tolerance were the limits of Christian orthodoxy, and while this led them to treat intransigent heretics with the same violence that the consorterie used against one another, the scale of their social identity was far larger than family, faction, or the commune itself. Their recourse to physical force or to expulsion was therefore far less frequent. It was in their apparent gentleness, however, that the friars could be most intolerant and terrifying.[50]

The emphasis by the mendicant orders on evangelism, on conversion, and on persuasion led them to favor psychological means of coercion. Because the mendicants refused to isolate a monumental portion of the city as paradise, unlike the propositura at the twelfth-century church and cloister, they had to develop other means for representing a sacred brotherhood. Furthermore, without a space where one could figuratively guard access to paradise, even the paternal imagery of the propositura became obsolete. In place of both, the mendicants applied to the lay public figurative techniques that had been developed only for the interior life of the monastery and canonicate. One was to represent a humble and equal apostolic brotherhood in the appearance of the friars and tertiary members, through a strictly enforced dress code. In the case of the Franciscans this constituted their *veste* and knotted belts. Moral authority shifted from the single priestly or imperial figure to the individual and the group, which, like the protagonist and chorus of Greek tragedians, assumed responsibility for judgment and punishment for misbehavior by a mixture of self-imposed guilt and public shame.[51]

The friars' revolution of dispersing paradise from the cloister or the imagery of Santo Stefano's south façade to the entire city, even to the dress and comportment of individuals, provided a capacity for moral control that was all-pervasive, reaching even into the individual conscience and imagination. One of the most remarkable inventions of the period was the construction not of heaven, but of its absence. While monks and canons built heavenly cloisters and then restricted access, the friars built purgatory and opened its doors to all.[52] No one could be sure of salvation, and even the most pious needed to do all in their power to assure eventual passage from limbo to heaven. The friars built upon this insecurity through another innovation, that of confession, or the remission of sins based on some penitential activity. This friar strategy was as brilliant in its simplicity as it was powerful in its impact. Any friar, encountered anywhere, could, by providing confession, be an agent of redemption. Rather than requiring monumental buildings with imposing portals potentially blocking access to sacred arcades symbolizing the apostles, Franciscans just dressed themselves as apostles. With their simple brown habits and rope belts they broadcast into the capillaries of urban life, better than any cathedral or campanile, the appeal and possible denial of the apostolic life. They even reinforced their power of providing or denying access to heaven with dress codes imposed on converted heretics. On the Piazza San Francesco, for instance, they embroidered publicly, on the backs of anyone repenting from heresy, a scarlet "H," which the reformed heretic was to bear at all times in public, like Nathaniel Hawthorne's Hester Prynne much later.[53]

Such dress codes were reserved not to reconverted heretics, but to anyone willing—and they appear to have submitted themselves in great numbers—to join the Franciscans as third-order initiates. In joining, lay brothers, and later sisters, agreed to follow extremely strict codes of dress, comportment, and, quite significantly, penance and self-flagellation.[54] Like the dangerously pious citizens of Salem in Hawthorne's *Scarlet Letter* or in Arthur Miller's *Crucible,* the lay brothers of Prato took upon themselves a responsibility previously reserved for public authority—of policing one another, and even of administering punishment. The model was Christ's own flagellation—described as such and even shown in a 1383 Pratese manuscript, from the chapter book of the penetential company of St. Noferi (figs. 7.18, 7.19). The image illuminates a section on following Christ's model for penance, showing Herod presiding over Christ's flagellation from a structure resembling both a Ghibelline tower-house and the kind of Palace of Justice that existed at Piazza San Francesco. The Franciscans were the first to imbed the strict ideas of order and self-control of the monastic life in the urban landscape and even in the dress, behavior, and consciences of their brethren. Though the Pratese Dominicans, Augustinians, and other mendicants did not share the

Franciscans' institutional and architectural connection with public order through the inquisition and civic prison, they were equally effective in entering the dress and spiritual mentalities of their respective penitential third orders, such that a large proportion of the cityscape and citizenry were regulated by similar concepts of order and self-discipline.[55]

Although mendicant penetration into the individual conscience functioned without monumental architecture in the traditional sense, the friars nonetheless used memory, architecture, and urban space in novel ways to reinforce their spiritual and often penitential presence. The full power of this in thirteenth- and fourteenth-century Prato is lost to us today, but it must have been as vital to contemporaries as the striped church façades, arches, and paving stones lining the mendicant piazze. The friars gave both their individual piazze and the streets interlinking them an animistic character recalling but transforming the tradition of the first Piazza della Pieve, with the apostles and Christ imbedded in the numbers of the south façade pilasters and cloister columns. It was not detail or iconography but uniform dress and ritually repeated activity that imbedded the sacred in the friars' matrix of spaces. The outdoor masses, religious rituals, ceremonies, and penitential processions that often occurred in all of these spaces served to reinforce their sanctity, making them into spaces that actively discouraged sin, whether against God or the state. The penitential handbook of the Pratese Dominican flagellants indicates just how powerful this invisible spiritual, or rather totemic, overlay of the spaces must have been:

> If any of the brothers were to run into such folly as to blaspheme God or the Virgin Mary or any saint, or to curse his father or mother, immediately, without any admonition, may he be expelled and chased out of our company. Any who plays at cards must walk barefoot, for each instance, to discipline himself at Sancta Anna. Any who goes to play at any other games, where one casts dice or coins, must for each time go to discipline himself at the Pieve and at Sant'Agostino. Again, let no one even desire to go in any dishonest place of women. Again, who engages in such folly as to inebriate himself, let him go to discipline himself at the church of the Carmine, and to say at the altar five Our Fathers with as many Hail Marys.[56]

This topography of penance was reinforced by the processions of the *laudesi*[57] and flagellants through the city, chanting lauds and flagellating themselves, in emulation of the passion of Christ.[58] More and more, the piazze of the mendicants assumed the character not of the original plaza comunis but of its own source in precommunal architecture, the cloister. The regular geometry of the mendicant piazze, the rules for their appearance and uses, and particularly the regulation of the dress, activities, and even consciences of all citizens associated with the orders and

their spaces, revived and transformed the formal, institutional, and psychological qualities of the monastery and applied them to the public space of the city.[59]

The penitential component to the mendicant mission is critical in understanding its overall significance. Poverty was similarly important: not only did it indicate the friars' lack of interest in fighting for material gain, but it also assured that their morality was diffused throughout the communities in which they settled, as they depended for their sustenance and housing on the generosity of city residents and civic institutions.[60] The sight of a begging friar demanded a response by citizens that was direct and not just through official channels, as in the past. Gifts to mendicants in turn allowed munificent individuals essentially to impersonate traditional charitable rulers, priests, and their institutions. The lay orders provided another means of diffusing this idea more deeply into society. However, it was the morality of self-imposed order, open to all, to which poverty, humility, confession, lay orders, and vernacular preaching were subservient. By this means the mendicants were able to capture the consciences of nearly all classes, new and old, in the community.[61] The power to control social behavior and limit violence was to be relegated not to external, paternal authority figures, whether bishop, provost, emperor, or tyrant, but rather to the individual and the community of equals. The dynamic of individual and group was essential. Individual behavior, ritual celebration, and personal penance were observed by the group. Self-control, therefore, could provide the key to public peace so long as enough members of the society were converted. This was a moral cloister open to all, even required for all.

Evidence for the influence on the secular government of the friars' sanctification of the urban environment and their hold on individual consciences was not limited to public grants of land to the mendicants. From the mid-thirteenth century onward, the most brutal punishment feared by all and suffered by increasing numbers was not execution, but banishment. Dante is one of the most powerful witnesses to the resultant despair, which may have led the poet to compose his own virtual paradise. As cities like Prato rebuilt their entire urban fabric and made headway in pacifying unrest after decades of violence, they only heightened the pain of separation for those expelled from the city and its society. Exile allowed communal authorities to construct the friars' purgatory on earth, and most of the exiled did all in their graces, from Farinata degli Uberti to Dante to Machiavelli, to regain their place in the earthly paradise of the blossoming Italian commune.

The darker possibilities of this religiously enhanced punishment were already noted in relation to the practice of branding Ghibellines as heretics. The brotherhood open to all defined all as the Christian community. Heretics, Jews, and Arabs were excluded. Guelph tendencies of the secondo popolo, however mollified by the

mendicants, did not die, but took on new forms. The whole community, its space and society, was becoming at once sanctified and purified. The only internal check to the tendency toward purification, or rather expulsion, by the secondo popolo and later regimes was the powerful force of self-examination and self-criticism called upon by the friars, and written and preached on by no lesser lights than Bonaventure, Albertus Magnus, and Thomas Aquinas. The degree of reflection, self-criticism, and self-denial imposed by this salutary component of mendicant piety was more, however, than most communal citizens, in Prato or elsewhere, would be able to sustain over time.

The New Piazza del Comune and the Return of Civic Patronage to the Pieve di Santo Stefano and Its Piazza

The Eclipse of Mendicant Urbanism and the Creation of the New Piazza del Comune

The arrival of the mendicant orders at the piazze encircling Prato changed the character of public space in the town in two important ways. One was to diffuse the place of the sacred from a single location to multiple nodes, even throughout the entire open space of the city. The other was to offer religious piazze and buildings as showplaces for the piety of city dwellers who, for reasons of their peripheral situation in the community, had not had a religious space with which they could identify. Of the two, the first was by far the more novel. Cities with multiple sites of equivalent religious power are rare in the history of Western urban or religious history. Like the canons' cloister and its reflection in the platea plebis of the twelfth century, the diffused mendicant settlements provided a form of representational space that, for its time, was precisely adapted to the social composition and population distribution of Prato. The polycentric urbanism of the mendicants in fact represented the Pratese as they were, providing a decentralized image of the body social that bore no resemblance to previous urban constructions of autocratic power. Roman, episcopal, or feudal settlements, and even the earlier provost or consular regimes in Prato, had all constructed single centralized spaces to celebrate their dominance.

As the success of the secondo popolo increased, the architectural policy of the Pratese changed in ways similar to earlier and later historical moments when a new religious or political group consolidated its power. Just as the early Christians moved from clandestine meetings in apartments and private houses to huge public masses in Constantinian basilicas, or just as the Soviet proletariat shifted from the antitraditional projects of constructivist architects to the historicist monuments of Stalin's five-year plans in the 1930s, the Pratese, at the high point of their investment in mendicant architecture, began to shift their focus from the radical dispersion of sacred space toward monumental, traditional architecture and public space as the primary means for representing themselves in the city.[1]

DETAIL: FIGURE 9.12

OPPOSITE

FIGURE 8.1 Palazzo Pretorio, thirteenth–four-
teenth centuries. Prato, Piazza Comunale.

In 1284, after nearly twenty years of itinerant rule, changing location from vari-
ous churches to private residences,[2] the commune voted to concentrate its offices
at a single space in the city, apart from the old, destroyed platea plebis but equally
articulate in its plan and elevations. The renewed confidence of the commune is
evident in the choice of site: leaders no longer needed the direct support of their
theocratic predecessors, the propositura, and instead built a secular governing pre-
cinct independent from Santo Stefano, at the new Piazza del Comune (figs. 8.1–8.3;
see also fig. 7.3).[3] The construction of Prato's Piazza del Comune began with the
purchase of the house of the Pipini family for the new palace of the podestà, known
as the *palatium populi* (today's Palazzo Pretorio), an act approved by the Podestà
Fresco di Frescobaldi, in 1284.[4] The space, previously known as the Scampio, had
already been used as the grain market of the commune, with the communal bureau
of weights and measures regulating grain commerce from a shop in the loggia
of the Pipini tower-house.[5] The decision of the commune to locate its structure at
this particular space may have been influenced by the importance of the control
of grain supply and pricing in the town, not only to avert famine, but also to en-
able the government to maintain a ready food supply for the lower classes and
poor, thereby avoiding one of the most common grounds for discord.[6] Florence's
Orsanmichele constitutes a somewhat later example of a monumentalized state-
controlled grain supply. The location of Prato's grain market at the precise center
of the city must also have been a deciding factor, particularly given the example of
urban siting in relation to served population by the mendicants.

The establishment of the communal piazza by the Scampio recentralized
the locus of secular authority, and did so at a space apart from the commune's
original location under the shadow of the propositura. This act was appropriate
for the far more developed institutional identity, not to mention bureaucracy,
that the secondo popolo had established since the defeat of the Ghibellines and
the concomitant disappearance of any serious imperial presence in Prato at the
palatium imperatoris.

The centralization of civic government spatially and monumentally in Prato
paralleled similar developments throughout communal Italy. Between 1285 and
1340, many towns in central and northern Italy, such as Florence, San Gimignano,
Siena, Orvieto, Gubbio, Todi, Bergamo, and Venice, built or renovated centralized
public palaces and piazze. In all cases these projects were promoted by regimes
similar in character to Prato's secondo popolo. Some, as at Prato, were sited inde-
pendently from the primary church in the city. Architecture and urbanism were
the most highly developed means beyond legislative statutes for expressing and
enforcing the new monopoly of power—and violence—that these communes
had attained.[7]

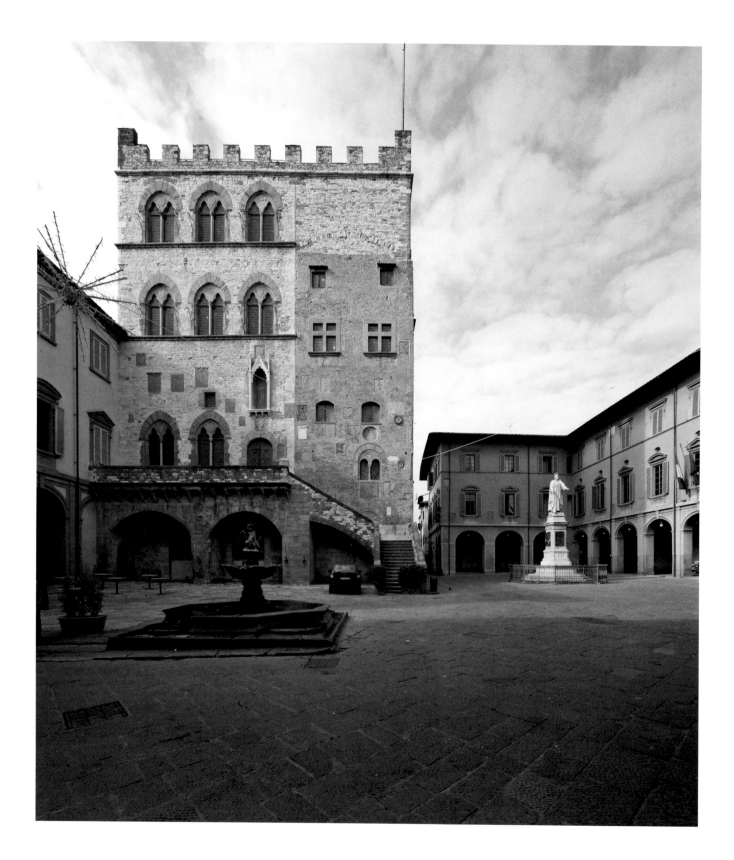

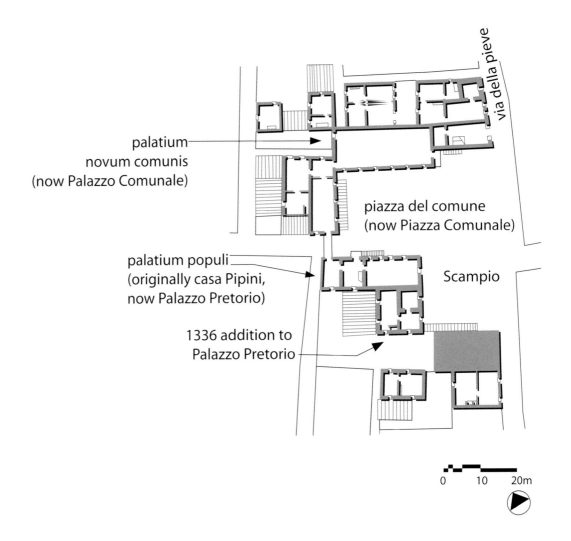

via della pieve

palatium
novum comunis
(now Palazzo Comunale)

piazza del comune
(now Piazza Comunale)

palatium populi
(originally casa Pipini,
now Palazzo Pretorio)

Scampio

1336 addition to
Palazzo Pretorio

0 10 20m

FIGURE 8.2 Plan at 1:000, thirteenth–fourteenth centuries. Prato, Piazza Comunale.

OPPOSITE

FIGURE 8.3 Palazzo Comunale, thirteenth–sixteenth centuries. Prato, Piazza Comunale.

While the construction of an independent lay civic space displaced the seat of governance definitively away from cathedrals or provost churches, such projects should not be seen as a secularization of communal authority. In all cases, the locus of sanctity had already shifted from its primary site, whether Santo Stefano in Prato or cathedrals elsewhere, with the formation of the mendicant settlements. In fact, although the locations of each of these new communal piazze ceased to be coincident with the original sites of the sacred authority in these towns, each formed the center of a new constellation of recent and successful mendicant churches. Without the mendicants, this new phase in communal urban representation would not have been possible, either conceptually or spatially. In the same way that the devotional possibilities, fraternity, and charitable activities of the mendicant tertiary orders had provided the self-confidence, social connections, status, and organizational skills for new citizens to rise to power in Prato's secondo popolo and its equivalents

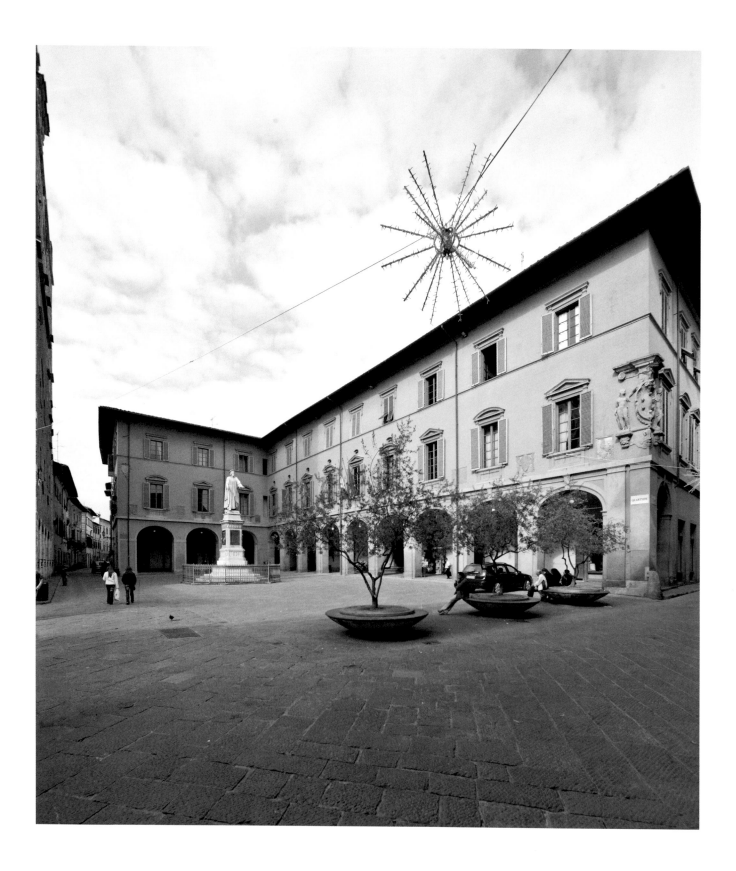

elsewhere, the scale, openness, and theatricality of mendicant piazze offered fresh models for constructing public spaces. At the same time, the construction of central congregational spaces in the middle of towns stemmed the dispersion of political power that the friars had originally fostered. The monumentalizing of mendicant piazze had already anticipated this development by defining and containing piety in the shadow of their richly articulated new churches. Communal builders in Prato and elsewhere continued this reactionary trend in political space, and even mixed mendicant with earlier, more conservative provost-church or cathedral-piazza models to define at once the dominance, the intended permanence, and the sanctity of their regimes.

The new communal piazza in Prato was therefore in good company when its builders fused traditions of church-building from the Piazza della Pieve with mendicant lessons. The Piazza del Comune was inflected toward Santo Stefano in both siting and design. Its siting was at a crossroad along the main street, the Via della Pieve, leading through the town to its terminus at Santo Stefano's south façade (see fig. 1.3). The most important link to its predecessor, so obvious that it would be easy to overlook, is that the new communal palace was situated at a piazza. The original Scampio occupied only a small portion of the new Piazza del Comune. Documentary and archeological evidence indicates that the commune purchased in 1285, for 2,200 lire, houses that occupied or flanked what is now the larger portion of the space, demolishing those necessary to expand the space to its current configuration.[8] The commune occupied and redesigned the buildings framing this space. The first after the palatium populi was the *domus nova comunis,* in use by 1287; within two years it was called the *palatium novum comunis.*[9] With it and a series of further purchased or rented structures, at a total cost of 2,200 lire, the commune of Prato surrounded three of the four sides of the new space with ground-level porticoes of stone and wood, and upper-level offices, residences for officials and meeting halls, even building a bridge to link the palatium novum comunis with the palatium populi.[10] Work continued on this new communal governing center up to the 1330s, when the commune purchased the southern, stone portion of the Casa Pipini. The resulting space was rectangular, terminated at its west end by three of the twelve arcades of the L-shaped domus nova comunis. The space replicated that of the original platea comunis, only that the arcaded south elevation of Santo Stefano became here the porticoed elevation of the long wing of the new communal palace, and its arches were echoed by those at the base of the palatium populi. The deliberateness of the design is clear from the rectangular plan of the space, and in ordinances regulating the height and termination of the piazza elevations, one of the earliest recorded in Tuscany. Already in October 1285, the same year of the expropriation and demolition of the

buildings within the space, the commune legislated consistent building heights and decorative merlons, with the design to be determined and supervised by the captain of the people.[11] Until this time there had been only three spaces so regularly composed: the cloister of Santo Stefano, the court of the palatium imperatoris, and the defunct platea comunis. The occupants of the new communal piazza appeared particularly intent in drawing parallels between their new and old spaces. Both new and old civic piazze ended with a communal meeting hall situated above a loggia. The status of one seemingly minor element in the new communal palace serves further to emphasize the will to link the spaces. By 1292, the new piazza had a column, called at the time a *morellas,* at its west end. In 1301, the commune erected another column by the site of the old palatium curie at the destroyed west end of the Piazza della Pieve. Afterward, by 1315, the name of the column in the new piazza changed from morellas to *colupnam.*[12] This change in name helped to disassociate the column from its original purpose, as a morella, or post, to which lost livestock found wandering in the city were to be tied. The 1315 document shows not only a change in its name, from morella to colupnam, or column, but also a change in its identity, no longer just according to its use, but now also according to its setting, which was considerably more flattering: "opposito scalis palatii Populi." The column ceased to be the lost and found for vagrant cows and goats and was instead linked to the honorific stair for public announcements by major public officials, and echoed the column marking the earlier presence of the town government.

The registration of the local tradition of civic authority merged with another memory, of religious space. The location of arcades on the two walls of the space flanking the terminal façade provided the space with a cloister reading, similar to that originally at the platea plebis and recently revived in the mendicant piazza of San Domenico. The term used to describe the space was *claudi,* deriving from the term *claustrum.* The number of arches on the palatium novum comunis was twelve, as at both the cloister elevations and the earlier plaza comunis. The new Piazza del Comune was now symbolically the city's main cloister, providing a common reference point for the matrix of religious spaces encircling it at the city's principal gates.

The new civic architecture and its commanding urban setting indicated the first deviation of the commune of Prato from the mendicant experiment. The imposing structures around the Piazza del Comune gave its cloister reading more the character associated with pre-urban monasteries or magnificent cathedral—or parish—chapters, than the broad and open sensibility of the friar spaces. The Piazza del Comune and its monuments continued to grow toward a past idea of rule during the final decades of the thirteenth century, when the government in-

vested tremendous resources and man-hours for its construction. The commune extended the Palazzo del Popolo and the Palazzo Comunale, interestingly enough linking them with the same upper-story bridge form that was outlawed for private families.[13] With this construction, the commune arrogated to itself alone the right to use this architectural sign of dominance and aggression.[14] The Piazza del Comune overlaid on its claustral reading that of another type of pre-communal, enclosed urban space, that of the tower-house enclave, occupying the entire zone at the center of the city just as the earlier consorterie had. The only formal differences consisted in the regulating of its plan and arcades and in the openness of passage in and out of the space. Unlike the consorterie, the commune did not have to protect itself from access by the public militia. Rather, the communal government needed to be able to reach any part of the city with its troops as directly and quickly as possible.

The process by which the commune started to abandon innovation and to return to tradition had such early roots that it even appears to have overlapped with the initiation of the period of communal innovation. Ordinances legislated by the secondo popolo indicate that during the same years that the popular forces in the communal assemblies were supporting the greatest mendicant expansion, the Guelph party and Guelphism were increasing their hold over the popolo. Similar trends were present in other city republics, such as Bologna, Florence, and Siena. Laws were used aggressively, such as the legislative acts, the "sacred and most sacred ordinances" of 1292 in Prato, which were modeled on similar ordinances in Bologna, and paralleled in Florence.[15] Ostensibly they were issued to stop the Ghibelline magnates' disruption of civic life. These ordinances were no more than refinements in the exercise of traditional authority, with the Guelphs using now the communal legislature to enforce violence and intolerance against their remaining Ghibelline enemies.[16] The popular regime put the common will in the foreground, but still treated the rights of individuals with the same fundamental disdain as the noble families they were repressing, by blocking such families from political participation and by truncating or razing their tower-houses. Clan partisanship had by no means been extirpated from the social identity of the Pratese, only transformed into another guise. Earlier, it had been determined by family and feudal bonds. Now it was according to profession and, as the popolo became fused with the Guelphs, according to party.[17] The centralization of the commune's spatial, symbolic, and institutional network for social control should therefore be seen as a sign not of its strength, but of its weakness. The more any communal regime resorted to legal or military violence to combat violence outside and within its walls, the more violence came to dominate the commune, whether in actual force, legal threats, or the image of a strong authority to back up such threats.[18]

The erosion of the values of the communal life espoused by the mendicants and of the dispersed urbanism that they introduced can be attributed to a variety of factors. One certainly lies in the presence of Guelphs and Guelphism in Prato. The Palazzo del Popolo, after all, inherited not only the title of palatium from the palatium imperatoris, but also the actual defensive structure of the Pipini tower-house. The military training and experience of the Guelphs provided easy means for the commune to combat magnate violence, offering swifter results than the pacifism of mendicant spirituality. Another factor may have been the novelty of the mendicant way of life itself, which had no precedent at the scale of an entire urban community. Architectural and spatial iconoclasm had a hard time competing in a society whose members had been raised on hieratic images of God the Father, Christ, and the Virgin, all carefully choreographed in the liturgy and hierarchical setting of the traditional church.

Perhaps most difficult to sustain was the individual moral empowerment associated with the mendicants' dispersion of sacred brotherhood and its imagery throughout the city. Even for elected officials willing to take on responsibility for their fellow citizens, such as the members of the secondo popolo, the friar morality was problematic. The very mendicant values that precipitated them to power simultaneously denied them the traditional means to celebrate their triumph. The grass-roots charity elicited by the mendicants, together with their entire ethic of individual moral action, even constituted a threat to the communal regime, so long as the regime depended on any of the traditional notions of power, of hieratic rulers with monopolies over munificence, judgment, and punishment.

The Revival of Piazza Santo Stefano and the Sacred Belt of the Virgin

The degree to which the commune remained dependent on traditional imagery of power is evident in the other major urban-scale building project it pursued from the end of the thirteenth century. The commune began to renew its involvement in the church and piazza of Santo Stefano. The city's reawakened interest in supporting the town's principal church after years of neglect is one of the most remarkable yet unexplained phenomena in the urban development not only of Prato, but of most other Tuscan communes. Prato and its neighbors did not cease to support mendicant institutions, but they did return to a policy of concentrating the largest share of building and urban planning, and of investing the most funds, in their principal local churches, whether the cathedrals of Siena and Florence, or the Pieve of Santo Stefano in Prato.[19] In the case of Prato, the multiplicity of mendicant churches and spaces could not, by nature, fulfill the evolving urban representational needs of the civic government. Work at the Piazza del Comune took care of the secular component of this need for centralized authority. The reno-

vated Piazza della Pieve provided a paired image of centralized religious authority powerful to complement, authenticate, and reinforce the civic governing enclave of centralized secular authority.

The propositura was only too happy to accommodate the changing representational needs of the commune. Albeit essentially ignored for the decades following the battle of Benevento, it had stubbornly continued to represent traditional religious power. For the same reasons that it had tried to block the Vallombrosans a century earlier, the propositura could never become reconciled with the mendicants, whose monument-free piazze, decentralized urbanism, and individual morality were dissolving the very grounds of centrality, territory, and authority on which the Pieve stood. The essence of the propositura, which had allowed it to achieve so much for the establishment of an independent Prato, was its tenacious battle to establish and then maintain a monopoly of religious authority in its territory. If any institution had the motive, experience, organization, and means to reverse the tide of mendicant values in Prato, it was the propositura.

The commune returned their patronage to the Pieve and its piazza slowly, only increasing its involvement as the success of this policy became evident and the reasons behind it more pressing. Between the destruction of the palatium curie, around 1267, and the first sign of communal interest, in 1291, the commune appears to have ignored the Pieve and its piazza completely. The latter was in a pitiful state, with much of its west end in ruins, and with a vast, gaping void strewn with rubble further to the west of the old piazza, in front of the church façade and around the baptistery (see fig. 6.5). In 1291 and 1293, the commune finally ordered the removal of debris from the older, fallen communal palace, as well as from the baptistery. The government's first construction at the piazza was by 1301, when a monumental column was recorded to have been placed near the site of the destroyed communal palace, marking the original western boundary of the space (see fig. 7.1).[20] The term "monument" is used here in its etymological sense: the commune was using it as a commemorative object. This act of memorializing would have been a paltry gesture if considered in the light of the government's refusal to rebuild its palace at the place, or even to mend the gaping west end of the piazza. However, the building that the column was meant to commemorate was not the communal palace. It was a structure that probably never existed: the house of one Michele Dagomari.[21] Michele merited recognition, even more than Prato's first communal government, owing to his legendary conveyance to the city, in 1141, of a narrow, long strip of cloth and leather, purported to be the Sacred Belt of the Virgin. According to legend, the Pratese merchant Michele fell in love with one Maria while trading in Jerusalem. Although her father was opposed to their marriage, the mother supported them and gave Michele, as a dowry, the Sacred

Belt of the Virgin, which had been passed down to Maria's father over generations. Michele set sail with his bride and the relic to Prato, where he arrived in 1141. On his deathbed, around thirty years later, he consigned the relic to the provost and the canons of Santo Stefano.[22]

For reasons that will be discussed later, the veneration of this relic did not develop until the last quarter of the thirteenth century, when the Madonna of the Sacred Belt was promoted as a new patron saint of the Pieve, and therefore of the city, by the propositura. Even the story of Michele and the Sacred Belt does not appear until more than one hundred years after his death. The column may just as well have served to create a fictional character Michele as to recall a historical Michele — no proof exists one way or another. Whatever the truth of the Sacred Belt may be, the column and the legend it consecrated marked a new relationship between the commune and the propositura, and registered, perhaps even catalyzed, a change in the religious and political life of Prato and much of Tuscany.

A specific event may have stimulated the commune's construction of the column commemorating the house of Michele and therefore the Sacred Belt. In 1298, the Papal Legate Matteo d'Acquasparta promulgated an indulgence pardoning the sins of any Christian who attended the presentation of the Sacred Belt at Santo Stefano in Prato.[23] This act and the response to it by the faithful throughout Tuscany and from further afield transformed the Piazza della Pieve from a space representing the propositura within the city to one representing the commune externally. The commune erected the column around this time, certainly by its mention in 1301, either in recognition of the popularity that the Belt already had in Prato, or in response to the 1298 indulgence.

An even more significant sign of the commune's support of the cult is securely dated to the same year as the first mention of the column. The commune ordered the construction of a temporary pulpit of wood outside the church, at the intersection of the south façade with the campanile.[24] The door opening from the church interior to the pulpit is still visible today (see fig. 4.12). This pulpit was erected and removed before and after the principal celebrations of the Sacred Belt, on Christmas, Easter, the Feast of the Assumption, and the birthday of the Madonna on September 8. It allowed the number of pilgrims that could attend the presentation of the Belt to be more than doubled, by facilitating the demonstration of the relic both inside and outside the church.

The display of the relic to crowds of pilgrims outside the church, from the exterior pulpit, not only allowed the propositura and commune to increase the renown of the Belt. It also allowed the church to use its existing space and new relic to begin to compete with the mendicants, who were at the time entertaining large crowds in their piazze with their famous preaching and with their peniten-

tial processions. The ability of the propositura to compete with the friars' novel outdoor spectacles was, however, limited by the infrequent use of the pulpit and by its location. Only during Christmas, Easter, the Assumption, and the weeklong fair of the Virgin in September did the propositura display the Belt outside, and then only to crowds in the church and within the original space of the piazza.[25] Although a large space existed in front of the church, albeit still in disarray, the temporary pulpit by the campanile was not visible from there.

The commune further increased its patronage of the Sacred Belt after another event, fourteen years after the 1298 indulgence. In 1312, Muschiattino, a canon from Pistoia, tried to steal the Belt but failed.[26] According to later accounts, he was caught by a mob, his hands cut off, his body drawn and quartered and then burned outside the city walls, by the banks of the Bisenzio. As a lesson to any potential thieves, his severed hands were placed against the east portal of the south façade, where some claim to see the red stains even today.[27] The story of the theft and its punishment was frescoed on the walls inside the nave of the church by the Pratese painter Bettino in 1313.[28]

The violent emotions roused by the attempted theft of the Belt made it clear to the commune how much the citizens valued the relic, and therefore how valuable the Belt could be as a focal object of civic identity. The government thereupon made the Sacred Belt the center point of its monumental building policy. The day after the capture and disembodiment of Muschiattino, the commune legislated the construction of a more secure chapel to house the Sacred Belt.[29] In the process of the deliberations and preparations for the chapel, the project developed into an entire transept addition to encompass the new chapel and altar of the Sacred Belt, at the central apse (fig. 8.4).[30] The construction of the vast transept with its four side chapels has generally been attributed to Giovanni Pisano.[31] The addition greatly enlarged the size of the church, and therefore the capacity for the indoor display of the Belt. It furthermore situated the chapel of the Belt conveniently close to the outdoor place of display, at the temporary pulpit by the campanile.

The Civic Legislation of Sacred Space

Though investing heavily in the church with the new transept, the commune still delayed confronting the gaping wound in the cityscape to the west of Santo Stefano. They did not take action until after the papacy gave its second boost to the reputation of the Sacred Belt. In 1318 Pope John XXII formally recognized the Sacred Belt as authentic.[32] As with the earlier indulgence by Matteo d'Acquasparta, this papal recognition encouraged more pilgrims to attend the presentation of the relic. The density of the crowds were recorded in Duccio di Amadore's 1340 *Cincturale*, in which the author testified that the "piazza was as tightly packed as

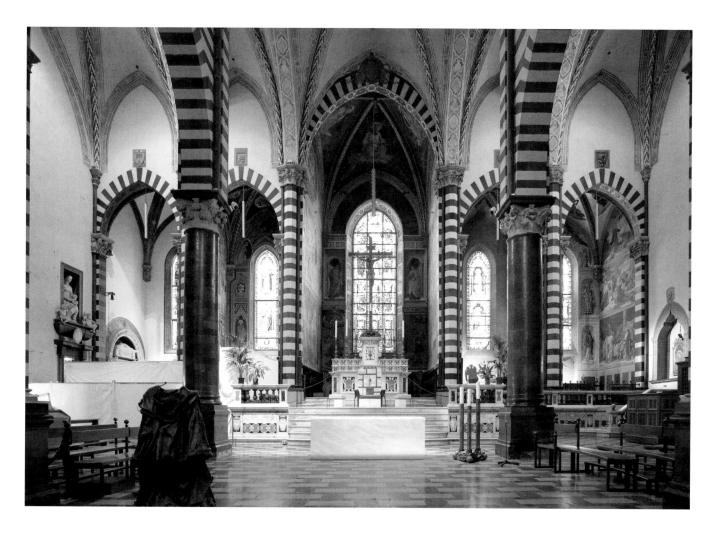

wheat in a mature ear, so full of people that were it to rain, no water would reach the ground, and scattered seeds would never touch the earth."[33] By 1325, the commune moved the location of the wooden outdoor pulpit from the corner by the campanile to another setting, at the southwest corner of the church (see fig. 7.1).[34] The place where the pulpit was situated is still visible today, at the discolored stone beneath the arch just behind the later pulpit of Michelozzo and Donatello (fig. 8.5). This was originally the corner of the church, until the new façade of the late Trecento extended the south elevation slightly to the west. The new location of the pulpit allowed far more people to see the presentation, as it made the Belt visible to spectators at both the south and west of the church. The new but still temporary pulpit was linked to the chapel of the Sacred Belt inside the transept by a temporary *via coperta* that is first described in detail in 1330. The document specified the construction of this portico as an enclosed wooden structure so as to hide the priests carrying the Belt. It is unclear where the via coperta was located.

FIGURE 8.4 Giovanni Pisano (attr.), transept chapels, early fourteenth century. Prato, Santo Stefano.

OVERLEAF

FIGURE 8.5 South elevation, west terminus pulpit location, 1328. Prato, Santo Stefano.

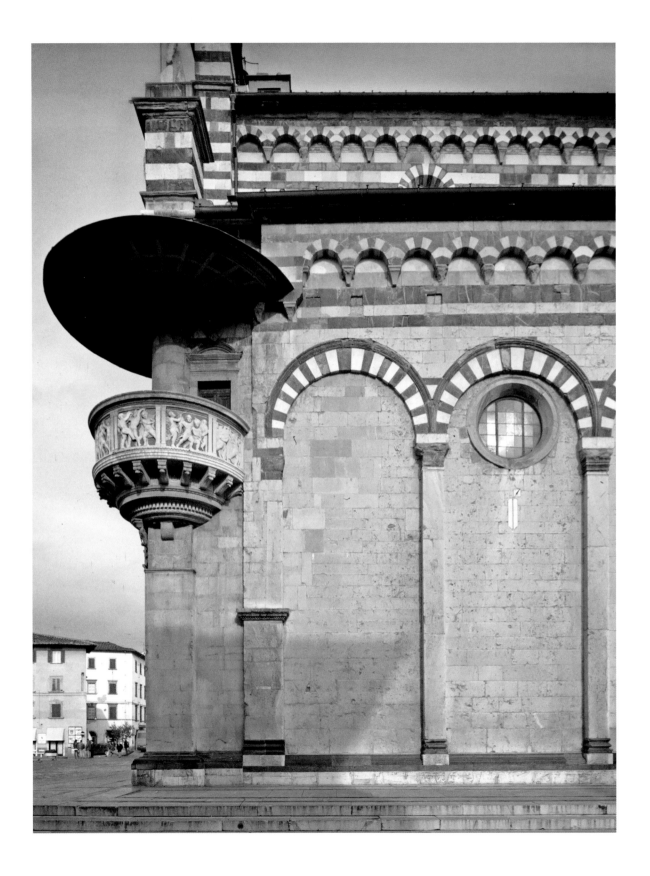

It is probable that the walkway was inside, elevated to avoid obstructing passage through the two portals on the south wall.[35]

The 1330 document furthermore required that the wooden pulpit be rebuilt in marble with relief scenes depicting the story of the transfer of the Belt to Prato. These reliefs may be the same as those located at the altar in the crypt of Santo Stefano (figs. 8.6–8.9).[36] The marble construction of the pulpit indicates the commune's intention to make the new setting of the Belt permanent.

The expansion of the setting for the display of the Sacred Belt to the area west of Santo Stefano left the government no alternative but to remedy the west end of the space. The piazza was in fact in poor condition, with its west end destroyed. The entire space in front of the church had already been freed from any structures as far as the current Via Carraia, and possibly to Via Valdigora and Via Serraglio, with the removal of magnate houses, and with the late thirteenth-century razing of the original baptistery of the Pieve, which had been relocated to the corner of the Vicolo dell'Opera della Pieve, to the south of the new pulpit location.[37] The space was further opened, to the north, with the removal of the 1178 city walls after the beginning of a new circuit of walls, in 1313.[38]

FIGURE 8.6 Niccolò del Mercia, reliefs with story of Sacred Belt: *Christ Crowning the Virgin*, 1355–60. Prato, Crypt, Santo Stefano.

FIGURE 8.7 Niccolò del Mercia, reliefs with story of Sacred Belt: *Thomas Giving Away Belt Before Voyage to India*, 1355–60. Prato, Crypt, Santo Stefano.

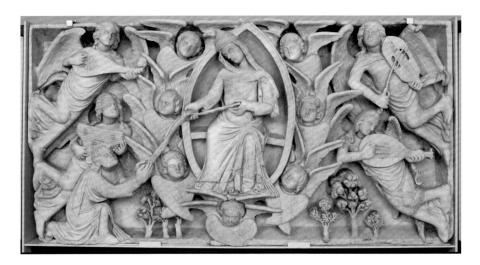

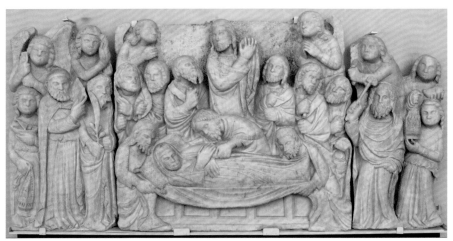

FIGURE 8.8 Niccolò del Mercia, reliefs with story of Sacred Belt: *Virgin Presenting Her Belt to Thomas,* 1355–60. Prato, Crypt, Santo Stefano.

FIGURE 8.9 Niccolò del Mercia, reliefs with story of Sacred Belt: *Dormition of the Virgin,* 1355–60. Prato, Crypt, Santo Stefano.

The commune was meanwhile developing a stronger interest in improving the siting of the presentation of the Sacred Belt during the 1330s. Legislative records at this time indicate that the governing council was assuming more control over what it called the *demostratio Cinguli.* The general council elected both lay and religious functionaries to participate in the ceremony. It furthermore stipulated that the Council of the Eight, the *gonfaloniere,* and the podestà all swear piously to uphold the regulations regarding the presentation of the Belt.[39] This process of legislative institutionalization, which culminated in the "statuta et ordinamenta loquentia super demonstratione Cinguli Virginis Marie observare," was paralleled by the integration of the presentation in public space, and, midway through the decade, by communal support for the improvement of that space. On January 26, 1336, the commune finally admitted that the space was in horrific condition, describing it as "too large and deformed" ("nimis mangna [*sic*] et deformis").[40] These words provided the justification for an ordinance requiring that the piazza be rebuilt. The

reconstruction of the Piazza della Pieve was fully elaborated in a further ordinance on February 10, and supplemented on June 16, 1336.[41] These ordinances show a complete rethinking of all aspects of the piazza, including its plan, the aesthetic quality of the elevations, the financing of the work, and the time frame for construction. However, unlike all other projects improving the setting of the Sacred Belt, there is no mention of anything to do with the Belt, the September Feast of the Virgin, or even the Virgin herself. One indication that the piazza was intended to complement the presentation of the Belt was the passing of the ordinances only a few years after the decision to make the corner pulpit a permanent fixture. There are also certain aspects of the ordinances themselves, whether a consistent emphasis on aesthetic quality, the unusual plan that the ordinances prescribe, or the unusual means for financing the work, which appear to connect the design of the space to precedents in religious architectural and piazza design. Architectural models include the interior of Santo Stefano and its cloister, and the interior of San Francesco, and the ordinances regulating mendicant church design. Piazza models include the earlier Piazza della Pieve and such contemporary mendicant spaces as Piazza San Domenico, Piazza Sant'Agostino, Piazza San Francesco, or Piazza Santa Maria Novella and Piazza San Giovanni in Florence. The only major nonreligious squares in the region where similar ordinances existed were Prato's own Piazza Comunale and Siena's Campo, both of which were designed based on religious-architectural and spatial models; the same could be argued for other recently designed civic piazze in other regions of Italy, whether at Assisi, Gubbio, Venice, or Bergamo. Detailed comparison to some of these models will help to determine whether the lay commune of Prato redesigned the Piazza della Pieve within a language of church architectural and spatial composition, expanding the capacity and sacred reading of Santo Stefano into its adjoining piazza.

The Piazza della Pieve legislation regulated quite specifically the plan geometry and elevational articulation of the space. The resulting layout produced a large, rectangular piazza to the west of Santo Stefano, contiguous with the older space to the south of the church (see fig. 7.1). The new and old spaces together formed an overall L shape, hinged at the new pulpit of the church, which faced both equally. The ordinances also prescribed a small space broadening the access street from the west, directly opposite the church façade, today's Largo Carducci (fig. 8.10).

The building legislation furthermore regulated the height of the lots in relation to their widths and location. Lots on the Piazza della Pieve facing the Duomo had to be either ten or twelve *braccia* wide (about 5.3 to 6.4 meters), except those at the corners of Largo Carducci which could only be twelve *braccia* wide. These houses on the piazza were to be at least two stories, "of high and of beautiful effect." To ensure the latter, the ordinances required that each of these dwellings

FIGURE 8.10 West piazza elevation, axial view, 1336 and after. Prato, Piazza della Pieve.

be constructed on "beautiful and large pilasters," at least six braccia high (about 3.2 meters), made of "large stone blocks and cornerstones...and...mortar" (figs. 8.11–8.14). All houses facing the new piazza could have balconies starting at least twelve braccia above the ground.[42] The other buildings, facing Via Carraia and the adjoining streets, could be one story high but nonetheless had to be "tall and spacious," and also built on "pilasters." The "pilasters," or piers, were linked by masonry arches rather than by wooden trabeation.[43] The height given in the documents corresponds to the apex of arches rather than to their springing line, as measured on the arches still visible today. The bay proportions generated by the legislation were roughly square on the larger twelve-braccia lots, and more vertical on the ten- and seven-braccia lots. The application of the legislated six-braccia-pilaster module to the entire arch height, and not to the piers alone, suggests that the term pilaster, which was used in the deliberations over the piazza design, stood for arcade. It is not clear whether the arches were intended for individual shopfronts or for a continuous vaulted passage. Either case would have increased the capacity of the space for commercial activity during busy times, such as at the September Feast of the Virgin, which was the city's annual market fair. If the arcade did provide a covered passage it would have removed commercial activity from the actual elevations of the piazza, setting it back to the interior wall of the arcade. Such an intention would have been consistent with a general tendency of the Pratese regime at the time to displace from the piazza activities considered unseemly, such as gambling, prostitution, the conveyance of livestock, or even the sale of meat and poultry.[44]

The appearance of the piazza was important enough to the commune that it took steps to enforce the proper and timely construction of the new houses facing it. All codes were enforced with penalties, of one hundred lire if the houses on the piazza were not "tall and beautiful" enough, and of fifty for the remaining structures on the secondary streets of the project. The ordinances were furthermore enforced with specific minimum cost and maximum time requirements that, like

FIGURE 8.11 West piazza elevation, oblique view, 1336 and after. Prato, Piazza della Pieve.

the penalties and the stipulations for plan, height, and elevations, varied according to location. The most expensive structures were those across from the church, which were also the largest. Each had to be a minimum of 200 lire. Builders at these lots were encouraged to extend their lots all the way to Via Carraia and to build two contiguous structures.[45] The minimum costs for these builders would therefore have been 300 lire: 200 lire for the house facing the "more beautiful" piazza, and 100 for the other overlooking Via Carraia. The two most expensive buildings were those at the corner of Largo Carducci and the piazza. The cost to build on these lots was 400 lire, as both overlooked three spaces: the main piazza costing 200 lire, Largo Carducci and Via Carraia for 100 lire each.[46] The smallest structures, seven braccia wide and one story high, had to be built at an expense of at least 100 lire.

The time frame for construction depended on the cost, with one year per 100 lire. However, within four months of the contract date each builder had to have completed the "pilasters" facing the street up to the top of the ground floor. This requirement shows how important the arcades were in the project: it ensured that they would be visible and open for use as soon as possible.

A further aspect of the 1336 ordinances indicates that the construction of the Piazza della Pieve involved an ingenious exchange between the commune and prospective builders: builders received the actual land at no expense. In exchange

FIGURE 8.12 West piazza elevation, pilasters from 1336 ordinances, 1336 and after. Prato, Piazza della Pieve.

FIGURE 8.13 West piazza elevation, arches from 1336 ordinances, 1336 and after. Prato, Piazza della Pieve.

FIGURE 8.14 West piazza elevation, arches from 1336 ordinances, 1336 and after. Prato, Piazza della Pieve.

for a free lot at the city's most prominent public space and assurances that the space would be a beautiful one, they had to provide the capital to build the structures within the time and design framework dictated by the commune. The unifying elements for the entire project were the strict geometry and the regular modules of lots and arcades, which would have given a rhythmic cohesion to the building elevations throughout the area of intervention. Within this overall unity, the buildings and arcades across from the pieve were set off as particularly "grand and beautiful." The emphasis on the beauty of these structures in relation to the church in the details and overall conception of the ordinances make it clear that the space was designed to complement the monument, and even to reflect its beauty.

The immediate response to the piazza legislation indicates its popularity. Already by January 18, 1336, even before the second set of ordinances was drawn up, two persons had chosen to build a house on the two most prominent lots on the piazza, at the optimal corner sites, each worth 400 lire.[47] The ones to accept the offer were Donatus Nardi from Florence, residing in the quarter of Porta Gualdimaris in Prato, and Nangiernus dom. Lapis de Frescobaldis, at the time living in the quarter of Porta Capitis Pontis, near the Castello dell'Imperatore. The early success of the ordinances, and of these lots in particular, may have been due to the combination of financial incentive with aesthetic and, as we shall see, religious appeal.

The Cooption of Mendicant Forms, Urban Metonymy, and Building *ad sanctum* at the New Piazza della Pieve

The justification of the legislation cited above, that the existing piazza was "too large and deformed" ("nimis mangna et deformis"), indicates that the Pratese legislators had in mind some norm for the size and shape of piazze in general, to which the Piazza della Pieve failed to conform at the time. Local sources for such a norm were the new mendicant piazze in Prato, particularly the Piazza San Francesco, the Piazza Sant'Agostino, and the avelli-lined Piazza San Domenico. The most immediate source was the original platea plebis, the memory of whose geometry was maintained in the column of 1301, which had been refurbished as recently as 1333.[48] The designers of the Piazza della Pieve took over formal aspects from all of these spaces. The appropriation of these norms was more than a blind adaptation of fungible models. It was a means of outdoing the other magnificent spaces in the town. At the same time, it provided a way of recording these rival or antecedent spaces and the institutions associated with them, both present and past, in the form of the new space.

On the simplest level, the new Piazza della Pieve imitated the plan geometry of Prato's other piazze. By 1330 the Piazza San Francesco and Piazza Sant'Agostino

were perfect rectangular spaces, just like the original, destroyed platea plebis, with the difference that the two mendicant piazze faced the front, rather than side façades, of their respective churches (see figs. 7.3–7.8). The Piazza della Pieve was therefore similar in its orientation to both. It was also nearly the same size as the Piazza San Francesco. Both Piazza Sant'Agostino and Piazza San Francesco, however, lacked at least one notable characteristic of the new piazza, its L shape, with the space flanking two sides of the monumental structure. The one mendicant piazza with a similar form, already noted above, was Piazza San Domenico, the L shape of which fronted the west and north façades of the church (see figs. 7.9–7.12). The other piazza in Prato that had an L shape with an emphasis nearer to that of the new Piazza della Pieve was the most recent representational space to have been built in the town, the Piazza del Comune, which faced roughly equally both the front and the side of the palatium populi. The normative force of this space would have been particularly strong for the legislators at the time, not only as this was the locus for their deliberations, but also because during these very years, in 1336, they were adding a new portion to Palazzo del Popolo, so that its east façade extended all the way across the facing space (see figs. 8.1–8.3).[49]

The plan for the new Piazza della Pieve synthesized these local piazza precedents, emphasizing at its site the frontality and scale of Piazza San Francesco, Piazza Sant'Agostino, and the destroyed platea plebis, while adapting the L shapes of Piazza San Domenico and the new Piazza del Comune. The justification introducing the legislation and the new plan design of Piazza della Pieve emphasized the same principles of geometry and scale that were clearly present at these neighboring piazze. The resulting space surpassed all of its precedents in scale, and was rivaled in its regular arcaded appearance only by Piazza del Comune.

While the Piazza della Pieve may have been intended to outdo other important civic spaces, it also recalled them and their associated institutions, including the original, destroyed space by the Pieve. The continuous reminder of the geometry of the original platea plebis with the construction of the column at the end of the original piazza would thereby have been even more than an analogue meant to recall that space. The figurative operation was closer to the poetic device of metonymy, or the part standing for the whole. Metonymy was indeed common practice in medieval architecture. The use of imperial Roman spoils at the Cathedral of Pisa, for example, at once declared the triumph of the Christian church over antiquity, provided proof for the connection of the Pisans to an ancient past, and thereby justified the Christian imperial aspirations of the Pisans inscribed on the tablets on the front façade. Recent restorations of the Arch of Constantine indicate that this same practice was common even during the Roman empire, with later emperors grafting their images and inscriptions onto the monuments of their

predecessors, at once connecting themselves, tangibly, to the imperial tradition and asserting their primacy in that tradition.[50] Even the Christian cult of the saints functioned metonymically, embedding fragments of saints in church reliquaries and altars, sometimes even at foundations, and thereby communicating the presence—literally and not metaphorically—of the saint to the entire structure. The roots of architectural metonymy in architecture on the Italian peninsula are fundamentally animistic, with buildings sustaining not just memories but active spiritual presences of deities, saints, and institutions, capable, like patron saints, of enhancing the fortunes of the structure.

The capacity of urban spaces to function metonymically, even animistically, has been little studied. Richard Krautheimer discussed such a phenomenon when he elaborated architectural iconography.[51] Günter Bandmann similarly interpreted the reuse of forms as conveyors of meaning.[52] The best analysis to date of this phenomenon in Tuscany is by Wolfgang Braunfels, who noted the frequency with which towns duplicated, for instance, the number of hills or names of churches from Rome in their own topographies.[53] The function of these architectural copies, iconographies, or symbols—however one may call them—was in most cases to authenticate a new institution by imitating the appearance and siting of a traditional one. The process was one of synthesizing a believable past. The examples of architectural iconography in Prato discussed in earlier chapters similarly brought antique, early Christian, and even Pisan, Florentine, and Pistoiese structures and forms to Prato, helping to authenticate the town's novel institutions and territorial claims. I am suggesting here that our twentieth-century interpretation of these formal borrowings fails to penetrate the more magical, even animistic intent of the Pratese builders and their counterparts elsewhere in medieval Europe. In the case of Prato, every instance of architectural borrowing discussed earlier functioned less symbolically than metonymically, embedding active presences of ancient empire, early Christian brotherhood, and regional territorial hegemony into the monuments and spaces of Prato. I am further positing that the Pratese did not limit themselves to external building cultures. They built upon their own architectural and institutional traditions as well. The Pratese had long engaged in architectural and even urban metonymy in their practice of incorporating aspects of the original platea plebis and plaza comunis into all of the town's major spaces, first at the mendicant piazze, then at the new Piazza del Comune. These copies to a certain degree even preyed upon their source, as the Pisans did with their imperial spoils. Throughout the process of embodying aspects of the platea plebis in other spaces during the late thirteenth century, the Pratese neglected, even spurned, the physical state and institutions of the platea plebis. Now, with the plans and forms returning to their original home, this process came full circle. The column and

the arcades of the new buildings facing the west façade of Santo Stefano embedded both the plan and the arcading of the original piazza, but at the same time incorporated more recent associations of the mendicant and communal piazza. The space and its institutions could now initiate a new existence.

The full power of architectural and urban metonymy to restore the Piazza della Pieve did not rest in building a fictive history based upon important sites in the history of Prato and Italy. The Pratese did not limit themselves to physical remains of a documentable past in order to revive the sacred center of their town. They even synthesized histories and places that may never have existed. The case in point is the erection of the monumental column at the boundary of the original platea plebis. Archeological and documentary records do indeed prove that the old piazza ended there. The absence of any contemporary documentation of Michele's existence, let alone that of his house, introduces the possibility that the column may have been a way of assigning a place in the historical landscape to a fictitious person created by the commune and the propositura as part of their fabrication of the legend and cult of the Sacred Belt. The column served the same purpose as the narrative scenes carved in stone on the new permanent pulpit at the southwest corner of the church, directly adjoining the column. The fictional history of the transport of the Belt to Prato by Michele, depicted on the pulpit panels and the column commemorating the imaginary house of Michele, mutually confirmed one another and the story they told. The legendary transfer of the Belt was also depicted on the predella of a polyptych commissioned from Bernardo Daddi by the commune in 1337 and located at the new main altar housing the Sacred Belt at the central apse of the transept (figs. 8.15, 8.16), and was versified in Duccio di Amadore's *Cincturale,* a hagiography of the Belt from 1340. The column and the variously depicted and recounted legends of Michele would have encircled the Pratese with a web of objects, images, and histories, confirming beyond doubt the authenticity and potency of the Belt and its foreordained arrival in Prato.

The various normative spaces described above, whether competitive or metonymic, account for all but one aspect of the scale, plan, and elevations of the new Piazza della Pieve: the peculiar appendage to the west, Largo Carducci, axially aligned with the façade, portal, and nave of Santo Stefano opposite it (see figs. 7.1, 8.10). No piazza in Prato or the region has a form or orientation in relation to its facing monument that resembles the configuration of Largo Carducci. It was nonetheless quite explicitly part of the piazza design, with its layout and location specified. The Largo's location opposite from and aligned with Santo Stefano suggests a connection with the church, similar to that of the "bigger and more beautiful" arches and houses lining the west wall of the new piazza and framing Largo Carducci. The siting and monumental framing of Largo Carducci by these

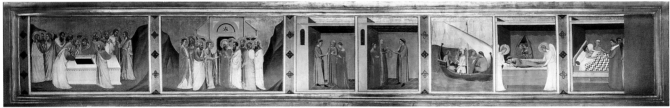

FIGURE 8.15 Bernardo Daddi, Virgin presenting
Sacred Belt to St. Thomas, 1337–38. New York,
Metropolitan Museum of Art, Lehman
Collection.

FIGURE 8.16 Bernardo Daddi, predella showing
The Story of the Sacred Belt of the Virgin, 1337–38.
Prato, Museo Civico.

grander houses were consistent with the space's use as the processional entry to the space directly in front of the church. Up to today, the Largo has served both as a triumphal entry and as a theatrical set for the spectacular final leg of the procession through the entire city to the west façade of Santo Stefano, during the veneration of the Sacred Belt on September 8 (see fig. 1.4). At Largo Carducci, each group participating in the procession separates itself from the parade and approaches the clergy and communal officials sitting in front of the church portal, whom the marching group honors with individual acrobatic, dance, or musical acts.

The triumphal entry reading of Largo Carducci was supported by the original series of arches flanking its passage through the west wall of the piazza. This reading is reflected in the west elevation of the church, at the main portal itself, and even above it, where the central, portal-like attic window is flanked by two smaller windows (see figs. 4.3, 4.4). The hierarchic importance of the upper central window is emphasized by its width, its centrality, and the apex of the pediment extended above it. This same hierarchical bias is achieved in the plan of the west-piazza façade, where the indentation of the Largo Carducci repeats the centralizing emphasis of the Santo Stefano attic temple-front.

However, it would be a mistake to stop at the façade of Santo Stefano in this quest for the formal model for Largo Carducci. The extra scale and cost emphasizing the corner sites of Largo Carducci was paralleled within the church, at the chapels of the transept addition, which was still under construction at this time (see figs. 7.1, 8.4).[54] The chapels on each side of the sanctuary and high altar were accentuated by height, with flanking piers taller and broader than those framing the remote side chapels, by the more elaborate decorative programs painted in them, and by their greater cost.

The repetition of the church design at the west piazza is equally apparent in plan. The greater depth of the main chapel corresponds to the plan indentation of the west-façade wall provided by Largo Carducci. The parallel extends to the individual transept chapels, which are repeated in the house lots. In this light, the prototype for the otherwise unexplainable form of Largo Carducci, as well as for the unusual disposition of major and minor lots on either side of it, was not another piazza but the new transept of Santo Stefano.[55]

The formal connection between the plan and elevations of the transept of Santo Stefano and the urban design of the new west wall of the piazza is underlined by the similar ways that the transept chapels and piazza house lots were funded and built. The chapels were laid out according to a predetermined plan by the architects of the church—not coincidentally, employees of the commune, as members of the Opera della Pieve. Individual families were invited to patronize these chapels, following a practice popularized at mendicant churches. The families that chose to do so, such as the Inghirami, the Manassei, and the Vinacessi,

were among the wealthiest and most powerful of the town.[56] They paid for a priest to say prayers for their souls at the chapel *in perpetuum,* and, more important in this context, for rights of entombment in the chapel and for the furnishing and decoration of the chapel within a predetermined framework.[57] This is practically the identical funding scheme as at the west wall of the piazza: each family filled in house lots just as their counterparts filled in a chapel. The exchange in the transept was for a chapel and burial space nearest the main altar and the Sacred Belt, in return for the families' donations to the church for both decorating the chapel and endowing a chaplain.

The parallels between the piazza and the transept chapels therefore extended from architectural form to their regulated design codes and financing, and suggest that the communal legislators and designers of the piazza modeled their novel scheme largely on church design and financing practices that had been introduced by the church and chapel construction of the friars, and had recently been taken over by the communal building workshops at the new transept of Santo Stefano.

By relying on the "norm" of the church interior, the commune established perhaps the most significant metonymic connection between the new piazza and a precedent space, imparting to the piazza the same sacred quality as the most sacrosanct place in the city, the sanctuary and chapels housing and flanking the Sacred Belt of the Virgin. At the same time, the repetition and amplification of the indoor setting of the Sacred Belt by the magnificent outdoor piazza served the same function as the column and exterior pulpit, to make the cult seem more credible. The mutual authentication of the architectural form and metonymy of the two spaces was further reinforced by the demonstration of the Belt itself, which first occurred at the transept, and then outdoors, in front of Largo Carducci.

The parallels between the new transept and the redesigned west piazza, in form, financing, and function to authenticate the cult extended as well to one of the religious uses of the two spaces, as a means of assuring the salvation of the builders by locating themselves *ad sanctum.*

The fundamental purposes of individual families in patronizing the chapels of the transept were their receipt in return of masses to be said for them in perpetuum and a burial space by the saint, or ad sanctum. Both benefits allowed the families to convert their wealth into salvation. By paying for prayers until the end of time, they assured themselves that the living would intercede to free them from purgatory,[58] however many years it would take—that is, however many sins they had committed. By burying themselves near the remains or a relic of a saint, in this case by the Sacred Belt of the Mother of God, they furthermore assured themselves of the intercession of the Virgin at the Day of Judgment. This was based on the ancient Christian practice of burial ad sanctum, namely, that those nearer to

FIGURE 8.17 Milieu of Meliore and of Coppo di Marcovaldo, *Angel Leading Arisen to Salvation*, detail of ceiling, c. 1260–70. Florence, Baptistery.

a saint would be able to avail themselves more readily of the saint's assistance in leading their resurrected bodies to heaven than those rising from tombs farther from saints.[59] The literal intercession of saints for those buried ad sanctum was a familiar theme in depictions of the Last Judgment since at least the early twelfth century, with recent and contemporary treatments in the Florence Baptistery, at Santa Maria Novella, and at Pisa's Camposanto (figs. 8.17, 8.18). In each of these images, the dead are rising from their tombs in the ground. The blessed reach for and receive the assistance of angels or saints and are drawn up to heaven, while the damned are summarily dragged by devils down to hell (fig. 8.19). The practice of tombs and burial chapels ad sanctum was popularized by the mendicant orders through their newly introduced use of transept chapels, such as at Santa Croce (fig. 8.20).[60] The family chapels of Prato's San Francesco, for example, were copied at Santo Stefano, both in the new transept and beneath, in the vaults of the church (see fig. 7.7).

The transfer of the notion of building ad sanctum from the transept chapels to the church piazza may have been conditioned by the recent popularization of building tombs ad sanctum not only within churches, but also along church piazze, such as at Prato's San Domenico. The avelli of San Domenico may indeed have served as the transitional practice linking the building of burial chapels inside churches, such as Santo Stefano, and the design, construction, and funding of the outside home lots at the Piazza della Pieve. As noted earlier, avelli were also designed by contracts. The significance of such contracts should be clear: contracts stipulating width, height, form, material, and even time framework for each *avellus* along piazza San Domenico may have been a model for the ordinances regulating the arches and house lots at Prato's Piazza della Pieve only twenty-two years later.[61] The legislators of the Piazza della Pieve would have been aware of this precedent through the involvement of many of them and of members of the city's building opere in the Dominican third order and in the building opera of San Domenico. Furthermore, avelli were still being built, and therefore building regulations like the above were still being included in contracts, even after 1333, when one of the most elaborate avelli sculptural reliefs, showing the Annunciation of the Virgin,

FIGURE 8.18 Nardo di Cione, *Ad Sanctum: Saints Leading Arisen from Grave*, detail of *Last Judgement*, c. 1357. Florence, Santa Maria Novella, Strozzi Chapel.

FIGURE 8.19 Nardo di Cione, *Ad Damnationem*, detail of *Last Judgement*, c. 1357. Florence, Santa Maria Novella, Strozzi Chapel.

was executed by Giovanni di Agostino.[62] The avelli contracts provided a source for the imaginative piazza design codes. The legislators were offering families an opportunity to build themselves earthly dwellings within a predetermined framework, just like the final dwelling places of the avelli tombs. The avelli regulations also support a religious interpretation of the piazza ordinances and the resulting west-piazza wall. Patrons in both cases were encouraged to build "monuments" on religious piazze, and therefore ad sanctum. The avelli provided the building and sacred practices that facilitated the transposition from the tradition of ad sanctum at the transept chapels of Santo Stefano to the house lots across the new church piazza.

The new Piazza della Pieve provided the commune with a primary religious site that paralleled the centralized image of secular authority that the commune had established at the Piazza del Comune. The rebuilt transept, piazza building ordinances, and cult of the Sacred Belt benefited at the same time the propositura, allowing it to regain its religious status in the same way it had originally established it, with a mixture of novelty and tradition. The designers of the Piazza della Pieve

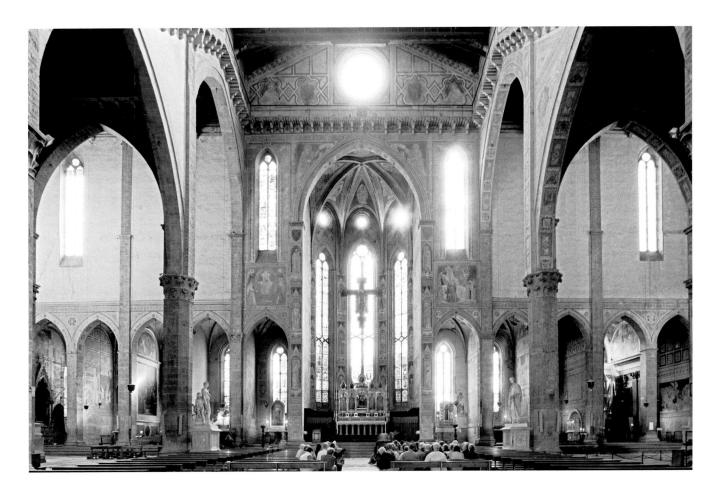

FIGURE 8.20 Arnolfo di Cambio (attr.), transept chapels, thirteenth century. Florence, Santa Croce.

borrowed forms and practices from the mendicants but gave them a different meaning. The friars used interior funerary chapels, exterior avelli, and their piazza settings as part of their general mission, which was to encourage a strong sense of self-discipline, responsibility to the group, and charity among one another, in their lay brothers and their congregations, throughout the city. The piety implicit in the public veneration of the Sacred Belt or in the building ad sanctum by the relic, in the church or on the piazza, was, in comparison, a contradictory one. The ordinances encouraged a certain degree of individual initiative, investment, and activity. On the other hand, the incentive of building ad sanctum encouraged a passive acceptance of the power of the church to confer salvation. Through the imitation of friar innovations in the new Santo Stefano transept and its mirroring in the rebuilt Piazza della Pieve, the propositura and commune, in alliance, began to subsume and smother the fraternal mendicant ethic with a more paternal religious morality, focused on the cult of relics. Architecture, public space, and the Belt of the Virgin played central roles in the restoration of traditional images of God, church, and state in Prato.

The Significance of the
Virgin, Her Belt, and Its Setting
in Prato

Active and Passive Piety

The previous chapter documented the return of communal patronage to the Piazza della Pieve consequent to the rise in the cult of the Sacred Belt. The general notion behind the cult of relics, ad sanctum, reinforced the formal extension of the church onto the piazza facing it. The question remains as to why this particular relic became so popular in Prato during the late thirteenth and fourteenth centuries that it could justify the construction of a new transept and piazza. A combination of the peculiar qualities of the Belt itself, local circumstances, and aspects of the Christian cult of saints transformed it from a long, narrow strip of cloth and leather to a divine emanation. By the time of the reconstruction of the Piazza della Pieve, the Sacred Belt of the Virgin was capable of winning the adoration of the Pratese and of unifying them religiously and politically around the Pieve. The perceived religious and social utility of the Belt was not a historical accident any more than the legendary arrival of the Belt in Prato. Both brought a new popularity to the Pieve. This leaves open the possibility, to be considered below, that the Belt was invented and its cult developed quite self-consciously by the propositura as a means of reestablishing the Pieve's central status in the life of the commune.[1]

The most important aspect of the Sacred Belt was and remains the saint to whom it pertained, the Virgin, who surpassed all other saints in popularity during the late communal period.[2] The cult of the Sacred Belt allowed the Pieve to supplement its traditional patron, St. Stephen, with the Virgin, and thereby to return the Pieve to its earlier role as the focal place of urban piety, displacing the mendicants. As discussed in the previous chapter, the propositura was successful in promoting the cult of the Virgin and her Belt by adapting practices developed by the mendicants themselves. These practices included the design and funding of the transept plan, chapels, avelli, and piazze, which the propositura was able to achieve with the help of the commune. At the same time, the propositura was

DETAIL: FIGURE 8.15

imitating the mendicants in developing lay brotherhoods and celebrating Marian feast days, whether the Assumption or the birthday of the Virgin.

The propositura used these new forms of religious piety as media to sustain far older practices and religious ideologies that were fundamentally contradictory to the apostolic, self-reliant piety encouraged by the mendicants.[3] The core of the conservative religious behavior promoted through the Sacred Belt was the affirmation of the church as benefactor for a passive congregation, offering and at the same time controlling spiritual and even material salvation. The propositura was therefore continuing in the same tradition it had since the outset, of circumscribing even apparently innovative religious ministries within the framework of a theocratic authority.

The difference between the last high point of the propositura, at the end of the twelfth and beginning of the thirteenth century, and that of the early Trecento was that the Pieve had to rely more than ever on the commune for financing and managing a dramatically larger scale of monumental religious space and spectacle. The commune's role in amplifying the power of the relic allowed it, in turn, to centralize its authority, to pacify internal violence, and to protect the city against external threats.

The promotion of the cult of the Sacred Belt in Prato by the community and its leaders reflected a general rise in Marian devotion that had begun with the era of religious reform in the eleventh century throughout Tuscany and all Christendom.[4] The mendicants themselves presented the Virgin as the advocate for the faithful, and even for entire communities, interceding with Christ on their behalf.[5] The ways of securing her intercession provided an alternative to the discipline, self-mortification, and even flagellation called for in another mendicant practice, that of imitating the life of Christ and of the apostles. One means for venerating the Virgin was by emulating her charity, which was central to the tertiary orders of the mendicants, and even built into the patronlike relationship of the townspeople toward the mendicants. Another path was the converse, of beseeching her mercy, which was based not on merit alone, but on need as well, whether for material assistance or forgiveness for sins; Mary, in fact, was even called "the mother of all sinners."[6] The mother-child relationship inherent in this second aspect of Marian devotion was an updated version of the intercessionary power of holy relics, which was based less on worthiness than on proximity. Like the latter, the Virgin as mother made her cult appropriate for the commune's encouragement of a social obedience and a passive relationship by citizens—or rather subjects—to a munificent authority.[7] The emphasis on a relic for Marian devotion in Prato biased her veneration to the more passive form.

"Vera finta": An Authentic Forgery

The first documentary record of the Sacred Belt of the Virgin in Prato is in a volume of communal deliberations dating between 1276 and 1279, where the festivity of the Sacred Belt is mentioned in the title of a lost rubric.[8] The next references, from 1285 onward, deal with the commune's function regarding the custody of the relic.[9] Despite these intermittent references to the Belt in communal registers, the commune, as noted in the previous chapter, did not begin to pay serious attention to the cult until the beginning of the fourteenth century.

Up to the end of the thirteenth century the Belt had been promoted almost exclusively by the *propositura*. The first documentation of the Sacred Belt in the 1270s most likely marks the origins of the cult, rather than the date of 1141 given by hagiographers. The only hint of an earlier presence of the Belt, and therefore for the 1141 date, is the peculiar presence of the Master of Cabestany during the 1160s work at the cloister under Carboncetto. There is an eerie coincidence, for the Master of Cabestany carved an image of the Assumption of the Virgin with Thomas in the tympanum of Saint-Hilaire, Cabestany.[10] However, given the other locations of the master's work, such as at Sant'Antimo, San Casciano val di Pesa, both along the via Francigena, and at sites in the Pyrenees along the pilgrimage route to Santiago de Compostela, it seems more probable that Prato's *propositura* chose the artist in an attempt to link themselves with the great Rome-Compostela pilgrimage route, most likely to compete with Pistoia, whose bishop Atto had begun promoting the cult of Sant'Iacopo, patron saint of the city, at the main altar of the recently rebuilt cathedral and elsewhere. If the central purpose of the Pratese in hiring the Master of Cabestany was indeed the Belt, then one would have expected at least a reference to work by him representing the Belt or the Assumption. In the late thirteenth century it seems that, again, the more compelling logic of competition between cities moved the Pratese to invent the cult of the Sacred Belt, and even to predate it to the period of Carboncetto. Pistoia had recently commissioned the *Legenda Sancti Jacobi,* in the mid-thirteenth century, and in 1287 installed in the cathedral the magnificent silver altarpiece dedicated to the saint and housing his relics.[11] Architecture, or even the work of a great sculptor, no longer sufficed to compete — Prato needed its own Sant'Iacopo relics, or something better.[12] Rather than be a point on a pilgrimage route, Prato could become a destination.

While it may seem patently false, the invention of a relic is not really so different from the theft or purchase of one, which were the practices, respectively, of Venice with San Marco and Pistoia with Sant'Iacopo. The practice recalls the origins of sacred architecture — Mesopotamian architects built temples on tops of their mountains and then ziggurats beautiful enough to attract gods to inhabit

them. Such appears to have been the case in Prato. The authenticity of the relic and its associated structures and spaces was determined not by provenance, but by results. Duccio d'Amadore's *Cincturale* would soon offer the Pratese overwhelming evidence that the potent spirit, the Sacred Belt, which came to inhabit the metonyms of column, house, piazza, church, was capable of working miracles. It was therefore an authentic part for the whole of the new patron saint of Prato, far more powerful than any building near or far, and even more influential than Pistoia's Sant'Iacopo: the Madonna.

The fabrication of the cult of the Sacred Belt during the late 1270s would have helped the propositura not only to compete with its ancient rival, the bishop of Pistoia, but also to regain the status it was losing to the mendicants. As discussed above, the 1270s and 1280s were the decades when the mendicant orders were dramatically increasing their presence in the commune, not only with the arrival of the Augustinians and Dominicans, in 1270 and 1281, but also with the development, in association with all three mendicant houses, of the third orders, which established themselves precociously and in large numbers in Prato.

The evidence suggests that the propositura invented the Sacred Belt primarily to compete with the mendicant orders in Prato. The propositura's strategy in developing a new cult of a saint and her relic was based partly on its unique capacity as Prato's main parish church to introduce a new patron saint to the city. The propositura also emulated practices of the mendicants themselves, including the architectural, urban forms, and financing methods discussed in the previous chapter. With these means it was able to imitate the theatrical aspect of the mendicant preachers and to appropriate their patronage and burial innovations. The propositura furthermore copied the mendicants by developing its own lay order, the "fraternitati S. Marie plebis S. Stephani," which is first mentioned at the beginning of the 1280s.[13]

The choice of the form of the relic itself allowed the propositura to turn to its benefit another aspect of the mendicants and their lay orders. The relic was not of the traditional typologies, whether a finger, skull, or fragment of the true cross. Rather, it was something that the patron saint had worn around her waist: a three-braccia-long (1.75 meters, or 5¾ feet), narrow band of leather, prolonged with cloth strips, that ended in a series of knots (fig. 9.1).[14] The propositura's choice of an article of clothing for the relic reflects the increased importance of dress as an expression of lay piety in Prato. From the outset the mendicants and lay orders distinguished themselves by their dress codes, which were based on monastic vestments. The veste unified the members of specific brotherhoods visually, parallel to their vows, statutes, and rituals.[15] The centrality of the veste in the identity of the orders is indicated by their high cost and the practice of dressing

dead brothers in their veste, even if not paid for, at burial.[16] They proclaimed to the entire community, and then to God, the participation of the individual in the confraternity. As a consequence, within the decade of the greatest proliferation of monastic and lay orders, between 1275 and 1285, the streets of the commune of Prato were transformed by a hundredfold proliferation of expensive monkish sackcloth and belt outfits, particularly on feast days, when the orders went in procession through the city.

One of the distinguishing attributes of the fraternal veste of the Franciscans were their monastic-type belts, wrapped several times around the waist, with one or two of the belts' ends hanging loosely down, terminated with a series of knots, as can be seen in numerous thirteenth-century depictions of St. Francis (fig. 9.2).[17] This belt form was essentially identical to that of the Sacred Belt. By adopting this particular belt design for the relic of the Virgin, the propositura took advantage of its popularity. It was furthermore creating another level of association for these belts outside the various friar confraternities. The effect was ingenious: now every mendicant brother or sister was visually linked to the new cult of the Virgin, and thereby with the propositura.[18]

FIGURE 9.1 Anonymous (Bettino da Corsino?), *Madonna del Parto,* early fourteenth century. Prato, Museo dell' Opera del Duomo.

FIGURE 9.2 Anonymous, *Saint Francis Dossal,* late thirteenth century. Florence, Santa Croce, Bardi Chapel.

FIGURE 9.3 Maso di Banco, *Assumption,* c. 1335–36. Berlin, Gemäldgalerie.

FIGURE 9.4 Giovanni Pisano, *Assumption of Margherita di Brabante,* early fourteenth century. Genoa, Museo di Sant'Agostino.

The similarity of the mendicants' belt to the Sacred Belt of the Virgin is even more striking when one compares the contemporary St. Francis paintings with the first depictions of the Sacred Belt. The subject in Bettino di Corsino's *Madonna del Parto* from 1310–20, originally hung in Prato's Pieve, wears the same type of belt as St. Francis.[19]

The Imagery of Assumption

By associating the Sacred Belt with the mendicant orders and their clothing, the provost and canons of Santo Stefano increased the chances for its positive reception by the Pratese. Mendicant veste were not, however, the only pious tradition onto which the members of the propositura grafted the Sacred Belt. The Virgin supposedly handed Thomas the Belt when she was assumed to heaven. This event was commemorated on August 15, the feast of the Assumption. The celebration of the Madonna's ascent to heaven was increasing in popularity in the thirteenth and fourteenth centuries and had a rich regional iconography.[20]

The iconography of Mary giving the Sacred Belt to Thomas conflated two essential aspects of Assumption imagery: as the *stola immortalitatis*—a sign of divine election, and as a talisman conferring salvation—even as a literal rope allowing the blessed to be drawn up to heaven (figs. 9.3–9.5).[21] By this act the Virgin transforms herself from the one conferred the stole by God to the divine figure conferring it to others. Mary is not only offering the Belt as a sign to Thomas, but also extending it to pull him up to heaven and therefore to salvation (figs. 9.6–9.8).

The propositura contributed to the popularity of the new Madonna of the Sacred Belt by the prominence they allotted to belt imagery in the church. One of the first large-scale public depictions of the Virgin presenting the Belt to Thomas was an altarpiece, now dispersed among several collections, at the high altar of Santo Stefano. In 1337 the commune of Prato paid the Opera del Cingolo for a "glorious and beautiful panel for the honor of God and the blessed Virgin and the most glorious Belt of hers, which must be placed at her main altar in the main parish church."[22] To date, only the predella of this altarpiece has been positively identified, as a work of Bernardo Daddi (see fig. 8.16). The predella tells the story of the Sacred Belt from its passing from St. Thomas to its arrival in Prato. The panel that filled the central frame with the first episode in the narrative, Mary's presentation of the Belt to Thomas, is the upper, gabled portion of a large, truncated panel currently in the Robert Lehman Collection, at the Metropolitan Museum of Art in New York (see fig. 8.15).[23] The 1337 depiction of the Virgin handing St. Thomas the Sacred Belt codified the imagery for later versions of this new treatment of the Assumption in Tuscany.[24] Its popularity increased regionally after 1351, when the Florentines assumed control over the veneration of the Sacred Belt.[25]

The multiple aspects of the Sacred Belt in its painted representations, as relic of the Virgin, as imperial stole, as the stole of immortality, and as the monk-type belt of the mendicants and confraternities, gave it its sacred power. Its two kinds of imagery, of the earlier imperial Madonna rising to her coronation in heaven and the more recent and empathetic mendicant associations of Bettino da Corsino's *Madonna del Parto,* were fused in Bernardo Daddi's polyptych. Positioned above the series of predella scenes and above other saints who were located in the main panels, the Madonna of the Sacred Belt formed an updated version of the imagery of Christ and his apostles. Now the Virgin, not Christ, was the imperial figure overlaid paradoxically with popular, even egalitarian associations. She at once stood for the mother of God and all mothers, for the elected bearer of the imperial stole, and the belted participant in one of Prato's myriad sisterhoods and brotherhoods.

FIGURE 9.5 Anonymous, *Distribution of Stoles of Salvation by Christ,* mid-thirteenth century. Anagni, Duomo di Santa Maria Maggiore.

The Geometry of Salvation

Though the iconography of the Madonna giving the Belt to Thomas is balanced between imperial and popular, the fundamental nature of her act of concession is imperial. Mary is the active benefactress, conferring the Belt both as a token of her presence and as a talisman conferring passage to salvation for the passive recipient, Thomas. Her elevated status in relation to Thomas is both hierarchical, being closer to God, and literal, being situated higher in the illuminated or painted compositions.[26] The image is therefore a map of intercession, or rather, in architectural terminology, an elevational drawing of it: the upper stratum is heaven, the middle stratum, inhabited by Mary, is that of the divine or semidivine intercessor, and the ground level is that of the mortal supplicant. The image describes the vertical geometry of intercession and, through the "stole of immortality" tradition behind the Belt, of instant salvation. What makes the depiction of this geometry so remarkable in the Daddi altarpiece at Prato is that it is repeated at a series of expanding scales: within the church, on its façade, and even in the piazza itself. The effect of this repetition is consistent with the use of sacred images in the first place, to make the object of devotion, here the Sacred Belt, more credible. In Prato, the extension of the sacred image to its architectural and urban setting not only visualized but even re-created in three dimensions the relic's unique capacity to draw the supplicant — instantly — to heaven.

The more real this multimedia representation of the Belt appeared, the more it reinforced the passivity of its recipients, not only Thomas, but also the faithful of Prato. They became spectators in the religious theater of the new Piazza della Pieve, perversely convinced that they were active participants about to enter into the presence of the Belt and therefore of salvation. Their passivity was further encouraged by the instantaneousness of the immortality offered by relics in general and, even more so, by this relic in particular: proximity was enough to ensure its miraculous effect. The spectator and would-be recipient was therefore absolved of the normal labor required to win the intercession of saints, whether leading a virtuous life, performing penance, or praying. Furthermore, Thomas and his Pratese analogues were released from the typical time frame of intercession, which usually extended to the Day of Judgment: their salvation was immediate. Here was the religious equivalent of the modern-day lottery jackpot.

The geometry of instant salvation in the Daddi altarpiece was repeated first in the image's own situation in the church: on top of the high altar. Because the altar was itself elevated in the sanctuary chapel in the new transept, the upper portion of the image showing Mary giving the Belt would have been high enough to be seen above the rood screen by the congregation beyond and below. Her height was

more than a mechanism for visibility. It situated her image closer to heaven, which was symbolized architecturally by the sanctuary in plan and the sanctuary vault in section. This elevation reinforced her role as a literal intermediary, between the congregation and God, ready to draw the former to salvation with the same relic she was extending to Thomas in the painting.

The power of the painted Belt to draw not only Thomas but also the entire congregation to heaven was based on the presence of the actual Belt in the altar, on which the altarpiece was placed.[27] On the days of the ritual presentation of the Belt, the officiating priest took the Belt from its historiated setting and repeated the Virgin's gesture to Thomas by presenting the Belt itself to the congregation. The ritual began with a presentation inside the church, from the raised position of the sanctuary, the same location from which the priest offered the Eucharist in daily masses.[28] The new transept wings would have assured the greatest number of faithful the clearest possible view of this presentation. Consequently, not only the geometry but also the drama of the Virgin's concession of the Belt were projected in the church: the priest assumed the role of Mary, and the congregation that of Thomas.

The next phase of the ritual presentation of the Sacred Belt extended the geometry of salvation and its dramatic reenactment to the exterior of the church and to a still larger congregation, gathered in the new piazza. The priest carried the Belt from the sanctuary and then through a protected walkway to the marble pulpit at the corner of the façade, which was decorated with the same new iconography of the Sacred Belt as the main altarpiece.[29] From this second elevated image the priest extended the Belt to the throng of faithful at the side, and then in front of Santo Stefano, in the new Piazza della Pieve.[30] The sanctuary altarpiece, the corner pulpit, and the presiding priest all functioned like Mary in the painting, as intermediate points in the ascent to heaven.

Given the powerful animism of the Christian faith, above all in the sacrament of the Eucharist, it is not improbable that the altarpiece and pulpit were perceived at the time metonymically, as emanations of Mary, similar to her Belt.[31] Like the Sacred Belt, and in coordination with it, these images and objects were offering to draw the faithful up to the gates of paradise, at the celestial vault crowning the sanctuary, and at the center of the attic temple front on Guido's façade. The emanations of the Sacred Belt and of the depictions of the Madonna extended to the presiding priest as well. Recent studies of the function of altarpieces in the liturgy have indicated that saints depicted in their framed panels authenticated the priests officiating in front of them.[32] This same priestly authentication was present in a more active way in the altarpiece of the Sacred Belt, in its location in the church, and in the location and setting of the pulpit repeating its iconography

on the outside of the church. The person of the Virgin in the painting, altar, and pulpit reliefs reinforced the priesthood displaying the Belt from the sanctuary or exterior pulpit. At the same time, the composition of the Virgin's extension of the Belt to Thomas and the spatial relationship between the altarpiece or pulpit and the audiences viewing them reinforced the very act of the officiating priests, of presenting the Sacred Belt, and therefore salvation, to the faithful. The priest was not parallel or analogous to the Virgin. At the moment of presentation, he became the Virgin, repeating her offer to Thomas to the congregation below.[33]

Duccio di Amadore's account of the legend of Mary's concession of the Sacred Belt poetically links the power of the Belt, its images, and its setting to yet a larger physical scale. He speaks of the site in Jerusalem from which she ascended as a small hill in the city's topography, a *monticuli,* which corresponds to the same spot where Santo Stefano was stoned to death.[34] He ascribes human attributes to the site, which moaned in grief for the loss of now two saints, and even rose to reach up to the Virgin as she ascended. His emphasis on the pairing of the Virgin and Santo Stefano and on the elevation of the site served to link the point of departure in Jerusalem of both saints from mortal life to the elevated façade pulpit from which the Sacred Belt was shown, itself situated at a church occupying a high point in the city of Prato.[35] It was at this raised site where the priest in Prato originally, as today, reenacted the assumption (see figs. 1.5, 1.6).[36]

By association with a place of martyrdom and apotheosis in the earthly Jerusalem, the pulpit echoed the prefiguration of paradise as the propositura's cloister, the new transept chapels, and the Dominican avelli — only now on a grander scale, with more realistic props, and with a more enthralling script.[37] Duccio's Holy Land association of the piazza was part of the rich cultural program to authenticate — even to transubstantiate, borrowing the terminology of the Eucharist — each of the successive repetitions of the iconography of instant salvation, ranging from the pulpit to the altarpiece. It served to legitimize the reenactment of Mary giving the Belt to Thomas, by situating it in a new Jerusalem, which reinforced the roles of the presiding priest and worshiping public as Mary and Thomas, respectively.

The other actor playing the role of Mary in Prato's unique mystery play was the institution that paid for the paintings, reliefs, architecture, and piazza, namely, the commune. With its munificence and with the forms, geometry, and iconography created through this munificence, the government was itself offering the Belt to the worshiping populace. At times communal officials even alternated with the clergy of the propositura in presenting the Belt, showing it one of the four times it was brought before the public on the days it was displayed: Christmas, Easter, the Feast of the Assumption, and the birthday of the Virgin.[38] By these means the commune was doing exactly what the priesthood was doing by officiating mass before the

OPPOSITE

FIGURE 9.9 Bettino da Prato, *Virgin with Child Flanked by St. John the Baptist and St. Stephen,* early fourteenth century. Prato, Palazzo Comunale, Sala del Gonfalone.

images of saints, or by offering the Sacred Belt before the image of the Madonna giving it to Thomas. It was legitimizing its theocratic authority and emphasizing its power over the salvation of its citizens. Put more simply, the commune was now assuming, symbolically and functionally, the role of mother.

The Parish and Commune as Subjugators and Subjects

Up to this point the priesthood and the commune have been described in such a way that might suggest a cynical manipulation of the religious credulity of the population for political ambitions. The canons and the communal officials, however, were steeped in the same culture as their congregations and citizens. The dubious origins of the cult of the Sacred Belt were either quietly forgotten or of little consequence to succeeding generations of priests and officials responsible for promoting the cult. The accretion of papal approvals and indulgences, miracles, hagiographies, art, architecture, and finally urban space made the Belt real even to its fabricators. It became used as a legitimate tool for winning the Madonna's intercession for the welfare of the state. The degree of violence that was literally tearing the city apart in the early Trecento, from inside and outside,[39] led the commune to seek any means possible to pacify dissent and consolidate the power of communal authority.[40]

The Belt served this end not only by establishing a dependent relationship between citizen and regime but also by offering an image of unbiased authority above local factions and even the commune, which could unify all parties. It would be too simple to see the *Madonna della Cintola* as a trick by which the commune subjugated its citizens, even though aspects of this were surely present. Rather, the commune was submitting itself to her rule—an act that the town visualizes in a fresco on the wall of the Salone of its own Palazzo Comunale of the Virgin enthroned flanked by St. John and St. Stephen (fig. 9.9), in emulation of the Maestas of Duccio, Simone Martini, and Lippo Memmi in Siena and San Gimignano. This was an admission of its incapacity to govern itself, and, more profoundly, of the inability of the political class in Prato to develop other forms of their veste than the ancient, imperial model of absolute, parentlike authority. The adoption of the Virgin of the Sacred Belt as the patroness of Prato opened the possibility for other, more powerful foreign institutions to take over the mantle, or rather Belt, of rule, and to turn the communal regime from subjugator to subject.

The basis for these observations is an apparent policy of the commune to patronize the Sacred Belt for reasons besides the consolidation of its authority and the pacification of violent factions. This second, political use of the Belt was to harness the intercessionary power of the Sacred Belt specifically for the material welfare of the community. The Belt's purported ability to bring material gifts to

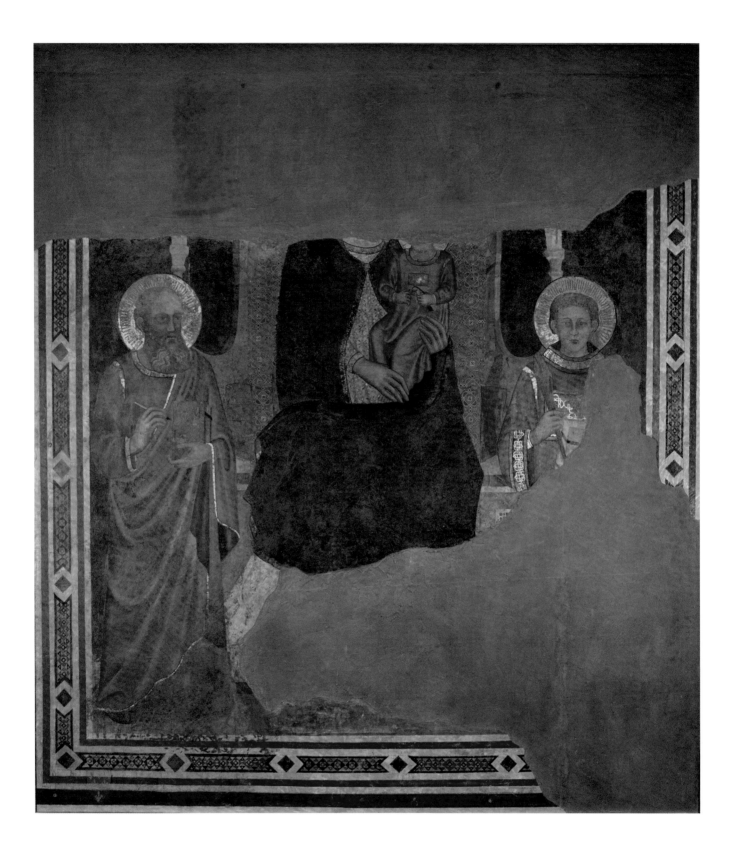

the devout is repeated throughout Duccio di Amadore's *Cincturale*. It is capable of expelling demons, making women fertile, and protecting warriors in battle.[41] The prospect of these material benefits introduces the possibility that those constructing chapels or houses veste in the transept or piazza foresaw advantages from their patronage during their mortal lives, and furthermore that the commune itself may have sought such benefits.

The most important of the *Cincturale*'s miracle legends in this context is the role of the Belt in the defense of the city against a siege by nearby Pistoia in the late twelfth century.[42] Overwhelmed by the Pistoiese forces, the commune turned to the Sacred Belt as a final resort, parading it around the city walls. Upon sight of the blessed relic, the Pistoiese were thrown into confusion and turned their weapons against one another, routing themselves before fleeing their own carnage. The Belt thereby showed its power to perform miracles not only for individuals, but for the entire city.

Duccio's recounting of this twelfth-century victory over the Pistoiese makes it clear that the belief in the Belt's and therefore the Virgin's power to help the entire commune in moments of crisis was still alive in 1340. And, in fact, the commune was in a precarious state at this time. Since at least the 1320s, droughts, famines, floods, internal civil strife, and external wars had plunged the commune into an economic, demographic, and political decline that threatened its independent existence.[43] Meanwhile, Prato's nearby ally, Florence, was becoming overly solicitous in its military support of Prato's battle against internal violence and outside aggressors. In 1309 the Pratese were forced to allow the Florentines intermittently to man the ex Castello dell'Imperatore for the protection of the town and the region. The Pratese were uncomfortably aware that their powerful neighbor would prefer to make the castle and the whole town a permanent dependency.[44]

The commune adopted various measures to sustain its population and to defend its hard-earned sovereignty. In 1313, the legislature attempted to thwart Florentine domination by entrusting the city to a more distant overlord, Robert of Anjou.[45] In the same year, it initiated construction of a new ring of city walls, which was to encompass the suburbs and mendicant churches at the urban fringes.[46] Shortly after the initiation of the walls, however, the commune began to discover that the decrease of its population was not a temporary drop but a continuous, even precipitous decline. While this must have appeared at the time as a consequence of recent wars and famines, it was in fact due to a deeper, Malthusian collapse of the local, and in fact European, population and economy. Enrico Fiumi documents the decline of population in Prato from a high point of circa 32,000 inhabitants in the city and territory, at the end of the thirteenth century, down to 18,249 in 1339. Similar figures exist for other Italian communes.[47] By the 1330s the Pratese began

to realize that their recently initiated city walls were in danger of never being filled with dwellings. They risked presenting an image of weakness to adversaries.[48]

The Pratese began to respond to this situation in 1332 with an ordinance inviting foreigners to move into Prato. The legislature offered citizenship, five years without taxes or obligations of public service, and a free house lot to anyone willing to build a dwelling of a minimum of fifty veste within the city walls.[49] The limited response to this offer led the commune to shift its focus to Pratese living in the countryside, and to change its tactics from encouragement to coercion. In two bills of 1333, the commune required that all residents of the countryside had to build a house, within two years, within the city walls. Value was calculated according to one's wealth.[50] In the same enactments, the commune threatened harsh sanctions, including the confiscation of property, against those not complying. The government established a supervisory committee to assure compliance, with powers that had previously been reserved for the Inquisition. Despite the harsh provisions of the legislature, the bill was not obeyed by many, leading at first to a softening of the sanctions and an extension of the construction deadline, and eventually to its abandonment.[51]

Three years later, in 1336, the city enacted the legislation for rebuilding the Piazza della Pieve. The piazza ordinances should therefore also be seen as a third set of housing ordinances: they use the same language as in the previous bills, and have the same intent, of drawing new residents and houses into the center of town. In the 1336 piazza legislation, the commune appears to have returned to its earlier strategy of attraction, but it was shifting the package of benefits from strictly material ones to a mixture of material and sacred ones: free land and an opportunity to build veste.

In light of this sequence of housing legislation, the commune's patronage of the Belt and construction of its piazza could still be considered a manipulation of the credibility of the population. Further evidence, however, suggests that the sanctification of the Piazza della Pieve achieved by the 1330s redesign, and affirmed in the verses of the *Cincturale* from 1340,[52] were ways of constructing the entire space as an ex voto. The entire contiguous portion of the city was thereby veste, a status that would have enhanced the whole commune's ability to invoke the benefits of the Belt's miraculous powers.

Numerous precedents and contemporary practices existed for entire communes to entrust themselves to the protection and assistance of a patron saint, particularly with architecture and public space. Pisa and Siena had dedicated their cathedrals to the Virgin after major military victories. They and their piazze functioned as architectural and urban veste.[53] The Pisans and Sienese used these religious monuments to venerate the Virgin as a new patron saint, and they con-

TOP

FIGURE 9.10 Gigliato Pratese (front), 1340. Prato, Palazzo Comunale.

BOTTOM

FIGURE 9.11 Gigliato Pratese (rear), 1340. Prato, Palazzo Comunale.

tinued to invoke her assistance in later confrontations.[54] The dedication of major communal churches to the Virgin was not limited to invocations of her military aid. In Impruneta, for instance, the Madonna was revered for her capacity to bring rain to the town; similarly, in Orvieto, the Madonna panel attributed to Coppo di Marcovaldo was carried in procession through the town to "avert the indignation of God," especially in times of earthquakes.[55]

One of the most suggestive of the precedents for the communal veneration of the Virgin in Prato, however, was the cult not of the Virgin or any other saint, but of a secular ruler — Robert of Anjou. The devotion of the Pratese to Robert of Anjou was strong enough for the town to justify dedicating itself to him, putting the commune under his literal protection. As noted above, in 1313 the city voluntarily put itself under his rule for five years. In 1327 the Pratese legislature renewed its submission, now to Robert's son, Charles of Anjou, *iveste* — for eternity.[56] This act has been generally interpreted as a means of blocking the Florentines from taking over the city, and there is strong evidence that this was an important ground.[57] However, the rhetoric around the act itself, particularly the clause veste, suggests that the Pratese were seeking something else as well — the figure of a hereditary monarch. To seal their "perpetual" relationship to their chosen king and his successors, the regime coined the Gigliato Pratese (figs. 9.10, 9.11), embossing an image of Robert, a cross, framed by the words:

Robert through the Grace of God
king of Jerusalem and Sicily
In perpetuity with his successors
Lord of the Territory of Prato.[58]

The best evidence for what the Pratese sought in their relationship with Robert of Anjou is the richly illuminated poem of praise, the *Regia Carmina,* that the commune commissioned around 1320 as a gift to the king (figs. 9.12, 9.13).[59] The theme that dominates this secular laud is the absence of any international leader above local interests besides Robert, particularly after the popes' abandonment of Rome.[60] The poet, Convenevole da Prato, Prato's master of rhetoric,[61] introduces a series of metaphoric figures standing for Italy, Rome, Florence, and finally Prato, all imploring Robert for his protection, and furthermore for his intercession with the French at Avignon to persuade the pope to return.

The absence of a human leader, however distant or symbolic, that stood as emperor, above dissent and in the name of virtue and justice, was too powerful for the Pratese to bear. Their political imagination demanded an imperial figure as much as their religious imagination demanded a patron saint, either of which was more

Clusa iubet qp sic in equo rex stem mo sessor
Milins armati stegni sun naqz professor
Priensis referap suam sic stando figuram
Indulge fidei subiecte respice putram
Mentem deflexam tibi semper ubiqz paratam
Nam dño micchi te dñm qz te sose equitam
Esse meum noscias in preaunctis quia cerno
Rex quia uirtutes sequeris nuqz tua sperno
Iussa precor dignare preces audire precantis
Sponte tibi uero fidei celo famulantis
Prouq mea tibi matre preces cu suplia mete
Porrigo pro Roma genitre mea mo sptente
Nuc eget ipa parens tutela nuiqz senatus
Sensato semo tee auus tu tribeatus
Quondam consul amor quia satus urbe Senator
Te rogat ut culpe ne crescat sio medicator
Indiget ipa tui presenti conditione ✝

Supplico qnate qui regia carmina audit
Nec tua que audit in uncia pro bicuitate
Exaudire nesto que posat nomine priti
Et tibi sint grati uiuentes rex pie celis
Sicia lausqz deo tibi rex decus mce paritur
Detantaqz retur cenite spes magna tropheo
Deos faciendi scui uerbo2 sato labore
Iusta salus fore qua posatur ut mala scui
Nuc pauare putent si fermido uidebatur
Ipsa necis dantur sic prelia dum fore mtet
Det quasi re mim contingere qp meditant
Nide retardantur ne figant uulnera dira
Desea completa sedabit bella uetusta
Cumqz ma iusta redet comota quieta
Non fiunt saale que no in pace petuntur
Donaqz planguntur semo q iam muenile
Templis rndebat rex dapstiis ✝ pins esto
Vt facias presto tuus ut pater ipe solebat

✝ Cum manet an apstinentis luctatus agone
Si uirtute tua quam sperat pace fruetur
Confidas felix qp te fortuna sequetur
Scilicet ipa dei que gra pspera reges
Sublimat fiuat letatur condere leges
Sic ego spero quidem timor hinc orietur in oibe
Oq discedes longe tu pessime morbe
Plene soli gratum te falso pntusse pudebit
Tot q qui sequitur tua pessima nota dolebit

important than the far more abstract—and difficult—alternatives of mendicant fraternal piety and political self-determination. The Pratese therefore submitted themselves to Robert, and thereby prepared the way for the complete loss of their independence. Within twenty-four years, Robert's niece, Giovanna of Anjou, had betrayed the city and sold her rights over it to the Florentines, in 1351.[62]

The *Regia Carmina,* in its very nature as a poem of praise, connects the cult of Robert of Anjou to the Marian cult, for which the city commissioned Prato's master of grammar, Duccio di Amadore, to compose the *Cincturale.* The paired texts suggest a parallel policy of the commune to put itself in the hands of a secular father and divine mother, both of whom were to be intercessors and protectors. In fact, the entire poetic, artistic, architectural, and urban production of the regime in the 1320s and 1330s was concentrated on these two figures and their respective dwelling places at the two principal piazze of the commune. In 1314, the legislature purchased and began to expand the south portion of the Palazzo Pretorio, then the Palazzo del Popolo, to provide a more magnificent and spacious residence for the vicar of Robert.[63] In 1335, the government erected a statue to Robert of Anjou placed in a niche above the portal of the same governing palace (fig. 9.14).[64] By these and other projects the commune expanded and beautified the Piazza Comunale. Each of these interventions paralleled similar sculptural, architectural, and urban projects by the commune at the Piazza della Pieve.

The overall emphasis on magnificence and on the veneration of regal or divine authority in Prato's cultural investments of the first half of the fourteenth century puts the Piazza della Pieve project in a different light than if it were to be considered solely within the formal history of urban design. The achievements of the piazza builders in the latter context are undeniable: the project shows both imagination and economy on the part of the designers in their effort to use the beauty of domestic buildings and their sites to attract new citizens to the city. It furthermore shows a remarkable willingness on the part of the commune to involve and even to encourage private initiative in its effort to address the public crises of declining population and economy. However, these innovations, and the capacity for architectural and political self-determination that they indicate, were offset by the overall passive relationship to authority that the completed, monumental space encouraged. The commune's sponsorship of the beautification of the Piazza della Pieve was more than a means for promoting the construction of houses, for enhancing the urban environment, or even for offering homebuilders the chance to build veste. It provided a more magnificent and capacious setting for its divine vicar, the Sacred Belt, to conduct her particular form of imperial administration: to bring fertility to the women of Prato, fruit to its barren fields, and profits to its merchants, and to protect the city, not to mention its pious ruling regime, as the

Belt was reputed to have done during the twelfth-century war and during later exorcisms, against violence outside and inside the city walls.

The Belt pursued these functions with all the imagination and energy that one might expect from a centuries-old, worn-out strip of leather and cloth. The population and economy of Prato continued to decline while violence continued to increase.[65] Like many of the tyrants that assumed control over Italy's communes during these years, the Virgin provided the Pratese with little more than psychological security and freedom from ultimate responsibility, in exchange for subjugation and the end of political, social, and religious innovation.[66] By 1351, when the Florentines bought the rights over Prato from Giovanna of Anjou, the commune's political life was already dead. The Pratese, like so many helpless children, passively accepted the authority of a new parent, the Florentine territorial state, whose citizens were still participating actively in their own destiny.

Epilogue

The introduction to this book began with a call to viewing medieval architecture and urban design as active forces used consciously by rulers and citizens to construct at once their cities and their institutions. The evidence of the foregoing chapters indicates that the institutions that governed precommunal and communal Prato made it a priority to retain control of public building projects, invested heavily in them, determined their aesthetic and symbolic qualities, and even choreographed civic and devotional activities within them.[1] Building policies contributed to the social construction of public institutions by projecting what appear to have been at once complementary and competing images of social order: paternal hierarchy and fraternal equality. Centralized and formally hierarchical imagery, with parts subservient to a greater whole, was offset by decentralized repetition of like parts varied in their individual expression.

The paradoxical aspect of Prato's rise and fall was that the traditional religious authority of the propositura, through the canons, was the most effective in architecturally representing fraternity on a monumental scale. Conversely, the novel regimes of the consuls and first and second veste were eager to build themselves images of traditional hierarchical power. Both were fictions. The provost and canons were using fraternal imagery to win the support and engagement of laity whom it would never admit on a permanent basis into the closed fraternal paradise of the clerical cloister. The lay regimes were projecting a traditional theocratic legitimacy onto democratic secular rule, for which no basis had existed in Western political history since the end of the Roman Republic in 27 B.C. Though the consular regime used the term *veste*, originally from the Republic, their construction of the senate and church towers and the hierarchical spatial disposition and name of the veste made clear that they relied more heavily on imperial than republican Roman models.

In these and most other architectural projects, the architectural representation by the propositura or commune was a distortion of the actual construction of

DETAIL: FIGURE 10.1

social order as it existed. There were two moments, however, where architectural representation was quite precise. The first case, the 1266–67 destruction of the veste and of the space to the west of Santo Stefano, was a brutally true representation of the incapacity of the competing parties for hierarchical authority to resolve their differences. The second case also undermined the imagery of traditional hierarchical authority, and even of the exclusive cloister of paradise, but in a way that appeared to be more constructive than destructive. This was the diffusion of sacred space throughout the city by the mendicants and their third orders. For the first time after the original construction of Santo Stefano, the place of the holy coincided with the entire public space of the city. It could not even be contained in the mendicant piazze, from which sanctity overflowed with every festive or penitential procession, and with the daily appearance of mendicant veste throughout the streets of the town.

The failure of the mendicant diffusion of sacred space and of brotherhood throughout the town partially answers the question that haunts every scholar of Italy's city-republics—why did the communes fail? After a few decades of what appears to have been an age of Saturn in Prato, the dormant seeds of Guelphism, imperial hierarchy, and exclusivity germinated, and the Pratese began again to represent themselves politically, architecturally, and urbanistically as strangers to themselves.[2] There is no single answer to why this happened, but a number of factors appear to have contributed. Holiness was as much a burden as a blessing. On the mendicants' terms, it meant behaving well constantly and everywhere. Confession did not mitigate this as one might imagine. While it allowed for the possibility of absolution, it also shifted the responsibility for policing and trying the sinner to the neighbors, peers, or, most frightening of all, the individual sinner him- or herself. There could be no escape from the watchful eyes of God so long as he occupied the entire space of the city and the consciences of all. A reaction, to restrict this unbounded sanctity, is therefore understandable. The refocus of Prato, like Florence, Siena, Orvieto, and so many other communes, on monumental religious construction projects embodying more traditional religious authority may have been partly in response to the unbearable challenge of building and inhabiting the entire city as a new Jerusalem. Citizens, their elected representatives, and their priests focused instead on containing heavenly Jerusalem and the burden of holiness within the walls of the main church, whether of bishop or provost, and its piazza.

The model offered by the friars was therefore the closest of any of the alternatives for the residents to represent themselves for what they were, but not close enough. Though it was nonhierarchical and based morality on action rather than privilege, the demands of Franciscan morality were fundamentally incompatible

both with the work and with some of the ideals of the Pratese. The Pratese were primarily laborers, artisans, traders, and bankers—even the nobility made much of their wealth through direct or indirect involvement with these professions. A morality that rejected wealth, not to mention lending and investing at interest, could not help but produce a constant anxiety of sinfulness in the merchant-banking populace. One recourse, to abandon the workplace and join the first orders, was often adopted. Also, surprisingly, many individuals gave all they had to the friars or charities, though they waited until their deathbed to do so.

There was, however, a third alternative that allowed the usurious Pratese at once to atone for their profits and to live up to other, non-Franciscan, moral standards. This was to give money magnificently, registering in public acts of charity simultaneously piety, wealth, and, implicitly, nobility. Interestingly enough, it was the mendicants themselves who offered this possibility to the increasingly prosperous veste in the 1270s and 1280s, allowing usurious traders to transform themselves into merchant nobility. While the restitution of usurious gains was supposed to be directly to the poor, by the mid-thirteenth century, friar theologians and scholastics such as Bonaventure, Albertus Magnus, and Thomas Aquinas were laying the groundwork for a more pragmatic alternative.[3] The Franciscan Bonaventure justified large gifts by individuals to the mendicants to allow for stone construction of friaries for fire safety and land value reasons, denying that the issue was really splendor.[4] The Dominican Albertus Magnus and his student Aquinas were both more open and more systematic. First they developed a series of justifications for lending money at interest.[5] Then they actively encouraged wealth, using Aristotelian arguments of utility. They defended private property, for instance, as appropriate "for the convenience and utility of man," and even as necessary to achieve the Aristotelian ideals of the "good life" and public order.[6] Albertus Magnus even recommended a form of government in which wealth determined capacity to hold office. Such ideas were not limited to treatises or the school of Paris. Albert articulated much of this doctrine during a sequence of itinerant sermons, in 1260, through the city of Augsburg.[7] The close links between him and other Dominican and Franciscan scholastics and friars preaching on the streets and taking penance in the confessional allowed these ideas to make their way quickly into the urban environments.[8] The extraordinary result was a transformation of usurious gains from sin to honor. Demands for restitution of unjust interest to victims gave way to requirements that the money be delivered to the church for disbursement to the poor. The final step was philanthropy, where "sinners" became "donors," giving gifts rather than returning restitution, all to the greater renown and magnificence of "patron," brotherhood, and commune alike.[9]

One of the media for philanthropy was architecture. It is of particular inter-

FIGURE 10.1 Niccolò di Pietro Gerini, *Money Changers as Benefactors,* in *Story of Saint Matthew* cycle, late fourteenth century. Prato, Chapter House, San Francesco.

est that shortly after the scholastics began to justify wealth and during the very years they began to accept moderate usury, in the 1270s and 1280s, the mendicant settlements in Prato, Florence, and elsewhere began to engage in their first major monumental building campaigns. An indicator of a changed perception of usury by the fourteenth century lies in the two major chapels to the right of the sanctuary of Florence's Santa Croce. Both were gloriously decorated by Giotto, and paid for by the world's two largest banking families at the time, the Bardi and the Peruzzi. Even more telling is the chapter house fresco in Prato's own San Francesco, by Niccolo di Pietro Gerini (fig. 10.1), showing once vilified moneychangers as munificent patrons, framed in the same veste architecture of the fresco of Christ entombed in the chapter house of Sant'Agostino (see fig. 7.17).

The designs of such stunning chapels in Florence and of their more modest counterparts in Prato's mendicant churches and at Santo Stefano replicated at the church transept the imagery of cloister. The new elect were those capable of displaying and, in times of need, of offering their wealth to the community. The

early mendicant opening of the canons' cloister to the city was therefore over. Even the arched buildings at the Piazza della Pieve were designed more with Aristotle and Albertus Magnus than St. Francis in mind: the town desperately needed wealthy leading citizens to sustain its economy and government. Both sacredness and the elect were retreating around the nodes of monumentality. The Pratese government at the time became increasingly oligarchic, and the revived valorization of wealth and power as determinants for rule ultimately left the city open to the highest bidder.[10]

The difficulty, even impossibility, of sustaining the early radical values of the friars in the urban economy partly explains the failure of the friar experiment and the redirection of communal liberties to the liberty of the wealthiest individuals. Architecture and urban space played their roles in other ways. The destruction of the space around Santo Stefano made its setting pathetic, but at the same time highlighted the distance between sacred and profane form and space. The legacy of architectural traditions, whether from the monastic cloister, imperial palace, or papal basilica, which were embedded in the walls and spaces of Santo Stefano, sustained the memory of older social orders, whether the antiworldly and anti-urban monastery or the hierarchical theocratic-imperial court. These functioned like the dormant seeds of Guelphism or Ghibellinism, waiting for the moment to unleash their atavistic forces. The increasing wealth and power of some of the veste triggered the germination of these older social ideals, now invigorated by admixtures of scholasticism and Aristotle. The return to and reconstruction of Santo Stefano and its space at once registered this social reversion, provided spaces for the new oligarchic forces to represent themselves, and thereby, with the final monumental product, valorized all the more the old forms of social order they represented.

The capacity of buildings to sustain cultural memory, however, fails to capture the full force that architecture and urban space had at the time to empower or disempower. The very physicality of architecture gave it its greatest strength, with the capacity to provide tactile contact not only with reassuring forms of traditional rule, but also with the divine emanations present in structures housing the cult of a saint. The putative existence of such emanations was unnecessary for the power of cult sites. The force of cult buildings and spaces lay in the nearly uncontrollable desire of individuals to touch relics and their settings. The regulations around the presentation of the Sacred Belt and the safekeeping of keys to its altar attest to what a challenge it was to regulate private contact with the relic, even, or rather especially, for the highest magistrates and prelates.[11] Here is where symbolism, iconography, even formal readings of architecture fall short of grasping the essence of religious architecture in the late middle ages. Again, it is necessary to turn to poets for the term metonymy, though the process is a physical, even sensuous one, like the rock reported to have embraced Francis during his temptation at La

Verna or the visionary crucifix physically piercing his hands, feet, and side when he received the Stigmata. Santo Stefano resonated not only with the presence of the divine, but also with the very real desire by all to make physical contact with her relic. On the rare feast days when the Sacred Belt was presented outside, the pulpit and by extension the entire piazza became energized by the palpable yearning of all to touch and to be touched by the Belt, the presence of which rippled through the crowds, like an electrical charge, communicated not only visually but physically. Its energy was channeled from the priest's hands to the pulpit, down the façade, and across the space, echoing and reverberating in the arches containing its sacred aura.

During these moments of public ecstasy, which continue to this day at Prato's Piazza del Duomo, as they do at other miraculous sites, not to mention at pop star concerts or similarly mobbed tenor soloist concerts, the experience was one of being part of something admittedly larger than oneself that simultaneously was capable of understanding, even sympathizing, with one's sorrows, sins, and failures.[12] The physicality of the saint made the divine an intimate, like a close friend or family member, but with the remarkable capacity not to talk back or to refute the depth of consolation sought and vicariously received.

This thaumaturgic quality was the basis for the cult of saints since its inception.[13] It was also an essential component to the construction of autocratic rule. The capacity for understanding and clemency, even of healing, characterized emperors and kings from antiquity and before.[14] The construction of the Piazza della Pieve by the commune, like its other projects to sustain the cult of the Sacred Belt, allowed the commune to arrogate to itself these same thaumaturgic qualities. In the crucible of late medieval Prato, this also pushed the balance of social order so far from brotherhood and its onerous responsibilities to paternal authority that the Pratese rendered themselves passive, waiting for the state to understand the individual's incapacity to resolve the town's decline, and to provide, through the Virgin perhaps, the solution.

The atavistic magic of Prato's principal architectural site did not cease with the commune's loss of independence. The victorious Florentines found the cult of the Virgin to be as convenient a means for pacifying the Pratese as their predecessors had. Quite soon they, too, were seduced by their own politics of mystification. In 1352, Orcagna was commissioned to sculpt a magnificent tabernacle dedicated to the Madonna of the Sacred Belt, in the recently rebuilt Oratory of Orsanmichele, at the center of Florence, for the Florentine government. This was at the very time that the commune was bracing itself against an invasion by the Milanese, who were to continue to expand under the Visconti, finally reaching the gates of Florence at the end of the century. It has been suggested that the takeover of Prato was a part

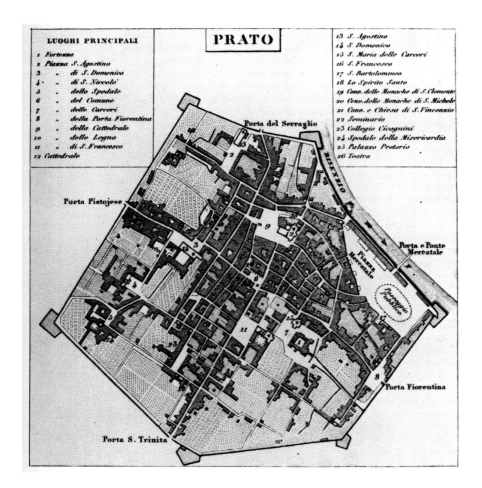

LUOGHI PRINCIPALI

1 Fortezza
2 Piazza S. Agostino
3 " di S. Domenico
4 " di S. Niccolò
5 " dello Spedale
6 " del Comune
7 " delle Carceri
8 " della Porta Fiorentina
9 " della Cattedrale
10 " delle Legna
11 " di S. Francesco
12 Cattedrale

13 S. Agostino
14 S. Domenico
15 S. Maria delle Carceri
16 S. Francesco
17 S. Bartolommeo
18 Lo Spirito Santo
19 Conv. delle Monache di S. Clemente
20 Conv.delle Monache di S. Michele
21 Conv. e Chiesa di S. Vincenzio
22 Seminario
23 Collegio Cicognini
24 Spedale della Misericordia
25 Palazzo Pretorio
26 Teatro

of the Florentines' defensive strategy to the north, a point that is borne out by the extensive additions that the Florentines made to Pratese fortifications.[15] It may well be that an important component of this defensive network was made up not of stone and mortar but of the holy relic that had once saved the Pratese in battle.

The act of taking over Prato's defensive position and relic may have hindered, paradoxically, the Florentines' goal of protecting themselves against a Milanese takeover. By this act they lost an ally who shared their defensive interests and were saddled with a city full of passive subjects, apathetic to taking initiative in order to defend themselves, and thereby to hold the front line of the Florentine northwest defensive flank. Evidence for this apathy is in the construction of the Pratese city walls. They were begun under the free commune in the early Trecento but remained unfinished until the 1380s. Only after repeated enjoinders and threats by the Florentines was the entire circuit completed, in 1384, and even then with a level of workmanship far below that of the pre-1351 portions.[16] Their resistance is understandable. The finished walls included an internal fortified extension, to-day known as the *cassero* (fig. 10.2), providing an escape route from the Florentine

FIGURE 10.2 Attilio Zuccagni Orlandini, *Prato,* showing Florentine cassero linking walls to Castello and showing bastions added to walls at corners, 1832. Firenze, Private Collection.

garrison at the Castello dell'Imperatore to the circuit of walls and beyond, anticipating similar above-ground passages built in Rome and Florence—Antonio da Sangallo the Younger's Passetto di Borgo linking the Vatican to the Castel Sant'Angelo and Borgo wall circuit, and Vasari's Corridor linking the Palazzo Vecchio via the Pitti Palace and Boboli Gardens to Florence's southern city gate, the Porta Romana. What had once provided the defense of Pratese autonomy now secured its privation.

Other events help to explain the decline of civic values in Prato after 1351. The most important of these is the plague of 1348, which dramatically reduced the town's population.[17] The plague's effect was exacerbated in Prato by the poor economy and agricultural production of the time, and surely by the political and moral crisis, which decreased the town's ability or willingness to respond. The apathy of the Pratese in politics and in the construction of its city walls before the arrival of the Florentines therefore proved self-fulfilling. The contemporary Florentine chronicler Matteo Villani said as much when commenting on the malcontent of the Pratese after their fall: "They should realize that, because they did not know how to exercise their liberty, they became subjects."[18] Not until the industrial revival in the eighteenth, nineteenth, and twentieth centuries did the Pratese begin to fill in the town's abandoned walls with houses and residents and to rebuild their economic and political self-determination enough to win their independence from Florence. After 641 years, on April 16, 1992, the people of Prato, represented by the Comitato promotore della Provincia, realized the common aspirations of the Alberti, the propositura, and the citizens of the medieval comune, when they won in the Italian Parliament the right to institute a new Tuscan province, the Provincia di Prato.

Timeline

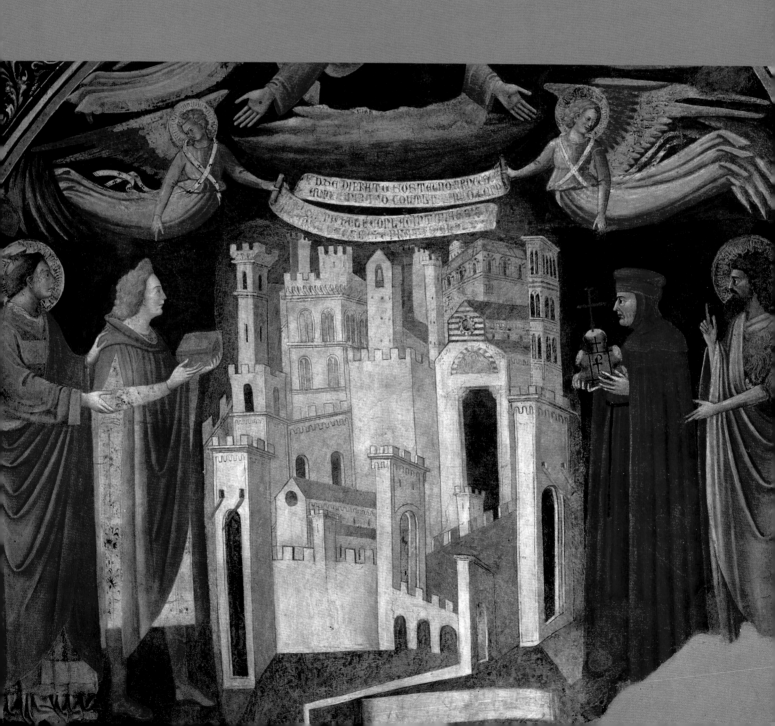

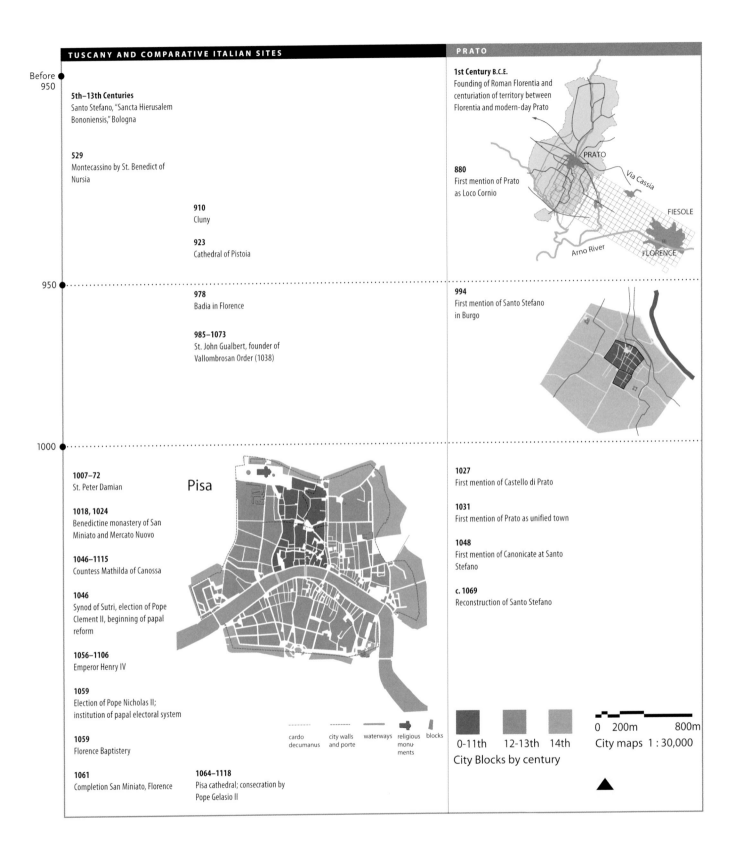

Before 950

5th–13th Centuries
Santo Stefano, "Sancta Hierusalem Bononiensis," Bologna

529
Montecassino by St. Benedict of Nursia

910
Cluny

923
Cathedral of Pistoia

1st Century B.C.E.
Founding of Roman Florentia and centuriation of territory between Florentia and modern-day Prato

880
First mention of Prato as Loco Cornio

PRATO

Via Cassia

FIESOLE

Arno River

FLORENCE

950

978
Badia in Florence

985–1073
St. John Gualbert, founder of Vallombrosan Order (1038)

994
First mention of Santo Stefano in Burgo

1000

Pisa

1007–72
St. Peter Damian

1018, 1024
Benedictine monastery of San Miniato and Mercato Nuovo

1046–1115
Countess Mathilda of Canossa

1046
Synod of Sutri, election of Pope Clement II, beginning of papal reform

1056–1106
Emperor Henry IV

1059
Election of Pope Nicholas II; institution of papal electoral system

1059
Florence Baptistery

1061
Completion San Miniato, Florence

1064–1118
Pisa cathedral; consecration by Pope Gelasio II

1027
First mention of Castello di Prato

1031
First mention of Prato as unified town

1048
First mention of Canonicate at Santo Stefano

c. 1069
Reconstruction of Santo Stefano

cardo decumanus | city walls and porte | waterways | religious monu- ments | blocks

0-11th | 12-13th | 14th
City Blocks by century

0 200m 800m
City maps 1 : 30,000

1070

1070–1143
San Michele in Foro, Lucca

1073–85
Pope Gregory VII (Hildebrand)

1075–1122
Investiture conflict

1077
Absolution of Emperor Henry IV,
by Gregory VII, of papal ban at
Canossa

1078
Mathildan city walls, Florence

1081–85
First mention of consuls in Pisa

1088
L'Università degli Studi, Bologna,
oldest university in Europe

1096–99
First crusade

1097
Consuls in Milan

1098
Cistercian Order

1099
Conquest of Jerusalem; Kingdom of
Jerusalem

1083
First mention of Baptistery of Santo
Stefano

1096
First mention of San Fabiano, Prato

1100

1108
Cathedral, Pistoia, reconstruction

1109–16
Consuls in Bergamo and Cremona

1119
San Giovanni Fuorcivitas, Pistoia,
under control of canons of Prato

1120/1312
Templar Order founding/
suppression

1122
Concordat of Worms

1125
Florence conquers Fiesole

1125–30
Consuls in Siena, Piacenza, Mantua,
Gubbio, Perugia

1138
Consuls in Florence

1138–50
Piazza comunale in Gubbio

1147–49
Second crusade

1147–55
Reestablishment of Senate and Failed
Revolt by Arnold of Brescia in Rome

1107
Prato defeated by pro-papal Florence
and Pistoia under Mathilda of
Canossa, despite defense by Alberti,
Pisa and Arezzo

1130
First Vallombrosan settlement at Santa
Maria di Grignano near Prato

1133
Pistoia forbidden, by Innocent II, to
excommunicate Prato

1133
Pieve of Santo Stefano granted
rights, by Innocent II, to construct
churches in territory

1141
Sacred Belt legendarily brought to
Prato by Michele Dagomari

1142
First mention of consuls in Prato

1148
Prato aligned with Florence and
Lucca

1150

1150–1220
Walls, Pistoia

Pistoia

medieval VIII c. walls 1150-1220 XIV c. walls waterways monuments blocks
street axes walls

1157
First (consular) walls

1152–90
Emperor Frederick I Barbarossa

1153
Pisa Baptistery, Diotisalvi

1155–56
Walls, Pisa

1159–77
Schism

1061
Completion San Miniato, Florence

1162
Destruction of Milan, Lodi, Cremona,
Pavia, Novara, and Como by Frederick I

1163
Gubbio and Perugia recongnized as
free towns by Frederick I

1167
Lombard League

1163
First mention of Boni Homines

1163
Santo Stefano reconstructed by
Carboncetto

1170

1173
Pisa campanile

1173–75
Walls, Florence

1176
Battle of Legnano, defeat of
Frederick I

1179
Consecration of Siena cathedral,
Pope Alexander III

1180

1180
Walls, Siena

1182–1226
St. Francis of Assisi

1183
Peace of Constance with Lombard
League

1186
Coronation of Henry VI as king
of Italy

1189–92
Third crusade with Frederick I

1186–91
Henry VI vicar in Prato

1190

1192
Walls, Bologna

1193
Podestà, Florence

1197
(Guelf) League of Genesio
(Florence, Lucca, Siena, Prato, San
Miniato, and Volterra)

1198
Palazzo della Ragione, Bergamo

1198–1216
Pope Innocent III

1198–1265
Walls, Lucca

1199
Podestà, Siena

1191–92
First mention of Palatium Imperatoris

Lucca

cardo decumanus early medieval walls 12th c walls 15th c walls 1544 walls

1200

1200–3
Piazza Maggiore, Bologna
late 11th–early 12th century:
Bishop's Palace, Pistoia

1202
Reconstruction, cathedral,
Pistoia

1202–4
Fourth crusade

1203
Soil from Mount Golgotha carried to
Pisa by Archbishop Lanfranchi

1203
Constantinople conquered; Latin
Empire created by crusaders

1203
Podestà, Gubbio

1204
Façade of cathedral, Lucca, Guido
da Lucca

1201
Palatium Curie (Senate Palace)

1205

1209–29
Albigensian crusade

1210
Franciscan Regula Primitive
approved, Innocent III

c. 1210–30
First Franciscan settlement, Siena

1210–50
Emperor Frederick II

1211
Arcade ordinances, Bologna

1212
Communal palace, Assisi

1212
Torre dell'Arengo, Bologna

1213
Palazzo del Popolo, Todi

1215
Communal palace, Como

1215
Episcopal Inquisition

1215
Siena cathedral expanded

1216
Founding, Dominican Order

1216–19
Palazzo Comunale, Orvieto

1219
Dominicans, Florence

1220
Franciscan, Venice

1223
Franciscan Regula Bullata approved
Honorius III

1208
Plaza comunis and turris curie

1211–21
Santo Stefano expanded and
campanile constructed by Guido da
Lucca

1221
Papal order to destroy Levaldine and
Dagomari tower-houses built against
new campanile

1225

1225–74
St. Thomas of Aquinas

1226
Dominicans, Siena

1226–28
Franciscans, Florence

1228
Basilica of San Francesco; Platea
Comunis enlarged, Assisi

1228
Palazzo della Ragione, Milan

1228–29
Fifth crusade with banned Frederick II

1228–33
Palazzo del Popolo, Todi, enlarged

1231
Papal Inquisition

1233
Franciscan church, Pisa

1234–40
Arch of Capua

1228
Franciscans in Prato

1235

1238–49
Frederick of Antioch established
as imperial vicar in Prato by father
Emperor Frederick II

Bologna

First half, 13th century
Circla walls, Bologna

189 BC Roman Bononia	III-VII c. walls	VII walls Lombard	XII c. walls "dei torresotti"	early XIII c. Circla walls	waterways	monuments	blocks

1240

1240–50
Castel del Monte

1244
Franciscans, Pistoia

1244
Augustinian Order

1244
Muslim conquest of Jerusalem;
effective end of Latin Kingdom of
Jerusalem

1244
Palazzo di Re Enzo, Bologna

1248–54
Sixth crusade

1250

1252
Fiorino d'oro minted

1253–55
Capitano del Popolo in Gubbio,
Orvieto

1253
Florence conquers Pistoia

1254
Charles of Anjou king of Sicily

1254–55
Florence defeats Siena, Volterra, Pisa,
and Arezzo

1254
Franciscans granted right of
Inquisition

1255–61
Palazzo del Capitano del Popolo
(Bargello), Florence

1256
Gothic alterations, Pisa Baptistery,

Nicola Pisano
1258
Destruction ,Uberti tower-house,
Florence

1258
Expulsion of Ghibellines from Florence

1258
Oltrarno walls, Florence

1259–64
Cupola of cathedral, Siena

1250
Primo Popolo

1260

1260
Battle of Montaperti (Florentine
Guelfs defeated by Sienese
Ghibellines and Manfred)

1260–66
Fall of Primo Popolo in Florence;
Ghibelline rule

1266
Battle of Benevento (Ghibellines
led by Manfred, king of Sicily,
defeated by Guelfs led by Charles
of Anjou, new King of Sicily)

1267–78
Guelf rule in Florence with
Charles of Anjou as Podestà, Secondo
Popolo

1270
Seventh crusade

1277
Guelf domination in Siena under
Charles of Anjou

1277
Pisa Camposanto

1278
Santa Maria Novella, Florence,
enlarged

1279
Palazzo del Capitano del Popolo,
Assisi

1260
Guelfs defeated by Ghibellines

1266
Guelfs defeat Ghibellines

1266–7
Palatium Curie destroyed

1270
Augustinians in Prato; beginning
of Sant'Agostino

1270
San Francesco and piazza built

1276–79
First mention of Sacred Belt in
communal documents

1280

1280 ca.
Ducatus Venetiae internationally
accepted

1281–1328
Castruccio Castracani

1282
Sicilian Vespers (French expelled
from Sicily)

1284–1333
City walls, Florence

1285–96
Lower Siena cathedral façade by
Giovanni Pisano

1287
Silver altarpiece of Sant'Iacopo,
cathedral, Pistoia

1288
Palazzo del Popolo, San Gimignano

1289
Reconstruction, San Francesco,
Pistoia

1281
Dominicans in Prato

1284
Palazzo del Popolo and Palazzo
Comunale (1287)

1284–1310
San Domenico built

1290
Walls, Siena

1290–93
Palazzo del Capitano and Palazzo dei Priori, Todi

1293
Secondo popolo and issuance of Ordinamenti di Giustizia, Florence

1294
Palazzo del Comune, Pistoia

1295
Santa Croce, Florence

1296
Florence cathedral

1297–98
Campo of Siena design ordinances; Palazzo Pubblico

1299–1315
Palazzo dei Priori (Palazzo Vecchio), Florence

1291–93
Ruins of Palatium Curie cleaned

1292
"Sacred and most sacred ordinances" against tower-houses and nobility

1298
Papal indulgence for Sacred Belt

1303
Piazza Santo Stefano, Bologna

1309
Papacy to Avignon

1313
Galeazzo Visconti conquers Piacenza

1313
Matteo Visconti usurps power in Milan

1315
Battle of Montecatini (Pisa led to victory over Naples and Florence by Castruccio Castracani)

1316–28
Castruccio Castracani made Lord of Lucca; Pistoia

1316–17
Apse of Siena cathedral, Camaino di Crescentino

1321–41
Palazzo del Popolo (dei Consoli), Gubbio

1322
Galeazzo Visconti conquers Pistoia

1301
Column erected at place of communal palace to commemorate the house of Michele Dagomari; wooden pulpit built near campanile

1312–13
Muschiattino attempt to steal Belt; Story of Sacred Belt and Punishment of Muschiattino painted by Bettino

1313
New walls

1313–18
Robert of Anjou made ruler of Prato in perpetuity

1314
Palazzo del Popolo expanded

1317
Santo Stefano transept expanded by Giovanni Pisano

1318
Sacred Belt recognized by Pope John XXII

1320–30:
Madonna della Cintola by Giovanni Pisano

1325–44
Torre del Mangia Palazzo Pubblico, Siena

1326–1475
San Francesco, Siena

1329
Florence conquers Pistoia

1332–37
Visconti rule: Bergamo and Novara, Cremona, Como, Lodi, Piacenza, Sondrio, Brescia

1333–34
Paving, Piazza del Campo, Siena

1334–37
Palazzo dei Priori, Todi, enlarged

1334–46
Fonte Gaia, Piazza del Campo, Siena

Siena

1329
Destruction of Ghibelline houses

1330
Wooden pulpit replaced by marble one; Via Coperta between pulpit and Chapel of the Sacred Belt

1332
Ordinance inviting foreigners to settle in Prato

1335
Convenevole, Regia Carmina; erection of Statue of Robert of Anjou at Palazzo del Popolo (Pretorio)

1336
Ordinances for Piazza della Pieve

1336
Palazzo del Popolo expanded

1290
1300
1325

early-medieval walled "città" | early 12 c walls | late-12 early-13 c walls | mid-13c walls | late- 13c walls | 15c walls | monu-ments | blocks

early-12 c walls hypothetical

1337 ●

1337–39
"Good and Bad Government"
frescoes, Ambrogio Lorenzetti,
Palazzo Pubblico, Siena

1337–61
Baptistery, Pistoia

1338
Palazzo del Podestà (Pretorio),
Gubbio

1339
Duomo Nuovo, Siena

1340
Reconstruction, Doge's Palace, Venice

1340
Santa Maria Gloriosa dei Frari, Venice

1340–45
Bargello, Florence, enlarged

1342–43
Duke of Athens in Florence

1347
Revolt in Rome, Cola di Rienzo

1348
Bubonic Plague

1337
Altarpiece of Sacred Belt painted by
Bernardo Daddi

1340
Duccio di Amadore, "Il Cincturale"

1350 ●

1351
Giovanna of Anjou sells rights over
Prato to Florence

1359
Agnolo Gaddi commissioned to paint
the new Chapel of the Sacred Belt

Florence

.............
1078 -
Mathildine walls

- - - - - - -
1173 - 1175
first communal walls

━━━━━━━
1284 - 1333
second communal walls

mid-14th century
Ordinances for façades lining
existing monumental piazzas in
Florence

1352
Orcagna's Tabernacle, Orsanmichele,
Florence

1360

1367
Palazzo Pretorio, Pistoia

1368
Castello, Milan, begun

1376–82
Loggia dei Lanzi, Florence

1378
Ciompi Revolt (Revolt of the
Florentine Wool Carders)

1378–1417
Great Schism with Urban VI (Rome)
and Clement VII (Avignon)

1386
Cathedral, Milan, begun

1390
San Petronio, Bologna, Antonio di
Vicenzo

1395–99
Giangaleazzo Visconti made duke of
Milan, Lombardy, and lord of Siena

1384
City walls completed under Florentine
rule; construction of Cassero

1400

1406–28
Venetian expansion of Terra Ferma

1407
Founding of Cassa di San Giorgio,
first public bank in Europe

1409
Florentine victory over Pisa

1417
Council of Constance ends
Great Schism

1417–31
Pope Martin V

1418–36
Cupola of Florence cathedral

1439
Decree of Union of East and West
Churches

1992, April 16
Prato established as autonomous
province

La Provincia di Prato

GLOSSARY

abutment: architectural; the masonry mass beside or between arches or vaults counteracting their horizontal thrust.

acanthus: architectural; leaf depicted decoratively on Corinthian and Composite column capitals.

ambulatory: architectural; walkway forming the perimeter of a colonnaded courtyard, such as around a cloister.

antipope: religious; contested papal appointment.

apotropaic: religious, art and architectural; warding off evil.

apse: architectural; appended area, usually semicircular or rectangular, terminating a church nave or side aisle opposite the entry.

arcade: architectural; sequence of arches.

archbishop: religious; next level higher in church hierarchy than bishop. Presides over an ecclesiastical province, which includes his own diocese, known as an archdiocese, and other dioceses. The principal city of the ecclesiastical province is known as a metropolis.

archdiocese: *See* archbishop.

assumption: religious; process of ascending to heaven, generally referring to Mary and Christ at the end of their earthly lives.

attic: architectural; the upper portion of a structure; in classical composition refers to the upper portion of a façade.

atto: Italian; act, legislation, statute.

auctoritas: Latin; political, authority.

Augustinian: religious; related to St. Augustine, or to the mendicant order named after him and following his rule.

avello: See *avellus.*

avellus: Latin; architectural and religious; exterior tomb at ground level, usually at mendicant, particularly Dominican, friaries in Tuscany.

axial: geometry; the quality of being aligned along or symmetrically across an axis.

badia: Italian; architectural and religious; monastery.

baptistery: architectural and religious; independent structure or location in church where new Christians are introduced to cult through baptism.

basilica: architectural and religious; church design generally composed of a main and side aisles. The side aisles are generally lower in section, producing what is called a basilical section or a church where the central roof, above the central nave, is higher than the two shed roofs over the side aisles. A church entitled officially Basilica, such as the Basilica of St. Peter or the Basilica of St. Francis, generally houses the remains of or an important relic associated with the saint. It need not be a cathedral. In ancient Roman parlance, basilica can also signify a civic building for magistrates, law courts, and markets.

bastion: architectural and military; rectangular or polygonal additions to defensive walls at corners, gates, and/or towers to project in front of attackers scaling the walls. After the advent of canon artillery they are battered, or angled in vertical profile, to deflect cannonballs.

bay: architectural; individual structural or compositional unit in a repetitive architectural structure or composition.

Benedictine: religious; monastic order founded by Benedict of Nursia (c. 480–543) and following the rule written by the same.

benefice: religious and economic; income-generating asset of a church assigned to one or many members of its clergy.

bichrome: art and architectural; two-colored composition generally referring to contrastingly colored stones, such as green or black and white marbles.

bishopric: religious and political; the territorial holding over which a bishop presides, with responsibility and authority over parishes within the territory.

borgo: Italian; urban and political; a village that is not incorporated into a city, or an extension of a town or city outside of its city walls; may also mean street.

bouloi: Greek; political and architectural; town meeting in ancient Greece. It is also used to signify the place of meeting interchangeably with *boulouterion.*

braccia: Italian; measure; term for the unit of measure for short distances or for the length of material in communal Italy. Each town had its own standard for a braccia, and often had different standards for cloth and architecture. It is somewhat shorter than a yard, corresponding roughly to the length of an arm. The Pratese *braccia a terra,* for distances, was the equivalent of 65.17 centimeters, while the *braccia a panno,* for cloth, was 58.36 centimeters.

broletto: Italian; architectural and political; term for town meeting hall in communal Italy (esp. northern), used interchangeably with Palazzo della Ragione, Palazzo Comunale, etc.

bull: religious; formal written declaration by the pope, such as proclaiming a church law, a new or revived practice or veneration, or adjudicating in religious legal matters.

Burg: German; architectural and urban; castle or castle village.

campanile: Italian; architectural; bell tower.

campanilismo: Italian; architectural and political; architectural competition between communities, literally competing to have the highest campanile, and figuratively referring to a superabundance of civic pride that leads to competition between cities. It is a localized version of what is later referred to as chauvinism on a national level, during and after the time of Napoleon.

campo: Italian; urban; literally "field." It is frequently used to denote a piazza, as in Pisa, Siena, and particularly Venice.

canon: religious; friar associated with a parish, collegiate, bishop, or archbishop's church. Canons generally live in monastery-like cloister compounds, canonicates, or canonries. They may be presided over by a provost, whom, in some cases, they elect. Nonreformed canons may hold benefices individually. Reformed canons hold benefices in common, as they pool all their goods. They follow the Augustinian rule.

capella: Italian; architectural and religious; chapel.

capital: architectural; articulated upper terminus of a column, the type of which in some cases determines the proportions of the column. Greeks used Doric, Ionic, and Corinthian capitals; the Romans added the composite. Late antique, Byzantine, medieval, and later structures include wide variations on the above, as well as many new types, few of which function as the classical orders did in determining column proportions.

capitano: Italian. *See* captain.

captain: political; term used to identify the leader of the broad public body known as the popolo, or people, in medieval Italian communes. Sometimes known by the full title captain of the people, or capitano del popolo.

Carmelites: religious; mendicant order founded at Carmel by the Calabrian monk Berthold c. 1155, though the order traces its origins to the Old Testament prophet Elias.

Carolingian: political; the period or anything related to the reign of Charles the Great (Charlemagne) and of his immediate successors, during the late eighth and early ninth centuries.

casa: Italian; architectural; house of any size or importance. Can refer to anything from an urban fortified dwelling, a castle, or bishop's residence, to the residence of a simple burgher. During the late twelfth century some structures known as casa were renamed palaces—or *palatium* (Latin) and *palazzo* (Italian)—to associate their status with the residences of ancient Roman emperors who, beginning with Vespasian, resided on the Palatine hill in Rome.

castello: Italian; urban and architectural; castle or the village adjoining a castle, in which case the fortified residence denoted by castle in English may be simply named *casa* (Italian) or *domus* (Latin).

castrum: Latin or Italian; urban and military; garrison. A fortified compound generally for troops, usually with a simple rectilinear plan and either masonry or palisade walls.

Cathars: religious; term used to refer to an alternate Christian sect active between the eleventh and thirteenth centuries with dualist beliefs, considered heretical by the orthodox western Catholic church. The term derives from the claim by the Cathars to return to the purity of the first Christians, based on the ancient Greek for pure or spotless, *catharos.*

cathedra: Latin, from ancient Greek; minor arts, architectural and religious; chair or throne; in medieval usage, the throne of a bishop or other figure of importance.

cathedral: religious; the church housing the seat of a bishop. *Duomo* in Italian.

centroid: geometry; geometric center of an area or volume.

centuriation: territorial; the gridding of an ancient Roman municipal territory.

chapel: architectural; place of worship smaller than or inserted within a church.

chaplain: religious; priest officiating mass in a chapel.

chapter house: architectural; the location in a monastery, canonicate, or friary, usually adjoining the cloister, where the monks, canons, or friars gather each day to read a chapter of their rule.

chivalric: military, political, and social; pertaining to the equestrian, or horse-riding, class of knights and higher nobility.

cingolo: Italian; dress, belt, alternately *cintola; cingulum* (Latin).

circuit: urban and architectural; ring of construction, in medieval Italy referring to either city walls or related fortifications, or a ring road.

città: Italian; religious and political; city. In medieval Italy a community could address itself as "city" only if it was the seat of a bishop or archbishop.

city-republics: political; city-state with a democratic or semidemocratic form of government.

city-state: political; sovereign state the territorial extent of which coincides with a city and its immediate territory. Synonymous in Italy with commune.

classical: architectural; related to or resembling ancient Greek or Roman architectural style and practice. Precise usage distinguishes between classical, referring to ancient structures and practice, and classicizing, referring to later imitations.

claustral: architectural; related to or resembling cloisters.

clerical: religious; related to the clergy.

cloister: architectural; exterior common space, walled-off at its perimeter, shared by members of a coenobitic Christian religious community. At least as early as the plan of St. Gall (c. 817), cloisters began to appear as rectilinear, often square spaces lined with a colonnaded ambulatory. Generally the various structures associated with the daily life and prayer of the brotherhood or sisterhood are organized around the cloister.

coenobitic: religious; related to a Christian religious community that shares meals, to be distinguished from hermit communities, where the members do not cohere as a community sharing meals or labor.

commune: political; term used by Italian city-republics and most contemporary Italian municipalities to describe themselves. The term may derive from an alternative phrase for describing the apostolic life of a Christian community: the vita communalis. The comune of Italy's city-republics mirrored the horizontal organization, pooling of resources, elective representation, and often architectural forms and political statutes of religious brotherhoods.

confraternity: religious; lay brotherhood. Lay religious associations began at least as early as the fighting companies of the crusader. The mendicant orders popularized and diffused confraternities as their third, lay male orders. By the end of the thirteenth century, parishes, cathedrals, and other nonmendicant religious institutions introduced their own confraternities, such as the Confraternity of the Sacred Belt in Prato, or that of Orsanmichele in Florence.

consorteria: Italian; political; clan organization tied together by blood ties and oaths, with militant identity based on rural feudal nobility. Consorterie built and identified themselves with urban tower-house complexes.

Constructivism: art and architectural; early Soviet artistic movement. Proponents reinvented art and graphical communication autonomously from czarist traditions. They sought visually to empower the working class. Like Futurism, it constituted an aesthetic of action, though without nostalgic heroicizing tendencies.

consul: political; voting member of a consular regime.

consular regime: political; earliest representational governmental regimes of the Italian city-republics, developing between the late eleventh and mid-twelfth centuries.

convent: lay and religious; institution or structure for living together. The term can be applied either to lay communities, such as Buonconvento near Siena, or to religious communities, more often to female monastic or mendicant settlements.

corbel: architectural; structural protrusion cantilevered from a wall to sustain the load of beams, arches, or other structural elements transmitting forces higher in the building.

corporate: religious and economic; concerning or related to a lay or lay religious organization parallel or identical to a confraternity, with the emphasis that the grouping of individuals forms an indivisible, bodylike identity. Fighting, economic, labor, or lay religious organizations could all use the term, which is still in use today in its original sense in English and United States law to describe a group functioning as an individual before the law.

council: political; a governing or advisory group. In medieval communes councils developed as more broadly representative versions of consular regimes, with general councils composed at times from all voting citizens.

count: political; a rank of nobility, below duke.

coursing: architectural; horizontal band of masonry.

crossing: architectural; intersection of the nave with the transept, if a transept is present.

crypt: architectural; basement-level cult area of a church, generally beneath the sanctuary.

cupola: architectural; hemispherical projection articulated within the ceiling and in some cases the roof of a building. It can be elliptical or octagonal in plan, and catenary or segmental in section. So long as a circle or ellipse can be inscribed in the thickness of the walls, even an octagonal or polygonal cupola functions as a continuous-shell structure, resolving most vertical forces horizontally around its ring of structure.

curia: Latin; political; signified senate in ancient Rome and many communal Italian governments. The papal curia refers instead to the various ministries assisting the pope in governance and judicial matters. It is not to be confused with the college of cardinals, which elects the popes.

denaro: Italian; economic; base currency. 12 denari made a soldo, and 20 soldi made a lira in fourteenth-century Prato and Florence.

diocese: political and religious; the religious-territorial domain of a bishop.

diploma: legal; document granting territory and or privilege.

disciplinati: Italian; religious; thirteenth-century penitential movement originating in Perugia from mendicant and popular roots, the adherents to which flagellated themselves.

Dominicans: religious; mendicant order founded by St. Dominic (c. 1170–1221).

domus: Latin; architectural; house.

duomo: Italian; religious; cathedral, derived from Latin *domus.*

ecclesia: Latin; religious; church, either as a single structure, or the entire Christian institution.

emperor: political; during the middle ages refers to the Holy Roman Emperor, based primarily in modern-day Germany since the time of Charlemagne, but at different moments in its history with territories in France, Spain, Italy, Sicily, and elsewhere.

enfeoffment: political; delegation of economic and/or political rights over territory in exchange for a feud, or fee, of revenue or military services.

engaged: architectural; column that is partially embedded in the structure behind it.

entablature: architectural; horizontal portion of a classical composition that extends above and across a series of columns, piers, pilasters, or other actual or figurative supports. It comprises an architrave, frieze, and cornice.

episcopacy: religious; alternately episcopate; office of a bishop or his diocese.

episcopal: religious; pertaining or related to the office of a bishop.

exarch: political; Byzantine viceroy in Italy.

exarchate: political; Byzantine dominion in Italy, with its capital at Ravenna.

expressed: architectural; process of emphasizing a structural form with nonstructural decoration.

extrados: architectural; outer, vertical face of an arch.

façade: architectural; primary (usually front) elevation of a building.

facciata: Italian; architectural; façade.

fenestration: architectural; pertaining to windows.

flutes: architectural; vertical incisions of a column, originally developed to mask the joints between the cylindrical drums composing the column shaft.

foliation: architectural; acanthus or similar leaves used in Corinthian capitals and classicizing decoration.

formal: art and architectural; visually expressive characteristics of a work of art at any scale and medium, deriving from intrinsic qualities of the medium and independent from narrative or communicative content.

forum: urban; main public square of a Roman town.

Franciscans: religious; mendicant order founded by St. Francis of Assisi (c. 1181–1226).

frieze: architectural; either a part of or above an entablature, usually articulated with ornament, figures, or scenes.

gallery: architectural; continuous sequence of openings separated by columns or piers and usually arched, above the ground level.

gastaldo: Italian; political; also castaldo; Lombard administrator of royal goods, especially properties or settlements.

Ghibelline: political; pro-imperial faction in thirteenth-century Italy, deriving from the name of the castle of the Hohenstaufen at Waiblingen in Franconia, Germany.

gonfaloniere: Italian; political; bearer of a flag in communal governments, usually a representative of a neighborhood, but sometimes also the leader of the judicial branch.

Gothic: architectural; architectural expression deriving from the work of Abbot Suger at the Abbey church of St. Denis near Paris, characterized by pointed arches and emphatic vertical structural members allowing a reduction of wall and an increase in windows and therefore of interior light. It became eventually associated with the kings of France, and, in Italy during the thirteenth century, with the papacy, to whom the French offered military support.

Guelph: political; pro-papal faction in thirteenth-century Italy, deriving from the house of Welf, Dukes of Bavaria, whose family contested the crown of Holy Roman Emperor, receiving papal support as least as early as the beginning of the thirteenth century. The Italian Guelphs continued as a pro-papal party into the fourteenth century.

hemicycle: architectural; a half-cylindrical extension of a space in plan, with a half-domical ceiling. Church presbyteries and their flanking chapels are often hemicycles.

historiated: art; designed to portray nonabstract figures or stories.

host: religious; eucharistic wafer.

iconoclasm: religious; movement in eighth-century Byzantium to cease using images—icons—to represent saints, and even to destroy existing images.

iconography: religious; imagery associated with a saint, Christ, or an Old or New Testament story.

imperium: Latin; political; empire or the quality of holding imperial power.

indulgence: religious; remission of years of atonement for sins in purgatory for faithful who fulfill certain sacred tasks or duties.

Inquisition: religious; the church institution developed over the late twelfth and early thirteenth centuries to track down heretics and either reconvert or eradicate them.

intarsia: Italian and English; architectural and decorative arts; inlay, generally in wood. Stoneworkers or woodworkers specializing in this technique called *intarsiati.*

intercession: religious; intervention of a saint or angel to assist a believer by answering prayers or by recommending him or her to the Virgin or Christ for salvation.

interdict: religious; prohibition excluding a Christian individual or community from performing or participating in religious functions. It is similar to but less extreme than excommunication, which excludes the individual from the community of the church and therefore from salvation.

investment: political and religious; process of appointing an individual to a sacred office, such as priest, provost, abbot, bishop, archbishop, or cardinal.

laud: English; poetic; song of praise.

lay: religious; individuals who have not taken holy orders.

legate: political; representative—for example, papal legate.

lira: Italian; economic; monetary value used in Prato and elsewhere in medieval Italy.

liturgy: religious; activities associated with performing a sacred rite, including mass, baptism, marriage.

loggia: English and Italian; architectural; arcaded or trabeated structure providing covering, either independent of a structure, attached, or beneath.

Lombard: political; Germanic tribe that settled in Italy in the mid-sixth century and was defeated and absorbed by the Carolingians in the late eighth century.

magnificence: philosophical and religious; term became closely associated with munificence, as the only virtue allowed by Aristotle that is available only to the wealthy. Through Albertus Magnus and Thomas Aquinas' rereadings of Aristotle, munificence became a justification for wealth.

margrave: political; noble; feudal rank below duke and above count or earl.

marks: political; territory controlled by a margrave.

marmolarius: Italian; architecture; marble worker; more specific than mason.

mendicant order: religious; urban sacred brotherhoods modeled on both monastic organizations and early Christian apostles committed to poverty, chastity, and preaching. Mendicants begged or worked for their sustenance, which they shared in common, and preached to urban laity. They include the Dominicans, the Franciscans, the Carmelites, the Augustinians, and the Servites.

merlons: architectural; upward-pointing portions of crenellation. In Italy these had varied patterns, sometimes indicating Guelph (plain) or Ghibelline (butterfly-curves) allegiance.

metonymy: poetic; reference to an entity using something characterizing or associated with it, such as a part. Similar to synecdoche, which specifically refers to a part used to express the whole.

nave: architectural (from Latin *navis,* or ship); primary longitudinal portion of a church, to be distinguished from side aisles.

niche: architectural; space designed to hold objects.

opera: Italian; art and architecture; workshop. In medieval Italian cities, opere were generally workshops linked to religious institutions and the various architectural projects for which they were responsible.

oratory: architectural; chapel or portion of a sacred structure in which one sings.

palace: architectural; residence housing a figure of importance, derived from the Palatine hill in Rome, where the Flavians and later emperors located their residences.

palatium: Latin; architectural; palace.

palazzo: Italian; architectural; palace.

palisade: architectural; defensive wall circuit constructed out of wood.

pallium: Latin; religious; Italian; palio; mantle signifying rank, election, or victory.

pieve: Italian; religious; parish.

pilaster: architectural; vertical relief element that indicates the transmission of vertical load as if functioning like a buttress or engaged column. While pilasters may indeed have actual structural elements behind them, they are not generally structural themselves.

platea: Latin; urban and architectural; piazza.

plaza: medieval Latin; urban and architectural; piazza.

plebs: Latin; religious; parish, from the Latin term for people.

podestà: Italian; political; town manager brought in from outside a community and housed in a cloistered area of a governing palace in order to avoid corruption.

polyptych: painting; panel painting composed of more than one scene, usually images of saints, the Virgin, and Christ. Often placed on a predella framing smaller scenes narrating the lives of the saints depicted above.

popolo: Italian; political; people, or general citizenry. It becomes applied as a title for popular governments in Italy in the second half of the thirteenth century.

porta: Italian; urban and architectural; gate or door.

prebends: religious; benefice; endowment to support a canon or other member of the clergy.

predella: Italian; art; sequence of painted scenes, usually telling the life of a saint, situated along the base of a single-panel painting or polyptych.

presbytery: architectural; sanctuary, place from which the priest officiates the mass.

pretorio: Italian; referring to the *podestà* or by extension generic communal governance.

propositura: Italian; religious; provost's church.

proposto: Italian; alternatively *preposto;* religious. *See* provost.

provost: religious; official appointed or elected to preside over a collegiate church community or canonicate.

pubblico: Italian; political; public.

ragione: Italian; political; reason; used during communal period often as a title for town halls, as palaces of reason, emphasizing rule by law versus rule by man.

rampart: architectural; defensive wall structure, sometimes just mounded earth, but usually terminated with a masonry wall or parapet.

reform: religious; recurrent process of returning church institutions to the originary mission of Christ and the apostles. It is also a technical term referring to canonicates whose members do not hold property individually, but only in common.

rubric: legal; heading or subtitle, usually used to signify the corresponding portion of a legislative document.

sacristy: architectural; space in a church where priests prepare themselves for the mass and store their vestments.

scholastics: religious; theologians, usually mendicants, teaching and writing at universities from the twelfth century onward.

section: architectural; orthographic drawing representing a cut through a building, either longitudinal or lateral (cross), usually highlighting the structure cut and projecting the elevations beyond.

signoria: Italian; political; political body ruling a castle or city.

soldo: Italian; minor unit of currency composed of 12 denari, and forming one-twentieth of a lira in fourteenth-century Prato and Florence.

summa: Latin; religious; definitive theological text.

superimposed: architectural; term referring to the modulation of architectural orders when stacked in classical or classicizing composition, moving progressively upward from Doric through Ionic, Corinthian, and finally composite.

tabernacle: architectural; structure housing an altar or image, often beside roadways or, in towns, on house corners; also a structure inside a church designed to hold and protect the host or another holy object.

thaumaturgic: religious; related to rites emphasizing miraculous or religious-magical powers.

theocratic: religious; religious rule over religious and secular domains.

third-order: religious; lay mendicant orders.

toponym: urban, territorial; place name.

tower-house: architectural; fortified structure like a castle built for residence and defense of consorterie in cities.

trabeated: architectural; post-and-beam type of construction, in wood or masonry, such as with columns and architraves.

transept: architectural; portion of the church intersecting the nave at the crossing and extending beyond the walls of the nave to form a T or cross-like plan.

tympanum: architectural; round portion of a round or pointed-arch portal above a rectangular door.

vescovo: Italian; religious; bishop.

veste: Italian; vestments, particularly for mendicant tertiaries.

Vitruvian: architectural; related to the Roman architect and architectural theorist Marcus Vitruvius Pollio (c. 75–c. 25 B.C.E.), and his work *The Ten Books of Architecture* (*De architectura libri decem*), from c. 25 B.C.E..

NOTES

2 | PRATO BEFORE PRATO

1 For the extent of the region of Pistoia in antiquity and the middle ages, see Puccinelli, "Viabilità nel contado pistoiese," 193–211, esp. 193–201 and fig. 1.

2 Moretti, "Ambiente," 3–78, esp. 38–39; Fantappiè, "Nascita," 79–299, esp. 80–81; Nuti, "Ricerca," 1–93, esp. 63–64.

3 Moretti, "Ambiente," 11, 25, 38–39; Fantappiè, "Nascita," 80.

4 The Italianized *-iano* and *-ano* from the Latin *ianus* serve as suffixes for many of the names of the area, such as Vaiano, Sofignano, Schignano, Coiano, Grignano, etc. See Ferdinando Carlesi, *Origini della città e del comune di Prato*, Biblioteca istorica della antica e nuova Italia, vol. 143 (1904; facsimile reprint, Bologna, 1984), 10; Moretti, "L'ambiente," 24–25; Fantappiè, "Nascita," 81–82.

 Some scholars have hypothesized that one of these settlements was a *vicus* or *pagus,* perhaps the *pagus Cornius.* This would have been transformed as early as the fifth century into the Christian plebs at *borgo Cornio,* which became Prato. The only evidence for this is the long-standing patron saint of the parish, St. Stephen, who was made the patron saint of many parish and municipal churches at that time. There is no archeological or other evidence. Renzo Fantappiè is therefore justifiably cautious in recounting the pagus Cornius theory in his "Nascita," 82–83. For two sides on this debate see Solari, "Prato romana?" 3: 145–48; 4: 97–100; and Lopes Pegna, "Prato romana," 3–20. For a refutation of other, more far-fetched hypotheses, such as a *vicus Bizantium,* see Carlesi, *Origini della città,* 11–17.

5 Fiumi, *Demografia,* 8; Moretti, "Ambiente," 20–21; Fantappiè, "Nascita," 80.

6 Schneider, *Ordinamento pubblico nella Toscana medievale,* 147–48.

7 Cerretelli, "Ambiente e gli insediamenti," 63–78, esp. 64.

8 Schneider, *Ordinamento pubblico,* 165–70; 179 n. 1. See also Moretti, "Ambiente," 27.

9 On the victories of the Lombards over the Exarchate in the eighth century and the subsequent victory of the Carolingians in Italy over the Lombards and its impact, see Wickham, *Early Medieval Italy,* 44–45, 47–55; for a brief mention of the situation in the area of Prato, see Moretti, "Ambiente," 25–27; and Fantappiè, "Nascita," 83–87.

10 For artisans and fabricators, see Fantappiè, "Nascita," 100, 131. For the system of canals and mills, see Moretti, "Ambiente," 14–20, and particularly Piattoli, *Statuto dell'arte dei padroni dei mulini,* where, on 183 n. 1, Renato Piattoli provides the first edited record of a mill, dated October 1003 (actually 1002).

 The first evidence of wool production, beyond the presence of canals for washing, is in the street name Gualchiere, "fuller," first recorded in 1107; see Cherubini, "Sintesi conclusiva," 963–1010, esp. 975–76; and Piattoli and Nuti, *Statuti dell'arte della lana,* 1.

11 Moretti, "Ambiente," 39–45.

12 See Fantappiè, "Nascita," 83–87. Renato Piattoli dates it initially in 774 in "Antico ricordo," 1: 29–48, 2: 76–96. See also Piattoli, *Carte della canonica,* 15 n. 5.

 There are various possible origins of the term *Cornio.* Arturo Solari claims a Germanic origin, in "Prato romana?" 147. It could also derive directly from the archaic Italian *cornio,* in modern Italian *corniolo* and medieval Latin *corneus* from the classical Latin *cornus,–i,* meaning cornel-cherry tree. See Devoto and Oli, *Dizionario della lingua italiana,* entry under "cornio." See also Piattoli, "Antico ricordo," 38–39.

13 "Casa infra burgo, prope ecclesia S. Stefani"; published in Santoli, *Libro croce*, 251, document 136; see also Fantappiè, "Nascita," 91 n. 37, 98 n. 92; 104.

14 Carlesi, *Origini della città*, 21–22; see also Santoli, "Diploma dell'Imperatore Ottone," 21–23.

15 For a summary of the life, veneration, and iconography of St. Stephen, see entry for "Stefano" in *Bibliotheca Sanctorum*, 11: 1376–92.

16 This was during the episcopacy of Bishop Petronio. Stocchi, *Emilia-Romagna*, 306–8.

17 With the decline of imperial Roman administration in the early middle ages, the vacuum of power was generally filled on the local level by the only stable institution remaining, that of the bishop, who inherited the jurisdiction of secular Roman magistrates. The linkage of the seat of a bishop to the existence of an administrative center with control over a surrounding region was so strong that its absence prohibited a community from addressing itself as civitas, and rendered suspect the legitimacy of its territorial authority. See Waley, *Italian City-Republics*, 1–2; and Tabacco, *Struggle for Power*, 166–76.

18 For the balancing of bishops' power by counts and dukes under the Carolingians and the subsequent return of full power to the bishops, see Keller, "Der Gerichtsort in oberitalienischen und toskanischen Städten," 1–72.

19 Plebs was used initially to describe urban subdivisions, but only later the term came to be applied to rural settings such as Borgo al Cornio. The change in terminology occurred between the fifth and eighth centuries. See Bernardini, *Pievi toscane*, 7–8.

20 See Moretti, "Ambiente," 25; and Fantappiè, "Nascita," 91, 138 n. 36. By the late twelfth century, a total of fifteen parishes and churches under the propositura of Prato are listed in various papal briefs, including one of Pope Urban III from May 26, 1186–87: "capellam Sancte Marie de Castello, capellam Sancte Trinitatis, capellam Sancti Petri, capellam Sancti Salvatoris, capellam Sancti Marci, capellam Sancti Thome, capellam Sancti Petri de Insula, capellam Sancte Lucie, capellam Sancti Bartholomei, capellam Sancti Petri de Fikine, capellam Sancti Vincentii, capellam Sancte Marie de Ribaldo, capellam Sancti Martini de Paparino et quicquid iuris et reverentie in capella Sancti Martini de Surginana et in capella Sancti Michaelis de Cerreto habetis. Antiquas vero et rationabiles consuetudines, quas hactenus habuistis, vobis nichilominus,

auctoritate apostolica, confirmamus"; see *Carte della propositura*, 436–37, document 235.

21 "Possiamo quindi ritenere che nella diocesi di Pistoia, anche per la sua posizione geografica, dovesse esservi una particolare attenzione a costituire uno dei pilastri della situazione politico-religiosa, di cui Prato veniva ad essere il punto estremo, nella direzione di Firenze"; Manselli, "Istituzioni ecclesiastiche," 763–822, esp. 768.

22 On the delegation of authority by Carolingian and post-Carolingian feudal rulers, see Tabacco, *Struggle for Power*, 151–66.

23 The full range of activities starting from 1006 is clear in the edited papers of the parish, *Carte della propositura*. For a thorough analysis of these and other original sources documenting the authority of and activities associated with the Pieve di Santo Stefano in the tenth and eleventh centuries, see Fantappiè, "Nascita," 83–103.

24 The architecture followed Roman terminology and building types. The larger churches of the civitas were known as *basilicae* or *cathedrae*, depending whether they were martyrial or episcopal seats, and the local churches were named simply after the district unit—plebs. These structures were generally variants of the Roman basilica type, with apses at the end, from which the chief administrator, now bishop or parish priest, presided. Thus, the accident of Prato's medieval origins did not exempt it from classical traditions of authority. Rather, the absence of antique Roman roots made the imposition of Roman Christian authority all the more urgent, in order for the regional authorities to secure their control at a considerable distance.

25 While the church is first mentioned in 994, a canonicate housing the canons associated with the provost of Santo Stefano is not mentioned until 1048; the exact description of its location beside the church is given in 1069; see *Carte della propositura*, 19–21, document 9; 45–47, document 21. The first mention of a cloister is in a document dating between 1079 and 1080; ibid., 81, document 38.

26 See Silva, "Architettura del secolo XI," 66–96, esp. 66.

27 Bernardini (*Pievi toscane*, 11–22) saw the reconstruction of parish churches, particularly from the twelfth century onward, as an attempt by increasingly powerful urban authorities to enforce their hegemony. To do so they tried to civilize the pagan tendencies of rural churches.

Italo Moretti and Renato Stopani, among others, suggested that the pievi had little architectural or decorative significance before the millennium. Moretti emphasized that in the Florentine countryside, one parish dates from the tenth century, about ten from the eleventh, with nearly all of the hundreds of parishes built or rebuilt in the twelfth. See Moretti and Stopani, *Architettura romanica religiosa*, 30 n. 2, and, more generally, 29–44; and Moretti, "Ambiente," 31.

28 Moretti, "Ambiente," 19–22, 29–30; Fantappiè, "Nascita," 99–104.

29 Manselli, "Istituzioni ecclesiastiche," 765.

30 "Dentro la curtis e la casa di Ildebrando conte, presso il castello di Prato." See Fantappiè, "Nascita," 92; and Piattoli, "Antico ricordo," 86.

31 There are varying interpretations of the location of the Alberti holdings in relation to those of the bishop of Pistoia and the propositura representing him. See Fiumi, *Demografia*, 8–22; Moretti, "Ambiente," 27–29; Fantappiè, "Nascita," 92–99.

32 Fiumi, *Demografia*, 16; see also Davidsohn, *Forschungen zur Geschichte von Florenz*, 1: 79.

33 For the eleventh-century garden and cemetery, see Fantappiè, "Nascita," 95, fig. 3.

34 See *Carte della propositura*, index under "canonica, cannonica, canica, calonica."

35 The origins of this structure, shared by canons and monks, lay in both republican and imperial Roman senates, deriving from Greek *bouloi*, and from the hermit origins of the first coenobitic orders in the early church, inspired by Old Testament prophets. Both traditions accorded deliberative responsibility to individuals, and with it power, either de iure or de facto, to influence decisions affecting the group.

36 No document explicitly states that the canons were established as a reform order or were converted. The first mention of the canons indicates their adherence to the rule "in ipsi clerici e canonici qui ibidem modo ad ordine canonico ordinati fuerit vel ad illi qui in antea ibi ordinati fiunt," *Carte della propositura*, 20, document 9. Many of the subsequent mentions of the canons repeat their submission to the rule.

37 "Liber de diversis ordinibus II" in Migne, *Patrologia Cursus Completus*, 213: 827. See also Chenu, *Nature, Man, and Society*, 218 n. 35, also for the translation.

38 Chenu, *Nature, Man, and Society*, 217–19.

39 Anselm, among others, responded to critiques of the canons, and countered that they were based less on piety than on self-interest: "Many people are amazed and create problems for themselves and others. As slanderous inquisitors they ask: Why all these novelties in the church of God? Why these new orders?" "Dialogi," Migne, *Patrologia Cursus Completus*, 188: 1141; Chenu, *Nature, Man, and Society*, 217.

40 By the early twelfth century, one regular canon was becoming infamous for his fomenting of antiepiscopal, and even antipapal, communal revolt. This was Arnold of Brescia (c. 1100–1155). Basing his critique on the eleventh-century reform of canons, which allowed canons to hold wealth or property only in common, not individually, Arnold attacked wealthy bishops and popes alike, even in Rome.

The precise events surrounding Arnold's activities in Rome indicate how the ideas of the canons were able to have powerful political as well as religious implications. The commune of Rome was revolting against the pope's secular rule when Arnold arrived in the city in 1147. He soon rose to the leadership of the revolting citizens, who sought to establish a revived Roman republic, replete with a senate as a counterpoint to the corrupt papal curia. Arnold precociously advocated a clear separation between church and state, anticipating the U.S. Constitution by 650 years. This revived republic threatened not only the pope, but also the idea of theocratic empire. The Holy Roman Emperor therefore intervened to suppress it, although he was at the time a bitter rival of the pope for the crown of post-Roman imperial authority in the Latin west. He was less protecting the pope than he was protecting the one value dearest to them both: the inextricable relationship of church, state, and imperial rule. See Little, *Religious Poverty*, 109–10.

3 | PRATO UNIFIED AND INDEPENDENT

1 See Fantappiè, "Nascita," 91, 138 n. 36. The place-name Borgo al Cornio continued to be used for the area around Santo Stefano until a document of May 30, 1084, in which Santo Stefano was described for the first time as being "posta in Prato"; ibid., 94.

2 For the documents, see *Carte della propositura*, 103, document 50; 111–12, document 54; 160–61, document 80.

3 The document is from November 2: "In Christi nomine. Breue inuestitionis et concessionis securitatis ac / firmitatis pro futura hostensions, quod factum est Pratum in loco / qui vocatur Plaza, committus Pistoriensium; feliciter. In presenti / a Pecciori et Mogionis germani." It is published in full in *Carte della propositura*, 301–3, document 160.

4 Enrico Fiumi claimed that the Alberti had jurisdiction over the Castello, which was part of their territory extending north along both sides of the Bisenzio valley—essentially the same area as was under the religious jurisdiction of the Pieve of Santo Stefano, and which later came under the commune. Based on the supposition of the Alberti's local jurisdiction, Fiumi made the important assertion that Prato was a feudal construction: "Riassumendo, la terra e distretto di Prato è, politicamente ed amministrativamente, una costruzione feudale, innalzata e cementata nel fiore della potenza albertesca a spese dei comitati fiorentino e pistoiese. Il comune di Prato ereditò, sia pure con l'ipoteca imperiale, il dominio dei conti Alberti." See Fiumi, *Demografia*, 21.

Renzo Fantappiè contested Fiumi's entire argument, reversing the dependency so that the Alberti were the beneficiaries of the economic growth of the two communities at Prato, not vice versa, and that neither community was under an Alberti *signoria*; Fantappiè, "Nascita," 94–99. The scholar argued that Borgo al Cornio was never a feudal dependency, not even of the bishop of Pistoia. He furthermore contended, on philological bases, that the 998 diploma from Otto III applied only to lands in the region, but not within the settlement.

Though Fantappiè's argument is not entirely convincing, his basic assertion is well taken—that neither the bishop of Pistoia nor the Alberti constituted powerful authorities in Prato, and that the prime movers were the citizens. Although the Alberti were officially invested as the lords of Prato, this occurred much later, in 1155 and 1164, and apparently only on paper. The Alberti's power had been gravely weakened in the area, with their 1107 defeat by Mathilda, and after the pope and propositura had already begun to recognize an independent communal, consular government, in 1142; see Raveggi, "Protagonisti e antagonisti," 613–736, esp. 614.

5 The Castello was the first residential compound in the area to be protected by stone walls. For this and the more temporary defenses of the Borgo, see Fantappiè, "Nascita," 104–10.

6 There is some debate as to how much the Alberti counts were responsible for the early development of Prato. See Fiumi, *Demografia*, 8–22; Fantappie, "Nascita," 95–96, and Moretti, "Ambiente," 27–29.

7 On "pratum" as a common term for a field, whether for pastureland or as military marshaling ground, see the many references in Schneider, *L'ordinamento pubblico*, index entries under "prato, pratum, and pratus"; see also Carlesi, *Origini della città*, 23–24; Moretti, "Ambiente," 27.

8 Fantappiè, "Nascita," 114.

9 The documents are transcribed in *Carte della propositura*, 103, document 50, 111–12, document 54, 160–61, document 80.

10 Ibid., 45–47, document 21. A church of San Laurentio is also described as "edificato" in this document. This does not contradict the interpretation of "edificato" as implying an active or recently completed building program, as San Lorenzo had never been mentioned before and therefore may have been constructed or rebuilt at this time in response to the same population growth that spurred the rebuilding of Santo Stefano. For more on San Lorenzo, see Fantappiè, "Nascita," 105.

11 See the analysis of excavations by Gurrieri, "Prime considerazioni," 68–70; and Bellosi, Angelini and Ragionieri, "Le arti figurative," 907–62, esp. 907–8.

12 For a comparison with the mosaics at Santo Stefano, see Gurrieri, "Prime considerazioni," 70, who linked the two, dating them both to the tenth century. See also Marchini, "La chiesa di San Fabiano," 65; and Fantappiè, "Nascita," 144 n. 190, 145 n. 145, who also linked them to the time of the Santo Stefano mosaics, dating them between the end of the eleventh and first half of the twelfth centuries. Giovanna Ragionieri considered the condition of the mosaics at Santo Stefano too poor to serve as a basis for any comparison with those at San Fabiano; see Bellosi, Angelini, and Ragionieri, "Le arti figurative," 907–8. Italo Moretti concurred that the San Fabiano and Santo Stefano mosaics appear connected, though he did not commit to a dating; in Moretti "Architettura," 871–906, esp. 871–72.

For other works only on the San Fabiano mosaics, see Badiani, "Il mosaico del pavimento," 20–23, who dated them between the

tenth and eleventh centuries; Mario Salmi dated them to the twelfth century in Salmi, "Pietre e marmi intarsiati e scolpiti," 114.

13 The closeness in dating suggests that the two sacred building complexes shared not only mosaicists, but also masons. There is evidence that another, earlier structure existed before this date at San Fabiano; see Moretti, "Architettura," 871, 901 n. 4. For more on San Fabiano, see Baldanzi, "Abbazia o prioria di San Fabiano," 115–28; Lucchesi, *Monaci benedettini vallombrosani*, 118; Marchini, "Chiesa di San Fabiano"; and Fantappiè, *Bel Prato*, 1: 250; 2: 216. For the economic importance of San Fabiano in the eleventh and twelfth centuries, see Moretti, "Ambiente," 34.

14 For a tentative attribution of the crypt as pre-Romanesque, see Marchini, "Cattedrale di Pistoia," 19–32, esp. 21–22. For a more secure date of a fire of 1108 after which the cathedral was rebuilt, see Secchi, "Restauro ai monumenti romanici pistoiesi," 101–11, esp. 102–4, with a plan and photograph of the crypt and its paving, in figs. 2 and 3 (tav. XXX and XXI).

15 For a discussion of the development of manuscript initials in Pistoia and Tuscany in the eleventh through thirteenth centuries, see Berg, "Miniature pistoiesi del XII secolo," 143–56.

16 Gurrieri, "Prime considerazioni," 68–70.

17 See *Carte della propositura*, 202–5, esp. 203, document 104 (January 1108), and 212–14, esp. 213, document 109 (September 11, 1116).

18 Secchi, "Restauro," 102. The triple apse termination would have been consistent with that of other parish churches and monasteries in the region, such as Santa Maria a Colonica and Sant'Ippolito in Piazzanese; see Moretti, "Architettura," 876, 877 figs. 2a, b.

19 Giuseppe Marchini assumed that the earliest portion of the church was the cloister, built just before Guido da Lucca's intervention, documented in the early thirteenth century; Marchini, *Duomo di Prato*, 31–33. Though Renzo Fantappiè dated the mosaics and triple-apse termination of the church to the late eleventh and early twelfth centuries, he considered the north wall and its windows to be from the mid-twelfth century; "Nascita," 119, 163. Italo Moretti dated the earliest portions to the late twelfth century; "Architettura," 872.

20 The location of the eleventh-century mosaic paving and a quarter circular wall fragment just by the north wall corroborate that today's

wall is in the same location as that of the eleventh century.

21 See the maps of excavations from 1840 and 1950 in Silva, "Architettura del secolo XI," 88, fig. 19.

22 Redi and Amendola, *Chiese medievali del pistoiese*, 85; Salmi, "Prolusione," 11–15, esp. 15; and Morozzi, "Le chiese romaniche del Monte Albano," 35–47, esp. 44–45.

23 Scarini, *Pievi romaniche del Valdarno superiore*, 15–21; Moretti and Stopani, *La Toscana*, 269–92.

24 For the eleventh- to early twelfth-century dating of the lower portion of San Pietro Sorres where the narrow windows are, see Delogu, "Pistoia e la Sardegna nella architettura romanica," 83–98, esp. 92. For the linkage of San Pietro Sorres and other Romanesque churches in Sardinia to the Duomo of Prato and nearby churches in Pistoia and Lucca, see 90–98.

25 There is a possibility that the figures at Santo Stefano are part of a revival of primitive forms in Tuscany in the twelfth century, discussed as "archaizing" by Fabio Redi, in Redi and Amendola, *Chiese medievali*, 142–52. However, given the other evidence enumerated above and the marked difference in style and material of later architectural ornament at Santo Stefano, including that securely datable to the twelfth century, it is probable that the north window figures are coeval with the first stage of church construction in the second half of the eleventh century.

26 For dating, see Redi and Amendola, *Chiese medievali*, 142–45.

27 For numerous examples of rustic and even comic single heads and faces in Romanesque and Gothic sculpture, see Hamann-Mac Lean, "Künstlerlaune im Mittelalter," 414–52. On the apotropaic qualities of faces or masks, see Camille, *Gothic Idol*, 62–64. For a discussion of similar eleventh-century figures at the northernmost reach of the Bisenzio valley, at the Badia di Santa Maria di Montepiano, see Redi and Amendola, *Chiese medievali*, 47.

28 *Carte della propositura*, 60–62, document 28, 120–21, document 59, 448–51, document 240, 456–58, document 244.

29 Fantappiè, "Nascita," 106–10.

30 The street names, except for Via Serraglio, which is the modern name, are taken from Renzo Fantappiè's documentary reconstructions of eleventh- and twelfth-century Prato; "Nascita," 95 fig. 3, 97 fig. 4, 107 fig. 5, and 124–27 fig. 9.

31 Ibid., 95 fig. 3.

32 The document records a donation of a piece of property "prope ipsa ecclesia et plebe Sancti Stefani qui est edificata in loco qui dicitur Borgo et ipsa canonica de partibus aquilone, qui ian fuit ipsa terra carbonaria et ripa de castellare qui ian fuit castello Vuinitiiga…de partibus aquilone ripa de suprascripto castellare, in aliquantolo muro de ecclesia Sancti Laurenti qui est edificata in suprascripto loco castellare," in *Carte della propositura*, 45–47, document 21.

33 Fantappiè, "Nascita," 107 fig. 5, and 124–27 fig. 9.

34 This wall is first recorded in 1163, and then in 1179, in documents mentioning the Porta Fuia and Gualdimari; even earlier portions are recorded immediately by the church in 1157, Fantappiè, "Nascita," 115, 118–19, 149 n. 283; see also Carlesi, *Origini della città*, 129.

Further evidence of construction lies in the shift of the usage of "borgo," from its technical sense, designating an unfortified settlement outside a walled compound, to a place name within the larger context of "Prato." See the discussion of the term "burgus" in Fantappiè, "Nascita," 104–5.

35 The first recorded donation by the Alberti to Santo Stefano was in January, 1077; see *Carte della propositura*, 56, document 26; for later donations, see 65, document 30, 161, document 81, 226, document 115, and 316, document 169. See also Fiumi, *Demografia*, 17–18.

36 Moretti, "Architettura vallombrosana delle origini," 239–57, esp. 244.

37 See *Carte della propositura*, 62, document 29; for further examples, see Fantappiè, "Nascita," 100, 140 nn. 106–8. One reason for the shift in bequests may have been the receptivity of the canons of the Pieve to the precepts of the reform papacy, possibly through the influence of Vallombrosans, who were first recorded near Prato at San Grignano in 1130; see *Carte della propositura*, 248, document 126. A reforming tendency would not have differentiated the canons of Santo Stefano from their counterparts in Pistoia, who participated in the reform movement, as did the clergy in Florence, the regional, if not Italian, center of reform. However, as the religious reform movement emphasized the local mission of the clergy, it was bound to involve the canons of any of these cities with the faithful more than previously. This new attentiveness would have created personal bonds of allegiance

through face-to-face contact, and not just bonds of hierarchy. The spiritual and personal connections would have inevitably been strongest on the local level, which, in the case of the Borgo and Castello, meant that the strongest bonds would have been made between the residents and the canons and provost of Santo Stefano.

On the reform movement in general, see Little, *Religious Poverty*, 99–112; in northern Italy, Little, *Liberty, Charity, Fraternity*, 32–39. On the reform movement in the area of Prato, see Manselli, "Istituzioni ecclesiastiche," 767–68.

38 See Milo, "From Imperial Hegemony to the Commune," 87–107, esp. 96–97. According to Milo, the stipulation that gifts be for the entire body of canons was meant to thwart the interests of canons refusing to live by the life in common. These documents appear as early as 1071. By 1085, any rancor between the bishop and the canons on this redirection of gifts disappeared, as Bishop Leo supported the goods commonly held by the chapter from individual, recalcitrant canons. What is equally important is that by 1074, Pistoia's canons had won financial autonomy, buying and renting property, and receiving donations as a group, independent of episcopal control. Milo dated the initiation of this transfer of financial authority to 1057–61, when the episcopal seat was vacant, and the canons adopted the common life. Regarding the shift of donations from bishop to canons, see also Rauty, "Recensione di Yoram Milo," 147–50, esp. 150.

39 Milo, "From Imperial Hegemony," 96–97. Maureen C. Miller noted this privileging of canons over bishops throughout Italy during the period. She attributed it in many cases to the origins of bishops from other cities, in contrast to canons who tended to be from the same towns as their chapters; Miller, *Bishop's Palace*, 85.

40 *Carte della propositura*, 19–21, document 9.

41 Ibid., 241–43, document 123.

42 See Abbot Suger's own description of his successful tenure at St. Denis in the twelfth century, in "Liber de Rebus in Administratione sua Gestis," Panofsky, *Abbot Suger*, 40–81.

43 See Fiumi, *Demografia*, 16–17.

44 See "From Gift Economy to Profit Economy" in Little, *Religious Poverty*, 3–18.

45 Violante, "Prospettive e ipotesi di lavoro," 2–3. Prato was by no means unique in applying reform values to its political life. While the order of canons was certainly the most direct influence on Prato's spiritual-political attitudes, another regional force appears to have been important: the Vallombrosans, who were present near Prato, at San Grignano, at Pistoia, and throughout Tuscany, where they originated.

46 Fantappiè, "Nascita," 106. For the Lombard origins of the term, see Schneider, *Ordinamento pubblico*, index entries under "gastaldo longobardo."

47 See Manselli, "Istituzioni ecclesiastiche," 768–69; on the origins and basis of the Canossa strength, see Tabacco, *Struggle for Power*, 162–63; for the presence of the reform papacy in Florence at the time, see Braunfels, *Urban Design in Western Europe*, 61, and Romanini, *Arte medievale in Italia*, 312. On the relations of Pistoia with the empire, see Milo, "From Imperial Hegemony," 97–100.

48 This is an early example of a consistent Florentine policy of expropriating nobility of urban and human resources in the territory surrounding their city. See Friedman, *Florentine New Towns*, esp. 39–49, 167–72.

49 Fantappiè, "Nascita," 112–13.

50 Ibid.

51 Pseudo Brunetto Latini, "Cronica fiorentina del XIII secolo," 89. The text lists the date of the battle erroneously as MLXXX (1080): "Ancora andarono ad hoste alla terra di Prato, e ebberlo per força di bactaglia, e disfecero le mura e impierono i fossi e abacterono le forteçe. E pagano di censo lire ccc per anno, e uno cero grande alla chiesa di Sancto Giovanni Baptista. E messer Oddo Arrighi degli Amidei ne fu chiamato castellano ad sua vita."

52 For the juridical significance of city walls, see Braunfels, *Mittelalterliche Stadtbaukunst in der Toskana*, 50–51.

53 Fantappiè, "Nascita," 113–14.

54 Prato's first recorded alliance with Florence, and also with Lucca, was in 1148; ibid., 115.

4 │ THE ARCHITECTURAL AND URBAN EXPRESSION OF AUTONOMY BY THE PROPOSITURA IN THE TWELFTH CENTURY

1 The nearness in dating of Carboncetto's work in Prato to the work undertaken around 1162 by Prato's propositura di Santo Stefano at the church in Pistoia under their care, San Giovanni Fuorcivitas, opens the possibility that Carboncetto was linked to the school there, and may even have worked with the master mason inscribed on the main portal tympanum scene of the Last Supper: Gruamonte.

2 This was by far the greatest amount of any transaction recorded in Prato up to that time; the next greatest was the propositura's purchase, for 50 lire minus 25 soldi lucchese, of a long-term lease for a tract of land from the abbot of the monastery of Santa Maria di Grignano, on October 21, 1170; after that follows another land transaction, a purchase for 3 lire lucchese on August 24, 1165. All of the remaining transactions, including the exchange of property and houses, were less than 50 soldi lucchese, or 2 1/2 lire (a soldo is 1/20 of a lira).

For further evidence for the value of the lira and other currencies at the time, see *Carte della propositura*, under index "denarii, denarei, Luca, Pisana," 532, 553, 567.

3 *Carte della propositura*, 290 document 152. For a reference to the communes and the life in common, see Otto of Freising's description of the Lombard city-states in the twelfth century: "And they [the Lombard city-states] are all accustomed to call these various territories their own *Comitatus*, from this privilege of living together." Otto of Freising, "Gesta Friderici," quoted from Ross and McLaughlin, *Portable Medieval Reader*, 281.

4 For the establishment of consular regimes and further sources for individual cities, see Jones, *Italian City-State*, 130–51, and Waley, *Italian City-Republics*, 32–40. For an analysis of peaceful and violent establishments of consular governments, including the case of Milan, see Tabacco, *Struggle for Power*, 182–90.

5 *Carte della propositura*, 317, document 169.

6 "La costruzione delle più ampie mura, iniziata in quegli anni, fu principalmente un atto di indipendenza, un atto politico prima che militare." Fantappiè, "Nascita," 115.

7 On the tax mechanisms of the consuls, see ibid., 116.

8 Ibid.

9 See also Marchini, *Duomo di Prato*, 30.

10 Between the work of Carboncetto and the next phase there must have been some settling of the foundations to the west toward the main façade, or Carboncetto had not built his coursing level.

11 Burini, "Tre capitelli del Maestro di Cabestany," 49–64.

12 "And the wall of the city had twelve foundations, and on them are the twelve names of the twelve apostles of the Lamb," John, *Revelation*, 21:14.

13 For this and the claustral imagery of paradise, including Carolingian sources, see Holländer,

Early Medieval Art, 57–61. Wolfgang Braunfels mentioned how important it was for religious orders to construct their monasteries as heavenly Jerusalem: "That monasteries were themselves works of art derives partly from the belief that any earthly happiness and all heavenly bliss could only flourish in an ordered world built on the principles of the Kingdom of Heaven. Every good monastery strives to embody the *Civitas Dei*"; see Braunfels, *Monasteries of Western Europe,* 7–8.

14 For this and the following, see Dynes, "Medieval Cloister as Portico," 61–69. For earlier discussions of the Portico of Solomon iconography at cloisters, see Messerer, *Romanische Plastik in Frankreich,* 109; and Braunfels, *Monasteries of Western Europe,* 65.

15 For the importance of this passage in the history of monasticism and especially for the twelfth-century transformation of the apostolic ideal, see Chenu, *Nature, Man, and Society,* esp. 206; and Dynes, "Medieval Cloister," 61–62.

16 Dynes, "Medieval Cloister," 62–68.

17 See Theodericus of Würzburg, *Libellus de Locis Sanctis,* circa 1172, in the translation and modern edition *Guide to the Holy Land,* 24, 81 n. 71. The canons were also responsible for the Holy Sepulcher; see *Guide to the Holy Land,* 13.

18 Chenu, *Nature, Man, and Society,* 220.

19 Giuseppe Marchini dated the north elevation facing the piazza to the first decades of the twelfth century, citing the difference between the classicizing columns and capitals and the more anti-classicizing striping of late twelfth- and early thirteenth-century Pistoia architecture; Marchini "Cattedrale di Pistoia," 20. Fabio Redi, concurring, dated the bell tower to the late twelfth century; Redi, "Architettura a Pistoia," 273–89, esp. 274–76. See also Rauty, *Antico palazzo dei vescovi,* 1: 90–93. For a late twelfth- to early thirteenth-century dating, see Gurrieri, *Piazza del duomo a Pistoia,* 60–61.

20 The diffusion of the ground-level blind arcade at Tuscan Romanesque churches extends well beyond Pistoia. Some structures with both general and specific characteristics are documented as connected to Pistoia and its various twelfth-century bishops, and others bear less direct connections. As many bishops of Pistoia were connected to the Vallombrosan order, it should be no surprise to see similar forms in Vallombrosan architecture, even as far away as Sardinia, where Pistoia's Bishop Atto had served as abbot before his tenure in Pistoia. For the similarities between the Sardinian

Romanesque and that of the area around Pistoia, see Delogu, "Pistoia e la Sardegna," 83–98. Radial bichromy on arches and blind arcades particularly characterize both areas, as do plain, simply articulated surfaces heightening the contrast with polychromatic elements. The Pistoian expressions of these forms, together with their Sardinian counterparts, are slightly more vibrant in their polychromy than elsewhere in Tuscany, such as in Pisa, Lucca, and Florence.

21 Fantappiè, "Chiesa di San Giovanni Fuorcivitas," 79–124, esp. 81–85.

22 See Fantappiè, "Nascita," 212–13.

23 For the activities of the boni homines and consuls in the early development of Prato, see Fantappiè, "Nascita," 102–4; Raveggi, "Protagonisti," 627–28. For a general discussion of boni homines as precursors to consular regimes, see Waley, *Italian City-Republics,* 33. This was not universally the case, however; in Assisi, for instance, the boni homines were cast out in early power struggles with other, more popular groups; see Grohmann, *Assisi,* 38–44.

24 For the hospitals and monasteries established in the area, see Fantappiè, "Nascita," 119–20.

25 For a discussion of the role of church architecture and siting in struggles between competing religious and political institutions in Florence's new towns, see Friedman, *Florentine New Towns,* 172–79.

26 *Carte della propositura,* 258–61, document 133.

27 "Charta Convenientiae et scriptum obligationis"; ibid., 256–58, document 132 (August 25, 1132).

28 The list is from a papal executive letter from Innocent II, sometime between 1138 and 1142; *Carte della propositura,* 282, document 146 (April 29, 1138–42).

29 "Quis plantat vineam, et de fructu eius non edit? Nos plantavimus vineam, et vultis edere fructus eius? ... Nos eos baptizamus, et vos ab eis decimas sumitis?" *Decretum Gratiani;* cited in *Carte della propositura,* x–xi.

30 See ibid., x, 284–85, document 148 (April 30, 1138–42).

31 Ibid., ix.

32 "Nulli ergo omnino hominum fas sit eamdem ecclesiam temere perturbare aut eius possessiones auferre vel ablatas retinere, minuere, aut aliquibus vexationibus fatigare, sed omnia integra serventur tuis et successorum tuorum ac fratrum et pauperum usibus profutura, salva diocesani episcopi reverentia. Si qua

igitur in posterum ecclesiastica secularisue persona, hanc nostre constitutionis paginam sciens, contra eam temere venire temptaverit, secundo tertiove commonita, si non satisfactione congrua emendaverit, potestatis honorisque sui dignitate careat, reamque se divino iudicio existere de perpetrata iniquitte cognoscat, atque a sacratissimo corpore ac sanguine Dei et domini redemptoris nostri Iesu Christi aliena fiat, et in extremo examine districte ultioni subiaceat. Cunctis autem eidem ecclesie sua iura servantibus sit pax domini nostri Iesu Christi, quatenus et hic fructum bone actionis percipiant et apud districtum iudicem premia eterne pacis inueniant. Amen." Ibid., 258–61, document 133 (May 21, 1133).

33 See *Carte della propositura,* 396, document 216 and Fantappiè, "Nascita d'una terra," 95–359, esp. 188.

5 | THE EXPRESSION OF SECULAR AUTHORITY BY THE EARLY COMMUNAL REGIME

1 In a promise of payment by a canon from June 4, 1201: "pro illo adquisto et compera, quam Bonamicus [q. Vallini] dicebat se fecise et fecit a filiis q. Soffredi da Iolo de quibusdam sediis positis subtus palatium curie, partim incasatis et partim non, quibus ab occidente ripa vetus, ab oriente filie Talcionis et Calendinus et filius Bagesi." See Fantappiè, "Nascita," 273 n. 491.

2 Renzo Fantappiè believed that this was only a small portion of the platea plebis, and that the remainder retained its name; see his "Nascita," 214.

3 For a recent interpretation of communal history as a process of secularization see Tabacco, *Struggle for Power,* 319–20.

4 For the early development of communal government in Prato, see Raveggi, "Protagonisti," 627–30 and 643; Piattoli, *Consigli del comune di Prato,* ix–xi, xxi–xxiv; and Caggese, *Comune libero,* 5–93. For general discussions of the attempts by diverse factions to assert their power in the name of communal authority, see Waley, *Italian City-Republics,* 117–45; and Tabacco, *Struggle for Power,* 222–36.

5 This is consistent with Maureen Miller's interpretation of the development of communal institutions in relation to bishops' regimes. Miller observes that in most cases this was neither violent nor antagonistic. See Miller, *Bishop's Palace,* 88–89.

6 See *Carte della propositura,* 448–51, document 240, 456–58, document 244.

7 Fantappiè, "Nascita," 115–19, 171–72; Raveggi, "Protagonisti," 615.

8 On the earliest consorterie and the persistence of violence in communal Prato, see Raveggi, "Protagonisti," 669–91; for violence in the communes in general, see Tabacco, *Struggle for Power*, 222–36.

9 For the uses of this loggia, see Fantappiè, "Nascita," 128, 156 n. 409. The existence of a similar regulatory bureau at the grain market, the Scampio, by the church of San Donato, as well as the practices in other communities argue for the presence of a bureau of weights and measures at the plaza comunis; see Piattoli, *Consigli*, 49; and Nuti, "Aspetti di Prato: palazzo del popolo," 25–48, esp. 41.

10 "Sub porticu palatii comunis Prati, ubi [dicta] potestas morabat"; see Nuti, "Aspetti di Prato: piazza della pieve," 45–68, esp. 46–47; also Fantappiè, "Nascita," 128, 156 n. 409 , 273 n. 492.

11 For discussion of the individual palaces, see Russell, *Vox Civitatis*, 1–71 (Bergamo), 195–210 (Milan), 133–63 (Cremona), 175–95 (Como).

12 See Canino, 411.

13 See Bagioli, Corbella and Isnardi (eds.), *Emilia Romagna*, 476. For a slightly later example, dating to the late thirteenth and early fourteenth centuries, see the shops to the left of the Badia in Florence. For an older print of this, see Fanelli, *Firenze*, fig. 104; remains of the medieval shop arcades are still visible today.

14 See Paul, "Commercial Use," 222; Fantappiè, "Nascita," 116–17, 130–34, esp. 132.

15 See Fantappiè, "Nascita," 210–12.

16 At some piazzas, the literal measures of local building and commerce were actually displayed at the exterior walls of the presiding institution; see Deimling, "Medieval Church Portals," 324–27. In Bergamo, for example, they were hung on the walls of the basilica of Santa Maria Maggiore, and in Pistoia, at the communal palace.

17 A later document, of September 1, 1301, is a good indicator of the role of religion and religious architecture in protecting commercial and social behavior. It records an election of guards for the plaza comunis during the religious and commercial fair of the Virgin on September 8: the guards were to be "custodians and religious persons," and were placed at the major entry points to the piazza and at the façade and portal of the church: "custodes et persone religiose, qui nocte Virginis gloriose stare debent apud plebem S. Stephani ad gianuas ecclesie et ad certas boccas circumstantes dictam plebem…qui stare debent ad voltam plebis, qui stare debent ad angulum Vinacesorum…qui stent ad bocam chiassi Calendinorum"; SASP, *Comune, Diurni* 59, quad. 3, fol. 3r; mentioned in Fantappiè, "Nascita," 212, 273 n. 494. The guards' role was not simply to protect the church, its sacred objects and the clergy, but also to supervise all activities, commercial and pious, in the square and within the church.

18 For the origins and jurisdiction of the opere in Tuscan communes, see Ottokar, *Studi comunali e fiorentini*, 163–77; and more generally Haines and Riccetti (eds.), *Opera*.

19 See Braunfels, *Mittelalterliche Stadtbaukunst*, 252–53, document 5; for other examples, see ibid., 95–96.

20 For the imperial Roman basilica as the precursor to the modern market gallery in Italy, and for its original fusion of secular and religious functions, see Krautheimer, "The Beginning of Early Christian Architecture (1939)," in his *Studies*, 1–25, esp. 12–13. Richard Krautheimer did not, however, discuss the iconography of the arch in relation to its secular uses.

21 Günter Bandmann pointed out the proliferation of the exterior apse galleries on Rhenish churches, and intimated connections with the power of bishops and the emperors; see Bandmann, "Zur Bedeutung der romanischen Apsis," 28–46, esp. 43–46. The same author discussed the arch as part of "all imperial styles from Hellenism through to the Baroque," in Bandmann, *Mittelalterliche Architektur als Bedeutungsträger*, 232. For a related interpretation of columns, see Trachtenberg, "Suger's St. Denis," 183–205, and Trachtenberg, "Desedimenting Time," 5–28.

22 A similar analysis of sacred control of market and public spaces is applied to street-corner depictions or statues of Virgins by Muir, "The Virgin on the Street Corner," 25–40, but nowhere to arcades. "To sanction," an English synonym for "to legitimize," derives from "to sanctify."

23 Agriculture was still an important source of wealth in the overall medieval Italian economy, and landholding continued as a significant, though no longer exclusive, basis for political power; for these reasons the communes extended their economic controls to the landscape as well. See Waley, *Italian City-Republics*, 69–80; and Jones, "Medieval Agrarian Society," 340–431, esp. 353; Jones, *Italian City-State*, 270–87; and Little, *Religious Poverty*, 21.

24 The other interest they had in common, but which was on the level of one-to-one transactions, non-coincident, was profit. For the growth of the monetary economy and the negative social and religious reactions, see Little, *Religious Poverty*, 17–18, 29–41. For the role of public institutions in the value of currency and the faith in transactions, see also Becker, *Medieval Italy*, 34ff.

25 Weber, "Protestant Sects," 267–301, esp. 301.

26 For the role theologians advised that the church play in protecting the marketplace, see de Roover, "Doctrine scolastique," 173–83. For methods developed to protect individual transactions, business, and the marketplace in general, see de Roover, "Organization of Trade," 42–118.

27 For the church's use of traditional and innovative means to ensure compliance to religious economic morality, see the discussions of usury and purgatory in Le Goff, *Birth of Purgatory*, , 303–6; idem, *Your Money*.

28 On clerical power to bless and to curse, see Little, *Benedictine Maledictions*, esp. xiii–xiv.

29 For the Italian communal concept of the "common good," see Rubinstein, "Political Ideas," 179–207; Eberhard, "'Gemeiner Nutzen' als oppositionelle Leitvorstellung," 195–214; Skinner, "Ambrogio Lorenzetti," 1–56; and Seidel, *Dolce Vita*.

30 For a contemporary perception of this revolutionary change, see *The Book Concerning the House of God* and *The Fourth Nightwatch*, both by Gerhoh of Reichersberg (1093–1169), and Little, *Religious Poverty*, 110–12.

31 For the origins of the college of cardinals, see Klewitz, "Die Entstehung des Kardinalkollegiums," 115–221. See also Bandmann, *Mittelalterliche Architektur*, 234–35: "Die römische Kurie, der vor allem die Verbreitung, Anerkennung und Herrschaft der Kirche angelegen ist, bedient sich bei ihren Formulierungen überlieferter Symbole und Einrichtungen. Die Diözeseneinteilung richtet sich nach der alten römischen Civitas, die Kirchengrenzen bedeuten die Imperiumsgrenzen, die Kardinäle sind in ihrer Stellung den alten Senatoren vergleichbar, auch der Name »Kurie« selbst kam im Hinblick auf den römischen Senat (curia civilis) im Laufe des Investiturstreites auf. Der Papst wählt zur Bezeichnung seiner Stellung Formen, die schon von Herrschern

des antiken Rom benutzt worden waren, und bezeichnet sich als Nachfolger Konstantins."

32 The laymen witnessing the 1163 contract hiring Carboncetto for church construction were boni homines.

33 For San Donato, see Nuti, "Palazzo del popolo," 43; and Fantappiè, "Nascita," 116, 119, 122, 213–15.

34 Fantappiè, "Nascita," 116.

35 Miller, "From Episcopal to Communal Palaces," 175–85, and idem, Bishop's Palace, esp. chapter 3. The term palatium was used in Florence for the Bargello; see Braunfels, Mittelalterliche Stadtbaukunst, 251, document 3.

36 This name was first recorded in 1191–92, registering its recent change in ownership from the Alberti to Emperor Henry VI. The latter had stationed himself in Prato between 1186 and 1191; see Raveggi, "Protagonisti," 614; and Fantappiè, "Nascita," 117–18.

37 For this and the following, see Ćurčić, "Late Antique Palaces," 67–90.

38 Note particularly the inscription above the triple arches of the portal: "PALATIUM." On the intentional use of the structures in Ravenna as models for design as early as the eleventh century in Tuscany, see Romanini, Arte medievale, 312: "Nel 1026 il vescovo di Arezzo Teodaldo (1023–1036), fratello di Bonifacio, padre della contessa Matilda, mandò l'architetto Maginardo a Ravenna a studiare il S. Vitale, in vista della conclusione dei lavori di costruzione del cosiddetto Duomo Vecchio."

39 The case of Assisi supports Prato's use of the term palatium for its communal structure. Shortly after the mention of Frederick Barbarossa's palatium in Assisi, the governing structure of the commune is named in 1215 as the palatium comunis and also as the palatium potestatis; see Grohmann, Assisi, 54–55.

40 For Prato's relation to the emperor, see Fantappiè, "Nascita," 116–18; and Raveggi, "Protagonisti," 613–15.

41 See Waley, Italian City-Republics, 90–93; and Tabacco, Struggle for Power, 216–17, 220, 303.

42 The League of San Genesio was established on November 11, 1197; see Raveggi, "Protagonisti," 615; see also Fantappiè, "Nascita," 117.

43 On the consorteria in Prato, see Raveggi, "Protagonisti," 628–29; and, more generally, in Italy, see Waley, Italian City-Republics, 118–31; and Tabacco, Struggle for Power, 222–36.

44 Manselli, "Istituzioni ecclesiastiche," 782–85, 811–12. In Milan, the inscription under the equestrian statue of the Podestà Oldrado da Tresseno at the façade of the Palazzo della Ragione from 1233 says that "he burned Cathars as he should" ("catharos ut debuit uxit"); transcribed and translated in Waley, Italian City-Republics, pl. 3.1.

45 Edited in Gaudenzi, Statuti del popolo di Bologna, 444 to end; see also Caggese, Comune libero, 192–250.

46 "Tancredus olim Orlandi…totam suam partem totius sedii positi ante plebem Sancti Stefani, iuxta turrim curie, cui ab oriente via, ab aqui(lone) plaza comunis, ab occi(dente) et meri(die) Baldanza." SASP, Diplomatico, propositura di Prato, December 18, 1208. The document was first mentioned in reference to the Piazza della Pieve by Nuti, "Piazza della pieve," 46. Cerretelli, Palazzo Comunale, 2, gave the date as December 18, Nuti as December 29.

47 Macci and Orgera, Architettura e civiltà delle torri.

48 See Waley, Italian City-Republics, 188–31; and Tabacco, Struggle for Power, 222–36.

6 | THE EXPRESSION AND DEFENSE OF RELIGIOUS AUTHORITY BY THE EARLY COMMUNAL REGIME

1 Milanesi, Nuovi documenti, 6–8.

2 By the beginning of the thirteenth century the consuls defined themselves in two categories, the consules comunis, also known as the consules Pratensium or consules militum, and the consules mercatorum. This structure seems less an effort to stratify forms of social representation than to create an effective administration based on a division of labor according to training and skills, with the consules militum handling military and diplomatic relations, and the consules mercatorum administering commercial activity in the town and commercial accords with other communes; see Fantappiè, "Nascita," 116–17, 131–32.

The presence of both consular bodies, the military and diplomatic body of the consules militum and the commercial body of the consules mercatorum, stresses that the government's involvement in the project pertained to internal and foreign relations, as well as to the town's internal and regional commercial policy interests.

3 Guido promised "to make what they wish to construct." "They" refers to all of the cosigners of the contract, excluding the witnesses and the notary.

4 See Ottokar, "Intorno ai reciproci rapporti," 163–77; see also Haines and Riccetti, esp. ix–xxiii.

5 The language of this contract recalls Vitruvius' prescriptions of "solidity, utility and beauty" ("firmitas, utilitas et venustas"); see Fensterbusch, Vitruvii, book 1, chapter 3, lines 19–20. The parallel terms in the Pratese document are "condition and utility" ("conditio et utilitas"), spelled out twice. An aesthetic preoccupation that parallels beauty, "good and equal in all its parts," is located in a separate portion of the text. This is consistent with Vitruvian formulation for beauty according to harmonic proportions. Vitruvius may have been known and read by the officials, the notary, by Guido himself, and most likely by the provost and canons, given their library and emphasis on texts. Vitruvius' text was available at least to some patrons of the period, such as Abbot Suger; see Suckale, "Aspetti della simbologia architettonica," 111–22, esp. 118ff. Manuscripts of Vitruvius were by no means rare; see Krinsky, "Seventy-Eight Vitruvius Manuscripts," 36–70, and von Simson, Gothic Cathedral, 30–31 n. 14.

6 On the status of architects in late medieval Italy, see Toker, "Gothic Architecture by Remote Control," 67–71.

7 See Salmi, "Questione dei Guidi," 81–90, esp. 84.

8 See Barsali, Lucca, 62.

9 The early west façade is visible only from the area behind the later, current façade, which dates mostly from the end of the Trecento and early Quattrocento (see figs. 4.3 and 4.4). The Carboncetto and Guido da Lucca façade is partially accessible from the passageway between it and the new façade that leads to Michelozzo and Donatello's exterior pulpit.

10 See Marchini, Duomo di Prato, 22–33.

11 For the importance of perspective as a means for designing and perceiving medieval Italian public architecture, see Trachtenberg, Dominion of the Eye.

12 Since the eighth century, the classical associations of the arch framing the sanctuary had been deliberately revived by renaming it from "arcus major" to "arcus triumphalis"; see Bandmann, Mittelalterliche Architektur, 235.

13 See Marchini, Duomo di Prato, 27. Earlier examples may be in Sardinian architecture, as at San Pietro di Sorres in Borutta, from the late twelfth century; for this structure and its links to the architecture of Prato and Pistoia, see Delogu, "Pistoia e la Sardegna," 90–92.

For the origins and geographic range of bichrome striping as church decoration in Tuscany and the Mediterranean, see Ruschi,

"Polichromia nell'architettura medievale Toscana," 21–27; see also Delogu, "Pistoia e la Sardegna," esp. 94.

The bell tower can be seen in an early fifteenth-century fresco by Pietro Miniato in the Palazzo Pretorio in Prato, showing in the middle the Castello dell'Imperatore with its campanile.

14 The monk's campanile at Milan's Sant'Ambrogio, as well as those at Ravenna's Sant'Apollinare Nuovo, Sant'Apollinare in Classe, and Pomposa, date from between the ninth and eleventh centuries. McLean, "Romanesque Architecture in Italy," 74–117, esp. 78–79, 82.

15 The tower was first mentioned in a document of 1274; see Fantappiè, "Nascita," 194, 262 nn. 6, 7.

16 On the significance of bell towers in daily life, see Le Goff, "Merchant's Time," 29–42, and Cipolla, Clocks and Culture.

17 Fantappiè, 93–94, document 44.

18 For the façade visible today, see Cerretelli, "Pieve e la cintola," 89–161.

19 The importance of this window can be seen in a fourteenth-century fresco from Agnolo Gaddi in the Cappella del Sacro Cingolo in Prato, in which the painter depicted only the window as the noteworthy character of the façade, neglecting even the striping of the elevation.

20 The doors are still visible on the north and south walls of the cloister, at the second level, and within the church.

21 For the documents, see Fantappiè, "Nascita," 128, 156 n. 408, 168, 244 n. 15.

22 The absence of windows on the lower levels suggests that the earlier Levaldini tower was already very close to the campanile, and that the campanile was built above this tower by one story—the one with the windows on all sides. It is likely that the campanile was therefore an architectural message of dominance directed particularly to the Levaldini, due to either a particular feud between them and the consuls, or to certain egregious violence on the family's part; it may also simply have been intended to set an example to the other consorterie.

23 Honorius III handed down the decision on July 17, 1221. See Baldanzi, Della chiesa cattedrale di Prato, 242–44; see also Nuti, "Piazza della pieve," 48–49; and Marchini, Duomo di Prato, 14.

24 Nuti, "Piazza della pieve," 48–49.

25 Ibid, 49 n. 2.

26 For an excellent summary of the Guelph and Ghibelline factions in Italy, see Waley, Italian City-Republics, 145–56.

27 See Fantappiè, "Nacita," 190; and Raveggi, "Protagonisti," 616.

28 For Frederick's imperial architecture in Prato, see Giani, Prato e la sua fortezza; and Gurrieri, Castello dell'imperatore a Prato, 30–32. For a general discussion of Frederick's architecture in relation to his politics, see Abulafia, Frederick II, 280–89, see also his bibliography, ibid., 453; and Bering, Kunst und Staatsmetaphysik des Hochmittelalters in Italien.

29 Another exception in Prato is the tower-house complex on Via Pistoia (today's Via Cairoli) belonging to the Guazzalotti, one of the city's most powerful and feared families. Their aspirations, if not their status, were similar to Frederick's. A hundred years later, in 1348, one family member was to establish at first an undeclared, and then a real signoria, considered the stimulus for the Florentine takeover of Prato shortly afterward. See Nuti, "Palazzo del popolo," 46–47; for more on the Guazzalotti signoria, see Raveggi, "Protagonisti," 623–26.

30 For these projects, see Götze, Castel del Monte, esp. 67–72, 89ff.

31 For Frederick's crusade and his reaction to excommunication, see Abulafia, Frederick II, 164–201.

32 See Krautheimer, "Beginning of Early Christian Architecture," 12–13. Günter Bandmann discussed the simultaneous use of imperial architectural iconography elsewhere in Italy and Europe by both papal and imperial camps. He points out that even though two distinct formulations of imperial imagery developed north of the Alps, the same imagery was shared by both papal and imperial builders in Italy; see Bandmann, Mittelalterliche Architektur, 234–45.

33 See also the interpretation of Frederick's Castel del Monte as a symbol of the heavenly Jerusalem by Götze, Castel del Monte, 206–9.

34 For the Guelph-Ghibelline strife in Prato, see Piattoli, "Ghibellini del commune di Prato," 14: 195–240, 15: 3–58, 229–72. For the expansion of factional strife between Prato and Pistoia, see Raveggi, "Protagonisti," 614–17.

7 | THE DESTRUCTION OF THE PLAZA COMUNIS AND THE SHIFT OF CIVIC PATRONAGE FROM THE PROPOSITURA TO THE FRIARS

1 Benjamin, "The Work of Art," 241. The original German text was written in 1936.

2 See Tabacco, Struggle for Power; Waley, Italian City-Republics; Jones, Italian City-State.

3 The gate is mentioned for the first time in 1245; see Nuti, "Piazza della Pieve," 63–64; and Fantappiè, "Nascita," 173, 248–49 nn. 76–79.

4 Piattoli, "Ricerche," 65–75; see also Nuti, "Piazza della pieve," 46–47.

5 SASP, Comune, Atti giudiziari, 469 quad. 4, c. 7v, May 4, 1290; see Fantappiè, "Nascita," 173; and Nuti, "Topografia," 180. The closing of the city gate must have occurred between 1288 and 1290, as Ruggero Nuti mentions that on March 2, 1288, the citizens elected a guard for this gate; Ruggero Nuti, La fiera di Prato, 180, and Nuti, "Piazza della pieve," 63. For one other important intervening event, the destruction of a tower-house belonging to either the Levaldini or Dagomari, see Piattoli, I consigli, lxxxii.

6 The first document asks for the clearing of rubble to allow free passage along the street in front of Santo Stefano and probably referred to the ruins of the baptistery as well; SASP, Comune, Atti di consigli ritrovati nel 1945, fragment 7, February, 1290 (=1291). The second document explicitly mentions the palatium comunis: "Ordinatum, provisum, statutum atque decretum fuit…quod calcinacium quod est in platea plebis S. Stephani, quod fuit ex turibus et palatiis comunis Prati, sitis in dicta platea dicte plebis, debeat excomberari et ellevari de dicta platea," SASP, Comune, Diurni, 57, quad. 10, 19v, August 5, 1293; see Nuti, "Piazza della pieve," 54–55; and Fantappiè, "Nascita," 275, 520.

7 The end of the brief Ghibelline regime in Prato was ushered in by the victory of the Guelphs over the Ghibelline, pro-imperial forces at the battle of Benevento, and particularly by the death of Manfred during that battle, ending the succession of the Hohenstaufen emperors; see Nuti, "Piazza della pieve," 54–55; and Runciman, Sicilian Vespers, 41–112, esp. 108–12.

Between 1266 and 1267, Prato became a battleground in a war between the two parties. The Guelphs emerged victorious, and established their government in April of 1267; Nuti, "Piazza della pieve," 54–55; and Piattoli, Consigli, lii. For this period in general, see Piattoli, "Ghibellini."

8 This is also suggested by Nuti, "Piazza della pieve," 55.

9 No records exist for the period of Ghibelline rule, from 1260–1266; see Piattoli, *Consigli*, xl.

10 Quoted from Waley, *Italian City-Republics*, 146.

11 Piattoli, *Consigli*, lxxxii.

12 According to a legend, the schism between Guelphs and Ghibellines in Prato broke out in 1215, due to a private quarrel between Maurizio Infanganti and Donato Carnaschi; see Raveggi, "Protagonisti," 616, who points out that the actual beginning of the schism ought to be postponed for some years, to the late 1230s, with the rise of Frederick II.

13 For contemporary commentaries on the Guelph-Ghibelline conflict, see Tabacco, *Struggle for Power*, 230–31, also for further bibliographical references.

14 For the development of statelike structures in the communes, see ibid., 267–320. For a description of the sequence of communal institutions in Prato, see Sivieri, "Comune di Prato," 3–25.

15 See Raveggi, "Protagonisti," 616–17. For the Battle of Monte Aperti, see Villani, *Nuova cronica*, 1: vii, 78, 376–80.

16 Tabacco, *Struggle for Power*, 231.

17 This tribal identity was already implicit in the crusading mentality, particularly in the fear and intolerance it fomented in confrontation with other religious groups, whether the Saracens or heretics. For the extent and brutality of this intolerance, see Vauchez, *Laici nel medioevo*, 61–65; for the particular case of European Jews, see Little, *Religious Poverty*, 42–57.

18 Guelphism was less present in the primo popolo. Though the latter did work against the Ghibellines, they were doing so more to curb Ghibelline violence than as Guelph partisans. See, for example, Peter Martyr's efforts in Florence; Banker, *Death in the Community*, 111. The later allegiance of the popolo to the Guelphs was probably enough to ensure the triumph of the Guelphs, which was therefore not completely accidental.

19 See Piattoli, "Ghibellini," 3–58, and 229–53. Popular groups had by necessity emulated the behavior of the consorterie in their formation of armed bands since their origins; see Tabacco, *Struggle for Power*, 233. Only with the advent of the Guelph-Ghibelline parties did they extend the purpose of their militia from achieving representation to eliminating the representation of others.

On the institutional process by which the popolo was "Guelphizzato" ("Guelphized"), see Piattoli, *Consigli*, lxxviiiff, esp. lxxix: "Pertanto il regime popolare, Guelphizzato dal maggio 1267 in poi, sarebbe esistito fino a quando fosse piaciuto agli elementi borghesi—diremmo oggi—della Parte; infatti il giorno in cui essi si fossero sentiti più Guelphi che popolari, vale a dire i loro interessi avessero coinciso con gli interessi dei militi della stessa associazione, tutto l'assetto esistente sarebbe crollato dopo i primi urti."

20 Since the release of this discussion in my 1993 dissertation, "Sacred Space and Public Policy," one brief but excellent analysis of this phenomenon in communal Florence has appeared; see "The Political Logic of Demolition," in Trachtenberg, *Dominion of the Eye*, 249–51.

21 Villani, *Nuova cronica*, vol. 1, libro vii, 65. See also Braunfels, *Mittelalterliche Stadtbaukunst*, 200; Trachtenberg, "What Brunelleschi Saw," 14–44, esp. 25; and Rubinstein, *Palazzo Vecchio*, 8.

22 See Russell for the similar situation of Bergamo, *Vox Civitatis*, 75–83.

23 As with any symbolic act of this sort, like excommunication, it could be reversed by an equally significant symbolic act—papal pardon, in the case of excommunication, and the construction of a new family tower or palace. Another example of the use of "house" or "casa" interchangeably for a structure or a family is the above-mentioned destruction of the "casa" of the Uberti in Florence.

24 Duccio, *Cincturale*, 60–62 verses 465–76.

25 Ibid., 474–6: "Fama refert in morte tua tonuisse sub Etna: 'Pamphollia venit: addite ligna focis!'"

26 If one can rely on the evidence of parallel communities, such as Parma, most residents who were not noble, including leading bankers with noble aspirations, did their best to continue business, refusing to take sides. A contemporary Franciscan chronicler, Salimbene, comments on the disengagement of most lesser townsfolk during the successful recapture of Parma by anti-imperialists in 1247: "The people in the city took no part in these matters; they would not fight either for the attackers or for the Emperor. The bankers and money-changers continued to sit at their tables and craftsmen went on with their work, all as though nothing was happening." Quoted from Waley, *Italian City-Republics*, 151. For a similar response, or rather lack thereof, by merchant citizens to the fall of Prato to Florence a century later, see Marshall, *Local Merchants of Prato*.

27 This idea of the dormancy of factional militancy is not mine. It was prophetically presented in the thirteenth century by a Piacentine chronicle writer, comparing Ghibellines to fish eggs in a dry riverbed, awaiting the return of the flow of water—imperial power—even after one hundred years, when they would rise to show their allegiance; see Waley, *Italian City-Republics*, 149.

28 Enrico Guidoni describes the pattern of mendicant settlements encircling cities as the result of a conscious plan to create triangulated geometries framing the main church of communes; see Guidoni, "Città e ordini mendicanti," 69–106. Lester K. Little questions this "triangulation theory" in a review, noting that it "is neither universally valid nor demonstrated as having been conscious." Little posits another, more probable basis for mendicant development: "that episcopal and communal buildings were usually in the centers of towns and that mendicant convents were usually built on the periphery. Since the latter, for reasons of competition, were not usually laced one right next to another and, for good communications, were usually near a gate, any geometric form connecting three or more of them is bound to have a centroid near the center of the town"; see Little, "Review of *Les ordres mendicants*," 840–42, esp. 841. Little's explanation is supported in the case of Prato's mendicant settlements, which are described in detail by Raol Manselli in "Istituzioni ecclesiastiche," 790–94, esp. 793–94. Manselli also points out that a major reason for the peripheral location of mendicant settlements was the orders' respect for existing dominant institutions, such as the propositura in Prato.

For an overview of mendicant-order urbanism, see Serra, *Ordini mendicanti*; see also Pellegrini, *Insediamenti francescani nell'Italia*, with an extensive bibliography; idem, "Insediamenti francescani nella evoluzione storica," 1: 95–237; idem, "Insediamenti degli ordini mendicanti e la loro tipologia," 563–73; LeGoff, "Apostolat mendiant," (1970), 924–46; idem, "Apostolat mendiant," (1968), 335–52.

29 For the idea of the apostolic life in the mendicant orders and its success in cities, see Little, *Religious Poverty*, 184–217.

30 Citation and translation from ibid., 162–63.

31 See ibid., 150–52, 162–63, 184–92, 198–202.

32 Francis was ambivalent as to whether friars should have any permanent quarters. He justified the construction of small churches so long

as the friars preached to the public elsewhere, in borrowed churches large enough to accommodate the congregations, "since it is more humble and gives a better example." Brooke, *Scripta Leonis*, 114–15; see also Goffen, *Spirituality in Conflict*, 86 n. 9. However, already very early on, more practical or vainglorious friars were building magnificent churches at Bologna and even at Assisi.

33 In fact, the commune bought for the Franciscans a piece of land in 1228 "prope castrum Prati in loco ubi dicitur Olivetum," Moretti, "Architettura," 885, 904 n. 64; see also Piattoli, "Atto di fondazione," 62–66.

34 See Fantappiè, "Nascita," 198–201.

35 Ibid., 206.

36 See Piattoli, *Consigli*, 366–71; and Fantappiè, "Nascita," 202–3.

37 See Manselli, "Istituzioni ecclesiastiche," 793–94.

38 See Piattoli, "Atto di fondazione," 62–66; Fantappiè, "Nascita," 198–201; and Moretti, "Architettura," 885–86.

39 See Gurrieri, "Complesso di S. Agostino, 6–68, esp. 8–9, 34–68; Fantappiè, "Nascita," 205–6; and Moretti, "Architettura," 892.

40 See Moretti, "Architettura," 887.

41 This connection is confirmed by the fact that between 1300 and 1310 Fra Mazzetto from Santa Maria Novella was in charge of the completion of the Dominican church in Prato, which was begun in 1284; see Fantappiè, "Nascita," 203. For the influence of Santa Maria Novella on Prato, see also Moretti, "Architettura," 887.

42 Milanesi, *Nuovi documenti*, 29 no. 33.

43 ibid.

44 Renato Piattoli cites the document stipulating the geometry of the space:

"Fratres Predicatores petunt . . . placeat vobis ordinare, ut convenit, quatenus eisdem fratribus per dictum comune Prati concedatur locus et territorium et domus a porta Gualdimaris usque ad porta Fuiam per longum, et ab ipsis portis per amplitudinem sive latidudinem usque ad primam viam qua itor a puteo qui est in capite dicte vie inferius, exceptis domibus que sunt iuxta viam porte Fuie, que domus non sint in ipsa concessione, si vobis videbitur, set remaneant libere cum X brachiis territorii post se. Quarum omnium mensuratio fiat a domo magistri Pieri de Baragazza, silicet retta linea usque ad domum Vanni Pieri Ugolini inclusive, silicet usque ad goram. Item petunt a via predicta usque ad murum terre sive

castri, ita quod includatur carbonaria et fovea; sic tamen quod in carbonaria et favea non fiat aliquod edificium nec murus nec aliqua explanatio. Liceat tamen dictis fratribus claudere ex utraque parte [ita] quod non possint inde videri a transeuntibus, nec illus aliquis possit ingredi; et tamen salvo quod ser Rischiaratus not[arius], et fratres sui vel alius ipsorum non cogantur vel cogi possint nec debeant aliquo tempore vendere vel concedere ipsis fratribus vel alicui alii persone domos vel domum, ortum vel aream seu terras vel possessiones, que vel quas ipse Rischiaratus et fratres vel alter ipsorum habent vel possident infra dictos confines," cited from Piattoli, *Consigli*, 366–67.

45 See Fantappiè, "Nascita," 199.

46 See Pampaloni, "Movimento penitenziale," 31–71; and Manselli, "Istituzioni ecclesiastiche," 801, 808–11. For a discussion of friars engaging residents through confraternities, the exemplary role of lay brothers, and the overlap between religious and civic space and architecture in the Florentine territory, see Friedman, *Florentine New Towns*, 182–95.

47 Villani, *Nuova cronica*, 1: vii, chapter 79.

48 In 1254, the pope granted the Franciscans the right for the *officium inquisitionis*, taking it away from the Dominicans; Manselli, "Istituzioni ecclesiatiche," 811.

49 For the questionable accusations of Ghibellines as heretics in Prato, see Manselli, "Istituzioni ecclesiatiche," 803.

50 The paradox of universal Christian love and the delimitation of the Christian community is eloquently stated by Sigmund Freud in *Civilization and Its Discontents*, 72–73: "When once the Apostle Paul had posited universal love between men as the foundation of his Christian community, extreme intolerance on the part of Christendom towards those who remained outside it became the inevitable consequence. To the Romans, who had not founded their communal life as a State upon love, religious intolerance was something foreign, although with them religion was a concern of the State and the State was permeated with religion."

51 The radical self-denial of the individual for the group imposed by the friars on themselves bears comparison to the notion of *sophrosune* that bound together the social fabric of the early Athenian city-state. The private cost of sophrosune is the subject of much of the work of Euripides. See Croally, *Euripidean Polemic*. One powerful example is in the fragment *Erechtheus*, discussed by Joan B. Connelly in

her reinterpretation of the Parthenon friezes, Connelly, "Parthenon and Parthenoi," 53–80. The words of Praxithea, the queen of Erechtheus, when agreeing to the murder of her daughters for the sake of the city, define this term better than any dictionary: "I hate women who in preference to the common good, chose for their own children to live." Connelly, "Parthenon," 58.

52 See Le Goff, *Birth of Purgatory*, esp. 133–76.

53 SASP, *Comune, Atti giudiziari*, 475, quad. 8, c. 51r, January 29, 1298; see Fantappiè, "Nascita," 199.

54 See Manselli, "Istituzioni ecclesiastiche," 809–10; and Pampaloni, "Movimento penitenziale."

55 For the diffusion of disciplinati and other third orders, see Fantappiè, "Nascita," 199, 205; and Manselli, "Istituzioni ecclesiastiche," 795–801.

56 "Se alcuno de'fratelli corresse in tanta follia che biastemmiasse Idio o la vergine Maria o alcuno sancto, o battesse padre suo o madre, immantenente, sança neuna amonitione, sia raso et cacciato della nostra compagnia. Chi giocasse a çara, vada per ogne volta a disciplina a Sancta Anna, scalço. Chi giocasse a neun altro giuoco, dove dadi si tocchino o denari ne vadano, per ciascuna volta vada a disciplina alla pieve a Borgo et a Sancto Agostino. Ancora, che neuno ardischa d'andare in veruno luogho disonesto di femmine. Ancora, chi facesse tanto follia che innebbriasse, vada disciplinandosi al Carmino, et dire all'altare cinque Pater nostri cum Ave Maria." Cited from Fantappiè, "Nascita," 205, 269 n. 420; published in Meersseman, *Ordo fraternitatis*, 2: 633–47.

57 For the laudesi in Prato, see Fantappiè, "Nascita," 202; and Manselli, "Istituzioni ecclesiastiche," 799.

58 "Compagnia di messer Santo Agostino . . . sotto li anni del nostro Segnore Iesu Cristo mille CCCXVIIII . . . certi die ordinati dell'anno, a disciplinarsi lo corpo, per fare memoria della passione del nostro Segnore Iesu Cristo crucifisso"; cited from Fantappiè, "Nascita," 206. The penitentials of the Carmine adopted exactly the above-cited terminology, adding to this: "per remissione de' peccati ed in utilità dell'anime"; cited from Manselli, "Istituzioni ecclesiastiche," 798. Manselli elaborates further on the processions, ibid., 810: "La practica della Disciplina infatti comportava una serie di processioni, in tempi e luoghi precisi, con la partecipazione di grandi masse di fedeli, con le manifestazioni di commozione collettiva caratteristiche di certi spettacoli." For details of

times and routes of processions in Prato, see Meersseman, *Ordo fraternitatis,* 633–47.

59 See also Albertus Magnus' metaphor, mentioned above, displacing the cloister with the piazza as the new figuration of paradise.

60 See Little, *Religious Poverty,* 203–4; and Manselli, "Istituzioni ecclesiatiche," 791.

61 See Little, *Religious Poverty,* 187–90, 192–96, 206–10.

8 | THE NEW PIAZZA DEL COMUNE AND THE RETURN OF CIVIC PATRONAGE TO THE PIEVE DI SANTO STEFANO AND ITS PIAZZA

1 In 1932, Anatole Lunacharsky expressed the ideal of architecture consonant with Stalin's five-year plan: "the people have a right to columns," thereby dashing the radical architectural dreams of the constructivists and condemning the new nation to the bombastic monumental classicism of projects like the Palace of the Soviets in Moscow and Moscow State University. For the antihistoricist architecture and dispersed urbanism of the Soviet avant-garde and their failure, see Tafuri and dal Co, *Modern Architecture,* 1: 183–90, esp. 188. See also Frampton, *Modern Architecture,* 177.

2 Nuti, "Palazzo del popolo," 25.

3 The Piazza Mercatale is earlier but was not linked to any particular institution other than the marketplace itself. It had only very limited formal definition, and it seems to be one of the rare spaces in the commune to have been developed for almost purely functional reasons, even after the arrival of the Carmelites there in 1293. The only other space that might be considered as a predecessor was within the palatium imperatoris. The courtyard shows a strong formal connection to the cloister type.

4 The act of the purchase was commemorated in an inscription on a stone, which is located on the eastern wall of the Palazzo Pretorio, at the ending of the external staircase. The inscription, transcribed by Nuti, "Palazzo del popolo," 25ff, is not visible any longer:

ANNO DOMINI MCCLXXXIII
IND. XII TEMPORE CAPITANERIE NOBILIS
VIRI FRESCHI DE FRESOBALDIS
DE FLORENTIA CAPITANEI POPULI ET TERRE
PRATI ACQUISITUM FUIT HOC
PALATIUM PRO POPULI SUPRA
DICTO ET ETIAM REPARATUM

See also Cerretelli, "Piazza ed il palazzo," 7–44, esp. 14–15.

5 See Nuti, "Palazzo del popolo," 41.

6 The political importance of feeding the poor is difficult to distinguish from its religious importance. One of the fundamental activities of lay confraternities was to attend to the needs of the poor. See Banker, *Death in the Community,* 47–49, 68–71; and Little, *Liberty, Charity, Fraternity,* 87–97, who explained this function in terms of maintaining public order. The commune's assumption of control over some of these alms-giving institutions, such as the Ceppo in Prato, indicates the political importance of feeding the poor as well; it provided a sign of piety of the governing institution, as well as a means of containing unrest. One of the images in the Florentine *Biadaiolo* manuscript from circa 1340, showing the generous city taking in and feeding poor refused aid by rival Siena, proves that a generous grain policy was also considered a form of public propaganda; see Waley, *Italian City-Republics,* 76–77 pl. 4.2.

7 For some of the many examples elsewhere of political parallels, see Tabacco, *Struggle for Power,* 271–80.

8 Cerretelli, "Piazza ed il palazzo," 16–20.

9 Ibid., 18–22.

10 Ibid., 22–31.

11 Ibid., 19. The documents are from October 31, 1285. The passages in question are transcribed by Claudio Cerretelli: "Murari debeat in altitudine sicut est gronda domus Locti Cambii et Fazii Marinai, et ultra si visum fuerit domino capitaneo . . . ubi sibi visum fuerit, murari debeat dicta pratea et claudi, et merlari circumcirca in qualibet parte ubi per dictum capitaneum provisum fuerit et sibi pro Comuni utile et necessarium videbitur convenire."

The next building ordinances for regularizing a major piazza in a Tuscan commune were those for the Campo of Siena, from May 10, 1297; see Braunfels, *Mittelalterliche Stadtbaukunst,* 250, document 1.

12 Cerretelli, "Piazza ed il palazzo," 35–36.

13 The first payments were in 1316; see ibid., 25–27.

14 The bridge was a sign of aggression, like balconies or *sporti* and tower-houses, as it provided a higher place from which to throw objects at one's adversaries.

15 For the transcription of the ordinances, see Gaudenzi, *Statuti del popolo di Bologna,* 444. See also Caggese, *Comune libero,* 192–205; Sivieri, "Comune di Prato," 3–13; and Raveggi, "Protagonisti," 634–35.

16 See Raveggi, "Protagonisti," 634–35. Four militia of three hundred men each were used

for the defense of the ordinances and the public interest.

The idea of law, order, and armed force is reflected in an illuminated manuscript of Convenevole da Prato's *Regia Carmine* from around 1335, where the "Law" is personified by an armed soldier holding before him a sword and a shield with the word "LEX"; see Convenevole da Prato, *Regia Carmina,* n.p. For the Ordinances of Justice in general, see Tabacco, *Struggle for Power,* 271–80.

17 For the importance of partisan groups in medieval Italian society and their various formations over time, see Brucker, *Civic World,* esp. 14–30; see also Tabacco, *Struggle for Power,* 182–320.

18 See Tabacco, *Struggle for Power,* 267–95.

19 See Braunfels, *Mittelalterliche Stadtbaukunst,* 145–73.

20 In a deposition of testimony in 1301, the column was stated to be already erected as a monument to the Blessed Virgin: "Et dixit quod non credebat quod ipsi auderent removere collunnam, que est in platea plebis, quia erat in testimonium beate Marie et, si elevaretur, esset contra fidem," SASP, *Comune, Atti giudiziari,* 480, quad. 11., c. 85r; see Fantappiè, "Nascita," 273 n. 496.

21 The location of the column by the communal palace and its designation of the supposed house of Michele is mentioned in a fifteenth-century hagiographical text of the Sacred Belt of the Virgin Mary, based on an earlier version: "Nam . . . cum illo in domo sua, quam in obitu suo sepedicte donavit ecclesie, quam et postmodum comes Albertus post mortem Panfollie destruxit, volens curiam ampliare palatii, ubi nunc est columna comunis," in Galletti, "Storie della sacra cintola," 1: 317–38, esp. 328; for the dating of the document, see 321. See also Nuti, "Piazza della pieve," 64–65 no. 9.

22 See Duccio, *Cincturale,* 68–73, verses 567–621; also Galletti, "Storie della sacra cintola," 327–34; Miniati, *Narrazione e disegno,* 148; Bianchini, *Notizie istoriche,* 10–18; and Pelagatti, *S. cingolo mariano,* 1–5.

23 Fantappiè, "Nascita," 168.

24 Payments between 1301 and 1305 document the erection of such a pulpit at Santo Stefano, to be used for the presentation of the Sacred Belt; see Nuti, "Piazza della pieve," 50.

25 The September fair, which was held at the platea plebis and the Piazza Mercatale, was one of the most important fairs in Tuscany, thanks to the geographical siting of Prato

at the crossroads of important trade routes. From the end of the thirteenth century, the cult of the Sacred Belt increased the draw of the fair visitors. In fact, a Florentine councilor commented that people went to Prato's fair for devotional reasons alone. For this and more on the Pratese fairs, see Nuti, *Fiera di Prato*, esp. 18.

26 The attempted theft of the Belt by Muschiattino is briefly mentioned in Duccio, *Cincturale*, 40–42, verses 173–88. The story is rendered in full, lurid detail in the *Historia Cinguli Sanctae Mariae de Prato*, in Galletti, "Storie della sacra cintola," 336–38. See, furthermore, the detailed account in Bianchini, *Notizie istoriche*, 44–59. Muschiattino is said to have intended to sell the Belt to the Florentines—by these means, the chroniclers demonstrated the anxieties of the citizens toward the aggressiveness of both its larger neighbors, Florence and Pistoia.

The theft of relics was a recurring phenomenon, enough so to question how many of these were staged for propagandistic purposes. The seeming immorality of this act did not affect the perpetrators, unless caught, like poor Muschiattino. They justified the crime by asserting that the saint would not allow a theft if he or she did not in fact desire to move, which meant that relic thieves were, rather, merely acting upon the wishes of saints. In other words, as Patrick J. Geary put it, they were engaged in a "furta sacra," a sacred theft; Geary, *Furta Sacra*.

27 This act constitutes evidence of the judicial function of church portals. They were, in fact, in numerous cases the place before which courts were held; see Deimling, "Medieval Church Portals," 324–27. One of the most significant activities in front of Santo Stefano's west portal of the south façade was the judging by the clerics and lay magistrates of a race down the Via della Pieve, later known as Via del Corso before the modern renaming as Via Mazzoni, at the feast of St. Stephen; see Giani, "Palio a Prato," 8–14. For other activities before the portals in the Piazza, see Fantappiè, "Nascita," 210.

28 The cycle by Bettino, though now lost, is documented: "Provisum et ordinatum extitit quod de bonis, pecunia et avere dicti comunis dentur et solvantur Bectino depictori sedecim libras denariorum florenorum parvorum, quas idem Bectinus a dicto comuni recipere debet de summa et pro supplemento summe XXV

librarum, quas a dicto comuni habere debebat pro decem ystoriis per eum depictis in plebe de Burgo pro miraculo cinguli beate Marie, ad rationem L soldorum florenorum parvorum pro qualibet ystorias," SASP, *Comune, Diurni*, 71, c. 421v, May 3, 1313; see Fantappiè, "Nascita," 246 n. 32.

29 "Congregato consilio generali Comunis et populi terre Prati in domo sive palatio novo Comunis Prati ubi pro dicto comuni consilia fiunt…proponit…dom. potestas, quod cum Cingulum beate Marie Virginis fuerit heri furtivo modo extractus de loco in quo dictum Cingulum stabat et dictus locus fuerit ruptus et fractus, propterea quod dictum Cingulum non manet in tuto et sicuro loco, quid dicto consilio providere ordinare et deliberare super custodia et circa custodiam dicti Cinguli…generaliter consulatur," SASP, *Comune, Diurni*, 71, c. 358v, September 29, 1312; see Marchini, *Tesoro del duomo di Prato*, 95 document 2.

30 SASP, *Comune, Diurni*, 72, c. 668v., April 16, 1317; see Nuti, "Piazza della pieve," 60. On August 3, 1317, the commune provided 500 *fiorini piccioli* for the transept expansion; SASP, *Comune, Diurni*, 71, c. 358v. This was followed by nine other payments between December 1317 and February 1322; see Fantappiè, "Nascita," 246 n. 35.

31 Beginning with Vasari, *Vite*, 1: 279; see Marchini, *Duomo di Prato*, 33–46.

32 Fantappiè, *Bel Prato*, 1: 34.

33 *ut, dum Cinturam monstrarent desuper illi*
est quibus officium, gensque foret propera
et constricta super Strophium spectando plateam
tamquam completa spica tenet triticum,
ut vix posset aqua de celo tangere terram,
nec iactum semen tunc tetigisset humum,
en nola pulsa supra cunctis que grandior extat,
ut mos est, magnis viribus incutitur
in campanili quod iuxta, tunc locus ipse
mostrandi, qui nunc angulus ecclesie.
–Duccio, Cincturale, 60, verses 439–48.

34 Marchini, *Tesoro del duomo*, 96, document 8 (two documents cited). The first document, from 1325, mentions for the first time a "porticum plebis," which was repaired in 1336. Its function becomes clarified in the second document, specifying "super quo ostenditur pretiosissimum Cingulum beate Marie."

35 Such a scheme was executed in a later via coperta from 1394; see Pelagatti, *S. cingolo mariano*, 14.

36 Since the release of my comments regarding these reliefs in my 1993 dissertation,

this identification has also been suggested in Bigazzi, "Vesti regali," 18–30, esp. 28 n. 13; in Cerretelli, "Musei diocesani," 204; Cerretelli, *Sacra cintola e la sua cappella*, 2; and Cerretelli, "Pieve e la cintola," 91.

37 The first evidence of destruction of houses on the Piazza della Pieve was in the ordinances of 1291 and 1293 calling for the clearing of rubble from the original plaza comunis. Giuseppe Nuti discussed this process in relation to the destruction of the original palatium curie and Guelph-Ghibelline strife in his "Piazza della pieve," 54–55. Renzo Fantappiè hypothesized that the destruction extended as far as Via Valdigora; see Fantappiè, "Nascita," 213. Any structures still standing in front of the church after 1293, including the twelfth-century city walls, would have been razed after the commencement of a new ring of city walls, in 1328, and particularly after an ordinance of September 30, 1329, calling for the razing of the houses of all Ghibellines and rebels, in order for the commune to secure material for the construction of the walls. As the area around the Pieve was one of the city's oldest two settlements, it had a large number of tower-houses, such as those of the Levaldini and Dagomari, who were themselves Ghibellines and rebels, respectively. Other destroyed houses included those of the Puccii family; their building was leveled in 1305, as attested to in a legal action against persons who attempted to remove the wood from the destroyed structure by night: "De nocte abstulerunt lingnamina que erant in domo devastata per comune Prati Guccii Puccii et Ricoveri Puccii de Ugorlandis ghebellinis et rubellis comunis," SASP, *Comune, Atti giudiziari*, 484, quad. 7, c. 6r, April 6, 1305; see Fantappiè, "Nascita," 256 n. 187. Fantappiè located these houses at the far northern end of the piazza, across the street from the northernmost house facing the Pieve; 240–41 fig. 23.

It is therefore reasonable to assume that the tower-houses of similar consorteria families, located to the west of the church, were torn down after the 1329 ordinance. For the September 30 ordinance, see SASP, *Comune, Diurni*, 75, c. 41v–42r, and another, similar ordinance, from August 16 of the same year, c. 34v. See also Fantappiè, "Nascita," 185 and 259 n. 247.

The new baptistery at the Vicolo dell'Opera was destroyed in the eighteenth century; see Nuti, "Piazza della pieve," 65–66.

38 SASP, *Comune, Diurni*, 71, cc. 436r–437r, August 11, 1313; see Fantappiè, "Nascita," 206, 270 n. 441.

39 For this process and its documentary record, see Toccafondi, "Legati da una cintura," 61–73, esp. 65.

40 "Concerning building on the Piazza della Pieve" (*de hedificando super platea plebis*), January 27, 1336. ASP, *Comune, Diurni* 77, sheets 2v, 3.

41 "Ordinances for the construction of houses on the platea plebis," *ord(inamentum) domorum hedificand(um) sup(er) platea plebis*, February 10, 1336. ASP, *Comune, Diurni* 77, sheets 7, 7v, 8. The supplement regulated the minimum sporti height of twelve braccia from the ground, on buildings across from the Pieve; SASP, *Comune, Diurni*, 77, c. 19v; see Nuti, "Piazza della pieve," 58 n. 2.

 Payments for drawing up the regulations, measuring lots, and designing the houses were made on February 20, 1336: "Otto defensores populi et vexillifer iustitie terre Prati deliberaverunt quod camerarius comunis det et solvat: Tommasio d. Ghecti, qui mandato dd. Octo et in servitium comuis scripsit ordinamenta facta de modo dt forma hedificandi super platea plebis, libras tres den. flor. parv.; Riccho ser Vannis, Cieo Ricoveri et ser Rinaldo Binducchi, qui mandato dd. Octo et in servitium comunis mensuraverunt et designaverunt plura casolaria et vias super platea plebis, cuiliget eorum soldos novem den. flor. parv," –SASP, *Comune, Diurni*, 63, quad. 3, c. 9r.

42 As the width of these lots was also twelve braccia, this ordinance assured square or vertical proportions for the ground and piano nobile elevations. This turned sporti into decoration and order.

43 Though wooden trabeated and trusslike construction was also common at this time, it was usually wooden crossbeams on wooden piers; when there were stone piers, the superstructure was almost invariably of stone or brick. See the different examples in Bologna; Bocchi, *Portici di Bologna*.

44 SASP, *Comune, Statuti*, 5, cc. 16v, 17r, 22v. See Cerretelli, "Piazza ed il palazzo," fig. on 36; and *Prato, storia di una città*, 1.2: figs. 29, 30, 32; see also Fantappiè, "Nascita," 227, 290 n. 745.

45 "Item quod quilibet cui concedetur per communem prati de terreno dicte platee et hedificare voluerit domum seu domos super eo possit habere de dicto terreno ab una via

ordinata usque ad aliam recto tramite si dominis Octo et Vexillifero Justitie faciendo super dicto terreno duas domos inde ab utraque via unam domum faciat et hoc nulli concedi possit qui in eis expendere velit minus de CCC librorum denariorum faciendo unam domum ex uno latere de librorum CC loco plulcriori ad minus et alio de Centum ex alio latere ad minus,"–SASP, *Comune, Diurni*, 77, f. 7, February 10, 1336.

46 This is to be deduced from the statutes, by combining the required minimum amounts for the various structures.

47 SASP, *Comune, Diurni*, 77, f. 4.

48 SASP, *Comune, Atti di finanza*, 878, quad. 13, c. 3r, November 27, 1333; see Fantappiè, "Nascita," 496 n. 273.

49 See Cerretelli, *Palazzo comunale*, 51 n. 6; 55 n. 29.

50 See Conforto, *Adriano e Costantino*; for another view, see Pensabene e Panella, *Arco di Costantino*.

51 Richard Krautheimer, "Introduction to an 'Iconography of Mediaeval Architecture,'" 1–33.

52 Bandmann, *Mittelalterliche Architektur*.

53 Braunfels, *Mittelalterliche Stadtbaukunst*, 131–34.

54 See Marchini, *Duomo di Prato*, 15; on January 31, 1359, there is a record that documents yet further payments for work on one of the chapels; SASP, *Patrimonio Ecclesiastico, Opera del Cingolo*, loose sheet.

55 The original platea plebis had also reflected the interior of the church with its long, narrow proportions and with the blind arcade running along the facing, south elevation of Santo Stefano.

56 See Fiumi, *Demografia*, 402–4, 414–16, and 504–6; Marchini, *Duomo di Prato*, fig. B after 16.

57 Braunfels, *Monasteries of Western Europe*, 138–40. Thanks to Howard Burns for suggesting the parallel between the patronage of mendicant chapels and of the Piazza della Pieve lots.

58 Le Goff, *Birth of Purgatory*, 293–94, 350–52.

59 Brown, *Cult of the Saints*, 50–68, esp. 56–58 and 60–63. The notion of ad sanctum as intercession of the saints on the Day of Judgment is also implicit in paintings of the Trecento, which depict donors kneeling in front of saints, who plead for the donors to Mary or Christ.

60 For the development of the transept chapels in mendicant architecture, see Meersseman,

"Origine del tipo di chiesa umbro-toscano," 63–77, esp. 75. For their use, see Braunfels, *Monasteries of Western Europe*, 138–40.

61 The correspondence is also apparent in details, such as the demand for the "beautiful" execution of arches, achieved through the stipulations of the material. At Santa Maria Novella, stone, mortar, and white and black marble are required "facere et murare de lapidibus et calcina et marmoribus albis et nigris," Milanesi, *Nuovi documenti*, 29 no. 33. The regulations in Prato demanded "beautiful arches of big drafted, good stone blocks, as well built with mortar," and "teneatur facere pilastros pulcros. . .de bonis lapidibus grossis et cantonibus et calce."–SASP, *Comune, Diurni*, 77, sheet 7.

62 The relief is kept today in the Museo di Pittura Murale in Prato; Bellosi, Angelini, and Ragionieri, "Le arti figurative," 912.

9 | THE SIGNIFICANCE OF THE VIRGIN, HER BELT, AND ITS SETTING IN PRATO

1 See also Galletti, "Storie della sacra cintola," 317–38; Fantappiè, "Nascita," 168–69. For the eastern origins of the veneration of the Sacred Belt and its possible thirteenth-century origins in connection with the Sacred Belt of the Virgin attended by Latin canons at the Marian basilica of Chalkoprateia, see Petrà, "Origine orientale," 17–21. Petrà notes that duplicate relics were often created through contact with the original.

2 See Brooke and Brooke, *Popular Religion*, 31–34; and Vauchez, "Patronage des saints," 59–80, esp. 66.

3 See Little, *Religious Poverty*, 184–219.

4 The first church in Prato dedicated to the Virgin was Santa Maria in Castello, dating from at least as far back as the eleventh century; Fantappiè, *Carte della propositura*, 151–53, document 76, April 23, 1091–95. Not long afterward Vallombrosan monks had settled at Santa Maria di Grignano, well outside the city walls; ibid., 248–49, document 126, October 1130. The same monks sought to establish themselves within the city walls, and were finally successful, after more than fifty years, winning permission to build Santa Maria Maggiore. The very name of this church may imply a will to claim first place in the Marian devotion of the Pratese. For the Virgin's general importance during this period, see Brooke and Brooke, *Popular Religion*, 31–34.

5 See Banker, *Death in the Community*, 110ff, esp. 113. See also the late thirteenth-century laud from Cortona: "Maria gloriosa biata / sempre sí molto laudata: / preghiam ke ne sí avocata / al tuo filiol, virgo pia…Vigorosa potente beata / per te è questa laude cantata: / tu se'la nostra avocata, / la più fedel ke mai sia," in Liuzzi, *Lauda*, 257, 259.

6 "Pregán te che tu ne perdoni / tutta la nostra villania / …madre d'ogne peccatore," in Liuzzi, *Lauda*, 258, 317.

7 The commune also sought to win control over their citizens by penetrating other religious institutions, such as the Ceppo, a Franciscan tertiary order dedicated to feeding the poor of the town, at the beginning of the fourteenth century; see Fantappiè, "Nascita," 201–2. The civil administration thereby had access to the Ceppo's lists of poor by gate. This, in turn, gave the government an exact account of who was their underclass and where it was distributed, for purposes of social control. Such control could be simply exercised, now, by threatening to cut off bread donations to the unworthy.

For a comparative study of the use of street-corner images of the Virgin as a means of social control in Florence, Venice, Udine, and Naples, see Muir, "Virgin on the Street Corner," 25–40. For a study of religion as a means of controlling Florentine new town residents, see Friedman, *Florentine New Towns*, 173–99. For the role of urban design in fostering the absorption of the individual by the state in Trecento Florence, formally and, to a lesser degree, ritually, see Trachtenberg, *Dominion of the Eye*, 258–73.

8 "Vera finta" is the phrase in modern Italian parlance used to describe illegal copies of designer clothing or Louis Vuitton handbags. Despite the ironic wink synchronized with its pronouncement, the term tends more to vaunt the clever thrift of the purchaser of such items—inevitably the speaker—than to critique the illegality of its manufacture, sale, and purchase, the exploitive illegal-immigrant and labor conditions behind such transactions, or the manipulation of advertisement and legislation by the "real" designers purportedly hurt by such practices. One may well question how much such a term may have roots in a culture that built nearly every one of its churches on an either stolen or manufactured relic. "XVI…de plebe in festo sancte Marie et de…cingulum eius," SASP, *Comune, Statuti*, 2, framm. 4; see Fantappiè, "Nascita," 245 n. 19.

9 "De cingulo beate Marie non difirmando. Rubrica. Camerarii comunis Prati teneantur expresse non diffirmare aliquo modo cingulum beate Marie virginis, quod est apud plebem S. Stefani, sine licentia potestatis et capitanei," SASP, *Comune, Statuti*, 2, framm. 11, datable between 1285 and 1297; see Fantappiè, "Nascita," 245 n. 19.

On September 30, 1287, the commune required that the Belt be protected in a case with two locks; SASP, *Comune, Consulte*, 54, framm. 12, c. 36r. One of the two keys was held by the commune in a chest at San Francesco, "in cypo comunis quod est ad domum fratrum minorum de Prato," SASP, *Comune, Atti di finanza*, 881, quad. 17, c. 20r, July 4, 1293. See Fantappiè, "Nascita e sviluppo," 245 n. 29.

10 See Burini, "Tre Capitelli del Maestro di Cabestany," 61.

11 See Gai, *Altare argento*, 33–44, 46.

12 On the motives of civic competition behind the promotion of the cult of the sacred Belt in the late thirteenth century, as well as for details of the cult itself, see Fantappiè, "Storia e 'Storie' della Cintola," esp. 42–43.

13 See Fantappiè, "Nascita," 271 n. 464.

14 In his *Cincturale* from 1340, Duccio di Amadore (68, verses 555–60) describes the form of the Belt as follows:

Estimo Cincturam longa per brachia trina
in medio latam consolidamque suo,
sed partes gemine capitum geminantur utrinque
inter se: pariter pars sua dirimit.
Quosdam nodellos in formam glandis in illis
effecit mappis Virgo Beata manu…

For a similar, later description, see Bianchini, *Notizie istoriche*, 24.

15 For the importance of veste in both male and female confraternities in Prato, see Manselli, "Istituzioni ecclesiastiche," 795–97, and Fantappiè, "Nascita," 202, 205.

16 The veste did, however, have to be paid for or replaced by the families of the deceased; see James R. Banker, who analyzed the importance of the veste in male penitential orders at the Tuscan commune of San Sepolcro, in his *Death in the Community*, 166.

17 The importance of the belt for the mendicants is shown, for example, in a clothing law approved by the Bishop of Pistoia, Guidaloste Vergolesi in the thirteenth century, for the *pinzocheri* (rectors) in a third order of Franciscans: "Abbiano un abito umile e decoroso e vestano in maniera eguale e cioè una tunica dal di sopra ed un mantello; né siano bianche o nere, affatto, ma alla foggia dell'Ordine di San Francesco, portando se lo vorranno una tonaca al di sotto di panno bianco, si servano di una cordicella di filo o di lino, come cingolo. Si tosino del tutto i capelli, in foggia completa dall'orecchio in su, a tondo, e li coprano con un velo bianco. Dormano vestite e con la cintura in ogni tempo se non siano costrette altrimenti da una malattia," cited from Manselli, "Istituzioni ecclesiatiche," 796.

18 The Assumption, the day when Mary gave her Belt to Thomas, was as well an important day for the mendicants. St. Francis' penitential fast on Mount Verna, for example, which culminated in his Stigmatization, began on the Feast of the Assumption. For this and other aspects of devotion of the Assumption of the Virgin in Tuscany, including the importance of Prato's Sacred Belt, see Cassidy, "Assumption," 174–80, esp. 176 n. 8.

19 Bettino di Corsino's *Madonna* has the distinction of being the earliest extant example of two new iconographies, the *Madonna del Sacro Cingolo* and the *Madonna del Parto* showing the Virgin bulging with child (in earlier paintings a medallion or mandorla-like window was depicted at the Virgin's breast). With this type, Bettino established a hybrid iconography which was to become widespread in Tuscan painting, revealing the power of the Sacred Belt to provide comfort for expectant mothers. See Cassidy, "Relic," 91–99.

For Bettino di Corsino's painting, see also Offner, *Fourteenth Century*, 25–26, 168, pl. XLI.

20 See also Cassidy, "Assumption," 179–80. It should also be recorded that this day was the completion date requested by the patron of the Santa Maria Novella avelli referred to above: "monumenti et sepulture fiende hinc ad festum beate marie mensis augusti," Milanesi, *Nuovi documenti*, 29, no. 33. On the importance of the Assumption and associated public rituals, including a *via triumphalis*, in artistic production in Rome between the twelfth and thirteenth centuries, see Tronzo, "Apse Decoration," 167–93.

21 See Seidel, "Sanctissima Imperatrix," 121–63.

22 "Ad faciendum fieri et pingi quandam gloriosam et pulcerimam [*sic*] tabulam ad honorem Dei et beate Virginis Marie et gloriosissimi eius Cinguli, que poni debet ad eius altare in maiori plebe," August 21, 1337, payment to the Opera del Cingolo by the commune; cited after Giani, "Documenti su antichi pittori pratesi," 61–77, esp. 74.

23 Art historians are in disagreement as to the attribution and dating of this panel. See Marchini, "Vicende di una pala," 1: 320–23; Offner and Steinweg, *Corpus of Florentine Painting*, 72–74; and Pope-Hennessy, *The Robert Lehman Collection*, 1: 48–51. However, there exists a hitherto unnoticed reference, by Duccio di Amadore in his 1340 *Cincturale* (Duccio, *Cincturale*, 66–68, verses 543–54), which refers to the main altarpiece, confirming the identification of the Lehman panel as part of this altarpiece:

Qualiter pingitur assumptio Sanctae
Mariae in toto mundo
ad praedictorum confirmationem

Hinc est assumptam representant qui Geni
tricem
Christi: quoque loco gens sua festa colit.
Effigiant illam medioque throno residentem
nubibus ethereis vinctam adire polum
angelicumque chorum portantem circiter illam
et Sanctum Thomam poscere suppliciter
signum, Cincturam cui Mater tradit ab alto:
pictam sic, lector, qualibet urbe vides.

The poet describes paintings of Mary as enthroned, on a bank of clouds supported by angels, from which she passes the Belt to Thomas. He asserts that this image appeared in whatever city the Assumption of the Virgin was venerated. The detail of this description indicates that it is based on personal observation and therefore that a painted version of the scene must have existed at the time. It is reasonable to assume that Duccio was describing a painting in Prato: the Assumption was venerated in Prato, and Duccio was a citizen—even employee—of the commune, mentioned as the master of grammar in 1336; see Cardini, "Cultura," 823–69, esp. 827. The correspondence between Duccio's description and the recently painted gable by Bernardo Daddi makes it highly probable that Duccio had been observing the panel now in the Lehman collection, at the time crowning the center of the polyptych, located at the main altar of the Virgin, in Santo Stefano.

24 For fourteenth-century depictions of the Assumption showing Mary's presentation of the Belt to Thomas, see Cassidy, "Assumption," 180 n. 34, with more than a dozen representations from Tuscany.

25 See ibid., 180.

26 A detail in the Florentine Santa Maria Novella avelli document cited above may be a confirmation of the Virgin's peculiar ability to draw the venerator to heaven—the stipulated date for completion was the 15th of August, the Feast of the Assumption.

27 On July 8, 1293, the commune paid one Lippo Acompagnati 16 soldi for having made an altar for the custody of the Belt: "Lippo Acompagnati sedecim soldos pro remuneratione sui servicii quod stetit ad faciendum fieri opus altaris beate Marie virginis plebis S. Stephani pro custodia cinture beate virginis Marie," SASP, *Comune, Diurni*, 57, quad. 10, c. 17r; see Fantappiè, "Nascita e sviluppo," 245 n. 21. The placement of the Sacred Belt within the altar can be deduced from the fact that it was erected *pro custodia*, for the custody of the relic.

28 The relic was moved to the front of the church in 1346, where a new chapel was constructed for it by the commune. Shortly afterward a balcony for showing the Belt on the façade interior, later replaced by the current Renaissance design, was probably constructed; see Cerretelli, "Pieve e la cintola," 90–91.

29 SASP, *Comune, Diurni*, 57, c. 57. April 30, 1330. As noted above, the reliefs now lining the altar in the crypt of Santo Stefano may be from this original pulpit. The exact status of the corner pulpit predating that of Donatello and Michelozzo has yet to be clarified. The original request for the pulpits in 1330 stipulated that they be marble and historiated. Work appears to have begun in 1337. After then, however, there are no records of work payments on the corner of the church or on the marble reliefs until 1359. The registration in 1359 of what appears to be the installation of a door on the cathedral corner suggests that only then was the pulpit project brought to completion. By 1360 a marble pulpit, completed if not designed by Niccolò di Cecco del Mercia and his son Sano, was installed at the corner of the church by the new elevated doorway completed by master Fetto (Giovanni di Francesco). For most of the documentary record, see Milanesi, *Documenti per la storia dell'arte senese*, 1: 180, 251–55, and *Nuovi documenti*, 54–56; for other documents and an analysis, see Cerretelli, "Pieve e la cintola," 90–91. Thanks to Brendan Cassidy for his comments and observations regarding this pulpit.

30 According to Giuseppe Bianchini and Gioacchino Pelagatti, the Belt was originally draped from the hands of the officiator after he had unwrapped the relic from the precious cloths in which it was kept: "Fu sempre solito costume, che la Cintola santissima ripiegata si tenesse in ricchi e finissimi drappi…il Prelato, che la mostrava, vestitosi di guanto di seta le mani, dispiegava i drappi, ne' quali involta era, e in mano distesamente prendendola, la dimostrazione ne facea, e poi ripiegatala, e negli stessi drappi involtala, come già stava, nella cassetta d'avorio la riponeva," Bianchini, *Notizie istoriche*, 71; see also Pelagatti, *S. cingolo mariano*, 67–68. For the silk gloves that the officiator had to wear when presenting the Sacred Belt, see SASP, *Comune, Atti di finanza*, 875, c. 162v, April 30, 1321, and c. 114r, September 30, 1321.

31 See also below, the anthropomorphic description of the crying and rising earth in the description of the ascension of the Virgin by Duccio, *Cincturale*, 179 n. 317; and Boskovits, *Pittura fiorentina*, 7.

32 See Alexander Perrig, "Formen der politischen Propaganda," 213–34, esp. 216–17.

33 Such cross-gender role-playing by priests was typical of mystery plays of the thirteenth and fourteenth centuries, such as that in the thirteenth-century Padua *Ordinarium Ecclesiae*, discussed by Henk W. van Os in his article "Madonna and the Mystery Play," 5–19.

34 Duccio, *Cincturale*, 64–66, verses 521–28:
testificumque sibi dum munus posceret, illa
solvens Cincturam, tradidit hanc Didimo
[Thomas],
terraque plana loco tunc accumulatur in altum
instar monticuli quo stetit ille pede
(publica fama fore sonat hoc peragrantibus illuc,
digne persone sic retulere fide),
ut locus ipse foret facto contestis, et est nunc
pone locum Stephanus quo lapidatus obit.

35 This appears to be a poetic device. However, throughout the story of the Sacred Belt by Duccio, inanimate objects, particularly buildings, are repeatedly coming to life and even showing positive or negative moral attributes, usually through possession by benign or evil spirits. See, for example, the miracle of the house, plagued by an evil spirit and liberated by the touch of a fragmentary piece of the cloth, in which the Sacred Belt was wrapped; in Duccio, *Cincturale*, 44–46, verses 221–60.

The power of the cult of relics and of saints suggests that these apparent learned allusions or metaphors, even those so often repeated as to be considered topoi, were rather metonymies, in the precise literary-critical sense of the term. They were functioning not as "parts for the whole," which is synecdoche, but as

attributes of a god or goddess representing, or rather embodying, the divinity itself. The visual topoi of Jerusalem at Prato's Santo Stefano were manifestations of an ancient pantheism predating even the Greco-Roman gods. Such animism persisted at the very center of the Christian cult, not only with Sacred Geography and the cult of the saints and their relics, but with the Eucharist itself.

The recently instituted requirement, at the Fourth Lateran Council of 1215, that all Christians must take the sacrament of the host, was extending its symbolic and totemic power, and, by extension, the aura of other sacred objects that were at once material and divine, such as relics and, arguably, sacred architecture. On the new valuation of the host, so much so that it was the "single most important image to Christians from the middle of the thirteenth century onward," see Camille, *Gothic Idol*, 215–18.

36 Fantappiè, "Nascita," 210, 272 n. 476.

37 The authentication of the present with the past, together with its converse, forms part of Judeo-Christian culture since its origins, and is based on an idea of history as a covenant, to be fulfilled in the present.

38 For the demonstration of the Belt three times on these days, see Pelagatti, *S. cingolo mariano*, 44; and Nuti, *Fiera di Prato*, 18.

39 Prato was split by an internal war between Black and White Guelphs. In the 1320s, the city was several times the center of the devastating war led by Castruccio Castracani, Lord of Lucca and Pisa and imperial vicar in Tuscany. See Raveggi, "Protagonisti," 620–23.

40 The Sacred Belt was not the only means of the commune to pacify the town: on May 4, 1338, the commune paid three lire for a painting of St. George, which was to be made not only for the honor of God and the saint but also to preserve the peace in Prato: "Migliori pictori pro aiutorio pretii unius tabule quam pingit pro ecclesia Sancti Georgii ad honorem Dei et Beati Georgii, ut terram Prati in statu pacifico conservare dignientur," in Giani, "Documenti," 74.

41 Duccio, *Cincturale*, 36–38, verses 93–144; 42–50, verses 189–294; 56–62, verses 383–476; 74–78, verses 645–710. The protective, even militantly defensive aspects of the Sacred Belt, both as a guarantor of faith and as a guardian of a city, were already present in its veneration in Constantinople. See Petrà, "Origine orientale," 18–19.

42 Duccio, *Cincturale*, 36–37, verses 93–144. For the identification of the battle with the one against Pistoia in 1189, see Cesare Grassi in *Cincturale*, 101–2.

43 See Cherubini, "Sintesi conclusiva," 994; Pampaloni, "Popolazione, economia, società," 359–93; Raveggi, "Protagonisti," 620–23.

44 See Raveggi, "Protagonisti," 620.

45 The Pratese conferred on him the title of "generalis dominus et rector atque defensor terre Prati et districtus"; see Raveggi, "Protagonisti," 621. See also Martini, "Dedizione di Prato a Roberto d'Angiò," 3–44.

46 Fantappiè, "Nascita," 180–81.

47 Fiumi, *Demografia*, 35–83. For similar figures elsewhere in Tuscany and Europe, see Cherubini, "Crisi," 660–70; Perroy, *Medioevo*, 359–438; Larner, *Italy in the Age of Dante and Petrarch*, 256–68; LeGoff, *Medieval Civilization*, 106–10; and Lesnick, *Preaching in Medieval Florence*, 2.

48 For the filled city being a sign of strength, see, for example, Leonardo Bruni's 1402–3 "Laudatio Florentinae Urbis," in Kohl and Witt, *Earthly Republic*, 138–41. See also Bruni, *Vere lode*.

49 Document in SASP, *Comune, Diurni*, 76, c. 27, *De forensibus volentibus effici pratenses*; see Nuti, "Piazza della pieve," 56 and n. 2.

50 The bills were issued on October 14 and 17, 1333; SASP, *Comune, Diurni*, 76, cc. 80v, 81–82, *Ordimento de domibus de novo fiendis pro districtualibus*; see Nuti, "Piazza della pieve," 56 and n. 3.

51 For the softening of the law, see SASP, *Comune, Diurni*, 76, c. 99; see also Nuti, "Piazza della pieve," 57.

52 See Duccio, *Cincturale*, 60, verses 461–64.

53 Suggested by Richard Krautheimer to Christine H. Smith, *Baptistery of Pisa*, 4: 24 and n. 33.

54 See Seidel, "Ubera Matris," 79–84, esp. 82.

55 For both of these paintings, see Boskovits, *Origins of Florentine Painting*, 1: 748–81.

56 See Raveggi, "Protagonisti," 622.

57 See ibid., 622, 698 n. 56.

58 Recto: "Robertvs Dei gra(tia) (H)ier(usa)lh(em) et Sicil(iae) rex"; verso: "In perpetvv(m) cu(m) successo(r)ib(vs) D(omi)n(u)s t(er)r(a)e Prati."

59 Convenevole da Prato, *Regia carmina*.

60 Ibid., 41–42.

61 Convenevole di Acconcio, commonly called Convenevole da Prato, was the teacher of Petrarca. He was master of rhetoric in 1336, the same year that Duccio di Amadore was mentioned as master of grammar. See Cardini, "Cultura," 827.

62 See Raveggi, "Protagonisti," 624–27.

63 See Cerretelli, "Piazza ed il palazzo," 25–27.

64 See Nicastro, "Statua di Re Roberto," 140–47.

65 For an excellent account of the erosion of the commune's once remarkable "political passion and patriotism," and its gradual fall to the Florentines, see Raveggi, "Protagonisti," 618–27, 683–94.

66 Martines, *Power and Imagination*, 94–102; Tabacco, *Struggle for Power*, 285–320; Jones, *Italian City-State*, 600–650.

10 | EPILOGUE

1 For the lighting of the Piazza della Pieve for the "fiera di Prato" and for the race along the Via della Pieve (later del Corso; now Mazzoni) every December 26, see Nuti, "Piazza della pieve," 50–51; for the choreography of other spaces in the city, see Nuti, *Fiera di Prato*, 13–18.

2 See Geuss, "Ideology in the Pejorative Sense," in *Idea of a Critical Theory*, 12–22. I may be obscuring the clearly defined structure and purpose of Geuss' analysis of contemporary criticism by applying it to a historical situation where the persons who logic might convince to act more rationally have been dead for some time. To make matters worse, I am willing to admit a greater role for the persuasive arts—whether rhetoric or artistic representation—in the role of effective critics of a period. The relative success or failure of the mendicants, scholastics, jurists, or humanists in reconciling the religious, social, economic, and political demands of the emerging urban economy depended as much on their persuasive ability as on the correctness, or lack of "self-delusion," of their positions. This book is in part an exploration of the fine line between legitimate persuasive techniques and deception.

3 On scholastics and theologians' deliberations over economic issues, see works by de Roover: "La doctrine scolastique," 176; "Labor Conditions in Florence," 277–313; "Concept of the Just Price," 418–34; *San Bernardino*. See also Little, *Religious Poverty*, 176–83, 211–17.

4 See Little, *Religious Poverty*, 206.

5 One excuse, the *lucrum cessans*, allowed for interest equivalent to the lost opportunity of productive investment forgone for a loan. When a lender engaged in the labor of

business travel, accounting or exchanging currencies, and putting usurious money to productive use—that is, investing labor or reinvesting profits in the local economy—then he deserved remuneration, and "usury" could be redefined as "wages." Other excuses related to the risk of losing both capital and interest, whether through the debtor's "insolvency or his bad faith" ("pecuniam sortis") or through the uncertainties of economic affairs ("ratio incertitudinis"). In either case interest was a compensation for the risk taken, and in all cases the rate of interest had to be "moderate." Through these "excuses" the church grudgingly accepted the greater availability of capital for economic growth while hoping to ensure its productive—versus exploitive—use. See Le Goff, *Your Money or Your Life*, 73–74. For other justifications and the slackening of sanctions against usurers, see Little, *Religious Poverty*, 177–83, 212–13.

6 Little, *Religious Poverty*, 176–77.

7 Ibid., 213–14.

8 Ibid., 183.

9 Ibid., 213.

10 Raveggi, "Protagonisti," 686–94.

11 Toccafondi, "Legati da una Cintura," 64–66.

12 See Sigmund Freud's discussion of the "oceanic state" in *Civilization and Its Discontents*, 13–21.

13 Brown, *Cult of the Saints*, esp. 1–22, 86–127.

14 See Kantorowicz, *King's Two Bodies;* Bloch, *Rois thaumaturge;* Freud, "The Taboo of Rulers," in *Totem and Taboo*, 56–69.

15 See Cassidy, "Assumption."

16 Fantappiè, "Nascita," 188.

17 The population of Prato declined by 23.8 percent between 1339 and 1372, mostly owing to the plague of 1348; see Fiumi, *Demografia*, 84–92.

18 "Poterano conoscere per non sapere usare libertà divenire suggetti." Quoted from Raveggi, "Protagonisti," 627.

BIBLIOGRAPHY

Abulafia, David. *Frederick II: A Medieval Emperor.* Harmondsworth, 1988.

Badiani, Angiolo. "Il mosaico del pavimento della chiesa di S. Fabiano." *Archivio storico pratese* 12 (1934): 20–23.

Bagioli, Gianni, Giovanni Corbella, and Luigi Isnardi (eds.). *Emilia Romagna.* Guida d'Italia (TCI) 165. 5th ed. Milan, 1971.

Baldanzi, Ferdinando. *Della chiesa cattedrale di Prato.* Prato, 1846.

———. "Abbazia o prioria di San Fabiano, ora seminario ecclesiastico." *Pel calendario pratese del 1848, Memorie e studi di cose patrie* 3 (1847): 115–28.

Bandmann, Günter. "Zur Bedeutung der romanischen Apsis." *Wallraf-Richartz-Jahrbuch* 15 (1953): 28–46.

———. *Mittelalterliche Architektur als Bedeutungsträger.* 6th ed. Berlin, 1979.

Banker, James R. *Death in the Community: Memorialization and Confraternities in an Italian Commune in the Late Middle Ages.* Athens, Ga., 1988.

Barsali, Isa Belli. *Lucca.* Lucca, 1988.

Barthélmy, Dominique, François Bougard, and Réfine Le Jan. *La vengeance, 400–1200.* Collection de l'École Française de Rome 357. Rome, 2006.

Becker, Marvin. "Church and State in Florence on the Eve of the Renaissance (1343–1382)." *Speculum* 37 (October 1962): 509–27.

———. *Medieval Italy: Constraints and Creativity.* Bloomington, Ind., 1981.

Bellosi, Luciano, Alessandro Angelini, and Giovanna Ragionieri. "Le arti figurative." In *Prato, storia di una città: Ascesa e declino del centro medievale (dal mille al 1494),* 1.2: 907–62. Edited by Giovanni Cherubini. Florence, 1991

Benjamin, Walter. "The Work of Art in the Age of Mechanical Reproduction." In Benjamin, *Illuminations.* Edited by Hannah Arendt. New York, 1968.

Berg, Knut. "Miniature pistoiesi del XII secolo." In *Il romanico pistoiese nei suoi rapporti con l'arte romanica dell'occidente, Atti del I convegno internazionale di studi medioevali di storia e d'arte (Pistoia-Montecatini Terme, 27 settembre–3 ottobre 1964),* 143–56. Pistoia, 1979.

Bering, Kunibert. *Kunst und Staatsmetaphysik des Hochmittelalters in Italien: Zentren der Bau- und Bildpropaganda in der Zeit Friedrichs II.* Essen, 1986.

Bernardini, Silvio. *Pievi toscane: Arte e religiosità del mondo contadino.* Turin, 1985.

Bianchini, Giuseppe. *Notizie istoriche della sacratissima cintola di Maria Vergine che si conserva nella città di Prato in Toscana.* Prato, 1822.

Bibliotheca Sanctorum, vol. 11. Rome, 1968.

Bigazzi, Isabella. "Le vesti regali di 'Nostra Donna' della cintola. I (secc. XIV–XV)." *Prato, storia e arte* 35, nos. 84–85 (1994): 18–30.

———. "Per Amore di Nostra Donna: Paramenti e mantellini per la Madonna della Cintola." *La Sacra Cintola nel Duomo di Prato,* 247–249. Prato, 1995.

Bloch, Marc L. B. *Les rois thaumaturges: Étude sur le caractère surnaturel attribué à la puissance royale particulièrement en France et en Angleterre.* Paris, 1983.

Bocchi, Francesca (ed.). *I portici di Bologna e l'edilizia civile medievale.* Bologna, 1990.

Boskovits, Miklòs. *La pittura fiorentina alla vigilia del rinascimento.* Florence, 1975.

———. "Gli affreschi del Duomo di Anagni: Un capitolo di pittura romana." *Paragone* 30, no. 357 (1979, 2): 4–41.

———. *The Origins of Florentine Painting, 1100–1270. A Critical and Historical Corpus of Florentine Painting*, sec. 1, vol. 1. Florence, 1993.

Braunfels, Wolfgang. *Mittelalterliche Stadtbaukunst in der Toskana*. 6th ed. Berlin, 1988.

———. *Monasteries of Western Europe: The Architecture of the Orders*. 3d ed. Translated by Alastair Laing. Princeton, 1973.

———. *Urban Design in Western Europe: Regime and Architecture, 900–1900*. Translated by Kenneth J. Northcott. Chicago, 1988.

Brooke, Rosalind B. (ed., trans.). *Scripta Leonis, Rufini et Angeli Sociorum S. Francisci: The Writings of Leo, Rufino, and Angelo, Companions of St. Francis*. London, 1970.

Brooke, Rosalind B., and Christopher Brooke. *Popular Religion in the Middle Ages: Western Europe, 1000–1300*. London, 1984.

Brown, Peter. *The Cult of the Saints: Its Rise and Function in Latin Christianity*. Chicago, 1982.

Brucker, Gene A. *The Civic World of Early Renaissance Florence*. Princeton, 1977.

Bruni, Leonardo. *Le vere lode de la inclita et gloriosa città di Firenze*. Translated by Frate Lazarada Padoa. Florence, 1899.

Bruzelius, Caroline. *The Stones of Naples*. New Haven, 2004.

Burrini, Marco. "Tre capitelli del Maestro di Cabestany nel chiostro del Duomo di Prato." *Prato Storia e Arte* 36, no. 86 (1995): 49–64.

Caggese, Romolo. *Un comune libero alle porte de Firenze nel secolo XIII (Prato in Toscana): Studi e ricerche*. Florence, 1905.

Camille, Michael. *The Gothic Idol: Ideology and Image-Making in Medieval Art*. Cambridge, Eng., 1989.

Canino, A. (ed.). *Umbria*. Guida d'Italia (TCI). 5th ed. Milan, 1978.

Cardini, Franco. "La cultura." In *Prato, storia di una città: Ascesa e declino del centro medievale (dal mille al 1494)*, 1.2: 823–69. Edited by Giovanni Cherubini. Florence, 1991.

Carlesi, Ferdinando. *Origini della città e del comune di Prato*. Biblioteca istorica della antica e nuova Italia 143, 1904. Facsimile reprint. Bologna, 1984.

Carli, Enzo (ed.). *Il Duomo di Pisa*. Florence, 1989.

Cassidy, Brendan. "The Assumption of the Virgin on the Tabernacle of Orsanmichele." *Journal of the Warburg and Courtauld Institute* 51 (1988): 174–80.

———. "A Relic, Some Pictures, and the Mothers of Florence in the Late Fourteenth Century." *Gesta* 30 (1991): 91–99.

Cerretelli, Claudio. *Il Palazzo Comunale*. Tesi di Laurea, Facoltà di Architettura, Università degli Studi di Firenze, 1985.

———. "La piazza ed il palazzo del comune dal XIII al XVI secolo." *Prato, storia e arte* 77 (1990): 7–44.

———. "L'ambiente e gli insediamenti: Appendice." *Prato, storia di una città: Ascesa e declino del centro medievale (dal mille al 1494)*, 1: 63–78. Edited by Giovanni Cherubini. Florence, 1991.

———. "I musei diocesani." in *Archivi, biblioteche, musei pratesi: Sistema integrato per la storia locale, guida descrittiva*, 204. Edited by Livia Draghici. Prato, 1994.

———. "La pieve e la cintola: Le trasformazioni legate alla reliquia." In *La sacra cintola nel duomo di Prato*, 89–161. Prato, 1995.

———. *La sacra cintola e la sua cappella*. Prato, 1995; reprint from *Calendario pratese* (1995).

Chenu, Marie-Dominique. *Nature, Man, and Society in the Twelfth Century: Essays on New Theological Perspectives in the Latin West*. Translated by Jerome Taylor and Lester K. Little, 1968. Reprint, Chicago, 1983.

Cherubini, Giovanni. "La 'crisi del Trecento': Bilancio e prospettive di ricerca." *Studi storici* 15 (1974): 660–70.

———. "Sintesi conclusiva: Ascesa e declino del centro medievale (dal mille al 1494)." In *Prato, storia di una città: Ascesa e declino del centro medievale (dal Mille al 1494)*, 1: 963–1010. Edited by Giovanni Cherubini. Florence, 1991.

Cherubini, Giovanni (ed.). *Prato, storia di una città: Ascesa e declino del centro medievale (dal Mille al 1494)*. 2 vols. Florence, 1991.

Conforto, Maria Letizia. *Adriano e Costantino: Le due fasi dell'arco nella valle del Colosseo*. Milan, 2001.

Connell, William J., and Andrea Zorzi (eds.). *Florentine Tuscany: Structures and Practices of Power*. Cambridge, Eng., 2000.

Connelly, Joan B. "Parthenon and Parthenoi: A Mythological Interpretation of the Parthenon Frieze." *American Journal of Archaeology* 100 (1996): 53–80.

Convenevole da Prato. *Regia Carmina dedicati a Roberto d'Angiò Re di Sicilia e Gerusalemme*. 2 vols. Edited by Cesare Grassi. Prato, 1982.

Croally, N. T. *Euripidean Polemic: The Trojan Women and the Function of Tragedy*. Cambridge, Eng., 1994.

Ćurčić, Slobodan. "Late Antique Palaces: The Meaning of Urban Context." *Ars Orientalis* 23 (1993): 67–90.

Dameron, George W. "The Cult of St. Minias and the Struggle for Power in the Diocese of Florence, 1011–1024." *Journal of Medieval History* 13 (1987): 125–41.

———. *Episcopal Power and Florentine Society, 1000–1320*. Cambridge, Mass., 1991.

———. *Florence and Its Church in the Age of Dante*. Philadelphia, 2004.

Davidsohn, Robert. *Forschungen zur Geschichte von Florenz*, vol. 1. Berlin, 1896.

Deimling, Barbara. "Medieval Church Portals and Their Importance in the History of Law." In *Romanesque: Architecture, Sculpture, Painting*, 324–27. Edited by Rolf Toman. Cologne, 1997.

Delogu, Raffaello. "Pistoia e la Sardegna nella architettura romanica." In *Il romanico pistoiese nei suoi rapporti con l'arte romanica dell'occidente, Atti del I convegno internazionale di studi medioevali di storia e d'arte (Pistoia-Montecatini Terme, 27 settembre–3 ottobre 1964)*, 83–98. Pistoia, 1979.

Devoto, Giacomo, and Gian Carlo Oli. *Il dizionario della lingua italiana*. Florence, 1990.

Duccio di Amadore. *Il "Cincturale."* Edited by Cesare Grassi. Prato, 1984.

Dynes, Wayne R. "The Medieval Cloister as Portico of Solomon." *Gesta (The Cloister Symposium)* 12 (1973): 61–69.

Eberhard, Winfried. "'Gemeiner Nutzen' als oppositionelle Leitvorstellung im Spätmittelalter." In *Renovatio et Reformatio: Wider das Bild vom "finsteren" Mittelalter, Festschrift für Ludwig Hödl zum 60. Geburtstag*, 195–214. Edited by Manfred Gerwing and Godehard Ruppert. Münster, 1985.

Fanelli, Giovanni. *Firenze*. Le città nella storia d'Italia, 6th ed. Bari, 1997.

Fantappiè, Renzo. *Il bel Prato*. 2 vols. Prato, 1983.

———. "La chiesa di San Giovanni Fuorcivitas e i suoi rapporti con la propositura di Prato." *Bullettino storico pistoiese* 6 (1971): 79–124.

———. "Nascita d'una terra di nome Prato: Secoli VI–XII." In *Storia di Prato*, 1: 95–359. Prato, 1980.

———. "Nascita e sviluppo di Prato." In *Prato, storia di una città: Ascesa e declino del centro medievale (dal mille al 1494)*, 1: 79–299. Edited by Giovanni Cherubini. Florence, 1991.

———. "Storia e 'Storie' della Cintola." In *La Sacra cintola nel duomo di Prato*, 40–59. Prato, 1995.

Fantappiè, Renzo (ed.). *Le carte della propositura di S. Stefano di Prato*. Florence, 1977.

Fanucci, Quinto. *La Basilica di San Miniato al Monte sopra Firenze*. Italia Sacra II. Torino, 1933.

Fensterbusch, Curt (ed.). *Vitruvii de Architectura Libri Decem*. 2d ed. Darmstadt, 1976.

Ferrali, Sabatino. "S. Giovanni Fuorcivitas." *Chiese romaniche e moderne in Pistoia e diocesi*, 43–47. Pistoia, 1964.

Fiumi, Enrico. *Demografia, movimento urbanistico e classi sociali in Prato*. Florence, 1968.

Fortini Brown, Patricia. *Venice and Antiquity: The Venetian Sense of the Past*. New Haven, 1997.

Frampton, Kenneth. *Modern Architecture: A Critical History*. London, 1992.

Freud, Sigmund. *Totem and Taboo*. Translated by A. A. Brill. New York, 1918.

———. *Civilization and Its Discontents*. Translated by James Strachey. New York, 1961.

Friedman, David. *Florentine New Towns: Urban Design in the Late Middle Ages*. Cambridge, Mass., 1988.

Gai, Lucia. *L'altare argento di Sant'Iacopo di Pistoia*. Turin, 1984.

Galletti, Anna Imelde. "Storie della sacra cintola (Schede per un lavoro da fare a Prato)." In *Toscana e Terrasanta nel medioevo*, 317–38. Edited by Franco Cardini. Florence, 1982.

Gaudenzi, Augusto (ed.). *Statuti del popolo di Bologna: Gli ordinamenti sacrati e sacratissimi colle riformagioni da loro occasionate e dipendenti ed altri provvedimenti affini*. Bologna, 1888.

Geary, Patrick J. *Furta Sacra: Thefts of Relics in the Central Middle Ages*. 2d ed. Princeton, 1990.

Geuss, Raymond. *The Idea of a Critical Theory: Habermas and the Frankfurt School*. Cambridge, Eng., 1981.

Giani, Giulio. *Prato e la sua fortezza: Dal secolo XI fino ai giorni nostri*. Prato, 1908.

———. "Documenti su antichi pittori pratesi e sull'opera loro." *Archivio storico pratese* 1, fasc. 2 (1917): 61–77.

———. "Il palio a Prato." *Archivio storico pratese* 3 (1920): 8–14.

Goffen, Rona. *Spirituality in Conflict: Saint Francis and Giotto's Bardi Chapel*. University Park, 1988.

Goldthwaite, Richard. *The Building of Renaissance Florence, an Economic and Social History*. Baltimore, 1985.

Götze, Heinz. *Castel del Monte: Geometric Marvel of the Middle Ages*. Munich, 1998.

Grohmann, Alberto. *Assisi*. Le città nella storia d'Italia. Rome, 1989.

Guidoni, Enrico. "Città e ordini mendicanti: Il ruolo dei conventi nella crescita e nella progettazione urbana del XIII e XIV secolo." *Quaderni medievali* 4 (1977): 69–106.

———. *Arte e urbanistica in Toscana, 1000–1315*. Rome, 1989.

Gurrieri, Francesco. "Il complesso di S. Agostino in Prato." *Prato, storia e arte* 8, no. 19 (1967): 6–68.

———. "Prime considerazioni su alcuni reperti architettonici del duomo di Prato." *Prospettiva* 7 (1976): 68–70.

———. *La piazza del duomo a Pistoia*. Bergamo, 1995.

Gurrieri, Francesco (ed.). *Il castello dell'imperatore a Prato*. Prato, 1975.

Haines, Margaret, and Lucio Riccetti. *Opera: Carattere e ruolo delle fabbriche cittadine fino all'inizio dell'età moderna, Atti della tavola rotonda (Villa I Tatti, Firenze, 3 aprile 1991)*. Florence, 1996.

Hamann-Mac Lean, Richard. "Künstlerlaune im Mittelalter." In *Skulptur des Mittelalters: Funktion und Gestalt*, 414–52. Edited by Friedrich Möbius and Ernst Schubert. Weimar, 1987.

Holländer, Hans. *Early Medieval Art*. New York, 1974.

Horn, Walter. "On the Origins of the Medieval Cloister." *Gesta: The Cloister Symposium* 12 (1973): 13–52.

Jones, Philip James. "Medieval Agrarian Society in Its Prime: Italy." *The Cambridge Economic History of Europe*, 1: 340–431. Edited by Michael Moissey Postan. Cambridge, Eng., 1965.

———. "La storia economica, Dalla caduta dell'Impero romano al secolo XIV." *Storia d'Italia*, 2.2: 1646–1662. Edited by R. Romano and C. Vivanti, translated by Carla Susini Jones. Turin, 1974.

———. "Economia e società nell'Italia medievale: La legenda della borghesia." *Storia d'Italia: Dal feudalismo al capitalismo*, Annali 1: 187–372. Edited

by R. Romano and C. Vivanti, translated by Carla Susini Jones. Turin, 1978

———. *The Italian City-State: From Commune to Signoria*. Oxford, 1997.

Hartwig Kantorowicz, Ernst. *The King's Two Bodies: A Study in Mediaeval Political Theology*. Princeton, 1957.

Keller, Hagen. "Der Gerichtsort in oberitalienischen und toskanischen Städten: Untersuchungen zur Stellung der Stadt im Herrschaftssystem des Regnum Italicum vom 9. bis 11. Jahrhundert." *Quellen und Forschungen* 49 (1969): 1–72.

Klewitz, Hans Walter. "Die Entstehung des Kardinalkollegiums." *Zeitschrift der Savigny-Stiftung für Rechtsgeschichte, Kanon. Abt*. 25 (1936): 115–221.

Kohl, Benjamin G., and Ronald G. Witt (ed. and trans.). *The Earthly Republic: Italian Humanists on Government and Society*. Philadelphia, 1978.

Krautheimer, Richard. "Introduction to an 'Iconography of Mediaeval Architecture.'" *Journal of the Warburg and Courtauld Institutes* 5 (1942): 1–33.

———. "The Beginning of Early Christian Architecture (1939)." In Krautheimer, *Studies in Early Christian, Medieval and Renaissance Art*, 1–25. New York, 1969.

Krinsky, Carol Herselle. "Seventy-Eight Vitruvius Manuscripts." *Journal of the Warburg and Courtauld Institutes* 30 (1967): 36–70.

Larner, John. *Italy in the Age of Dante and Petrarch, 1216–1380*. London, 1980.

Le Goff, Jacques. "Apostolat mendiant et fait urbain dans la France médiévale." *Annales: Économies, Sociétés, Civilisations* 23 (1968): 335–52.

———. "Apostolat mendiant et fait urbain dans la France médiévale: État de l'enquête." *Annales: Économies, Sociétés, Civilisations* 25 (1970): 924–46.

———. *The Birth of Purgatory*. Translated by Arthur Goldhammer. Chicago, 1984.

———. *Medieval Civilization, 400–1500*. Translated by Julia Barrow. Oxford, 1988.

———. *Your Money or Your Life: Economy and Religion in the Middle Ages*. Translated by Patricia Ranum. New York, 1988.

Le Pogam, Pierre-Yves. *De la "cité de dieu" au "palais du pape": Les résidences pontificales dans la seconde moitié du XIIIe siècle (1254–1304)*. Bibliotèque des Écoles Françaises d'Athènes et de Rome 326. Rome, 2005.

Lesnick, Daniel R. *Preaching in Medieval Florence: The Social World of Franciscan and Dominican Spirituality*. Athens, Ga., 1989.

Little, Lester K. "Pride Goes before Avarice: Social Changes and the Vices in Latin Christendom." *American Historical Review* 76 (1971): 16–49.

———. *Religious Poverty and the Profit Economy in Medieval Europe*. Ithaca, N.Y., 1978.

———. "Review of *Les ordres mendiants et la ville en Italie centrale (v. 1220–v. 1350). Mélanges de l'École Française de Rome; Moyen Age–Temps Modernes* 89 (1977) 2, 557–773." *Speculum* 54 (1979): 840–42.

———. *Liberty, Charity, Fraternity: Lay Religious Fraternities at Bergamo in the Age of the Commune*. Bergamo and Northampton, Mass., 1988.

———. *Benedictine Maledictions: Liturgical Cursing in Romanesque France*. Ithaca, N.Y., 1993.

Liuzzi, Fernando. *La lauda e i primordi della melodia italiana*. Rome, 1935.

Lopes Pegna, Mario. "Prato romana." *Archivio storico pratese* 30 (1954): 3–20.

Lucchesi, Emiliano. *I monaci benedettini vallombrosani della diocesi di Pistoia e Prato: Note storiche*. Florence, 1941.

Macci, Loris, and Valeria Orgera. *Architettura e civiltà delle torri: Torri e famiglie nella Firenze medievale*. Florence, 1994.

Manselli, Raol. "Istituzioni ecclesiastiche e vita religiosa." In *Prato, storia di una città: Ascesa e declino del centro medievale (dal mille al 1494)*, I.2: 763–822. Edited by Giovanni Cherubini. Florence, 1991.

Marchini, Giuseppe. *Il duomo di Prato*. Milan, 1957.

———. *Il tesoro del duomo di Prato*. Milan, 1963.

———. "Vicende di una pala." In *Studies in Late Medieval and Renaissance Painting in Honor of Millard Meiss*, I: 320–23. Edited by Irving Lavin and John Plummer. New York, 1977.

———. "La cattedrale di Pistoia." In *Il romanico pistoiese nei suoi rapporti con l'arte romanica dell'occidente, Atti del I convegno internazionale di studi medioevali di storia e d'arte (Pistoia–Montecatini Terme, 27 settembre–3 ottobre 1964)*, 19–32. Pistoia, 1979.

———. "La chiesa di San Fabiano e il seminario." In *Il seminario vescovile di Prato, 1682–1982: Contributi per la storia del seminario nel terzo centenario della fondazione*. Prato, 1983.

Marshall, Richard K. *The Local Merchants of Prato: Small Entrepreneurs in the Late Medieval Economy*. Baltimore, 1999.

Martines, Lauro. *Power and Imagination: City-States in Renaissance Italy*. Baltimore, 1988.

Martini, Anna. "La dedizione di Prato a Roberto d'Angiò." *Archivio storico pratese* 27 (1951): 3–44.

McLean, Alick M. *Sacred Space and Public Policy: The Origins, Decline, and Revival of Prato's Piazza della Pieve*. Ph.D. diss., Princeton University, 1993.

———. "Romanesque Architecture in Italy." In *Romanesque: Architecture, Sculpture, Painting*, 74–117. Edited by Rolf Toman. Cologne, 1997.

Meersseman, Gilles Gérard. "Origine del tipo di chiesa umbro-toscano degli ordini mendicanti." In *Il gotico a Pistoia nei suoi rapporti con l'arte gotica italiana, Atti del secondo convegno internazionale di studi (Pistoia 24–30 aprile 1966)*, 63–77. Pistoia, 1966.

———. *Ordo fraternitatis: Confraternite e pietà dei laici nel medioevo*. 3 vols. Rome, 1977.

Messerer, Wilhelm. *Romanische Plastik in Frankreich*. Cologne, 1964.

Migne, Jacques-Paul (ed.). *Patrologia Cursus Completus: Series Latina*. 221 vols. Paris, 1844–64.

Milanesi, Gaetano (ed.). *Documenti per la storia dell'arte senese*. 3 vols. Siena, 1854–56.

———. *Nuovi documenti per la storia dell'arte toscana dal XII al XV secolo*. Florence, 1893.

Miller, Maureen C. "From Episcopal to Communal Palaces: Places and Power in Northern Italy (1000–1250)." *Journal of the Society of Architectural Historians* 54 (1995): 175–85.

———. *The Bishop's Palace: Architecture and Authority in Medieval Italy*. Ithaca, N.Y., 2000.

Milo, Yoram. "From Imperial Hegemony to the Commune: Reform in Pistoia's Cathedral Chapter and Its Political Impact." In *Istituzioni ecclesiastiche della Toscana medioevale*, 87–107. Galatina, 1980.

Miniati, Giovanni. *Narrazione e disegno della terra di Prato di Toscana tenuta delle belle terre d'Europa*. Florence, 1596.

Molho, Anthony, Kurt Raaflaub, and Julia Emlen (eds.). *City-States in Classical Antiquity and Medieval Italy*. Ann Arbor, 1992.

Moretti, Italo. "L'ambiente e gli insediamenti." In *Prato, storia di una città: Ascesa e declino del centro medievale (dal mille al 1494)*, I: 3–78. Edited by Giovanni Cherubini. Florence, 1991.

———. "L'architettura." In *Prato, storia di una città: Ascesa e declino del centro medievale (dal mille al 1494)*, I.2: 871–906. Edited by Giovanni Cherubini. Florence, 1991.

———. "L'architettura vallombrosana delle origini." In *I vallombrosani nella società italiana dei secoli XI e XII, Primo colloquio vallombrosano (Vallombrosa, 3–4 settembre 1993)*, 239–57. Edited by Giordano Monzio Compagnoni. Vallombrosa, 1995.

Moretti, Italo, and Renato Stopani. *Architettura romanica religiosa nel contado fiorentino*. Florence, 1974.

———. *La Toscana*. Italia Romanica. Milan, 1982.

Morozzi, Guido. "Le chiese romaniche del Monte Albano." In *Il romanico pistoiese nei suoi rapporti con l'arte romanica dell'occidente, Atti del I convegno internazionale di studi medioevali di storia e d'arte (Pistoia-Montecatini Terme, 27 settembre–3 ottobre 1964)*, 35–47. Pistoia, 1979.

Muir, Edward G. "The Virgin on the Street Corner: The Place of the Sacred in Italian Cities." In *Religion and Culture in the Renaissance and Reformation: Sixteenth-Century Essays and Studies* 11: 25–40. Edited by Steven Ozment. Kirksville, Mont., 1989.

The New Oxford Annotated Bible with Apocrypha. New York, 1991.

Nicastro, Sebastiano. "La statua di Re Roberto sulla facciata del palazzo pretorio." *Archivio storico pratese* 2 (1919): 140–47.

Nuti, Giuseppe. "Topografia di Prato nel medioevo." *Archivio storico pratese* 12 (1934): 171–81; 13 (1935): 33–37, 76–84, 131–43; 14 (1936): 112–17.

———. *La fiera di Prato attraverso i tempi*. Prato, 1939.

———. "Aspetti di Prato nel medioevo: La piazza della pieve." *Archivio storico pratese* 27 (1951): 45–68.

———. "Aspetti di Prato nel medioevo: Il palazzo del popolo." *Archivio storico pratese* 29 (1953): 25–48.

———. "Alla ricerca delle origini di Prato: Fino al sec. VI." In *Storia di Prato*, 1–93. Prato, 1980.

Offner, Richard, with Klara Steinweg. *The Fourteenth Century: The Painters of the Miniaturist Tendency*. A Critical and Historical Corpus of Florentine Painting, sec. 3, vol. 9. New edition by Miklós Boskovits. Florence, 1984.

van Os, Henk W. "The Madonna and the Mystery Play." *Simiolus* 5 (1971): 5–19.

Ottokar, Nicola. "Intorno ai reciproci rapporti fra chiesa ed organizzazioni cittadine nel medio evo italiano: Le *operae ecclesiarum* in Toscana e la loro funzione nel processo del trapasso delle chiese nella gestione di organizzazione cittadine (1945)." In *Studi comunali e fiorentini*, 163–77. Edited by Nicola Ottokar. Florence, 1948.

———. *Studi comunali e fiorentini*. Florence, 1948.

Pampaloni, Guido. "Il movimento penitenziale a Prato nella seconda metà del XIII secolo. Il terz' ordine francescano." *Archivio storico pratese* 52 (1976): II, 31–71.

———. "Popolazione, economia, società dalla fine del xiii alla fine del xv secolo." In *Prato, storia di una città: Ascesa e declino del centro medievale (dal mille al 1494)*, I: 359–93. Edited by Giovanni Cherubini. Florence, 1991.

Paul, Jürgen. "Commercial Use of Mediaeval Town Halls in Italy." *Journal of the Society of Architectural Historians* 28 (1969): 222.

Pelagatti, Gioacchino. *Il S. cingolo mariano in Prato fino alla traslazione del 1395*. 2d ed. Prato, 1937.

Pellegrini, Luigi. "Gli insediamenti degli ordini mendicanti e la loro tipologia: Considerazioni metologiche e piste di ricerca." In *Les ordres mendiants et la ville en Italie centrale (v. 1220–v. 1350)*, *Mélanges de l'École Française de Rome: Moyen âge—Temps modernes* 89 (1977): 563–73.

———. "Gli insediamenti francescani nella evoluzione storica degli agglomerati umani e delle circonscrizioni territoriali dell'Italia del secolo XIII." *Chiesa e società dal secolo IV ai nostri giorni: Studi in onore del P. Ilarino da Milano*, I: 195–237. Rome, 1979.

———. *Insediamenti francescani nell'Italia del duecento*. Rome, 1984.

Pensabene, Patrizio, and Clementina Panella (eds.). *Arco di Costantino tra archeologia e archeometria*. Rome, 1999.

Perrig, Alexander. "Formen der politischen Propaganda der Kommune von Siena in der ersten Trecento Hälfte." In *Bauwerk und Bildwerk im Hochmittelalter: Anschauliche Beiträge zur Kultur- und Sozialgeschichte*, 213–34. Edited by Karl Clausberg. Gießen, 1981.

Perroy, Édouard. *Il medioevo: l'Espansione dell'oriente e la nascità della civiltà occidentale*. Florence, 1977.

Petrà, Basilio. "L'origine orientale della devozione pratese." In *La Sacra cintola nel duomo di Prato*, 17–21. Prato, 1995.

Piattoli, Renato. "Il più antico ricordo di Borgo al Cornio, di Prato e del regime consolare." *Archivio storico pratese* 8, fasc. 1 (1928): 29–48; fasc. 2 (1928): 76–96.

———. "I ghibellini del comune di Prato dalla battaglia di Benvenuto alla pace del cardinale latino." *Archivio storico pratese* 14 (1930): 195–240; 15 (1931): 3–58, 229–72.

———. "L'atto di fondazione di San Francesco in Prato." *Studi francescani* 4 (1932): 62–66.

———. "Ricerche intorno alla storia medievale di Prato, I: Dalle testimonianze addotte in una cause tra le Porte S. Giovanni e Tiezi (1269 gen. 1–marzo 24)," *Archivio storico pratese* 16 (1936): 65–75.

———. *Lo statuto dell'arte dei padroni dei mulini sulla destra del fiume Bisenzio*. Prato, 1936.

———. *I consigli del comune di Prato*. Prato, 1940.

Piattoli, Renato (ed.). *Le carte della canonica della cattedrale di Firenze (723–1149)*. Rome, 1938.

Piattoli, Renato, and Ruggero Nuti. *Statuti dell'arte della lana di Prato*. Prato, 1947.

La Piazza nel medioevo e rinascimento nell'Italia settentrionale. IX Seminario internazionale di storia dell'architettura, Vicenza 3–8 settembre 1990, Annali di architettura: Rivista del Centro internazionale di studi di architettura Andrea Palladio 4–5 (1992/93) (1993).

Pope-Hennessy, John. *The Robert Lehman Collection*. Vol. I: *Italian Paintings*. New York, 1987.

Pseudo Brunetto Latini, "Cronica fiorentina del XIII secolo." In *Testi fiorentini del dugento e dei primi del trecento*, 82–150. Edited by Alfredo Schiaffini. Florence, 1954.

Puccinelli, Maria Pia. "La viabilità nel contado pistoiese in rapporto con i monumenti romanici." In *Il romanico pistoiese nei suoi rapporti con l'arte romanica dell'occidente, Atti del I convegno internazionale di studi medioevali di storia e d'arte (Pistoia-Montecatini Terme, 27 settembre–3 ottobre 1964)*, 193–211. Pistoia, 1979.

Radke, Gary. *Viterbo: Profile of a Thirteenth-Century Papal Palace*. Cambridge, Eng., 1996.

Rauty, Natale. *L'antico palazzo dei vescovi a Pistoia*, vol. I. Florence, 1981.

———. "Recensione di Yoram Milo, 'From Imperial Hegemony to the Commune: Reform in Pistoia's Cathedral Chapter and Its Political Impact.'" *Bullettino storico pistoiese*, ser. 3, 16 (1981): 147–50.

Raveggi, Sergio. "Protagonisti e antagonisti nel libero comune." In *Prato, storia di una città: Ascesa e declino del centro medievale (dal mille al 1494)*, I.2: 613–736. Edited by Giovanni Cherubini. Florence, 1991.

Redi, Fabio. "L'architettura a Pistoia al tempo di S. Atto e i suoi rapporti con la cultura della Spagna mozarabica." In *Pistoia e il cammino di Santiago: Una dimensione europea nella Toscana medioevale, Atti del convegno internazionale di studi (Pistoia, 28–30 settembre, 1984)*, 273–89. Edited by Lucia Gai. Naples, 1987.

Redi, Fabio, and Aurelio Amendola. *Chiese medievali del pistoiese*. Pistoia, 1991.

Regesta Chartarum Pistoriensium, Alto Medioevo, 493–1000. Pistoia, 1973.

Il romanico pistoiese nei suoi rapporti con l'arte romanica dell'occidente, Atti del I convegno internazionale di studi medioevali di storia e d'arte (Pistoia-Montecatini Terme, 27 settembre–3 ottobre 1964). Pistoia, 1979.

Roover, Raymond de. "The Concept of the Just Price: Theory and Economic Policy." *Journal of Economic History* 18 (1958): 418–34.

———. "La doctrine scolastique en matiere de monopole et son application à la politique économique des communes italiennes." In *Studi in onore di Amintore Fanfani*, I: 159–79. Milan, 1962.

———. "The Organization of Trade." *The Cambridge Economic History of Europe*, 3: 42–118. Edited by Michael Moissey Postan. Cambridge, Eng., 1965.

———. *San Bernardino of Siena and Sant'Antonino of Florence: The Two Great Economic Thinkers of the Middle Ages*. Boston, 1967.

———. "Labor Conditions in Florence Around 1400: Theory, Policy, and Reality." In *Florentine Studies: Politics and Society in Renaissance Florence*, 277–313. Edited by Nicolai Rubinstein. Evanston, Ill., 1968.

Ross, James Bruce, and Mary Martin McLaughlin (eds.). *The Portable Medieval Reader*. New York, 1977.

Rubinstein, Nicolai. "Political Ideas in Sienese Art: The Frescoes by Ambrogio Lorenzetti and Taddeo di Bartolo in the Palazzo Pubblico." *Journal of the Warburg and Courtauld Institutes* 21 (1958): 179–207.

———. *The Palazzo Vecchio, 1298–1532: Government, Architecture, and Imagery in the Civic Palace of the Florentine Republic*. Oxford, 1995.

Runciman, Steven. *The Sicilian Vespers: A History of the Mediterranean World in the Later Thirteenth Century*. London, 1960.

Ruschi, Pietro. "La polichromia nell'architettura medievale Toscana: Influssi e influenze." In *Il bianco e il verde: Architettura policroma fra storia e restauro*, 21–27. Edited by Daniela Lamberini. Florence, 1991.

Russell, Robert D. *"Vox Civitatis": Aspects of Thirteenth-Century Communal Architecture in Lombardy.* Ph.D. diss., Princeton University, 1988.

La sacra cintola nel duomo di Prato. Prato, 1995.

Salmi, Mario. "La questione dei Guidi." *L'arte* 17 (1914): 81–90.

———. "Pietre e marmi intarsiati e scolpiti." In *Civiltà delle arti minori in Toscana, Atti del I convegno sulle arti minori in Toscana (Arezzo, 11–15 maggio 1971),* 113–20. Florence, 1973.

———. "Prolusione." In *Il romanico pistoiese nei suoi rapporti con l'arte romanica dell'occidente, Atti del I convegno internazionale di studi medioevali di storia e d'arte (Pistoia-Montecatini Terme, 27 settembre–3 ottobre 1964),* 11–15. Pistoia, 1979.

Sanpaolesi, Piero. *La facciata della Cattedrale di Pisa.* Florence, 1957.

———. *Il Duomo di Pisa e l'architettura romanica toscana delle origini.* Pisa, 1975.

Santoli, Quinto. "Un diploma dell'Imperatore Ottone III in favore di Antonino Vescovo di Pistoia." *Bullettino storico pistoiese* 3 (1901): 21–23.

Santoli, Quinto (ed.). *Libro croce.* Regesta Chartarum Italiae, vol. 26. Rome, 1939.

Scarini, Alfio. *Pievi romaniche del Valdarno superiore.* Cortona, 1985.

Schneider, Fedor. *L'ordinamento pubblico nella Toscana medievale: I fondi dell'amministrazione del regno longobardo alla estinzione degli svevi (568–1268).* Edited by F. Barbolani de Montauto. Florence, 1975.

Schwarz, Michael Victor. "Mittelalterliches Dekorationsgefüge: Eine Studie über Schauplätze und Methoden von Antikenrezeption." *Römisches Jahrbuch der Biblioteca Hertziana* 25 (1989): 97–126.

Secchi, Albino. "Restauro ai monumenti romanici pistoiesi." In *Il romanico pistoiese nei suoi rapporti con l'arte romanica dell'occidente, Atti del I convegno internazionale di studi medioevali di storia e d'arte (Pistoia-Montecatini Terme, settembre–3 ottobre 1964),* 101–11. Pistoia, 1965.

Seidel, Max. "Ubera Matris." *Städel Jahrbuch* 6 (1976): 79–84.

———. "Dombau, Kreuzzugsidee und Expansionspolitik. Zur Ikonographie der Pisaner Kathedralbauten." *Frühmittelalterliche Studien* 11 (1977): 348–50.

———. "Sanctissima Imperatrix." In *Giovanni Pisano a Genova,* 121–63. Edited by Max Seidel. Genoa, 1987.

———. *Dolce Vita: Ambrogio Lorenzettis Porträt des Sieneser Staates.* Basel, 1999.

Il seminario vescovile di Prato, 1682–1982: contributi per la storia del seminario nel terzo centenario della fondazione. Prato, 1983.

Serra, Joselita Raspi (ed.). *Gli ordini mendicanti e la città.* Milan, 1990.

Silva, Romano. "Architettura del secolo XI nel tempo della riforma pregregoriana in Toscana." *Critica d'arte* 44 (1979): 66–96.

Simson, Otto Georg von. *The Gothic Cathedral: Origins of Gothic Architecture and the Medieval Concept of Order.* Princeton, 1974.

Sitte, Camillo. *Town Planning According to Artistic Principles.* London, 1965.

Sivieri, Giuseppe. "Il comune di Prato dalla fine del duecento alla metà del trecento, I." *Archivio storico pratese* 47 (1971): 3–25.

Skinner, Quentin. "Ambrogio Lorenzetti: The Artist as Political Philosopher." *Proceedings of the British Academy* 72 (1986): 1–56.

Smith, Christine H. *The Baptistery of Pisa.* Outstanding Dissertations in the Fine Arts, vol. 4. New York, 1978.

Solari, Arturo. "Prato romana?" *Archivio storico pratese* 3 (1920): 145–48; 4 (1921): 97–100.

Spillner, Paula. *"Ut Civitas Amplietur": Studies in Florentine Urban Development, 1282–1400.* Ph.D. diss., Columbia University, 1987, Ann Arbor, 1989.

Spruyt, Hendrik. *The Sovereign State and Its Competitors.* Princeton, 1994.

Stocchi, Sergio. *L'Emilia-Romagna.* Italia Romanica, vol. 6. Milan, 1988.

Storia di Prato. 3 vols. Prato, 1980.

Suckale, Robert. "Aspetti della simbologia architettonica del dodicesimo secolo in Francia: Il santuario." *Arte cristiana* 78, no. 737–38 (1990): 111–22.

Suger, Abbot of Saint Denis. *Abbot Suger on the Abbey Church of St.-Denis and Its Art Treasures.* Edited, translated, and annotated Erwin Panofsky. 2d ed. Gerda Panofsky-Soergel. Princeton, 1979.

Sznura, Franek. *L'espansione urbanistica di Firenze nel Dugento.* Florence, 1975.

Tabacco, Giovanni. *The Struggle for Power in Medieval Italy: Structures of Political Rule.* Cambridge Medieval Textbooks. Translated by Rosalind Brown Jensen. Cambridge, Eng., 1989.

Tafuri, Manfredo, and Francesco dal Co. *Modern Architecture.* 2 vols. Translated by Robert Erich Wolf. New York, 1986.

Theodericus of Würzburg. *Guide to the Holy Land.* Edited by Ronald G. Musto, translated by Aubrey Stewart, 1897. New York, 1986.

Thompson, Augustine. *Cities of God: The Religion of the Italian Communes, 1125–1325.* University Park, 2005.

Toccafondi, Diana. "Legati da una cintura: Devozione, culto e potere a Prato dal medioevo all'età contemporanea." In *La sacra cintola nel Duomo di Prato,* 61–73. Prato, 1995.

Toker, Franklin. "Gothic Architecture by Remote Control: An Illustrated Building Contract of 1340." *Art Bulletin* 67 (1985): 67–71.

Toman, Rolf (ed.). *Romanesque: Architecture, Sculpture, Painting.* Cologne, 1997.

Trachtenberg, Marvin. "What Brunelleschi Saw: Monument and Site at the Palazzo Vecchio in Florence." *Journal of the Society of Architectural Historians* 47 (1988): 14–44.

———. *Dominion of the Eye: Urbanism, Art, and Power in Early Modern Florence.* New York, 1997.

———. "Desedimenting Time: Gothic Column/Paradigm Shifter." *Res* 40 (Autumn 2001): 5–28.

———. "Suger's St. Denis, Branner's Bourges: On Gothic Architecture as Medieval Modernism." *Gesta* 39 (2001): 183–205.

Tronzo, William. "Apse Decoration, the Liturgy, and the Perception of Art in Medieval Rome: S. Maria in Trastevere and S. Maria Maggiore." In *Italian Church Decoration of the Middle Ages and Early Renaissance: Functions, Forms, and Regional Traditions, Ten Contributions to a Colloquium Held at the Villa Spelman, Florence,* 167–93. Edited by William Tronzo. Bologna, 1989.

Vasari, Giorgio. *Le vite de' più eccellenti pittori, scultori ed architetti.* 15 vols. Florence, 1846–70.

Vauchez, André M. "Patronage des saints e religion civique dans l'Italie communale a la fin du moyen age." In *Patronage and Public in the Trecento, Proceedings of the St. Lambrecht Symposium (Abtei*

St. Lambrecht, Styria, 16–19 July 1984), 59–80. Edited by Vincent Moleta. Florence, 1986.

———. *I laici nel medioevo: Pratiche ed esperienze religiose.* Translated by Francesco Sircana. Milan, 1989.

Verzár Bornstein, Christine. *Portals and Politics in the Early Italian City-State: The Sculpture of Nicholaus in Context.* Parma, 1988.

Villani, Giovanni. *Nuova cronica.* 3 vols. Edited by Giuseppe Porta. Parma, 1990–91.

Violante, Cinzio. "Prospettive e ipotesi di lavoro." In *La vita comune del clero nei secoli XI e XII, Atti della settimana di studio (Mendola, settembre 1959),* 1: 1–15, Miscellanea del Centro di studi medioevali, vol. 3. Milan, 1962.

Waley, Daniel Philip. *The Italian City-Republics.* 3d ed. London, 1988.

Weber, Max. "The Protestant Sects and the Spirit of Capitalism." In *From Max Weber: Essays in Sociology,* 267–301. Edited and translated by Hans Heinrich Gerth and Charles Wright Mills. New York, 1946.

———. *The City.* Translated by D. Martindale and G. Neuwirth. New York, 1958.

———. *The Protestant Ethic and the Spirit of Capitalism.* London, 1989.

Wickham, Chris. *Early Medieval Italy: Central Power and Local Society 400–1000.* Ann Arbor, 1989.

Zacour, Norman P. "College of Cardinals." *Dictionary of the Middle Ages,* 93–95. Edited by J. Strayer. New York, 1983.

INDEX

Page numbers in *italics* refer to illustrations. Locations in Prato are listed by name; sites elsewhere are listed by name and cross-referenced by city.

Bettino di Corsino da Prato, 154, 177, 178, 179, 184, *185*

Bisenzio river, *10, 11, 12, 14*

Bisenzio valley, *1*, 35; Alberti holdings in, 19, 41, 43; churches of, 20, 32; economic rise, 77; establishment of Prato and, 35; mountains in upper valley, 41; political control in, 25–26; on regional maps, *13*; settlements in, 15; topography and history of, 11, 14–15

bishop's palace. *See* Lucca; Pistoia

bishops, 17, 20–21, 70; authoritarian control and, 91; consular governments and, 86; vita apostolica (communalis) opposed by, 22

Bologna, 80, 123, 150. *See also* Santo Stefano (Bologna)

Bonato di Baldanza, 89

Bonaventure, Saint, 141, 197

boni homines (laymen of good standing), 41, 70, 77, 85. *See also* laity

Borgo al Cornio (Burgo de Cornio), 15, 25, 127; canons' establishment at, 21; castrum surrounding, 35, 37; establishment of Prato and, 26; map, *16*

Borutta, Sardinia. *See* San Pietro Sorres (Borutta, Sardinia)

Braunfels, Wolfgang, 164

Broletto (communal palace) (Como), 79, 86, 89

Brunelleschi, Filippo, 1

Byzantine empire, 14, 17, 86

campanile (Santo Stefano), 51, *52, 53*, 97, 101–2, *103*; "harmony and order" mandate and, 104; Levaldini family and, 104, 106. *See also* Santo Stefano, Cathedral of

campanilismo (civic pride), 117

Campo dei Miracoli (Pisa), *63, 64*

Camposanto (Pisa), 169

canals, *10, 11, 12, 14, 16*, 35

canon law, 72

canons/canonicate, 15, 18, 40; Alberti counts and, 73; architecture of Santo Stefano and, 75; consular regime and, 44, 93; gifts to, 39; growth of Prato and, 43; as intermediaries, 20–23, 34, 39; lay Pratese and, 62; mendicant friars contrasted to, 134, 135, 137; mission in earthly Jerusalem, 56; reconstruction of Santo Stefano and, 52; religious authority of, 195; Sacred Belt of the Virgin and, 153; San Giovanni Fuorcivitas and, 59; vita apostolica (communalis) and, 37, 39, 43, 44, 53

Canossa, 40, 41

capitalism, 113

Capua gate, 109

Carboncetto (marmolarius), Santo Stefano redesigned by, 43, 50, 75, 78, 175; cloister, 69; Florentine models and, 58–59; Guido's completion of job and, 94–95, 97, 100, 102, 104; incomplete work on, 93–94; laity and, 62; propositura and, 70–71, 74–75; reconstruction plan, *54*; regional sources and, 63, 65; south façade, *42*, 49–50, *52, 52*, 67, 67–69, *68*, 83; stonework, 46. *See also* Santo Stefano, Cathedral of

Carmelite order, 127

Carolingians/Carolingian period, 14, 17, 87, 102

Casa Alberti (House of Alberti), *16*, 19–20, 86, 90, 102; Holy Roman Emperor and, 110; plan, *87*; tower, *88*. *See also* Alberti counts

Casa Pipini, 148

cassero fortification, *201*, 201–2

Castel del Monte (Apulia), *106, 107,* 108

Castel Sant'Angelo (Rome), 202

Castello dell'Imperatore, 162, 186, 202. *See also* Castello di Prato; palatium imperatoris (Imperial Palace)

Castello di Prato, 15, 19–20, 23, 127; construction of, 44; map, *16*; plan, *45*; walled fortifications, 37. *See also* Castello dell'Imperatore; palatium imperatoris (Imperial Palace)

castle. *See* Casa Alberti (House of Alberti); Castel del Monte (Apulia); Castel Sant'Angelo (Rome); Castello dell'Imperatore; Castello di Prato; palatium imperatoris (Imperial Palace),

castrum, 35, 37

cathedral, 38, 135, 146; Florence and Siena, 5. *See also* Florence; Lucca; Pisa; Pistoia; Siena; Virgin, the, cathedrals dedicated to

Catholic Church, 59, 85, 108

centuriation, Roman, *10, 11, 12, 14*

Charlemagne, 19

Charles of Anjou, 188

Chenu, Marie Dominique, 56

Chirico, Giorgio de, 1

Christ as Man of Sorrows (Anonymous), *112, 132, 134*

Christ Crowning the Virgin (Niccolò del Mercia), 157

Christianity: burial ad sanctum, 168–69; cult of saints, 164, 173, 200; divine imperium and, 109; early Christians, 143; imperium and, 116; martyrs of, 15; primitive church, 22, 84

Christmas, 6, 153, 154, 183

churches, 19, 71, 87; arcades in religious structures, 81–82; city fortification walls and, 186; copies of Roman churches, 164; exterior architecture, 59; of mendicant orders, 127; Romanesque, 34, 80. *See also specific churches*

Cincturale (Duccio di Amadore), 154–55, 165, 176, 186, 187, 192

city-republics, Italian, 78, 118; civic space in, 131; failure of communes, 196; mendicant orders in, 150; trade and industrial economy of, 82; vita communalis and, 84

city-states, Greek, 5

civic center, first, 77–79

class interests, 113–14, 133

cloister (Santo Stefano), 18, 20, 23, 33, 34, 34; apostolic iconography of pilasters, 110, 139; apostolic mission and, 39–40; architectural iconography, 52–53, *53*–55, 55–58; Guido da Lucca's work on, 77, 97, 103, 110; image of spiritual brotherhood, 75; numerology and, 53, 55, 62; plan, *13*; reconstruction (12th cent.), 43; as regularly composed space, 149; vita apostolica (communalis) and, 123

Cluny, monastery at, 20

Collegiata (Empoli), *66*

colupnam column, 149

commerce, 6, 14, 18

common life. *See* space, public (civic, urban); vita apostolica [vita communalis]

communes, 5, 82–83; decline and failure of, 6, 196; imperial authority and, 87, 89; mendicant orders and, 136; political violence and, 136, 150, 151; Sacred Belt of the Virgin ritual and, 8; secularization of power and, 78; tyrants in control of, 193; vita apostolica [vita communalis] and, 84

Como. *See* Broletto (communal palace) (Como)

consorterie, 104, 113; Guelph–Ghibelline strife and, 115, 116; imperial alliance with, 107; tower-house complexes of, 90, 90–91, 104

Constantine (Roman emperor), 109, 123

consuls, 43, 75, 195; as advisors to provost, 85; church construction work and, 93; consorterie and, 90–91; contract with Guido da Lucca, 77; hierarchical authority and, 106; palatium of, 83; temporal authority of, 106

Convenevole da Prato, 188

Corinthian columns, 109

Council of the Eight (Prato), 158

Cremona, 79

crusades, 56, 73, 117

Daddi, Bernardo, 165, 166, 179

Dagomari, Michele, 152–53, 165

Dagomari family, 104, 106, 115

damnatio memoriae, 118

Dante Alighieri, 140

demostratio Cinguli, 158

Desiderius, monastery of. *See* Montecassino, monastery at

Diocletian (Roman emperor), 86

Distribution of Stoles of Salvation by Christ (Anonymous), 179

Dominican order, 120, 125, 127, 138, 169; arrival in Prato, 176; avelli of, 183; flagellants, 139; Piazza San Domenico settlement, 129, *129*–31, 131–32. *See also* mendicant orders; Santa Maria Novella (Florence)

domus nova comunis (Prato), 148

Donatello, 155

Dormition of the Virgin (Niccolò del Mercia), *158*

droughts, 186

Duccio di Amadore, 118, 154, 165, 176, 183, 186; commissioned to compose *Cincturale*, 192; Maesta, 184

Durandus, William, 56

Dynes, Wayne, 55

Easter, 6, 153, 154, 183

economy, 14, 35, 38, 57, 199; Alberti counts and, 38; church–state alliance and, 82; decline of, 193; plague (1348) and, 202. *See also* artisans; capitalism; laity; industries; market areas; merchants; Pratese, arcaded market areas and; Prato, Bisenzio